DIDION & BABITZ

LILI ANOLIK

SCRIBNER
New York Toronto London Sydney New Delhi

Scribner
An Imprint of Simon & Schuster, LLC
1230 Avenue of the Americas
New York, NY 10020

First Scribner hardcover edition November 2024

SCRIBNER and design are trademarks of Simon & Schuster, LLC

Simon & Schuster: Celebrating 100 Years of Publishing in 2024

For information about special discounts for bulk purchases,
please contact Simon & Schuster Special Sales at 1-866-506-1949
or business@simonandschuster.com.

The Simon & Schuster Speakers Bureau can bring authors to
your live event. For more information or to book an event,
contact the Simon & Schuster Speakers Bureau at 1-866-248-3049
or visit our website at www.simonspeakers.com.

Interior design by Kyle Kabel

Manufactured in the United States of America

5 7 9 10 8 6

Library of Congress Contol Number: 2024016287

ISBN 978-1-6680-6548-8
ISBN 978-1-6680-6550-1 (ebook)

Excerpts from the poem "Eve" by Ronee Blakley,
© Sawtooth Music, ASCAP, 2022. Used by permission.

IMAGE CREDITS

Pages 20, 43, 67, 68, 112, 140, 179, 221, 226, 266, 270, 279, 302, 314, 331 Eve Babitz Papers,
the Huntington Library, Art Museum, and Botanical Gardens. Courtesy of Mirandi Babitz
and the Huntington Library; pages 35 and 65 © Julian Wasser, courtesy of Craig Krull Gallery,
Santa Monica, California; page 58 courtesy of Walter Bredel; page 69 courtesy of Griffin
Dunne; page 81 from Tulane University yearbook, 1949; page 86 courtesy of Maurice Read;
pages 117, 122, and 169 © Camilla McGrath; page 127 © Henry Diltz; page 145 photo by
Adger Cowans. Dominick Dunne Papers, e_dd_0022, The Dolph Briscoe Center for American
History, the University of Texas at Austin; page 224, courtesy of Susan Doukas;
page 251 courtesy of Jeanne Field; page 335 Joan Didion, Céline Campaign SS 2015,
New York 2014 (uncropped) © Juergen Teller, all rights reserved

To my sons, Ike and Archie.
To Eve's mother, Mae.

PART ONE

L.A. WOMEN

One of the things I'm starting to think about is that serious people just don't think that gossip, the *spécialité de ma maison,* is serious. It's always been regarded as some devious woman's trick, some shallow callow shameful way of grasping situations without being in on the top conferences with the serious men. Gossip has always been considered *tsk tsk.* Only how are people like me—women they're called—supposed to understand things if we can't get in the V.I.P. room? And anyway, I can't stand meetings. I'd much rather figure things out from gossip.

—Eve Babitz

Nobody forces women to buy the package.

—Joan Didion

If intense fascination is love, then I loved Eve Babitz.

I met her in the spring of 2012. She was living in a one-bedroom apartment in a sun-faded building on a motionless street on the east side of West Hollywood. Entering the apartment was difficult, near impossible. Why isn't easy to explain. There was, first of all, her radical strangeness. This sounds like a polite way of calling her nuts, and she was nuts. (Huntington's disease had been eating away at her brain for well over a decade.) But she wasn't only nuts, and she wasn't always nuts. There were plenty of lucid moments. The problem was the stench—black, foul, choking—that surrounded the apartment like a force field.

It was the intensity of my fascination that allowed me to, at last, on a winter's day in 2013, breach the force field, make it past her front door. The lights were off, shades tightly drawn against the California sunshine. I waited for my vision to adjust. It did, and what I saw was full-scale filth: trash piled on every surface, crammed into every crevice, so that it seemed to be growing from the floor, the furniture, the walls; so that it seemed alive, like a species of jungle plant. There was no room to sit, barely to stand. And the smell—that thick, hot stink—clogged my nostrils, my throat. I couldn't swallow or move or think. I had to open my mouth to breathe.

Any hopes I might have had that Eve kept records or personal papers were dashed the instant I crossed the threshold of Unit 2 at 951 North Gardner. Nothing could survive an environment so putrid. Not even Eve, who succumbed to Huntington's on December 17, 2021, age seventy-eight.

Yet something did survive after all. In the deepest reaches of a closet I didn't know existed was a stack of cardboard boxes. These boxes were pristine, the seals of duct tape unbroken. Inside: journals, photos, scrapbooks, manuscripts, letters.

No. Inside: a lost world.

Preface

My book on Eve Babitz, *Hollywood's Eve*, came out in 2019. Writing it was my way of driving a stake through her heart.

It wasn't that I didn't love her. It was that I loved her too much. I'd been in her thrall for nine years. Ever since I bought a used copy of *Slow Days, Fast Company* from a third-party seller on Amazon back in 2010. My appetite for details about her was gnawing, unappeasable. Her sister, her cousin, her old lovers and rivals and companions, were now my friends. And when I wasn't on the phone with her, I was on the phone with them discussing her: her character and past; her motivations, both opaque and lucid; the various plot holes in which her narrative abounded.

My preoccupation was unbalanced, fetishistic. Sick is what it was. And it made me sick—anxious and grasping and, in some obscure yet vital sense, self-abandoned. I needed to stop living her life, reclaim my own. I needed to get violent.

That's what was going on with *Hollywood's Eve*, which, by the way, started out a different book entirely—a book about L.A. from the mid-twentieth century to the early twenty-first, Eve a key figure in it though one among many. And then Eve took over. (To be clear, I don't mean Eve the person, who was, by the time I knew her, an Eve made of shadow, there but not. I mean Eve the energy, Eve the spirit.) Took over with my blessing. The idea was to give in to my obsession, submit to it, let it derange me, so that, by the end, either it would be gone or I would. A kind of auto-exorcism.

As plans go, a risky one. It worked, though. After publication, I no longer felt beset or crazed. Was able to tend to my growing family. (When I met Eve, I was pregnant with my first son. I'd have my second two years later.) Pursue new interests and projects: an oral history of the writers of Bennington College, class of 1986, for *Esquire*; a podcast on former adult star Traci Lords for a company called Cadence 13. To, in short, think about something—*someone*—else.

I was saved.

It was on New Year's Day 2021 that Eve's sister, Mirandi, FaceTimed me. Mirandi and I usually spoke every week but had skipped the last few: holiday madness. And our talk was happy, empty—what we said less important than the act of saying.

We were twenty minutes into the call. She was telling me about Eve and Eve's move the month before to an assisted living facility in Westwood, the one Eve had resisted for years.

"Eve loves it," Mirandi said. Immediately she amended this statement: "Well, Eve doesn't hate it."

I was only half listening. Archie, my younger boy, had entered the room and was tugging on my arm. He wanted to play. Realizing I was nodding even though Mirandi hadn't said anything that required a nod, I forced my head to stop. I bugged my eyes at Archie—a warning—and said to Mirandi, "What does she not-hate about it?"

"There's somebody to clean her room for one thing. And cook."

"It's like living in a fancy hotel. Big surprise she's not bitching." I ignored the look Archie was giving me for *bitching*, then decided not to. "Sorry," I mouthed.

Mirandi laughed. "Yeah, one she never has to check out of."

Pulling Archie onto my lap, I changed my tone, made it serious. "Is there anything she needs? I mean, that I can get her?"

Mirandi to Archie: "Well, hello there, young man." To me: "No, I think she has everything."

"Sure?"

Mirandi raised a finger. "She told me to tell you to send P. G. Wodehouse."

"Did she say which books?"

"No."

"I'll just send a bunch. Text me her address when we get off the phone."

Mirandi said she would, then launched into a convoluted story about the difficulty of closing on Eve's apartment. Eve, it seemed, hadn't paid her mortgage for more than a year. Wells Fargo had sold the note to another company, which had in turn sold it to yet another company, and that company was now demanding Mirandi produce all manner of oddball documents. Plus, the escrow agent, a "darling Jewish Persian," was, all of a sudden, acting less darling, and Mirandi suspected alcoholism.

Archie was getting restless in my lap. I waited for Mirandi to pause, take a breath, so I could break in, let her know I had to go. Only she broke in first, interrupting herself to say, "Oh, I meant to tell you. I was cleaning out Evie's closets—mostly throwing things away—but at the back of one, underneath a whole load of crap, I found these boxes. Mother must've packed them when Evie left Wilton Place all the way back in—" She stopped, her lips moving in silent calculation.

"2001," I supplied automatically.

"That's right. Evie must've forgot about them or she never would've left them alone. Well, I opened one." Mirandi leaned into the screen confidentially. "You're not going to believe what's in it. Letters. Lots of letters—to Eve, from Eve, and . . ."

Mirandi's words had just touched my consciousness, barely grazed it, when I felt my mouth go dry, a queasy flutter in the pit of my stomach. A voice inside my head whispered, *She's back.*

Archie began swinging his legs, a heel connecting painfully with my shin. I pushed him roughly off my lap. He whimpered—a distant buzz.

"Everything all right, honey?" Mirandi said.

I rubbed my eyes, the eyes that used to be mine, and nodded. "Sorry, yes. You were saying about the boxes?"

Mirandi talked, but I couldn't hear a thing she said. Fear and dread were beating in my blood along with my heart, a wet, heavy pump pump pump.

Those boxes.

I kept waiting for Mirandi to ask me to fly to L.A., go through them with her. But weeks passed, and she didn't. And so, as Eve had shoved

them to the back of her closet, I shoved them to the back of my mind. And that's where they stayed for almost a year.

In that almost year, I got things done: I turned the oral history of the writers of Bennington College into a podcast, sold a proposal for a book on the same subject to Scribner, wrote various pieces for various magazines. I took my sons to school, my dog to the park, my husband for granted. Occasionally I cleaned. Less occasionally I cooked. I was never not busy.

And then, a few days before Christmas 2021, Eve, who'd been dying gradually, died suddenly.

Her memorial was held in mid-January. The ceremony ended, and Mirandi pulled me aside. Lowering her mask—Covid was still raging—she asked if I'd go with her to the Huntington Library while I was in town. (The Huntington had acquired Eve's archives, the boxes included, the boxes principally.) Unable to think of a polite way of saying no, I said yes.

The next morning, I took an Uber to the Huntington, just outside Pasadena in San Marino. I arrived before Mirandi. This was intentional. I didn't know what kind of reaction I was going to have and wanted to have it in private.

My driver dropped me at the wrought-iron gates. I walked down a winding path, through the grounds—spectacular, though I scarcely noticed—to the research library. At reception, I slipped off my mask. The guard held up my ID to my face to make sure the two matched. Rubber gloves were given to me, along with the solemn instruction not to touch photographs or negatives bare-handed. I was then led into a large, silent room full of tables. I sat at one in the back, playing with the fingers of the gloves and waiting for the man behind the desk to put down his newspaper, bring over the first box. Above my head a wall clock softly ticked. I listened to it, listened to time, and tried to control my caroming thoughts.

The boxes would turn out to be no big thing, I told myself. Mirandi was doubtless overvaluing their contents. "Lots of letters" probably meant a few faded postcards mixed with dry-cleaning stubs, unpaid bills, junk-mail flyers, and takeout menus from restaurants that had long since gone under. Eve, after all, was the slob of the world. Hadn't Mirandi found Ed Ruscha's *Eve* drawing—worth a couple hundred thousand, minimum—on the filth-covered floor of her bedroom, a giant footprint in the middle of

it, for God's sake? Maybe I came here for nothing. Maybe she really was done with me. Maybe I'd be spared.

At last, the man slid the box onto the tabletop. I smiled my thanks. He didn't smile back, and several seconds passed before I understood why: he couldn't see my smile; it was behind my mask.

The man returned to his desk. I waited for him to reopen his newspaper—a screen between us—then reached for the box. With a trembling hand I lifted the lid.

The first item I pulled out, a letter. It was a page and a half long, typewritten with handwritten corrections, from Eve to "Dear Joan." *Dear Joan.* I stared at those two words—uncomprehended, incomprehensible—until it dawned on me what they meant: "Dear Joan" was *that* Joan, *the* Joan.

Joan Didion.

Excitement rose in my throat like bile. Phrases began leaping out at me: "burning babies," "foggy brains," "ill bred, drooling, uninvited Art." I squeezed my eyes shut. When I opened them, I dragged them to the first line and started to read, making myself go slow.

Dear Joan:

This morning I telephoned and wanted you to read *A Room of One's Own*, because it struck me because I was thinking about what you said about Quintana and the sprinklers and I was again remembering this shimmer of accuracy that Virginia Woolf got in *The Waves* (which you say you haven't read).

It's so hard to get certain things together and especially you and VW because you're mad at her about her diaries. It's entirely about you that you can't stand her diaries. It goes with Sacramento. Maybe it's better that you stay with Sacramento and hate diaries and ignore the fact that every morning when you eye the breakfast table uneasily waiting to get away, back to your typewriter, maybe it's better that you examine your life in every way except the main one which Sacramento would brush aside but which V. Woolf kept blabbing on about. Maybe it's about you and Sacramento that you feel it's undignified, not crickett [*sic*] and bad form to let Art be one of the variables. Art, my God, Joan, I'm embarrassed to mention it in front of you, you know, but you mentioned burning babies in locked cars so I can mention Art.

You said that the only thing you like to do was write. Just think if it were 200 years ago and the only thing you liked to do was write. I know I'm not making sense, but the thing beyond what your article on the women's movement was about was what *A Room of One's Own* is about. The whole women's thing that is going on now is so stark and obscene most of the time that no wonder one recoils in horror. But for a long, long, long time women didn't have any money and didn't have any time and were considered unfeminine if they shone like you do, Joan.

Just think, Joan, if you were five feet eleven and wrote like you do and stuff—people'd judge you differently and your work, they'd invent reasons . . . Could you write what you write if you weren't so tiny, Joan? Would you be allowed to if you weren't physically so unthreatening? Would the balance of power between you and John have collapsed long ago if it weren't that he regards you a lot of the time as a child so it's all right that you are famous? And you yourself keep making it more all right because you are always referring to your size. And so what you do, Joan, is live in the pioneer days, a brave survivor of the Donner Pass, putting up the preserves and down the women's movement and acting as though Art wasn't in the house and wishing you could go write.

It embarrasses me that you don't read Virginia Woolf. I feel as though you think she's a "woman's novelist" and that only foggy brains could like her and that you, sharp, accurate journalist, you would never join the ranks of people who sogged around in *The Waves*. You prefer to be with the boys snickering at the silly women and writing accurate prose about Maria who had everything but Art. Vulgar, ill bred, drooling, uninvited Art. It's the only thing that's real other than murder, I sometimes think— or death. Art's the fun part, at least for me. It's the salvation.

When I reached the last line, I took a deep breath, only to find I couldn't. My breath refused to catch, turn over. All I could do was breathe rapidly, shallowly, skimming off the top of my lungs.

A lovers' quarrel. That's what this letter was. The tone that alternated between j'accuse and groveling, the recriminations and resentments hurled like thunderbolts, the flashes of rage, despair, impatience, contempt. Eve was talking to Joan the way you talk to someone who's burrowed deep under your skin, whose skin you're trying to burrow deep under.

I was hearing a conversation I wasn't supposed to hear, and my eyes listened ravenously. That I was behaving like a sneak and a snoop, a Peeping Tom peering through the keyhole, an eavesdropper crouched beneath the window, didn't escape my attention. And I felt guilty about it, I did. But I couldn't stop. Something profound was being revealed to me.

It wasn't news that Joan and Eve were part of the same scene in the late sixties and early seventies. (The Franklin Avenue scene was what I called this scene in my head because it centered on a ramshackle house in a gone-to-seed section of Hollywood where Joan lived with her husband, writer John Gregory Dunne, and their adopted daughter, Quintana: 7406 Franklin Avenue.) Nor was it news that Joan had done Eve a good turn with *Rolling Stone*. (Joan recommended a piece Eve had written on the girls of Hollywood High to the magazine, and the magazine took it. Eve's first byline.) What was news: that Eve's feelings for Joan were urgent enough, passionate enough, to compel her to write a letter so blatantly aggrieved.

And so subtly vicious. When she refers to Joan as "you, sharp, accurate journalist," she means to draw blood. The letter was written in 1972, by which time Joan had published three books, two of them novels, *Run River* and *Play It as It Lays*, and was about to start a third, *A Book of Common Prayer*. That she thought of her novels as her "real" work, her journalism as what she did in between novels, a way of keeping her hand in, there's little doubt. For Eve to call her a journalist was thus a whopping put-down.

I knew Eve so well. But, after reading this letter, I realized that I didn't know Eve at all. Or, more accurately, that I knew the wrong Eve.

When I was writing *Hollywood's Eve*, I had full access to her. Since 2012, she'd taken my calls day and night, answered any question I cared to ask. I didn't, though, have full access to Eve of, say, 1972; that is, Past Eve. And Past Eve was the Eve I wanted. Past Eve could, of course, be found in Eve's memoir-like books. Only not really, not actually. In converting life into art, Eve had removed herself from the life. In other words, the *I* in her stories wasn't quite the *I* telling her stories, even if all autobiographical writing is poised on the premise that the two are one and the same, a single coherent entity. The letter to Joan proved that they weren't coherent. The *I* voice in it was sharper, darker, more devastated, less casual.

And, besides, 2012-and-beyond Eve might have been honest about her life, but she was—again—at a remove from it. The years had put her at a

remove. She'd grown detached from her earlier self. When I met her, she was old and, in her way, at peace. In this letter, however, she was young and in a fury. Was preserved in the chaos and confusion, turbulence and tension, of the ongoing moment. Time hadn't yet made her impervious. Or healed her wounds. They were raw, bloody, and she was picking at them so they were rawer, bloodier still.

Then there was the third obstacle: her charm. In 2019, New York Review Books Classics released a collection of her best uncollected pieces, including "I Used to Be Charming," about the 1997 fire that nearly burned her alive, leaving her in too much pain for social graces. But that title was baloney. Even at the end, when she'd lost her health, mind, and marbles, she still had her charm, and it wouldn't allow her to admit to anger or unhappiness. (Charm—maintaining it, spinning it—was for Eve a matter of honor, I think.) And it was yet another barrier, yet another remove.

I stood up from the table abruptly, hitting my chair with the backs of my knees, sending it skittering. I left the room, then the building. Once outside, in the privacy of the gardens, I tore off my mask and began sucking in long drafts of cool air.

It was back. My love for Eve's astonishing, reckless, wholly original personality and talent. I knew immediately and with utter certainty that the story I'd been planning to tell, had accepted money to tell—Bennington Class of '86—would have to wait. Instead, I'd tell Eve's story again. Except this time I'd tell it differently. Better. Because I wouldn't be telling just Eve's story. I'd be telling Joan's story, too. Joan, Eve's opposite and double, completing and revealing Eve as Eve completed and revealed her. (What else I realized after reading the letter: that I also knew the wrong Joan. Or, rather, that I knew only the Joan that Joan wanted me to know. I'd always taken Joan at her persona, which I'd never, until this moment, noticed was one.) And because I wouldn't be telling Eve's story alone. The telling would be a joint effort, Eve no longer merely my subject but my collaborator, my colluder, my accomplice, as well. I had her letters now, hundreds of them. And those uncanny pieces of paper, so intimate you didn't read them so much as breathe them, made her more alive than ever, even if she was, technically speaking, dead.

She and I would write this new book together.

I hooked the straps of my mask back over my ears. As I looked up, I spotted Mirandi in front of the library. She was waving at me. I returned

the wave and started to make my way out of the gardens, first slowly, then quickly, then more quickly still. Like I was running from something and to something at the same time.

It was the horror of losing myself in Eve again.

It was the thrill of losing myself in Eve again.

I couldn't get away fast enough.

I could hardly wait.

To the Reader

Didion & Babitz is a book about two women: Joan Didion and Eve Babitz. Their identities are distinct and contained; yet, at the same time, interchangeable and overlapping.

They met in June 1967. A few months before, in March 1967, Ingmar Bergman's *Persona*, also about two women, was released in the United States. The movie tells a story of an actress (Liv Ullmann), who refuses to speak, and her nurse (Bibi Andersson), who is driven to breakdown by this refusal. Really, though, the movie tells a story of spiritual vampirism: of performing and being, speech and silence, linearity and circularity, and domination through passivity. The famous image of Ullmann and Andersson gazing into a mirror, each at her own reflection and at the other's, which is, of course, an alternative version of her own—a mirror that becomes a whirlpool—was often what I pictured while working.

What this book attempts to do:

See Joan Didion plainly; see Eve Babitz plainly. Except Joan Didion can't be seen plainly. She's opaque enough, elusive enough, withheld enough, far-fetched enough, that she's almost a ghost. Not a person so much as a presence. (By design, I believe. She's emotionally secretive to the point that she's very nearly rendered herself emotionally invisible.) And it isn't possible to look at her directly. Only from the corner of the eye, in—and I'm borrowing a phrase of hers here—"fitful glimpses." Or through a glass darkly. Eve Babitz is that glass.

What this book also attempts to do:

Elucidate the complicated alliance between Joan Didion and Eve Babitz, a friendship that went bad, amity turning to enmity, and that had a lasting effect on both writers, as well as on Los Angeles letters and culture in particular, American letters and culture in general. (Confession: I'm calling what they had a "friendship" because I need to trap their dynamic in language; name the space it occupied in society; make it, in a word, official. But, as it happens, their dynamic is untrappable, unnameable, and unofficial. It was simultaneously more than a friendship and less; was as profound and rare as true love, as profound and rare as true hate.)

Elucidate the formation and development of the artistic consciousness, the female artistic consciousness specifically.

Elucidate an era: Seventies L.A., that is, post-Sixties L.A., the Seventies being the aftermath (or hangover) of the Sixties. And elucidate a scene in L.A.: the Franklin Avenue scene; a scene that had for Joan Didion and Eve Babitz all the explosive vitality that the scene at Les Deux Magots on the Left Bank had for Ernest Hemingway and F. Scott Fitzgerald; a scene that would be the making of one, the breaking and then the remaking—and thus the *true* making—of the other.

Both era and scene begin and end with tabloid tragedies. The first is the murder of actress Sharon Tate, her unborn child, and the guests at her house in Benedict Canyon by followers of Charles Manson in the summer of 1969. The second is the murder of actress Dominique Dunne at her house in West Hollywood by her boyfriend, sous chef John Sweeney, in the fall of 1982. Other eras, scenes, and tabloid tragedies will, however, also be explored, recorded, dramatized.

Lastly, a warning: People are inclined to get a little soft in the head where Joan Didion is concerned. They go teary-eyed at the thought of her wifehood, her motherhood, her widowhood, her bereft-motherhood; and prefer to emphasize the romantic aspects of her literary ascent, dismissing or ignoring the unromantic—her draconian discipline, for example, or her hard-driving perfectionism, to say nothing of her greedy and grinding ambition to be great or the coldness at her core. This book, though, will resist the urge to sentimentalize because this book believes that to sentimentalize is to patronize. And because this book expects artists to offer access to worlds otherwise inaccessible, not serve as models for

well-adjusted wholesomeness. (By the way, this book *likes* her greedy and grinding ambition, *likes* her cold core. In this book's opinion, her greedy and grinding ambition and cold core are among her most beguiling traits.) And, finally, because this book is interested in telling the truth rather than a bedtime story.

I don't imagine that Joan Didion ever received real dividends from domestic life, no matter how frequently she referenced her husband and daughter. It was creative life—the splendor of achievement, the mastery of artistry, the glitter of fame—that made her heart skip, her blood sing. And a career as prodigious as hers requires a keen sense of combat, not to mention a brute force of will, both of which she possessed in abundance. She did anything and everything necessary to go all the way. And if she wasn't squeamish about it, what excuse have we?

In other words, Reader: don't be a baby.

Eve in high school.

Eve Bah-bitz with the Great Big Tits

Eve, apart from being a good and important writer herself, is the key that unlocks the very good and very important Joan. We will, therefore, establish Eve first.

Before we cue the "Once upon a time . . . ," though, a note: There are no sections in *Didion & Babitz* that are rewritten versions of sections in *Hollywood's Eve*, except for this one. I think that's because I can't start Eve's story any place but the beginning. Not the beginning beginning since I'm about as interested in where people were born and their lousy David Copperfield childhoods as Holden Caulfield was. The true beginning, which, for me, is the moment a person becomes aware—socially aware, sexually aware, self-aware. That moment happened for Eve, so I've always believed, in the bathroom at Hollywood High School.

And now, cue the "Once upon a time . . ."

It's 1959. You're sixteen, in the eleventh grade. And you're where you are any time you're not in class: the girls' room on the second floor of the Liberal Arts Building of Hollywood High. And you're doing what you're doing any time you're in the girls' room on the second floor of the Liberal Arts Building of Hollywood High: sharing a cigarette with Holly, though you'll call her Sally when you write about her years later in *Rolling Stone*.

Holly, who blew her chance the moment she took it, signed to Twentieth Century–Fox then dropped the next day for bleaching her hair an atomic bombshell shade of blond, Marilyn Monroe's exactly. (The studio didn't want the new Marilyn Monroe as it had the old under contract and shooting *Let's Make Love* right on the lot. It wanted the new Jean Seberg, the fresh-faced beauty plucked out of Iowa and obscurity to play Joan of Arc, and under contract at Columbia.) Holly, who's taken up with a group of twenty-somethings from her acting class, the Thunderbird Girls, knockouts all in blue eye shadow and cinched-waisted cocktail dresses, cruising the Sunset Strip in—what else?—Thunderbird convertibles, spending their weekends in Palm Springs making ring-a-ding-ding with Frank Sinatra. Holly, who chases fifteen milligrams of Dexamyl with four cups of coffee just to drag herself to homeroom. Holly, who is your best friend.

And then there's your family:

Your father, Sol, from Brooklyn, New York, is a studio musician (Twentieth Century–Fox), a former member of both a philharmonic (the Los Angeles) and an orchestra (the Hollywood Bowl), and a onetime regular at Central Avenue jam sessions (with Fats Waller, Jelly Roll Morton).

Your mother, Mae, from Sour Lake, Texas, is an artist, her medium quill and ink. Also, parties. She's known for her beauty and charm; her chignon with the rose in it; her chiles rellenos, the chiles just hot enough.

Your godfather, Igor Stravinsky, from St. Petersburg, Russia, is the mercurial and massively influential composer, his most famous work famous to you because it was featured in that Disney-perpetrated kitsch atrocity, *Fantasia*. (Every time you hear *Le Sacre du Printemps*, you picture those stupid cavorting cartoon dinosaurs.) He gave you your name and a sense of life's supreme possibilities. You gave him an ant farm.

Your house, on the corner of Cheremoya and Chula Vista at the foot of the Hollywood Hills, is packed so full of musicians there's barely space for their instruments: Kid Ory and Joseph Szigeti, Marilyn Horne and Ingolf Dahl. Marni Nixon, whose voice has already come out of the mouths of Sophia Loren (*Boy on a Dolphin*) and Deborah Kerr (*The King and I*), will soon come out of the mouths of Natalie Wood (*West Side Story*) and Audrey Hepburn (*My Fair Lady*), rehearses in your living room.

In your front yard, mowed once a week by Mr. Sorenson, the hired man (no household chores for Sol, can't risk his violinist's hands), the two

Kenneths, Rexroth and Patchen, deliver readings. Poetry, though, bores you blind, so you ask Lucy Herrmann to tell you stories inside. Lucy's husband Bernard—Uncle Benny to you—is putting the finishing touches on the score for Hitchcock's latest thriller-chiller, *Psycho*. (When, in a year's time, you go to the theater to see the movie, you mostly don't because you're covering your eyes with your palms. You do, however, hear Sol's bow and strings shrieking along with Janet Leigh in that shower in cabin one of the Bates Motel.)

There are tales of picnics on the L.A. River with Charlie Chaplin, Greta Garbo, Bertrand Russell, the Huxleys, the picnickers arriving by limousine with baskets prepared by Chaplin's wife, actress Paulette Goddard. "Because she was quite a gourmet," your godmother, Vera Stravinsky, explains to you.

Once, on a vacation to Santa Fe, Sol took a detour, drove to the middle of nowhere, so you could meet the painter Georgia O'Keeffe—tall, ancient, flinty-eyed—observe how she lived. You'd liked the handsome boy who sat at her feet and rubbed them. You hadn't liked the chow dogs who barked at you.

The bell tolls and you take a final drag on your cigarette. As you turn to flick the butt out the window, you see it: the fifty-foot-tall mural of Rudolph Valentino, the exquisite Latin androgyne with almond-shaped eyes, in the role that drove the 1921 moviegoing public into a state of rapture; of frenzy; of insanity. The Sheik, Hollywood High's mascot. The giant close-up, painted on the side of the boys' gymnasium, depicts him in windblown headdress, gazing moodily past the track and football field. Perhaps at Paramount Pictures, a few blocks away on Melrose. Perhaps at Persia's desert splendor, oceans away on the other side of the world.

This reproduction of the silent-screen icon, crude as it is, corny as it is, transfixes you. You can't look away. Now, don't forget. You've got, on the one hand, your high-culture background: Arnold Schoenberg, the composer, laughing as you and your sister Mirandi, younger by three years, get stuck together with bubblegum during the premiere of his latest piece at the Ojai Music Festival; Edward James, the art collector, telling you that your beauty surpasses that of the Marquis de Sade's great-granddaughter; Vera Stravinsky, the dancer and costume designer, teaching you the point of caviar. And you've got, on the other hand, your pop-culture context: Roadside Beach, where you bodysurf and eat pineapple snow cones, eye the juvenile delinquents eyeing you; Hollywood Boulevard, where you join

the crowd in front of Grauman's Chinese Theatre, watch Marilyn Monroe and Jane Russell, in matching cleavages and clashing polka dots, press their palms into wet cement as cameras click and flash; the Luau in Beverly Hills, where you and Holly buy Vicious Virgins (two kinds of brandy, five kinds of rum, a splash of lemonade, and a gardenia floating on top) with your fake IDs, bat your lashes, also fake, at men twice your age.

As if that weren't enough, there's your disposition, naturally romantic. Consequently, the melodrama of the image before you—larger-than-life, large as the movies—grips and beguiles. The longer you stare, the more susceptible you become to its dark fascination, its trashy-profound glamour.

And then, just like that, your imagination is captured, your tastes formed. Even if you don't think much of the movies or the people who make them, your sensibility will be, from this moment on, cinematic. Hollywood, with its appeal to the irrational and the unreal, its provocation of desire and volatility, its worship of sex and spectacle, will forevermore be your touchstone and guiding light. Its ethos is your ethos, its values your values.

You're Eve Babitz, future muse and artist, observed and observer, chronicler of scenes, stealer of them, too; and you're poised to enter a new decade.

* * *

Okay, Reader. I want to get Eve to 1967 and Franklin Avenue, when and where she meets Joan, with maximum efficiency. (I like motion, color, urgency, no explanations or afterthoughts, full speed ahead, and I assume you do too.) To that end, I'll skip over her young adulthood entirely, except for two key moments: (1) the moment she completes her first successful artistic act; (2) the moment she completes her second successful artistic act.

Eve's first successful artistic act: a photograph, taken on October 12, 1963.

Only in order to understand the how and why of it, never mind the what and when, we need to back up slightly, to the spring of 1961.

Eve, eighteen, was drowsing her way through classes at Los Angeles City College during the day, wide-awake and running wild with the Thunderbird Girls at night. And then her mother told her that her father was moving

to Europe—"It was to study the six violin solos of Bach or something, I don't know, Bach was his obsession"—and that the family would be moving with him. They'd be gone for a year, maybe two.

Eve lasted eight weeks. "The only place I liked was London and we spent most of the time in Paris," she said. "I hated Paris because it's actually horrible. It's cold. And French men are so short. In heels I towered over them. I couldn't stand it. I needed to come home."

But home was gone. "My father rented our house, the Cheremoya house, to these crazy people. They ripped up the floors, and destroyed the plumbing, and there was electrical wiring all over the place. Then they ran off without paying rent. My father couldn't do anything other than sell it, I guess. He and my mother bought a house a few blocks away on Bronson, and they did it sight unseen because they were still in Europe with my sister. My aunt Tiby found it for them, and it was perfectly nice. But, for me, the past was torn off right there, right when my parents sold Cheremoya."

Eve went back to LACC. Not, however, to the Thunderbird Girls.

The cause of the break, a book. William Styron's *Lie Down in Darkness*, about the very beautiful and very doomed Peyton Loftis. "The Thunderbird Girls stuck to one book," said Eve, "and I read every book. They all loved *Lie Down in Darkness*. They thought they were the girl in it. I thought it was a miserable excuse to commit suicide, which seemed to be its purpose." (*Lie Down in Darkness* is, in so many ways, an early version of Joan's *Play It as It Lays*, a novel that will also give Eve fits. Peyton Loftis winds up in a body bag for much the same reason that Maria Wyeth, *Play It*'s heroine, winds up in a loony bin: because, according to Styron, the only way to save your life in a compromised world is to take it; because, according to Joan, the only sane response to the modern condition is insanity.) "I never got headaches but I got a headache from that book. And for the Thunderbird Girls, it was their Bible. I'd had enough."

The break, though, was about more than bummer taste in literature. The Thunderbird Girls, with their garter belts and merry-widow corsets, their dreams of alimony checks as big as the Ritz, were the last of a line. They were the height of style yet also, Eve sensed, on the verge of extinction. "They'd perfected a way to be that made them obsolete from just two strokes of God's Japanese paintbrush—Marilyn dying and the Beatles," she later wrote. She was looking for something new.

New came in the form of a friend she didn't like: Myrna Reisman. "Myrna managed to get her way no matter what," said Eve. "Myrna walked up to me one day at LACC and asked me if my godfather was Stravinsky, and I said, 'Yeah,' and she said, 'Great, I'm going to pick you up at eight.' She took me to Barney's. I was nineteen and suddenly life was fun."

Barney's was Barney's Beanery, a bar at the intersection of Holloway and Santa Monica in West Hollywood where young artists did their drinking. There that night, sitting in the back with the young artists—Ed Kienholz, Billy Al Bengston, Robert Irwin—was a young non-artist, Walter Hopps. Hopps was cofounder of the Ferus Gallery, around the corner from Barney's on La Cienega.

Hopps was just thirty in 1962, but he was already one of L.A.'s wisest seers. A fourth-generation Californian, he grew up in Eagle Rock, the son, grandson, and great-grandson of doctors. When it was time for college, he obligingly registered for science classes at Stanford and then UCLA. It was his art history classes, though, that moved him.

Wrote Eve:

> I remember him telling me, somewhere in my past, that while he was majoring in premed he happened accidentally to open some galleries just for diversion. But it wasn't until 1957 or so, when he opened the Ferus Gallery with John Altoon and Ed Kienholz, that the myth of the West began to solidify: "Whatever Walter says goes."
>
> And what Walter Hopps said, subliminally but with perfect control, was, "*This* is the place."
>
> "*This,*" we all sort of wondered, "is the place?" We thought New York was the place. New York *says* it's the place, and we all know New York's right, so how could this—L.A.—be the place?

That L.A. is the place was an unstated statement as simple as it was radical. And it was already familiar to Eve because her parents and parents' friends had been un-stating it to her since she was a child. How exciting it must've been, though, to hear it unstated by somebody who was nearer her own age. Somebody who all the right people thought was the right person. Somebody who was serious business.

L.A.'s primacy was the premise on which Hopps's gallery was based. Unlike, say, the L.A. County Museum, once picketed by Mae and Vera Stravinsky for deeming not a single L.A. artist worthy of space on its walls, Ferus exhibited the work of locals. Its first show was of Boyle Heights' own Wallace Berman, and resulted in a bust by the vice squad: Berman led away in handcuffs. (One of his assemblages contained an erotic drawing. "Okay, where's the dirty stuff?" said the cops as they broke down the door.) The scandal didn't hurt Hopps's standing any with L.A. art patrons, an easily scandalized bunch. Maybe because in his Brooks Brothers suit, starched shirt, narrow tie, and owlish glasses, he looked the very picture of respectability, every inch the doctor he never became.

At the end of the night, Hopps told Eve that if she swung by Ferus, he'd show her things. She swung, he showed: installations by Ed Kienholz; paintings by John Altoon; ceramics by Ken Price; and then, the inside of his apartment, one floor above the gallery. Afterward he said he'd call her.

When he got back from Brazil.

In a couple of months.

"You know *Sex and the City*?" said Eve. "Well, if there'd been a *Sex and the City* out here, Walter would be Mr. Big. He's the guy who's always pulling the rug out from under you."

While Eve waited for Hopps, she killed time with his artists. There was Ed Ruscha—"the cutest"—and Ken Price—"maybe cuter." Also, Ron Cooper—not an artist Hopps showed at Ferus, but an artist nonetheless, and "cute too in a Toshiro Mifune way"—with whom she'd move in, and then, eight days later, out. ("She told me she'd had enough," said Cooper.)

Eve was evidently too busy rolling around on her bed to make it. Recalled a friend who'd drop in on her periodically, "That girl was such a slob. And she had all these guys coming over all the time. I'd look around and be like, 'Where the fuck do they fuck?'"

She couldn't help herself. "She thought the L.A. artists were terrific," said Laurie Pepper, Eve's cousin. "And sex was how she showed her appreciation. She had a crush on the whole scene."

And it was the scene more than any guy in it that Eve thrilled to. "I have always loved scenes," she wrote, "bars where people come in and out

in various degrees of flash, despair, gossip, and brilliance, and the scene at Barney's was just fabulous."

So fabulous, in fact, that the moment she discovered it is steeped in a kind of personal and historical significance. "Paris in the Twenties was what all of us were searching for," said Mirandi. "What Hemingway and Fitzgerald had found in the cafés is what we all wanted—the Moveable Feast. And Eve and I had just been to Paris. There was no sign of that scene. None. We went to La Coupole. We went to Le Dôme. Those places were empty. Nothing was happening. We were so disappointed. And that disappointment is why Eve understood that Barney's was something special. She thought of herself as an artist—a painter—and wanted to be around other artists. And Barney's was where the artists were at. The people there had been drawn by who knows what forces, and they really had been drawn because they came from everywhere. I think Eve looked around, and saw the level of talent, saw all that youth and hope and drive, and said to herself, 'Barney's in L.A. in nineteen sixty-whatever-year-it-was is Paris in the Twenties.'"

That summer, Eve's parents asked her to rejoin them in Europe. This time she'd make a go of it.

It was August 6, 1962, and the Babitzes were driving through the South of France when the Volkswagen bus Sol had just purchased began to sputter and shake. They pulled over in the town of Nîmes. The newspaper headlines there less read than screamed: MARILYN EST MORTE!

Marilyn, no last name required since everybody knew which Marilyn.

Marilyn, who Eve, age ten, walking home from swim class, eyes stinging with chlorine and smog, saw immortalized in front of Grauman's—handprints and high-heel prints.

Marilyn, Eve's beacon of hope ever since Mae pointed out that Marilyn was as much of an artist as the grim-faced and forbidding Georgia O'Keeffe. "I used to wander down Hollywood Boulevard hoping that Georgia O'Keeffe wasn't really just a man by accident because she was the only woman artist, period, but then [my mother] told me Marilyn Monroe was an artist and not to worry," wrote Eve. "And so I realized she was right and didn't."

(A side note: The one unequivocally admiring piece on a woman that Joan wrote was her Georgia O'Keeffe profile. And the reason she was so wild for O'Keeffe was precisely *because* of O'Keeffe's grim-faced and forbidding qualities. She exulted in O'Keeffe's "crustiness" and "pepperiness." Called O'Keeffe a "hard woman," the ultimate compliment for Joan. Here's how you know it was the ultimate compliment for Joan: she paid it to herself. In *The Year of Magical Thinking*, her book about the death of John Dunne, she quoted, multiple times, until it became a kind of refrain or mantra, the social worker who called her a "cool customer." Quoted it ironically, but not really. Really, quoted it sentimentally. She was taken with the description. It's how she saw herself. How she wanted to be seen.)

The barbiturate overdose, a "probable suicide" according to the official ruling, was a shock to Eve, even though Marilyn had been falling apart publicly for years. And in Eve's memory, the news drove her to the brink of nervous breakdown. She told me that her devastation was so profound she had to return to L.A., this time for good. "Well," she said. "I've never been too stable."

But Eve's memory is a mis-memory. She remained in Europe for another seven months.

It was the fall of '63. Eve had been back in L.A. since the spring, which meant Eve had been back at Barney's since the spring, the scene there still so good she didn't have to care about any other. Almost every night, she'd hit up the bar. "I exhausted all the possibilities of Barney's," she wrote. "It would get so that there would be 10 guys who didn't know each other who I'd balled."

Eve was chasing so many men at the same time to distract herself from the fact that, for her, there were only two. Brian Hutton—we'll get to him shortly—was one, except not at that particular moment because he and Eve were in a fight. ("They were always my fights, he was never in them, he used to just wait until I stopped being mad.") Which was why her other one-and-only truly was her one-and-only: Walter Hopps. ("I guess he didn't like South America any more than I liked Europe.")

Hopps was a formative influence on Eve. He taught her how to see.

Hopps's vision, Eve believed, was visionary, his perception extrasensory. What was hidden from other people—i.e., the future—was revealed to

him. He could discern it in the present. For example, Andy Warhol was, in the early sixties, viewed as a commercial artist and therefore not an artist at all. It was Hopps, along with Ferus co-owner Irving Blum, who, in July 1962, gave Warhol his very first fine-arts show: those Campbell's soup cans, thirty-two mouthwatering flavors.

Wrote Eve:

If Walter Hopps decided someone was cool, the person was (in my opinion) cool for all eternity. So when he explained to me one night over chile at Barney's that Andy Warhol was going to have a show at the Ferus, I said, "What? The soup can guy? You're kidding!"

How could that soup can guy be cool? (And his hair?) . . .

"He's seven jumps ahead of everyone else," Walter may have said.

To understand the scope and magnitude of Andy Warhol in 1962 was also to be seven jumps ahead of everyone else. And Eve understood because Hopps made her understand. "Suddenly I had the eyes to see," she said. "Walter gave me the eyes."

And Hopps was about to demonstrate, once again, that his timing was right, his pitch perfect.

October 1963.

Hopps had convinced Marcel Duchamp, who, in 1917, turned a urinal upside down and signed it, thereby bringing into being Pop Art and postmodernism—Duchamp: "It's art if *I* say so"—as surely as he'd laid waste to Western culture and thought—Duchamp: "It's *art* if I say so"—to let the Pasadena Art Museum host his first retrospective. That is, had convinced arguably the most influential artist of the twentieth century, inarguably the most revolutionary, that a landmark moment in the career he was too hip, too avant-garde, to have—in 1921, he retired from art, took up chess—was best handled by an institution nobody'd ever heard of in a town about to become synonymous with the word "geezer." (Jan and Dean's "The Little Old Lady from Pasadena" would drop within the year. *Go granny, go granny, go granny, go!*)

The epochal shift had begun. Los Angeles: from cultural wasteland to cultural hot spot.

The cultural-wasteland talk was nonsense, obviously. Geniuses aren't dumb. To those with established reputations in the arts, the movie industry meant easy money. The reason L.A. was lousy with geniuses, which Eve knew better than anyone since, as a kid, all she had to do was walk from her living room to her kitchen and she'd trip over three at least. And now L.A. was about to announce itself not just as a civilization but as a civilization in its ideal state—"*This* is the place"—and she wouldn't be there to utter a single "I told you so."

Eve's name had been left off the invite list to the party for the show's private opening. Hopps was notoriously absentminded. This oversight, though, was deliberate. How could he bring his girlfriend to the party when he was already bringing his wife?

A brief meditation on Eve and married men:

Sol and Mae Babitz were, in Eve's view, a perfect couple. For them, marriage wasn't happily ever after, it was ecstatically ever after. "My mother was a stacked little hubba hubba from Sour Lake, Texas [who] snagged my father, a kind of N.Y. intellectual Trotskyite Jew," she wrote. Then added, "My parents neck a lot."

Only, before Mae could marry Sol, she had to get rid of her husband. "Oh yeah, Mae's first husband," said Laurie. "Pancho, that's what he was called. If I ever knew his last name, I've forgot. What I'd always heard from my mother about Pancho was that he was an Italian, the headwaiter at one of those movie-star clubs on the Sunset Strip—Ciro's maybe—and that Mae was running around with Sol behind his back." (Eve: "I don't think my mother thought of it as cheating. She felt like she was in a European situation.")

All of which is to say, Eve was bred to both revere matrimony and not take it altogether seriously. Perhaps adultery even struck her as romantic, irresistibly so. And it wasn't as if she couldn't keep herself in check. After all, she never slept with a friend's love or ex-love, no matter how cute he was, how good the drugs he was holding. Honor among thieves, etc.

The Duchamp party began on the evening of October 7, careened into the early-morning hours of October 8.

It wasn't the typical slapdash, slop-pot L.A. art affair—people wearing whatever clothes they'd thrown over their bathing suits, drinking cheap Chablis out of plastic cups, wandering from gallery to gallery. (Monday Night Art Walks, they were called.) It was high style and high gloss and altogether ultra-super-duper: black ties and pink champagne and the Hotel Green.

Guests included movie stars (Dennis Hopper); the children of movie stars (Hopper's wife, Brooke Hayward, daughter of Margaret Sullavan); underground movie stars (Taylor Mead); people played by movie stars (Beatrice Wood, the real Catherine—the Jeanne Moreau role—in Truffaut's *Jules and Jim*); as well as L.A. artists who looked like movie stars (Ed Ruscha, Billy Al Bengston, Larry Bell); and a non-L.A. artist who was making his own version of movie stars, Superstars (Andy Warhol).

Also: Mirandi Babitz, the date of Julian Wasser, a contract photographer covering the event for *Time* magazine. "My little sister went and I didn't," said Eve. "The humiliation and so forth."

Eve hugged her pillow that night and cursed her faithless lover. "I was only twenty, and there wasn't a way I could really get to Walter. But I decided that if I could ever wreak any havoc in his life, I would."

Not an idle threat.

Eve was holding a glass of wine, standing in front of Duchamp's best-known painting, *Nude Descending a Staircase, No. 2*, at the public opening, which she was attending with her parents, home from Europe at last. Every so often, she'd slide her eyes over to Duchamp and Hopps, themselves on exhibit, playing chess on an elevated platform. She was unable to track the game's progress, though, because Julian Wasser wouldn't stop pestering her. "Julian kept coming up to me and saying lewd things like 'Why don't you fuck me?' and being his usual boring self."

And then Wasser came up to her and said something unusual and not in the least boring.

Their conversation, according to draft number six of Eve's optioned-but-never-produced screenplay, *Portrait of the Artist as a Young Slut*, went something like this:

Wasser, unhooking the Nikon from around his neck, said, "I'm going to take a picture of Duchamp and a girl. You want to be the girl?"

"Okay," said Eve.

He popped open the camera, replaced old film with new. "Playing chess."

A beat.

Then Eve said, "Oh, right, because that's what he gave up art for."

Wasser, his eyes on the film as he pulled it taut, "And naked. You, not him."

Another beat.

Then Eve said, "Oh, right, because—" She gestured to the painting.

"Still in?"

"Still in."

Wasser bared his teeth in a grin. "Great. Then we're all set."

"Have you told Duchamp about this?"

"As the French would say, *Non.*"

"Don't you think you'd better? What if he doesn't like it?"

Wasser, Nikon back around his neck, started to walk off, on the job again. "He'll like it."

"What makes you so sure?"

"He's a man, isn't he?"

Eve watched Wasser disappear into the crowd, then drained her glass in a single swallow.

Saturday, October 12, early morning. Eve sat beside Wasser in his shiny toy of a car, a Ford Fairlane convertible, top down. They were headed to the Pasadena Art Museum.

Eve was on the road, but really she was on a cloud. The more she thought about Wasser's idea, the more she liked it: he'd be making *Nude Sitting at a Chessboard*, a sequel to *Nude Descending a Staircase*, with her in the starring role. How brilliant.

How Hollywood, too. What could be more hopeful-ingénue than baring all? It was practically a local rite of passage, the de rigueur desperate act of the camera-ready cutie when the wolf was howling at the door. Even for Marilyn. Especially for Marilyn. (Admitting she was the golden girl and wet dream in the Golden Dreams calendar did as much for Marilyn's career as any movie.) Except Eve wouldn't be baring all to make money. She'd be doing it to make mischief.

And art.

Suddenly, though, Eve wasn't on that cloud anymore, was plummeting to earth. Maybe this wasn't such a hot idea after all. Maybe this was just Wasser laying a line on her. Maybe only a fool wouldn't have known she was about to be played for one. At least there was still time to call it off.

Eve had just opened her mouth when Wasser turned to her. "You aren't going to chicken out, are you?" he said, his tone accusatory.

Not trusting her voice, she shook her head.

Wasser patted her hand, laughed. "Stick with me, kid, and you'll be ruined."

Twenty minutes later they arrived at the museum. After exchanging her blouse and skirt for a smock, she sat at the chessboard in the center of the room. As she waited for Duchamp to appear, Wasser to set up, she chain-smoked, tried to fend off the panicked thoughts swarming her like bees.

At last, everybody was accounted for, all arranged. Wasser gave the signal. Eve rose, her mother's advice ringing in one ear—"Never put anything in writing or a photo"—her father's in the other: "Take his queen!"

She dropped the smock.

Eve and Duchamp were in the middle of their third game and engrossed when Hopps entered the room, stopped short. The gum he'd been chewing fell out of his mouth.

"Hello, Walter," said Eve, barely looking up from the board.

Duchamp inclined his head in a slight bow. "*Bonjour.*"

Hopps just stood there, staring, until Wasser said, "Walter, do you mind? We're working here."

Hopps, making apologetic noises, backed out the door.

In the resulting photograph, Eve and Duchamp sit at a chessboard. Duchamp's hand is raised, his wrist cocked, in anticipation of his next move. Eve, legs crossed at the ankle, chin propped on her palm, waits for him to make it. She might have something on. The radio, for example, or Chanel No. 5. You wouldn't know it from looking at her, though. Not that Duchamp, his sangfroid as immaculate as his suit, is. He has eyes only for the game. Willful obliviousness is essential here. Neither Duchamp nor Eve

can acknowledge her state in any way. If he leers or smirks, if she betrays the faintest hint of nerves or self-consciousness, she'll be truly exposed—naked rather than nude. Art will have become cheesecake, and that will be that. It's a walk across a high wire without a net. Yet both Duchamp and Eve reach the other side, *pas de* sweat. Their mutual aplomb carries the day.

"Take his queen!"
(© Julian Wasser. Courtesy of Craig Krull Gallery, Santa Monica, California)

Eve had certainly progressed since Hollywood High. No longer was she content to be a mere looker-on, a member of the audience. She was ready for her close-up now. Only she refused to take it. Wasser's finger clicked and clicked that morning. In most of the shots, her features were visible. She chose one in which they were not. (Wasser, a rogue but also a gentleman, granted her final say.) And, in so doing, she turned an extroverted gesture into an introverted, a demand for attention into a plea for privacy, stardom into anonymity. The photo was thus a fulfillment of her paradoxical desire: to reveal herself to the world so a single person would see.

What else the photo was: her chance to be Marilyn. In *The Seven Year Itch*, Marilyn was The Girl, a gorgeous ninny bringing the midlife crisis of shy married man Richard Sherman (Tom Ewell) to climax. In Wasser's rendering, Eve was the American Dream made lush, nubile flesh, as though

sprung full-blown from the imagination of the European aesthete, lean as a blade, dry as a bone, opposite her. Like Marilyn, Eve was a sex object who was also a sex subject, exploiting herself every bit as ruthlessly as any of the men—Wasser, Hopps, Duchamp—exploited her. She wasn't just model and muse, passive and pliable, but artist and instigator, wicked and subversive.

"Walter thought he was running the show," Eve told me, her voice cool, deadpan even. "And I finally got to run something."

Posing with Duchamp did for Eve what she hoped it would. It allowed her to get even with Hopps. Get one up on, in fact. He'd achieved the impossible by landing the retrospective, but it's her image that's forever associated with it. ("Every artist on the planet knows [that photograph]," said Wasser.)

She didn't just run his show, she stole it.

*　　　*　　　*

Eve's second successful artistic act: a letter, written on April 14, 1964.

Only, in order to understand the how and why of it, never mind the what and when, we need to back up slightly. Back up slightly again, I should say. (Don't worry, Reader. We won't be retracing our steps. We'll take a different route.)

It's generally reckoned that the Sixties didn't begin in this country until November 22, 1963, when an assassin took out JFK with a magic bullet. For Los Angeles, however, the beginning came sooner, on August 4, 1962, when Marilyn Monroe took out herself with Nembutal. Either way, it was still the Fifties when Eve graduated from Hollywood High in 1960.

Though Eve loved Hollywood High in retrospect, at the time she wanted to be anywhere but there. The sororities ruled the school, and the sororities were beyond her powers of coping. (The Deltas, admitting into their ranks only the coolest and most gilded, were a particular source of torment. "Absolutely the prettiest, cuntiest girls," she said. "Unbelievably pretty and cunty.") She arranged her credits in such a way that she was able to finish a semester early, then knocked off her one remaining semester over the summer.

It was her last official day on campus when Eve got word that the vice principal wished to speak with her. She'd later write, "[I] thought, 'Oh, no, they're not going to tell me I can't spell and now I can't get out, are

they?' but instead [the vice principal] gave me the 'You are now about to embark upon the road of life speech,' which, I hoped, would keep her mind off the fact that come was dripping down my leg."

Dripping cum—geez, Eve really couldn't spell—was a new phenomenon for her.

Surprisingly, maybe even shockingly, Eve wasn't having sex while she was at Hollywood High. Not until the very last week, anyway. To an incredulous me, she said, "I was never asked out on a date the whole time I was in high school. I was pretty and everything, but I was an outsider."

Eve was a game woman, born ready, and with secondary sexual characteristics that were second to none. (She was wearing a 36DD by the time she was fifteen.) So how come she was lagging in the precocity department? Simple. She was self-conscious.

There was, first of all, the Mr. Magoo glasses. "Evie was so goddamn nearsighted," said Mirandi. "I mean, she was practically blind."

There was, too, the preoccupation that matched the Mr. Magoo glasses. "She was constantly reading, I mean, she'd walk reading," said Mirandi. "Mother used to make me walk with her so she didn't get run over by a car." It was *Arabian Nights* as a little girl, *À la Recherche du Temps Perdu* as a teenager. "I picked up Proust when I was in junior high, and I gave him to Eve," said Laurie. "She loved him right away. Loved the dirty parts—the sexual ins and outs, the jealousy over Albertine, all that."

And then there were those 36DDs. Now, Eve would come to regard her breasts as her glory, showcasing them in the tightest of sweaters, chin up, spine straight, a get-a-load-of-these gleam in her eye. But it would take a few years. While she was at Hollywood High, she dressed in loose skirts, baggy shirts, hunching her shoulders so that her body curled in on itself.

Nor did she beguile naturally. It was a learned skill, painstakingly acquired. "Eve practiced everything," said Laurie. "Anybody she thought was seductive and charming she'd study. How do you have a seductive voice? Well, you keep it to a certain volume and pitch. And it was the same thing with her laugh—she worked at it. And she measured her smile, which was the exact right three inches that you need to have a really good smile. She did whatever she could. She put herself in training."

Eve was spared the indignity of leaving high school a virgin. But only just. Paul Glass, twenty-five, a protégé of composer Ingolf Dahl and a friend of her father's, did the honors.

Four months into their affair, Glass left L.A. for Warsaw on a grant. He wrote Eve from Poland. "I cry every time I think that I am not holding you in my arms," he told her. "I can't even care anything about other girls because they are not my one and only Evie."

Eve, though, wasn't fooled. She knew that Glass was just playing his lover-boy part, delivering his lover-boy lines, and that they'd fallen in fantasy rather than love. She had to have him because of his tawny hair, his silky manners, his movie-star friends. He had to have her because she was Stravinsky's goddaughter.

Years later, in a piece called "Sins of the Green Death," she wrote, "After a suitable period of faithfulness, I found out for sure that my flashy lover had gone to the Alps with an old girlfriend, and then I felt free to indulge myself in the huge, new, unbelievably diverse world of men who wanted to sleep with me."

The "flashy lover" is, obviously, Paul Glass. Not once in the piece does she refer to him by name or even fake name, though she does identify the ale he used to accomplish his seduction. "What I'll remember always was not the flashy lover, who is a watery valentine floating translucently in a half-forgotten resort of souvenirs," she wrote. "What I'll remember always was the Rainier Ale."

And, indeed, Paul Glass seemed to have floated right out of her mind. Never did she mention him to me. (She gave my vulgar inquiry—"Who was your first boyfriend?"—the response it deserved: an eye roll followed by a face-palm followed by a non-answer: "Which first boyfriend? I had a lot of first boyfriends.") And yet, I don't believe she found him unmemorable so much as unreal—less a flashy lover than a dream one. And he dissolved upon waking because that's what dreams do.

If Paul Glass was her first boyfriend, Brian Hutton was her first boy-friend who counted. And Brian Hutton she talked about all the time.

On Eve's eighteenth birthday, Mae threw a party. Holly was invited, as were a few of her LACC classmates. Invited, as well, a woman named Deanne Mencher.

"I was a very serious and talented actress," said Mencher. "I'm short, though, and I've always had a weight issue, which limits your roles. But I was the star of the workshop circuit. So, I knew a lot of people, went out a lot. Eve was quite a bit younger than I was. Well, I've never paid much attention to age. Eve liked me, I think, because I was married at the time to Maurice Seiderman. Maurice was this absolute whiz of a makeup man. He's the one who aged Orson Welles in *Citizen Kane*—thinned Orson's hair, dimmed Orson's eyes, put jowls on Orson's face that he made out of foam plastic or something. And he invented all kinds of things having to do with the contact lens. He gave a pair to Eve, quite a gift back then since nobody had them yet. They contributed greatly to her attractiveness. I mean greatly. No more glasses to get in the way of her sex."

Thank goodness, because sex was about to come at her full throttle. Mencher, you see, didn't show up to the party alone. She brought with her a friend, an actor, but making the transition to director: Brian Hutton.

If Walter Hopps taught Eve how to see, Brian Hutton taught Eve how to fuck.

Recalled Mencher, "Brian said, 'What are you doing tonight?' I said, 'I'm going to a birthday party. You want to come?' He and I must have got separated while we were there. And then I find out the next day that he's met Eve and that they're a thing."*

In "Sins of the Green Death," Eve describes seeing him (unlike Paul Glass, Brian Hutton *is* accorded a name/fake name: Graham) for the first time. "[Graham] came in with a friend from an overcast night, so how is it that I remember him still as coming in alone from the stars? . . . He was swamped by girls, deluged in a tangle of beautiful arms and feminine exclamations of flower-petal softness. Three of the prettiest had twisted free of their conversations and it was like Santa Claus in an orphanage. I, it turned out, wasn't the only one."

* Eve also remembered meeting Hutton on her eighteenth birthday and at a party, though at a different party, a wild party she went to after her family party. But Mencher was absolutely adamant that she had it right; Eve had it wrong. "Of course I introduced Eve to Brian," she told me. "What the fuck do you think? Brian was my dear, dear friend. We were very thick. Very, very thick. I was in his acting class. He thought I was a brilliant actress, which made me love him even more. He would have jazz people over to his place, and we'd hang out until three, four in the morning. Eve didn't have anything to do with any of that. Not a fucking thing."

Not even close.

"All the women loved Brian," said Mencher. "He was just so gorgeous. And he was kind of slovenly and he shuffled and he had this earthy sexuality and he carried around a bottle of milk because he had ulcers. I used to talk to my therapist about Brian and go, 'He's so sexy, he's really sexy, but he's always cursing.' I couldn't put it all together. I guess I was quite repressed. But, I mean, he looked just like Tyrone Power. And that mouth of his—filthy! Oh, he had the filthiest mouth!"

It was from Brian Hutton and Brian Hutton's filthy mouth that Eve received her sexual education.

A brief meditation on Eve and sex—or, rather, on Eve and how Eve talked about sex:

On the one hand, freely. She got around and said so. I remember asking her—this was in 2016, at the beginning of the #MeToo movement—if she ever felt she'd been taken advantage of by men. She looked at me, widening her eyes behind her glasses à la Marilyn in *How to Marry a Millionaire*, and said, "What man could take advantage of me? I usually slept with him before he got the chance."

Yet, on the other hand, not freely at all. She didn't dish the dirt or get into the gamy details unless you pushed her, and even then she didn't give up much. For instance, I once had to ask her about the measurements of an old boyfriend, Doors front man Jim Morrison. (I was fact-checking a story told to me by another old boyfriend.) "Yeah, I guess Jim's cock was big," she said. "I didn't notice. Big cocks were never part of my"—she paused as if trying to think of just the right word—"criteria."

It may seem too theatrical—or too perverse—for hot-stuff Eve to be, at bottom, a lady, but that's our girl.

Because Eve was so discreet, it wasn't to her that I turned when I wanted to find out about her love life with Hutton. It was to Mirandi.

"Oh, Brian, Brian," said Mirandi. "Brian was really important to Evie. He was very cute and very hilarious and very married. He was absolutely

her sexual teacher. He showed her how to give head brilliantly, and she showed me, and then we passed it on to Laurie."

I wondered aloud if head was becoming a thing even good girls did by the early sixties.

Mirandi confirmed. "We used to be able to get away with hand jobs, but those days were over. What guys wanted was for a girl to give head and do it well."

When I asked whether girls got as good as they gave, she laughed. "No, we didn't. Eventually we'd clear that one up, but it took us a while. Not Evie, though. Evie got head from the beginning. She was nobody's fool. Unlike the rest of us."

Unlike the rest of us. Those five words ricocheted inside my skull like pinballs, ringing bells, lighting up bulbs.

Now, bear with me, Reader, because I'm about to make an intuitive leap and might land way wide of the mark. I believe that Eve's insistence on getting what she had coming when other women—out of shyness or uncertainty or sheer embarrassment—weren't is connected to her determination to be an artist. Of course, all artists, male and female, have to battle against convention as well as their own demons, so as to forge a sensibility and style. The battle against convention, however, is even bloodier, even more brutal and protracted for women, pre-boomer women especially. (It wasn't until the Sixties that the nineteenth century truly ended in America.) An artist must be willful, selfish, calculating, egoistic, and utterly without scruples. In short, not nice. And niceness is considered by many the sine qua non of womanhood.

What often happens with women artists is that, at a certain point, they need to sacrifice—or think they need to sacrifice—the artist for the woman, renounce their ambition in order to helpmate a husband or raise children or tend a home. In order to perform the duties required of the traditional feminine roles of wife and mother, basically. But that won't happen to Eve. While she'll encounter difficulties of her own, principally in finding her art, she'll prove immune to the biological and social imperatives that are doing a number on the rest of her sex.

Two other words of Mirandi's ricocheting inside my skull: *very* and *married.*

"When Brian got together with Eve he was living with Vicky, the woman he lived with his whole life," said Mencher. "Vicky was seven years older than he was, and very tiny, really quite petite. She had some kind of white-light experience—you know, she tried to commit suicide. After that, she began to wear mostly white, and a lot of it was gauzy. She looked like a wraith if you can envision such a thing. I certainly never talked to Vicky about Eve. Are you kidding? No, never!"

A second brief meditation on Eve and married men:

Earlier I talked about Eve's sexual morality—which laws she flouted, which she obeyed. She was, for instance, willing to have for a boyfriend someone else's husband. But she was not willing to have for a boyfriend someone else's husband if that someone was a friend.

There were those, though, who believed Eve had no sexual morality. To them, she was a shady lady and spider woman. In 1962, Deanne Mencher brought the cake to the wedding of a pair of unknown actors, Sandra Knight and Jack Nicholson. "Eve came with me," said Mencher. "Sandra would not allow Eve in the house. Eve was a pariah because women thought she was going to glom on to their men. She was kind of sleazy. She really was. I mean, that's how she was seen by a lot of women."

The affair with Hutton was full-tilt and only a few weeks old when Eve was informed by Mae that the family was going abroad.

"From the end of the war until 1958, my uncle Sol worked at Fox," said Laurie. "Then, for a bunch of complicated reasons, the musician's union called a strike. Well, that didn't work. The studios just ended up hiring cheaper orchestras overseas. So, that was the end of the studio contracts. In '61—I think '61—Sol got a couple of grants. This was thanks to Stravinsky and some other influential friends, but mostly to Stravinsky. What Sol believed was that the way Bach was played in modern times, with a regular beat and fast, was all wrong. The idea was that he'd go to Europe and record historically correct performances. He took Mae with him. Eve and Mirandi, too."

Eve wasn't happy about leaving L.A. She really wasn't happy about leaving Hutton. But it didn't matter. Even though she was eighteen now

and, in a legal sense, an adult, she was, in a practical sense, a child, and she'd go where her parents told her to go.

From Rome, the only place in Europe she liked because it reminded her of a place in America she loved—"Rome was distilled Hollywood for me"—Eve sent Hutton a letter. (This letter, incidentally, is from one of those cardboard boxes packed by her mother. Is, in other words, a treasure from a treasure chest. Many more treasures to follow.)

It read:

> First & foremost: I didn't get the money from you but I'm sure to soon because [American Express] is forwarding everything to Rome. Thank you for sending it though. I love you—send more (rather horrible aren't I). Second, I don't know when the hell I can get back. The closest chance looks like 6 months from now but even if I do come back I'll be the same dead weight I was before. [I'll] go straight to secretary school or prostitution & knowing me it would be prostitution.
>
> I'll write you lewd fuck letters and do some pornographic drawings for you soon.
>
> Eve

Eve delivered on her promise, writing Hutton dozens and dozens of the lewdest of fuck letters. And Hutton responded in kind. "We got over the 'I want to fuck you' part at the beginning of our correspondence," she explained, "and pretty soon we were elaborating on these fantastic scenes we would have when I came back."

Eve's erotic imagination was being stimulated, certainly. But so was her literary. She was collaborating on a dirty epistolary novel in real time. And then the dirty epistolary novel turned into a different sort of novel entirely.

One of the pornographic drawings that Eve made for Brian Hutton, captioned, "Eat your heart out, lifers!"

She wrote:

After a while (about 30 letters or so) it really became rather a chore to think of new scenes and fantasies and maybe that's where I learned how to write. [Brian and I], sometimes, devoted pages and pages to our respective philosophies and poured out our hearts on paper, folded the paper, put the paper in an envelope, stamped it and sent it off to the person on the other side of the ocean who would understand . . . I sharpened my wits and tried to be more amusing for him.

Keeping a sexual affair going using no touch, only words, will up your verbal game fast. "Eve was sending letters to Brian pretty much every day," said Mirandi. "And at some point she had to stop writing the same old tawdry shit and start to really write. That was in Rome, where she was living on her own. Mother, Dad, and I were in Florence. And Rome is when she began to think she could be a writer. It's when she established her habits. She could be totally on the scene, out every night, at the clubs, doing the boogaloo or whatever the Italian version of the boogaloo is, and then waking up early and absorbing things and writing them to Brian."

Better training for a young writer is hard to imagine.

Eve was out of distilled Hollywood, back in undistilled, by March 1963. "I called Brian and said, 'Give me the money to come home.' And he did."

She moved into the new house on Bronson. "Bronson had these little single-room cottages off the main house," said Laurie. "Income properties—that's what Mae called them, because she and Sol would rent them out. Evie took one. She painted the walls to look like that Jacques Demy movie—you know, the musical, *The Umbrellas of Cherbourg*. She used those same colors, rose and orange and blue and yellow. The cottage was kind of wonderful, even if it was Eve's usual pigsty."

There'd be no more classes at LACC for Eve. What she had left to learn, she decided, school couldn't teach her. "I got a job at this place called the Galton Institute where they do research and compile a bibliography on creative and cognitive processes in children," she told a friend. "What I do is type."

What she also did was write. From an account she gave later:

> I was living in this little paper bungalow—one room with a typewriter . . .
> I was writing my memoirs, of course, because I'd been to Europe (like
> Henry James) and wanted to write a book [that was] about being Daisy
> Miller, only from Hollywood.

Travel Broadens was the book's title. Sometimes she referred to it as
a memoir; other times, a novel. Either way, it was an expansion of her
letters to Hutton.

Eve seemed to know from the jump that she was incapable of inven-
tion. She could write only about herself and what had happened to her.
"Everything I wrote was memoir or essay or whatever you want to call
it," she said. "It was one hundred percent nonfiction. I just changed the
names." Mirandi corroborated: "I was Eve's first reader, always. She'd hand
something to me and say, 'Who's going to kill me if I write this?'"

A month after posing for the Wasser-Duchamp photo, Eve was working like
crazy to finish *Travel Broadens*. In fact, the final scene of *Travel Broadens* is
her posing for the Wasser-Duchamp photo. (Greedy art, scarfing down the
raw material of life without discretion or shame, digesting it, reconstituting
it, almost before it'd been lived!)

Eve was carefully blasé when she talked about *Travel Broadens*, down-
playing any eagerness or anxiety she might have felt. From a letter dated
November 8, 1963, and written to George, no last name, one of her fly-by-
night European romances: "The reason I started writing the thing in the first
place was because people were always asking me what I did and I'd always
have to say 'nothing' or lie." As if the book—"the thing"—were the merest
whim, a way of killing time between party invitations and wolf whistles.

From a letter dated one week later, and written to Mel, no last name
either,* another one of her fly-by-night European romances: "[*Travel
Broadens* is] written exactly like I talk . . . It's got no theam [*sic*] . . . and

* Though it's probably Welles. Mel Welles was an actor, best known for playing Mr. Mushnik
in the 1960 low-budget classic *The Little Shop of Horrors*.

it's pointless. That's the depressing thing about it. On the other hand it's got just <u>tons</u> of style, everyone says, and it's about the most honest (I don't cop out) thing I've ever read in that particular style."

Eve was keeping it light with Mel, same as she did with George. But she was also letting slip a hope and a hunger: she wanted to stun the world.

A definitive *Travel Broadens* doesn't, so far as I know, exist. But three drafts—two handwritten, one typed, with inserts and cross-outs, alternate versions of scenes—were discovered in the cardboard boxes/treasure chests. I've read them all.

Much of the writing in *Travel Broadens* is smart, vivid, original. And accompanying Eve's words are these light-fingered little sketches—very fast, very raffish—that pique and beguile. That's the good news. The bad news is that more of the writing in *Travel Broadens* is undisciplined and unconsidered. Which is why *Travel Broadens* is a creditable effort but, finally, an immature one: juvenilia with pictures. (To be gifted as both a writer and an artist was, I think, a liability to Eve rather than an asset. It kept her from the kind of single-minded focus needed to bring along a talent quickly.)

The work's primary point of interest, aside from the biographical information it imparts, is "Eve." "Eve" as in Eve the character, a fictionalized version of Eve the person. "Eve" will appear in every one of Eve's books, though sometimes she'll go by a different name—Jacaranda, say, or Sophie. The "Eve" in *Travel Broadens* is the spunky heroine of her own debauched romantic comedy. And not just the heroine, the plot, too. The drama of the book *is* the viewpoint, how "Eve" looks at the world, the people in it. "All [*Travel Broadens*] is is a blow by blow discription [*sic*] of how I saw what I saw," she wrote. "<u>Me</u> being a 19 year old, semi-hippy, marijuana smoking, pill taking, balling Sunset Strip cunt."

Charmingly heartless is the effect Eve's going for with "Eve," and she achieves it. The reader is impressed with the speed, the exhilaration, the impiety and incorrigibility, the sheer cheek, of this literary creation.

"Eve," though, isn't enough to compel attention for an entire book, even a short one, which *Travel Broadens*, the longest draft just shy of a hundred and thirty pages, is. After a while, she—or, rather, "she"—maddens, then exhausts. Drawn with a still-childish hand, the strokes bold but crude, "Eve" is Eve without dimension. A cartoon. The complexity of the real-life human has been excised for the sake of maintaining a comic tone. Eve,

as a writer, doesn't yet have the deftness or skill to accommodate shifts in mood or mode. Subtlety is beyond her.

An example of excised complexity is the death of Marilyn. (In case you haven't noticed, Reader, this book treats time in two ways: as linear, continuous, irrevocable; but also as circular, intermittent, flexible. Marilyn will die more than once. So will Jim Morrison. So will Sharon Tate and her houseguests.)

Here's how "Eve" talks about Marilyn's death in *Travel Broadens*:

[My family] arrived [in Nîmes] the day Marilyn Monroe did herself in. We were all heartbroken—most of the women I know are heartbroken about her. But now that I think about it I don't really mind—I mean if that's her shot she might as well do it—stop laying the responsibility on Hollywood's shoulders. Everyone knows she was the biggest chippy in town.

Not-so-charmingly heartless. Grotesquely heartless.

Falsely heartless, as well. Eve, as I mentioned earlier, told me she left Europe after news of Marilyn's overdose broke. Factually off the mark but emotionally spot-on. Marilyn's overdose affected her profoundly. Only she couldn't admit this in *Travel Broadens* because *Travel Broadens* is about how amusing it is to be Eve Babitz. Callousness and cynicism are essential to the amusement. Therefore, all non-callous, non-cynical feelings must be denied.

Brian Hutton is another example of excised complexity. Here's how "Eve" talks about him in *Travel Broadens*:

Brian is the guy that's keeping me and I consult him on all my extracurricular romances, just as he does me. We call it gravy since we know we always have each other. We can afford to dabble.

Eve is acting as if her second-class status in Hutton's life isn't a source of pain. As if her needs and desires are and always have been perfectly aligned with his. As if he is for her a bit of fun, nothing serious.

Here's how Eve talks about him in her journal:

Brian's back . . . I almost wept when he came in and I felt wildly confused, happy, furious . . . I feel so hopeless about him—there's nothing there

that's ever going to work out and he'll never 1) divorce his wife and marry me 2) see me a lot 3) make me his mistress in some dependable way 4) leave me alone. So I'm helpless and that's the story of my life with Brian.

But it wasn't a story she was prepared to tell. Not yet, anyway.

Eve was a man's woman. What I mean when I call Eve a man's woman: I'm not saying she liked to have sex with men, and they with her, though she did and they did. I'm saying there was an instinctive ease between her and them. Partly, I suspect, because of her breasts, which put her under the protection of a kind of charm. But only partly. Men were simply drawn to her. Not just as lovers, as friends. They might, at times, be neglectful of her, forget to consider her feelings. Rarely, however, were they deliberately hurtful. She didn't need to worry that their hearts would close against her suddenly and for no reason. (Earl McGrath—I'll introduce you to him properly in the next chapter—was the exception to the rule. Or maybe Earl McGrath was the exception that proved the rule since Earl McGrath took pleasure in making social mischief in the way that a certain type of amoral female takes pleasure in making social mischief.) She trusted them. And she looked to them for approval, sensing that they were likely to give it.

As a man's woman, Eve naturally turned to men—George, Mel, a few others—for advice on *Travel Broadens*. She'd soon raise her sights.

It was the spring of 1964. Eve decided to drop a line to the preeminent novelist of the day, Joseph Heller, whose black comedy *Catch-22* had knocked her sideways when she read it the year before in Europe. "I had a little office up at my house on Deronda," said Deanne Mencher. "In my memory, I see Eve sitting at my desk. She's coming up with the idea to send this guy a letter and is agonizing over what to say."

What she said:

April 14, 1964

Dear Joseph Heller:

A very terrible thing happened to me. I was born a girl. It would be O.K. if I were ugly or something or even startlingly unattractive, but as

luck would have it, I'm gorgeous, occasionally. Here's the thing. I wrote this fabulous book and I'm trying to get it published. So, I show it to people, and they say, "Gee, this is a fabulous book! Let's hop into bed. I can get it published for you." And that wouldn't be so bad either only everyone is so old and ugly and untalented. It always winds up with me running out of an apartment, clutching my manuscript to my over-developed chest, screaming obscenities all the way home on the bus, usually in a wet bathing suit.

Oh, Joseph Heller, what do you think I should do? I'm only 20 years old and this has happened 8 times already and pretty soon I'm going to run out of people and agents. I'm poor besides.

Sincerely yours,
Eve Babitz

What he said back:

May 26, 1964

Dear Eve:

I did receive the manuscript and did read it with much, much pleasure. I think it is eminently readable, but probably not publishable (there is a difference) but I thought we ought to try anyway. Good as it is, it will require a great amount of editing, more certainly than I could do for you by mail and more possibly than an editor would care to do . . . But since you have written it, and since I would like to see you grow old, fat, and prosperous at an early age, I will, if you have no objection, show the manuscript to my own editor at Simon & Schuster [Robert Gottlieb] and, after he murmurs some unconvincing excuse, to someone I know at Dell-Delacorte, for I know they are looking desperately for books and go wild over dirty ones like yours.

Joseph Heller

What Eve had done a few months prior with the Wasser-Duchamp photo she'd done again with the letter to Heller: played for a famous and significantly older man—Heller was then forty, a married father of two—the sexy young thing while also kidding the idea of playing the sexy young thing. It was artist as pinup. Eve as Marilyn.

Her second artistic success was thus an extension of the breakthrough she made with her first: same method, different medium.

And yet both artistic successes were ultimately artistic failures.

The Wasser-Duchamp photo got Hopps to refocus his attention on her. "It made him return my phone calls, which was what I wanted out of life," she told me. But it wasn't what she wanted out of life. Or at least it wasn't all she wanted. She also wanted a show at the only gallery in L.A. that mattered in her mind, the gallery Hopps started—Ferus—and that she didn't get. She was turned down.

The turn-down she received at the Ferus clubhouse, Barney's, was of a more subtle variety. Some of the Ferus-Barney's artists understood what she was, how special. "Eve was our Kiki of Montparnasse," said Ed Ruscha. Others, though, did not. "I liked Eve, but I didn't like being around her—she was always trying to get in your pants," said Billy Al Bengston. (Victorian notions of feminine decorum had no place in twentieth-century bohemia, yet there they were.) A little ditty was composed in Eve's dishonor: "Eve Bah-bitz / With the great big tits." Observed art critic Dave Hickey, in and around Barney's during this period, "Men artists are very, very welcoming of women artists who are ugly, but if they happen to be beautiful and sexy, the men hate them. A lot of those guys were scared of Eve. Most guys don't deal well with erotic charisma."

Eve put up a defiant front in response. "I thought I was good and my mother who was good thought I was good, and those were the only two opinions I cared about," she said. Still, it was a nasty reception, and I'm sure her feelings were hurt.

And then there was her letter to Heller. It worked better than she ever could have imagined. It led to an introduction to Robert Gottlieb, one of the most powerful editors in the land. In the end, though, it didn't work at all, because Gottlieb would pass on *Travel Broadens*.

I asked Eve why he passed.

"Gottlieb said the book needed more. I didn't know what he meant by 'more,' and I didn't try to find out. I just thought, 'Uh-oh,' and that was it."

Because I, unlike Eve, am incapable of leaving a cryptic remark alone, I said, "What does 'Uh-oh' mean? Were you upset? You must've been."

"Not really," she said. "I didn't care."

"No?"

"They wanted me to be the new Françoise Sagan and *Travel Broadens* to be the new *Bonjour Tristesse* [Sagan's scandalous novel, published in 1954, when Sagan was eighteen]."

"They told you that? They said that's what they wanted?"

Eve bit her thumbnail, impatient. "No, but I knew they did. And it seemed horrible to me to wind up like Françoise Sagan—miserable."

I waited for her to explain miserable how. When she didn't, I said, "Explain—miserable how?"

"Françoise Sagan was a psychotic depressive."

"What makes you so certain?"

"I could just tell. And it was fame that made her that way." Eve said this with a flat finality.

I sighed, changed the subject.

Eve's ambivalence about fame was real. (After all, she's the person who posed nude and then edited out her face, choosing the photograph in which her hair functioned like one of those black censor bars.) Her indifference to rejection, however, was not real, was fake, a cover for devastation. "Eve was so woundable," said Mirandi. "She didn't seem it, only she was. She could barely bring herself to write a thank-you letter to Robert Gottlieb. She couldn't bring herself to, actually. She started, but then she had to stop."

The thank-you letter that Eve started, stopped. It contained the date: June 16, 1964. A greeting: "Dear Mr. Gottlieb." And a single incomplete sentence: "I'm very grateful to you for your kind note on June 1st and I meant to [reply] only things got very confused—"

She would not make another serious attempt to write for seven years.

And Eve's failures weren't just artistic. They were romantic, as well.

"Brian and Eve were in love," said Mirandi. "Both of them, with each other. Eve was sexually in the bag for Brian, but so was Brian for Eve. He couldn't get enough of her in that way. Not that it mattered in the end. Brian was never going to leave his wife. Eve fought him on this, but he just

 

The photo is of a party that's gotten out of hand—people packed together, singly and in groups, vibrating with energy, ready for anything. At the still center is a table, bodies breaking and eddying around it. On the far side is Eve. Hopps, in his signature G-man suit, sits next to her. He's in mid-lip-lick, and light glints off the lenses of his glasses, obscuring his eyes, making him appear a bit wary, a bit compromised. As well he might, out in public with his baby-doll mistress.

Another mistress, the woman with the high cheekbones and dark hair, chicly short, is leaning into him: Jay DeFeo, thirty-six, from San Francisco, the rare female artist represented by Ferus. Her head is almost touching his. What suggestion—or threat—is she about to whisper in his ear?

It's Eve, though, who's the revelation. She seems out of sync with the party, her mood serious, subdued. And, in contrast to the other guests, all of whom, except for Hopps, are done up in the contemporary style, she looks timeless—out of time—in a simple black frock. Her face is turned to the camera, and as I gaze at it, I suddenly understand why she hid it with her hair when she was with Wasser and Duchamp: it's so naked. (As exposed as her body is in the Wasser-Duchamp photo is as exposed as her face—i.e., her soul—is in the Brittin.)

Eve, while scarcely out of her teens, has been assured and decisive in her actions. There was the chess match with Duchamp, of course. And the fan letter–cum–mash note to Joseph Heller. Also, the liaisons with married men. She refused to be intimidated by the opacity of adult sexual life, immersed herself in it instead, and in a way that was beyond reckless, was willfully oblivious to risks and consequences.

Her actions, though, are at odds with her feelings, which are considerably more delicate, nuanced, tentative. As this photo reveals. It's unfinished Eve that's on display here. The Eve whose rawness and tenderness are still raw, still tender, haven't yet hardened into an attitude or style, an armor to protect her from the world. Discernible in her expression is the pain that the romance with Hopps was causing her, the romance with Hutton already had.

And so she runs away from the pain. Runs all the way to New York City.

* * *

Two months before she ran, Eve had a conversion experience. "I was not culturally deprived, okay? My father had the same hat size as Albert Einstein. He got a Fulbright grant, a Ford grant, and then another Fulbright grant. He was this genius violinist and musicologist, and the only rock 'n' roll record he allowed in the house was Chuck Berry. And when I first heard the Grateful Dead and Jefferson Airplane and the Byrds—I mean, I didn't think they could play. Then [in January 1966] David Crosby took me to see the harmonica player Paul Butterfield at a club on Sunset called the Trip."

One performance by the Paul Butterfield Blues Band was all it took. "I couldn't believe it. Paul was so good and his band was so good. Up until then, I'd thought of the Sunset Strip as older. You know, as a place for Bing Crosby and people like that. But then came rock 'n' roll."

Rock 'n' roll, which was fueled by sex. Rock 'n' roll, which burned clean.

By early March, Eve had a new boyfriend: John Densmore. Densmore was the drummer for a band called Sound Machine, the lead singer of which, Clem Floyd, was Mirandi's boyfriend. Densmore was also the drummer for a band called the Doors, the lead singer of which, Jim Morrison, was Mirandi's best friend's boyfriend.

"I already knew Jim through Pam [Courson]," said Mirandi. "But I didn't know him as a singer since I'd never watched the Doors perform. Then one day, after John Densmore had rehearsed with Sound Machine, I drove John and his drum kit to this little hole-in-the-wall club on the Strip called the London Fog. The Doors were doing a sound check. I was at the beginning of an acid trip and sat in the back and listened. Well, I mean, my mind was blown. I couldn't believe that Jim, who I'd never found particularly attractive or interesting, was the same person crooning and shouting into that microphone. After I got home, I called Eve. I told her, 'You have to see this guy. He's Edith Piaf with a dick.'"

A description that was hard to resist. Eve didn't even try. She headed straight for the London Fog. "The first time I saw Jim, he didn't want to be onstage. He wanted to be three seats away. There were only about seven people in the room. He was in love with Pam at that time and I was actually dating another guy in his band. I managed to fuck him when no one was looking."

An excerpt from "Jim," a piece Eve wrote for Joan (above the title, a note: "Joan—for your Morrisoniana files—Eve xoxoxo"), but never gave to Joan:*

"Uh, hi," Jim drawled.

"Take me home," I replied.

"Home?" he asked.

"Yeah," I said. "You're not really going to just stay here now, are you, playing?"

"We don't play. We work."

"Oh," I said, "well, what about tomorrow night?"

So he came over the next night.

But he refused take her to bed until she consented to take him to see her dad. More from "Jim":

One of the things I told [Jim] was how my ridiculous father happened to be playing in an early music concert before a bunch of old ladies in Pasadena that night.

"Oh, let's go," he said.

"You're kidding," I replied.

"No, I'm not," he said. "I'm really interested."

So there we were, parking this '52 Cadillac I had outside Cal Tech where all these old ladies were going inside an auditorium to hear chamber music. And there was Jim wearing this suede outfit [with] pants tight enough to look like paint and this jacket which was bad enough except that without a shirt underneath his perfect lithe young rock n' roll torso shone through like a marble statue.

By the end of the first half during Intermission, I had had enough and I said, "We just have to go."

"Why?" he pleaded.

"Because," I said, "you can't be here. Listening to this. You just can't."

* I know for certain that Eve never gave it to Joan because Mirandi gave it to me. It's tacked to the corkboard above my desk.

The tone of this passage is comic. Eve is telling a funny story about Morrison and herself. But you know that tragedy is coming because of who she compares him to: "Those cheekbones of his, which made the way he looked with his vulnerable, yearning gaze, like Marilyn Monroe."

Morrison got to Eve. And a bond formed between them. Not a bond of the flesh. ("I can't remember what it was like sleeping with Jim Morrison because around him you were bound to be so drunk that things like that just slipped your mind.") A bond of the spirit. And this bond would prove taut yet elastic, evocative yet uncertain, improbable yet unbreakable. I'll talk about it more, but later.

What you need to know now: that Morrison was the start of a new life in L.A. for Eve. Only that start couldn't get started yet. "Three days after I met Jim," she said, "I moved out of L.A."

* * *

On March 6, 1966, Eve's world went from color to black and white when she left the lustrous pastels of her *Umbrellas of Cherbourg*–themed bungalow on Bronson Avenue in Hollywood for the urban-blight gray of a one-bedroom in a tenement on the Lower East Side.

A snatch of dialogue between me and Eve on the subject:

> **ME:** Living in New York—how was it for you?
> **EVE:** That experience was, like, totally downhill and bananas in every way possible.
> **ME:** What made you go?
> **EVE:** I decided to spend a year there even though I didn't want to.
> **ME:** Well, so, why did you?
> **EVE:** To complete my education.

Complete her education, by which Eve meant, of course, reach maturation. She wasn't an adult yet, and she knew instinctively that she couldn't become one in L.A. She had to go elsewhere. To the opposite of L.A. And not just the opposite of L.A., in opposition to L.A. L.A. was, for her, effortless, a piece of cake. And she needed to be in a place that demanded exertion, endurance, defiance. "Anything difficult,

as far as I've been able to determine, seems to work, and anything easy is just kidding yourself," she once wrote.

New York was Eve not kidding herself.

Her first job was at the *East Village Other*, an underground paper. Job as what, though, is the question. "I thought I was supposed to be *EVO*'s publicist," she said, "but I never could actually figure out what my job there was. So I threw a party."

A giant one. "It was an April Fools' Ball. It was held at some place on Bleecker and it was so packed I couldn't move. I was on acid. The Fugs played. A group that staged happenings—Fluxus—was there. Yoko Ono was part of Fluxus, so she was there, too. Her job was to make crepe paper streamers and then toss them all around. It was a den of iniquity, but the streamers made it look like a high school gym on prom night."

Later that spring, Eve, along with *EVO* cofounder Walter Bowart, testified about the ameliorative effects of LSD before a Senate committee that included Ted Kennedy.* The event was covered by the *New York Times*. From the article "Senators Urged to Take LSD 'Trip,'" in the paper's June 16, 1966, edition: "Eve Babitz, 23, a strawberry blonde, remarked of marijuana: 'It's not fattening, you don't get a hangover, it's not addicting . . . Everybody I know uses it except my grandmother.' Asked after the hearing

* In one of the boxes was a postcard addressed to "Senator Theadore [*sic*, plus wrong—Ted wasn't Theadore, he was Edward] Kennedy c/o Subcommittee on Juvenile Delinquency." It read:

> Dear Senator Kennedy,
> Thank you for your tolerance and good manners at the hearing. Mr. Tannenbaum said that you might get furious with us, but you were very understanding.
> I can see that you people must be in a very tough spot. You will surely be able to arrive at a thoughtful conclusion.
> Good luck.
> Peace Love
> Eve
> P.S. We like answering questions.

Eve couldn't have actually mailed this postcard, otherwise it would be in a box in Ted Kennedy's closet, not hers. But she got close. On it, a return address (147 Avenue A / NYC, NY / 10009). A stamp (George Washington, 5¢), too.

why she had not persuaded her grandmother to try, Miss Babitz replied: 'She's turned on already.'"

And it wasn't just Eve's name appearing in print. As *Playboy* had a Playmate of the Month, so *EVO* had a Slum Goddess. Eve was April's. Alongside two photos of her in a low-cut sweater, her hair windblown, her smile white-toothed and ear-to-ear, was a brief introduction: "I'm Eve, fresh from California Beatle-people. Hollywood & Vine, it's hard to make up my mind."

Hollywood & Vine, it's hard to make up her mind.

The Slum Goddess title simultaneously couldn't have mattered less and couldn't have meant more. "It wasn't anything," said Eve. "It was something fat men with cigars came up with, but I had to have it." Maybe because it offered irrefutable proof that she was a young woman making noise, a splash. In any case, she went to considerable trouble to obtain it. "There

was this girl—Robin. And Robin was supposed to be Slum Goddess for that issue. She was prettier than I was and she wore peacock earrings. She should've won, only I did. She'd get me back, though. She'd steal one of my boyfriends."

The boyfriend: Ralph Metzner, German, a PhD from Harvard, co-writer with Timothy Leary and Richard Alpert of 1964's *The Psychedelic Experience*. Robin, according to Metzner, was not the problem. "At the time Eve and I were together, I was using the I Ching. In one of our lovers' discussions around the issue of 'where is this relationship going,' we decided to consult it. The main pronouncement was 'The maiden is powerful. One should not marry such a maiden.' I interpreted that to mean we should discontinue our relationship. Eve, understandably, was pissed. But the oracle was right! The maiden was powerful."

Eve, it seemed, was falling into the same florid patterns in New York that she'd fallen into in L.A. Except something was different. *She* was different. There was in her an underlying sadness or dismay over what had happened—what hadn't happened—with Brian Hutton and Walter Hopps. And that she would have to go it alone in life was starting to look like a distinct possibility.

The feelings you could see in that Charles Brittin photo you can hear in this letter, written by Eve to Mirandi on October 21, 1966:

These days I'm trying very hard to figure out what it is I'm doing. I've thought of a lot of things and one day the thought that I might never live with a man or get married dawned on me. I thought in my mind that there are only three men I got smashed on anyway and two of them were inaccessible (Brian and Chico) and the third was John Barry [an artist], for some reason. And then I got a letter from John Barry. So he wants me to come to Oklahoma, drop everything and marry him and live in Oklahoma. Only, shit! Heaven forbid—Oklahoma! My God! So it turns out I can't do it.

Clearly, Eve was struggling to come to terms with who and what she was. It wasn't until 1974, at age thirty, that she'd declare for the first time,

in print, her intention never to marry—"My secret ambition has always been to be a spinster"—and she did it with a jollity, a bravado. She more than accepted her identity, she gloried in it, seeing the artistic intelligence that isolated her not as a thorn in her side but a star in her crown.

Yet it wasn't ever thus, as this letter, written when she was just twenty-three and still unformed, shows. (That thing I said earlier about her being immune to the biological and social imperatives doing a number on the rest of her sex? Not true. She only *appeared* immune.) She was getting an inkling of where her personality was driving her, of what her fate might be—how stark, how lonely, how extreme—and it scared her.

To be Eve Babitz was a daunting prospect even if you happened to be Eve Babitz.

Eve left *EVO* midsummer. "Walter Bowart said I was embezzling. But I didn't know how much I was supposed to be paid, so I took as much as I thought I deserved. I guess it was too much. He had to find me another job uptown. I worked for a guy who was an ad salesman for magazines. I hated it. I hated being put on hold."

It was more, though, than being put on hold. To her mother, she wrote, "The girls around here—where I work—cannot look beautiful. The whole system's against them looking beautiful. They have to have their hair done and they have to look a certain way and it is impossible for them to look decent."

Reading these words, I think of something Nick Carraway said at the end of *The Great Gatsby*: "I see now that this has been a story of the West, after all—Tom and Gatsby, Daisy and Jordan and I, were all Westerners, and perhaps we possessed some deficiency in common which made us unadaptable to Eastern life." Eve, too, possessed that deficiency. She had a heightened sensitivity to a type of beauty that New York refused to acknowledge—worse, sought to destroy—and therefore she and New York could not comfortably coexist.

Could not even uncomfortably coexist. What Eve wasn't able to say at the time in a letter to her mother, she was able to say years later in a letter to Joseph Heller:

Remember when I lived in New York and had to go to work on the subway every day and I had LSD relapses in the Pan Am Bldg when I went deaf and all the visuals looked cardboard flat? . . . A guy sat on my back and woke me up one morning there in N.Y., Joe, with his [hand] over my mouth and his voice telling me 'Don't scream.' Me being shallow me, I said "why not?" and he was so de-romanticised he finally grumbled 'Oh, o.k., shit,' and swung his legs off me and departed back out the fire escape . . . The worst thing about that gullible rapist was that I had a brand new kitten which I was positive he'd thrown out the window because it was obnoxious and mewed all the time. I went looking out all the windows and into the street in the 13° weather in my bathrobe with a butcher knife[,] and the kitten was nowhere, not in the garbage cans, not out any windows, just nowhere. I finally had to come inside and there the stupid cat had been inside the bedsprings throughout . . . She hadn't woken up. Of course the guy and I did keep our voices down, not wanting to disturb anybody.

It was as though New York to Eve wasn't a city in the real world so much as a forest in a fairy tale—grotesque and disjointed, glinting with menace, drenched in id. And to make it out was her hero's journey, a test of her entire being.

Yet if Eve was wretched in New York, she was often too excited to notice. Things she did while there:

Spend time with Andy Warhol. "We used to meet at Bickford's [cafeteria]. We both ordered the English muffins. He was so wonderful and sweet."

Made time with Joseph Heller. "I saw Joe and I couldn't resist. He was great because his idea of a date was to take me to a Chinese restaurant."

Befriended Carol Granison, a proofreader at *EVO*. "Carol looked just like me except she was Black."

Didn't befriend Edie Sedgwick, a fellow Slum Goddess. "I never met Edie. I didn't want to. I knew she was obnoxious, so I stayed out of her way."

Ran into Jim Morrison. "I saw him in the Village and couldn't believe it. He stayed over in my one-room, no-room apartment in the slums. We

drank enough Italian Swiss Colony Vin Rose that night to make anyone outside rock 'n' roll sick."

Worked for Timothy Leary. "He made me type all his lectures, and he couldn't write. He loved speed and gave it to everybody. I love speed, too, but it was still too high a price to pay, typing up all those goddamned lectures of his."

Got busted by G. Gordon Liddy, future mastermind of the Watergate break-in. "Actually, it was Tim Leary who got busted, but I was there. It was at that estate of his [in] Millbrook—that mansion with the Buddhas all over the place. I don't know why the cops didn't bust me, too. Maybe they thought I was cute."

Connected Frank Zappa to Salvador Dalí. "One of my favorite things I ever did. Dalí was at the St. Regis, and I took Frank Zappa with me. We drank Chartreuse and ate hash candy."

And, most important, took a tip from Walter Hopps.

From a letter she wrote to Sol and Mae:

What happened was that one day [Carol Granison and I] took a little LSD (about last May 12th) and we wandered into this gallery that Chico told me to go to and there were those Joseph Cornell collages that I've mentioned about five thousand times in the past months and that's when it was all over about what I was going to do as far as art is concerned.

Cornell was the *Eureka!* moment for Eve. "I'd always considered myself a prodigy at art," she said. "But what Joseph Cornell was doing was so beyond anything I'd ever seen or even thought of. Afterward I went out and bought all these magazines to make my collages, which is when I started doing art madly."

That Eve should have received Cornell as a revelation isn't altogether surprising. His work was homespun and pie-faced and Americana, and, at the same time, sophisticated and surrealist and European. He did boxes as well as collages, and every box was a private reverie or fantasy. A private movie theater, too. Cornell was an idolater of Hollywood. He'd make boxed tributes to Lauren Bacall, Greta Garbo, Hedy Lamarr, and—of course, naturally—Marilyn Monroe. "Custodian II (Silent Dedication to MM),"

featuring a fragment of a constellation chart, a chunk of driftwood, and a gold ring with a chain, is one of his most mysterious and moving pieces.

Seeing the Cornell show both clarified and advanced Eve's artistic ambition. She'd found her new passion: collage. What's more, she'd found a way to fuse it with her other new passion: rock 'n' roll. She'd make rock 'n' roll album covers from her collages, and thereby outmaneuver the insult and condescension of the Ferus-Barney's artists. (In rock 'n' roll, fucking didn't disqualify you; it put you in the running.)

Realizing that she'd got what she came for and didn't have to stay a second longer, Eve put her collages on a bus, herself and her cat on a plane. "In New York, I was blind, thrusting myself here and there," she said. "I couldn't wait to leave."

And then, one year to the day after she arrived, she was gone.

Social Masterpieces

Eve has made it, Reader. It's 1967, the year she first walked into Joan's house on Franklin Avenue.

So, who was Joan in 1967? A Joan who was not yet Joan Didion.

She'd published her first book, a novel, *Run River*, in 1963, when she was living in New York. *Run River* was assured and arresting. It was also traditional, a generational drama with marriages and divorces, christenings and funerals, changes of fortune, betrayals—probably the reason critics and audiences paid it little mind. ("Traditional" can so easily translate to "dated," "corny," "irrelevant.") A painful outcome for any writer, extra painful for one who wanted to be noticed—nay, spectacular—so badly.

Undoubtedly Joan was a genius. But it isn't enough to be a genius. You must also be lucky: right time, right place.

Joan published her second book, the nonfiction collection *Slouching Towards Bethlehem*, in 1968 (right time), while she was living in L.A., at 7406 Franklin Avenue (right place). In contrast to *Run River*, *Slouching*, its title piece set in the counterculture capital of Haight-Ashbury, where the center isn't holding, not even close, felt contemporary. Dangerously contemporary: a drug dealer eating macrobiotic, a five-year-old tripping on hallucinogens.

It wasn't. What it was: an old-fashioned Gothic tricked out in New Journalism clothing. Sometimes, though, a costume change is all it takes. *Slouching* was a cultural sensation. It made Joan one, too.

In an outtake from Betsy Blankenbaker's 2000 documentary, *New York in the Fifties*, Joan and John Gregory Dunne sit side by side. Dunne says to the camera, "[*Slouching*] was reviewed by someone in the *New York Times*," then to Joan, "Boom!—all of a sudden, you were a figure." *Time* magazine commissioned portraits, sending a contract photographer, Julian Wasser (yes, him again).

Joan Didion, 1968: Cool Rider.
(© Julian Wasser. Courtesy of Craig Krull Gallery, Santa Monica, California)

Wasser's name might be unfamiliar to you, this book the very first time you're hearing it, but the picture you have of Joan in your mind is likely one he took. I'll jog your memory: Joan, hair parted down the middle and flowing past her shoulders, in a long jersey dress, loose yet clinging. Her expression is defiant, dreamy, maybe a little bored. In several shots, she's leaning against a Corvette Stingray, or sitting in the driver's seat, elbow on the window frame, a Pall Mall smoldering between her fingers. Her props give her an authority, a swagger even—the cocksure tilt of that cigarette, the blunt phallic force of that car—but her presence is chaste. (How could Joan be sexual? That desire, erotic or otherwise, might snarl for satisfaction within an aura so cool, a form so slight, seems inconceivable.)

Joan, thirty-three, had at last become Joan Didion. And she'd done it on the Franklin Avenue scene.

7406 Franklin Avenue was Joan's house; 7406 Franklin Avenue was Earl McGrath's scene.

How to explain Earl McGrath, a person who defies explanation? Eve gave it a shot in a 1970 letter to artist Chris Blum. "Would you like to hear about my friend Earl?" she asked, and then proceeded to detail McGrath's early life: first as a runaway Catholic schoolboy from a one-horse town in the Midwest; next as a short-order cook, a merchant marine, the amour of a Zen monk (Richard Baker), the amour of an avant-garde poet (Frank O'Hara). After moving to New York, he took a wife (Countess Camilla Pecci-Blunt) and a job at a studio (Twentieth Century–Fox) before taking acid, at which point he headed to California. "Earl is tall & slim & has a mustache & laughs & says funny things & gets shocked at even funnier things," she wrote. "Earl is wonderful at social masterpieces."

It was McGrath who met Eve first. On a June morning in 1967, Eve, twenty-four, lay in the bed of Peter Pilafian, road manager for the folk-pop group the Mamas and the Papas, when through the door breezed McGrath. McGrath was infatuated with Pilafian. Once he got an eyeful of a sleep-tousled Eve, though, he redirected the flow of his lovey-dovey. A romance, passionate yet sexless, began.

"Earl invited me to dinner & I went & didn't know what to wear," Eve told Blum. "I was uncomfortable at first but Earl's personality and energy are such that once the people got inside . . . all outside social factors were dropped. We might as well not have had names. We were at a benefit for Mr. Kite (Earl) and he loved us with this funny intelligent brilliant radiance like a diamond net. The next day he would call us all up and ask us questions like 'What did you say to Mrs. Dunn—she thinks you are the most brilliant person in California?' ["Mrs. Dunn"—and please note the misspelling—is how Eve refers to Joan in her letters and journal from this period.] The best party he had was one where everything finally got so splendid, so soft like gold silk & so graceful that I really thought I was in heaven."

Mr. Kite: Earl McGrath.

McGrath had a circle. "When Earl came here two or three years ago, he knew no one except the upper crust jet set he'd been accustomed to hanging out with," wrote Eve. "After about six months he had created a society of people who were not only the most talented around but who also all shared these incredible parties . . . He has the best young artists, writers, actors, poets with established people." The established people included Jasper Johns, Claes Oldenburg, Larry Rivers, Roman Polanski and Sharon Tate, Dennis Hopper.

McGrath also had an inner circle. In it:

Michelle Phillips, a Mama in the Mamas and the Papas. (Eve on Phillips: "Beautiful and completely impossible.")

Anne Marshall, a fashion model and Phillips's closest friend. (Eve on Marshall: "Anne went on dates with Cary Grant and Mike Nichols. She was blonde and fox-furred and was always flying to New York and London for the weekend. But she was still a lady. She had manners and wrote

thank-you notes. I once saw her wear a lynx coat to a rock 'n' roll concert, and it brought down the house. She and Michelle did everything together.")

Ron Cooper, the Toshiro Mifune–looking artist. (Eve on Cooper: "If you think *Satyricon* was weird, you should get into Ron Cooper's clutches for a while.")

Peter Pilafian, not just the road manager for the Mamas and the Papas, the electric violinist, as well. (Eve on Pilafian: "I'll go for any violinist no matter what. I see a violinist and I go insane.")

Harrison Ford, before he was Han Solo. (Phillips on Ford: "I didn't even know Harrison was an actor. I remember getting dragged to *Star Wars* at ten a.m. on a Saturday morning. I was sitting there, watching the screen, and all of a sudden Harrison comes on and I gasped and said, 'That's my pot dealer!'")

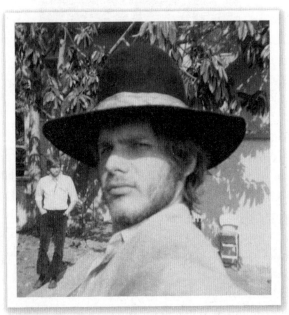

Michelle Phillips's pot dealer, Harrison Ford,
identified in Eve's 1969 scrapbook as "Harry."

And, of course, Joan and Dunne. (Cooper on Joan and Dunne: "I'd go over to their house all the time. Joan and I had a crush on each other,

a junior high school kind of crush, but nothing happened. We'd hang out in her backyard, talk, have a beer, a cocktail, whatever.")

The relationship between Joan and McGrath was a long-standing one, deep and full of funny gallantry. Another romance in which consummation was unthinkable. "Earl and I met in 1962, immediately loved each other, and never stopped," said Joan to *Vanity Fair* in 2016. "I very clearly remember sitting on the front steps [of the Franklin Avenue house] talking to Earl . . . We gave parties together."

The most storied of those parties took place on September 6, 1968. Joan's nephew Griffin Dunne, in junior high and up way past his bedtime, was a guest. "My aunt Joan had written this big deal book. I mean, *Slouching Towards Bethlehem* was over my head. But when I saw an ad for it on a billboard on Sunset even I understood that something important was happening. So, Joan and John were having this party for Tom Wolfe, who was in L.A. promoting *The Electric Kool-Aid Acid Test*. Joan called my mother to invite her and said, 'Janis Joplin is going to come after her show. Why don't you bring Griffin?' I just wandered around and sort of watched adults. Earl and Harrison went as movable art objects. Earl wore all white and Harrison wore all black. They stood back-to-back. And Earl, in white,

Griffin Dunne and his mother, Lenny, guests at the
Tom Wolfe party on Franklin Avenue in 1968.

would start a conversation with someone, then Harrison, in black, would continue it. I think they were stoned out of their minds. I was just waiting for Janis. And no one was really wanting to talk to a thirteen-year-old, except this bald guy in a Nehru jacket and a chain around his neck. He said, 'Boy, come here quick, quick, quick.' And he holds my wrist really tight, puts me in a seat next to him, and goes, 'I have taken ze acid, and I'm having ze bummer. You are ze only ray of light in zis horrible place.' It was Otto Preminger [Austro-Hungarian-born director of *Laura* and *Saint Joan*]. Anyway, there was a parking valet, but most of the cars were stolen in front of the house. Joan complained, and the valet said, 'Well, I didn't know you lived in such a ratty neighborhood!'"

In 1970, Joan's novel *Play It as It Lays* came out. *Play It* was a true product of the Franklin Avenue scene because a nightmare version of the Franklin Avenue scene served as backdrop: the L.A. of the very fast and very famous; Hollywood, L.A. But also because the Franklin Avenue scene was where Joan got her ending.

"Michelle Phillips told the best stories in town," said Eve. "I remember her once lying down on the floor of my apartment [during] a dinner party—Joan and John were there, Earl was there—and telling that amazing story about her friend Tamar."

That amazing story about Phillips's friend Tamar: Tamar Hodel, twenty-six, in despair over a failed love affair, decided to kill herself. She asked a teenage Phillips for help. "I begged Tamar for three days not to commit suicide," said Phillips. "Finally I said, 'If that's what you really want to do, I'm not going to stand in your way.' You know, when you're seventeen, you're really vulnerable and very insecure about everything. So, anyway, Tamar took twenty-six Seconal, then said, 'I want to be dead, but I don't want to look dead.' She went to the bathroom and was putting makeup on. The Seconal hit her all at once, and she went down. Small as I was, I managed to rock her back and forth into the bed. I lay down next to her and went to sleep. The next thing I remember was John [Phillips, Michelle's soon-to-be husband] standing there tickling my feet." An ambulance was summoned, and Hodel, fortunately, saved. "Joan called me up the next day and said, 'Is it all right if I use that story you told in the book I'm working on?' I said, 'Go ahead, it's all yours.'"

In *Play It*'s climax, Maria Wyeth lies in bed with her best friend, BZ, as he overdoses on Seconal. Maria and BZ fall asleep. They're found the next morning by Maria's husband. It's too late to summon an ambulance, and BZ, unfortunately, isn't saved.

Play It was an instant classic. A great Hollywood book, to be placed on the same shelf as F. Scott Fitzgerald's *The Last Tycoon* and Nathanael West's *The Day of the Locust*. And *Play It* is a Hollywood book not only because it's about Hollywood people, but also because it's a book that's (subliminally) a movie.

As the lead, Maria Wyeth, Joan cast herself. Check out the author photo—another Wasser—on the jacket and you'll see what I mean. It could be a headshot: a young woman, delicately pretty, with a slightly pained look on her face, as if she felt a migraine coming on. (Those who'd read "Migraine," Joan's piece in the June 29, 1968, issue of the *Saturday Evening Post*, would know that she suffered from the malady; and one of the first things Maria tells us about herself is, "From my mother I inherited my looks and a tendency to migraine.") This young woman has a gaze so direct it goes straight through the eye of the camera and into the viewer's eye. An actor's trick. Or a movie star's. Fitting since Joan is playing a sometime actor and movie star. (Primary among Maria's credits are the exploitation biker picture *Angel Beach* and the verité-like *Maria*.) Fitting, as well, since Joan didn't have readers, as writers do. No, she had what actors and movie stars have. She had fans.

And if you'd caught the Wasser shots of Joan in *Time*, you'd know that, like Maria, who soothes her jangled nerves by cruising the nerve pathways of the city—the San Diego Freeway to the Harbor to the Hollywood, etc.—Joan drives a Corvette. As you read *Play It*, you can't help but picture Joan cracking hard-boiled eggs on the steering wheel, as Maria does; or drinking Coca-Colas at Union 76 stations, one of Maria's habits. And you can't help it because Joan has designed it so you can't. She's as deliberate a creation as any of her books. (In 1965, Norman Mailer, watching her at a party, observed, "She's a perfect advertisement for herself.")

Stars, though, aren't stars in Hollywood. In Hollywood, directors are stars, stars their props. And in *Play It*, Joan is also that sort of star. If a prose equivalent of freeze-frames and jump cuts exists, then this novel is

full of them. Chapters are fractured, one just twenty-eight words long. And the pages resemble miniature movie screens, so bare are they, so white. There is, too, her way of seeing, eerily similar to a camera's: looking at everything, reacting to nothing, a mode of perception both alienated and alienating.

With *Play It*, Joan's literary fame truly took hold. She was now one of the country's biggest writers. A celebrity writer in the way that Norman Mailer was, or Hunter S. Thompson, or Tom Wolfe. Still more remarkable: that other writers—that is, male writers—allowed her to be a writer who was also a woman instead of insisting she be a capital-W Woman writer.

No modifier on "writer," no flies on Joan.

That Joan wasn't straitjacketed into the role of Woman writer was neither luck nor chance. She did it by being very, very good, and a very, very particular kind of good. A masculine kind of good is the way I would, with some trepidation, characterize it. She was the child of Hemingway, and eager to acknowledge her paternity. "When I was fifteen or sixteen I would type out [Hemingway's] stories to learn how the sentences worked," she said to the *Paris Review*. In fact, she was the son Papa always wanted, even if she was the daughter he never knew he had. Her sentences were, like his, as cold and clear and clean as spring water. Feelings were addressed, though only obliquely. To address them directly would be to violate the cowboy code. And Joan was from Sacramento, technically a city in Northern California, really an outpost of the Old West. (Joan's crush on John Wayne, already saddle-sore when she wrote her profile of him in 1965—"John Wayne: A Love Song"—wasn't, as many wish to believe, ironic.)

Yet alongside this reserve was reserve's opposite: exhibitionism. Every so often, she'd bare herself emotionally—a quick flash—and then cover up again, an impulse I would, with more than some trepidation, characterize as feminine. To wit, letting drop in *Life* magazine that she and Dunne were at the Royal Hawaiian Hotel "in lieu of filing for divorce," a disclosure revealing to the point of pornographic.

These contradictory extremes—of concealment and exposure, mystery and blatancy, male and female—should've canceled each other out but didn't. The paradox was riveting, thrilling.

* * *

"It had not been by accident that the people with whom I had preferred to spend time in high school had, on the whole, hung out in gas stations," wrote Joan. A good line, just not one that applied to her. The people with whom she spent time in high school were, on the whole, middle-class strivers, like herself. (At McClatchy High, she was on the Sophomore Ball committee and the Junior Prom. The student council, too. And the yearbook staff.) Or upper-class already-theres. (Joan was in the Mañana Club, known locally as the "rich girls' sorority," along with Nina Warren, daughter of California governor Earl Warren.) And it continued to not apply when she moved on to college, University of California, Berkeley, though only after Stanford turned her down (she wept at the rejection), and where she pledged Tri Delt (motto: "Let us steadfastly love one another"). Young Joan was, at least outwardly, every inch the all-American bourgeois girl.

The line did apply, however, to Eve, a low-high, profane-sublime bohemian-aristocrat by birth: her Jewish father played in the Twentieth Century–Fox Studio Orchestra during the week, wrote the violin fingering for Stravinsky on weekends; her Cajun-Catholic mother started out a waitress in a hash house, ended up an artist with a purchase prize from the Los Angeles County Museum of Art. (Joan's father, Episcopalian, sold insurance, then real estate; Joan's mother, also Episcopalian, was a homemaker.)

A low-high, profane-sublime, bohemian-aristocrat by temperament: at one of her parents' parties, Eve led Stravinsky by the hand to Stuff Smith, writer of the popular reefer song "You'se a Viper," just before Smith, afflicted mightily with the D.T.s, was carried off on a stretcher.

And a low-high, profane-sublime bohemian-aristocrat by inclination: at Hollywood High, Eve decided that the sororities weren't for her, as the Brownies hadn't been for her at Cheremoya Elementary. "Because there was a group, my style is cramped," she wrote. "I didn't want to be a Brownie girl, I just wanted to be a girl. So I quit." (Joan, incidentally, was a Brownie *and* a Girl Scout.) And after Hollywood High, Eve picked LACC, a city college, over the University of California, Los Angeles. "The only thing they could think to do with girls at UCLA was turn them into

educators," she said. "At least at LACC they left you alone. Besides, the parking was better."

I believe that every true artist is, in a fundamental sense, an outsider artist. Joan was a true artist. Therefore, Joan was an outsider artist. Joan, though, was an outsider artist from the inside. And rather than treating writing as a renegade pursuit and improvisational, she treated it as a rational profession—a *career*—with rules to follow, a ladder to climb. Her way, perhaps, of keeping her eyes from dropping. (If she saw that the ladder was actually a tightrope, she might have lost her nerve. "Aerialists know that to look down is to fall," she wrote. "Writers know it too.") Again and again, she opted for conventional modes and stratagems. As a senior at Berkeley, she won the *Vogue*-sponsored Prix de Paris essay contest. During her seven years at the magazine, she went from promotional copywriter to feature associate. In 1963, the year she got *Run River* published, she also got a husband, or, at any rate, a fiancé: Dunne, the son of a heart surgeon, an Easterner and a Princeton man.

By 1963, Eve, too, had a husband, though he wasn't hers: Walter Hopps (as you know, Reader). And to get back at him for inviting his wife, not inviting her, to the party he was giving Marcel Duchamp, she (as you also know, Reader) agreed to pose for Julian Wasser. In Wasser's photos of Joan and the Corvette, Joan's face is the focus. In Wasser's photo of Eve and Duchamp, Eve doesn't have a face, her face effaced, obscured by her hair. She's just a body, and that body is the antithesis of Joan's—an explosion of voluptuous flesh, and helplessly carnal.

And Eve getting naked for the camera was more than an act of revenge against her lover. It was an act of homage to her idol, the most famous nude model of them all, Marilyn Monroe. (Worth noting: Eve's artistic ideal was the opposite of Joan's. The supremely macho Hemingway, a man of action as well as letters, was a winner—of Pulitzers and Nobels, of Silver Medals and Bronze Stars. The intensely femme Monroe, conversely, was a loser even if she was the biggest star in the world—never so much as nominated for an Oscar, Miss Cheesecake of 1951 the kind of award Hollywood thought she had coming.)

In *Slouching*, Joan wrote, "[Self-respect] has nothing to do with reputation, which, as Rhett Butler told Scarlett O'Hara, is something people with courage can do without." Another good line, but, again, not one that

applied to her. Joan worked on her reputation as diligently as she worked on her books. (The line itself is Joan working on her reputation.) It was Eve who couldn't be bothered.

How having a well-managed versus a carelessly managed reputation plays out for a woman in practical terms: When I asked Wasser if he'd instructed Joan on how to dress or where to stand during their session, he replied, his tone reverent, "With a girl like Joan Didion, you just don't tell her what to do." When I asked him why he'd chosen Eve for the Duchamp photo, he replied, his tone contemptuous, "She was a piece of ass."

Eve stuck it out at LACC for three on-and-off semesters before deciding she preferred a sentimental education to a formal. She transferred to Barney's, an artists' hangout, and thus right where she belonged since an artist is what she was. Only the other artists—all men, naturally—didn't see her as an artist. They saw her as a muse.

A muse, as in one who inspires artists.

One who inspires artists, as in one who fucks artists.

A few of them understood what she was: an original and profound and for real. Yet most saw her the way Wasser did: as a piece of ass. She'd hit a wall, palpable if invisible, of male disdain.

She found a crack in the wall when she shifted focus, from the fine arts to the rock 'n' roll arts. Also, from fine artists to rock 'n' roll artists.

Now, the term "groupie" is one Eve assigned to herself. And, in the strictest sense, she was a groupie; which is to say, a woman in hot sexual pursuit of rock 'n' rollers. But, really, she was a courtesan; which is to say, a woman in hot sexual pursuit of the men of her era who moved and shook. It just so happened that the men who moved and shook in late sixties/ early seventies L.A. were rock 'n' rollers. Playing the courtesan-groupie was how Eve filled herself with the spirit of her time and place. She did it not for the thrill of conquest (though also for that), but to push herself to extremes. Used sex the way she used drugs. To, in the words of her first rock 'n' roller, Jim Morrison, "break on through to the other side." Reach exaltation. Transcendence.

In 1967, Eve convinced Stephen Stills to let her do the cover art for his band's next album, *Buffalo Springfield Again*. "I knew my early days of fucking around would pay off," she told Walter Hopps.

And for a while, they did. On Franklin Avenue, she wasn't looked down on for having a past that was very much her present. If anything, her sexual notoriety enhanced her value. "In every young man's life there is an Eve Babitz," said McGrath. "It is usually Eve."

And then the crack in the wall closed.

"Earl decided I was beyond the pale about 8 months ago," wrote Eve in that letter to Blum. "He decided I was vulgar or something."

My guess is that McGrath's envy rather than Eve's vulgarity was the reason he turned on her. Guys he was pining for, she was sleeping with— Peter Pilafian, but also Harrison Ford. "Earl was in love with Harrison," said Eve. "One time Earl and Harrison and I were taking acid at the beach in Malibu. And then I suddenly decided we had to go home because there were too many cops around, so we drove all the way back to Hollywood. We stopped for breakfast at the Tropicana. Harrison started talking about working on a movie with—what's the name of Barbra Streisand's first husband? Elliott Gould? Harrison said he thought Elliott was a nice guy. Well, Earl stood up and threw all the dishes on the floor."

In retaliation, McGrath attacked Eve where she was vulnerable. A year and a half into their friendship that had morphed into something else, he introduced her to Ahmet Ertegun, cofounder and president of Atlantic Records, ruler of the music world. (Rock 'n' roll stars, the dissolute princes of the age, bowed to *his* whims and wishes.) "Ahmet was interviewed on some TV show," recalled Laurie. "The interviewer said, 'Who are the beautiful people?' And Ahmet said, 'They know who they are.' He was talking about people with money, power, taste—people like him. Eve was quoting that line for days."

McGrath began working for Ertegun in a formal capacity in 1970, when Ertegun gave him a label to run, Clean Records—"Every man should have a Clean record"—but he was already working for Ertegun in an informal way. He was Ertegun's social director. In other words, Ertegun's procurer. Not something Eve would've known when he brought Ertegun to her apartment in 1969.

Ertegun was a cultivated man, an artist as well as a kingpin. (He wrote the lyrics for Ray Charles's "Mess Around," sang backup on Big

Joe Turner's "Shake, Rattle and Roll.") But there was a barbarous side to his nature, and he'd reveal it in his relationship with Eve, which wasn't a relationship at all, which was an arrangement. "Ahmet would call up Eve late at night, and she'd go over to the Beverly Hills Hotel," said Mirandi. "He always had the best drugs. Not just the best drugs, the best exotic drugs. He'd have things like opium. And there was room service all over the place, and champagne on ice. Evie loved all that. And she'd service him or whatever, and then she'd go home."

Eve had always been about overindulgence—profligacy and promiscuity, reckless and spectacular consumption—yet she'd remained unspoiled. Her capacity for pleasure was large, movingly so. Any delights or diversions that came her way, she accepted with gratitude. Which meant that her depravity was all on the surface. Underneath, she was an innocent.

That changed with Ertegun. "There would be times that we went to Earl's, after a show or a concert," said Mirandi. "I'd see the mix of people who were there. Top music people, like Mick Jagger. And I remember all of them talking around a table. They were half-cocked, drunk, and full of whatever. And the talk was so mean and mean-spirited. It would be directed at the girls, sometimes at Eve—these horrible put-downs. Most of the girls would just crumble. Not Eve. She'd figure out what the deal with you was and just go for the jugular. She'd say things that would cut you in half. And drugs like cocaine made her even more surly. So she'd give it right back to Ahmet. I worried she'd get slapped, but I think he liked it."

Eve could not, would not, flinch. And her bravura, her stupid physical courage, allowed her to hang on to her self-respect. (If Joan's conception of self-respect has a living embodiment, Eve is it.) Yet the experience with Ertegun was coarsening, brutalizing. On one level, her behavior was admirable. On another, it was bitter, frustrated, self-destructive—redundant, since McGrath was already so intent on destroying her, something he could do without consequence. She wasn't famous or attached. Mistreat her or drop her altogether and who'd rush to her defense?

Eve, of course, didn't back down or off. She stayed on the hard-living scene. Held her own, too. But at a cost. By late 1970, her excesses had become so excessive she was forced to coin a phrase—"squalid overboogie"—to give her suffering a name, a diagnosis. She was washed up sexually, emotionally.

And then she was washed up artistically, as well. One day, McGrath was watching her work. "Is that the blue you're using?" he asked, a question as tasteless and odorless as arsenic—and as lethal. It wiped out her artistic confidence. She'd sputter on as a collagist and album-cover designer for a few more years. Her life in the visual arts, though, was effectively over at that moment.

As McGrath was laying waste to Eve, he was shielding Joan, who already had a shield: Dunne. Joan took care to present herself as Dunne's wife, adopting his name socially, insisting friends address her as "Joan Dunne." ("Mrs. Dunn" was, I think, Eve making fun of her for this insistence, for playing the little woman to Dunne's big strong man.) Joan wanted the unassailability that marriage offered.

"Last night I had a good party," Eve wrote in her journal, entry dated February 12, 1970. "Wilhelm got here with this ex Marine who had 8 scotches and whose name was Jack Clement. He discovered Jerry Lee Lewis & produced [Lewis] & he wrote a bunch of songs like '[Ballad of a] Teenage Queen.' However he was very hostile & made a pass at Mrs. Dunn which caused her, John and Earl . . . to run out the door especially after Jack called Earl an asshole. I took acid during dinner and was wonderful."

This vignette is revealing of Joan. She might have balked at the safety of the drawing room, where well-bred young ladies clutched their pearls, their vials of smelling salts. Yet she was reluctant to risk the mean streets, particularly unescorted. The situation got too real, the smell of a rumble too sharp, and she was out of there, escorts in tow. Eve, on the other hand, prowled the mean streets, and prowled them alone, in four-inch heels and fishnet stockings, a bloody lip for a badge of honor. She faced death every single night. "I consider it fucking sport to go places alone and spend evenings figuring out what's going on cold," she wrote.

Joan was, by all accounts, withdrawn and inward. Yet she had a need to dominate the scene. How to do that? Get somebody to dominate it for you. Get McGrath, whose charm is the stuff of legend, but who's lacking—an artist with no art. (Social masterpieces don't, alas, count. They're gone by morning.) McGrath and Joan were essential to one another: she squared

his circle artistically; he squared hers socially. Eve described the parties at Franklin Avenue as "nonstop." When I asked if the parties were Joan's or McGrath's, she said, "Both. They were the same person."

So, Earl McGrath, the man doing Eve in, nourished Joan. Eve was getting eaten alive by him. Joan had her teeth sunk deep in his throat, was drinking, drinking, drinking with glassy-eyed, sweet-sucking bliss.

Joan Didion's (True) Origin Story

In the previous chapter, I said that the Joan Didion who started the Franklin Avenue scene with Eve and Earl McGrath in 1967 wasn't yet Joan Didion. A statement both true and false. True in the sense that Joan Didion wasn't yet a name, by which I mean, a known name. False in the sense that she was she, by which I mean, fully formed and on her way.

In other words: the Franklin Avenue scene wasn't where Joan's origin story was written. That story had been written years before—before Franklin Avenue, before L.A. even—only she hadn't much cared for how it'd come out. (Like most first drafts, it was an imperfect attempt.) No, the Franklin Avenue scene was where Joan's origin story was rewritten.

Written out of that rewrite: Noel Parmentel Jr.

I first came across the name Noel Parmentel Jr. in 2022, when I opened the last of the cardboard boxes, found a letter Eve had written to her cousin Patricia Helton in 1976. "There are certain people who never actually venture into my scanning region, people [like] Noel Parmentel Jr. who I've heard about all my life from various people who've been torn to shreds by him and his charm," she wrote. "Joan Didion's next novel is apparently about Noel Parmentel Jr."

Immediately I reached out to the writer Dan Wakefield, close to both Joan and Eve. (Wakefield had been Joan's friend since the late fifties; had

been Eve's boyfriend in 1971, Eve's friend thereafter.) The people they knew, he knew.

"Haven't you heard about Noel Parmentel Jr.?" he asked after I read him the relevant portion of the letter.

"No," I said.

"Oh, well, Noel Parmentel Jr. was the great love of Joan's life."

I leaned in and cupped an ear. *Say what and say who?*

* * *

Noel Parmentel Jr. seems more plausible as fiction than fact, a character out of a novel or movie: one of Hemingway's heroes but higher born; Rhett Butler, only from New Orleans instead of Charleston. He's too dashing, too devastating, built on too grand a scale to be real.

Noel Parmentel in the "Wheels, and What Have You"
section of the 1949 Tulane yearbook.

"Noel was a few years older than the rest of us," said Wakefield. "He was from some well-to-do Louisiana family. Graduated from Tulane. Married or had been, had a couple of kids. He'd served in the marines—Iwo Jima, I think. He was very tall, shambling, good-looking. You'd see him on McDougal Street in a white suit, the kind Tom Wolfe wore only Noel wore it first. He was very influential in political journalism circles. He was a writer, of course."

A writer, of course, but really a swashbuckler, a pen in his hand rather than a sword. "Noel was famous for putting down the right in the *Nation*, putting down the left in the *National Review*, and putting down everybody in *Esquire*," said Wakefield. "And he did it brilliantly. You should look up what he said about that Gore Vidal novel [*Dark Green, Bright Red*]. Vidal, who, as I'm sure you know, was gay, was blasting the United Fruit Company, and Noel called it 'the only anti-fruit novel Vidal ever wrote.' But Noel would call people phonies, get into fights, and a lot of people hated his guts. They got mad at me for even liking him. He was always holding a drink, a bourbon, rattling around the ice cubes in a glass as he held forth. He was always involved in some project that didn't get off the ground, but there'd be a party for it, to raise funds, you know? He'd get one of his rich-girl girlfriends to throw it in some big Park Avenue apartment. And he was always borrowing money. He even borrowed money from me, and I didn't have any money."

Parmentel, who didn't answer letters but who did answer the phone, let me come visit him in Connecticut, where he'd been living for the past thirty years, in early summer of 2023. Though he'd turned ninety-seven the week before, he retained his presence and force, to say nothing of his charm. His hair was snow-white and sparse, his eyes ironical, gamesome, and brightest blue. That he'd been Mr. Cool and a lady killer was something I could feel. There was to him a remote quality, an inner detachment or reticence. Yet under this detached reticence, I sensed a romanticism and a melancholy—a permanent hurt. He was still wounded by the way it had ended with Joan.

Parmentel recalled meeting Joan, twenty-two, fresh out of college, fresh to New York, in 1957. "She was writing promotional copy for *Vogue*. Her last year at Berkeley, she'd won something called the Prix de Paris. You know who'd won the Prix de Paris before Joan? Jackie Kennedy, Jackie Bouvier back then."

A note on Joan, *Vogue*, and the Prix de Paris: an ambitious female writer coming of age in the nineteen fifties, an aspiring bluestocking or bohemian, would no more have considered entering an essay contest held by America's premier fashion magazine than entering a beauty contest. The periodicals in which an ambitious female writer would wish to appear were the so-called "high-serious" quarterlies—the *Partisan Review*, for instance, or the *Kenyon Review*, places where art was presumed arduous, intricate, not for everybody. Joan, though, was a different kind of ambitious female writer, one who had little interest in becoming a bluestocking or bohemian. She wanted to make good in the slicks (she'd already applied for—and received—a guest editor position at *Mademoiselle*) while maintaining her elevated standards. In short, she wanted two incongruous things: the democratic fame of a popular hack and the aristocratic grandeur of an acknowledged literary genius.

Parmentel continued: "I was at a party, which I was far too often in those days. It's why Columbia finally gave up on me and I never got my doctorate. I was at a party every day and every night for about fifty years. This one was for John Sack, a *New Yorker* writer. He'd invited the woman I was seeing at the time—a wonderful woman, her family was a very blue-blood, social family, I'd never dream of discussing her in public—and she'd invited me. It was a room full of New York cocktail party-types, and there was this little girl sitting by herself. That was Joan. She was so shy, she couldn't talk. You had to get her to say 'Boo.' Now, everybody talked to everybody at that party, but Joan only talked to me. Right away I knew she was something special. And she knew I was something special, if you want to call me that. We were different from the rest of them. We talked all night, and we were still talking the next morning. We didn't leave each other's sides the whole weekend."

Joan already had somebody by her side, even if he was in California. Bob Weidner, her boyfriend of five years. They'd met at a beer bust on the Sacramento River shortly after high school graduation. "We drank Sankapooho punch, which was a local thing, made from rum and vodka and maybe muscatel, and sort of fruity," Weidner told me over the phone. "Nice on a first date." He and Joan were a couple throughout her time at Berkeley, where he was also a student. "I remember walking across campus with her. My roommate had just married his long-term girlfriend, and

Joan's roommate had just married her long-term boyfriend. She and I just assumed that we were next. The husband of my mother's younger sister owned a Lincoln-Mercury dealership in Bakersfield. They didn't have kids, and he was about to retire, and there was talk about me taking over the business once Joan and I were done with Berkeley."

Once Joan was done with Berkeley, of course, she headed to New York. She didn't break up with Weidner, stayed with him. But not enthusiastically. To friend Peggy LaViolette, she wrote, "Bob and I are getting along fairly well but I want to GET AWAY from California and school and my family and Bob and make something all my own."

And not for long. "Joan was in New York working at *Vogue*, but she'd come home to visit her family, to visit me, often," said Weidner. "I'd pick her up at the airport in San Francisco and drive her to Sacramento. I'd done this I don't know how many times—four, five, six. The last time, I did like I'd always done. I parked next to the garage at her parents' place, and it was a big property, so not very close to the house. And Joan and I were standing there, talking, and she started telling me about the sexual experience she'd had with this guy—Noel, I guess. 'Fucking,' that was the word she used, the only time she ever used that word in my presence. And I could see from her face that she'd really, really enjoyed it. Now, I haven't told this to many people, but she said to me, 'When it was over'—she meant the sex—'he slapped me on the ass.' And she loved that. I was seriously stunned. Joan and I had been together for so long. We did all kinds of sexual touching, but we'd never had sexual intercourse. We were innocent fifties kids. I believed that sex before marriage was the wrong thing to do, that I'd be spoiling the girl. So Joan and I had lots of fun together, but no sex. Anyway, after that conversation, I didn't try to contact her. She told me that story to let me know it was over, and it was over. I never saw her again. I was devastated."

Having cut ties with the boy back home, Joan was now free to pursue a relationship with a man of the world.

It was easy for Joan to fall in love with Parmentel. He was insolent, reckless, unafraid, self-inventing, with an excess of vitality and authority. "I was the most romantic figure in the world to Joan," he said, then added with a laugh, "That's her line, by the way, not mine."

It wasn't easy, however, for Joan to be in love with Parmentel. He was turbulent, caustic, wayward, his only constant unpredictability. "I could get around and move around," he said. "You couldn't pigeonhole me. Most of those other people I found parochial. They wanted to be part of some group or other. And I didn't want to be constricted. I might call Joan and tell her I was on my way over, and then show up two weeks later. I think I was dependable when it came to what I regard as the big things. But I wasn't worth a damn nine-to-five."

And any woman who believed he'd forsake all others was setting herself up for a letdown. "Noel romanced every woman he met," said Wakefield. "He was a ladies' man. Joan might have been his number one, but she wasn't his only one. And he could be just awful with women. He and I would be at a party, and he'd find the weak point of some woman, and then he'd go after her until she was in tears. He was the classic example of a man who attracted women by insulting them."

Joan, though, was hooked on Parmentel, in spite of his occasional cruelty, because of his occasional cruelty, which had for her, I suspect, an erotic charge. She wouldn't give him up. "He was her first mentor, her first lover, her first everything," said Wakefield.

Her first promoter, too. "Noel's the one who told me about Joan because Noel was telling everyone about Joan," said Wakefield. "'The correspondent from *Vogue*,' is what Murray Kempton [editor of the *New Republic*] called her. She was writing these wonderful pieces for *Vogue*, but I wasn't looking at *Vogue*, so I'd missed them. I had no idea how brilliant she was. Noel gave me some of her work and said, 'Read it. You'll love her writing.' He was like a super-agent. He'd just go up to people and make the case for Joan until they listened. He really made it happen for her."

Crucial since she wasn't going to make it happen for herself. "It wasn't that the men Joan was working with underrated her," said Parmentel. "It was that they didn't notice her. She just didn't register. I called her Mouse because she was so small, so quiet—timorous, really. But, my God, was she ambitious. She worked twenty-eight hours a day. One sentence, which was already almost perfect, she wrote again, and she wrote again, and she wrote again. She was compulsive but not stupidly compulsive. The sentence was always better the next time. I was the most important person in Joan's life,

Joan's career. I knew everything and everybody. She knew everything and nobody. And so I introduced her to people who were useful to her, people like Bill Buckley [editor of the conservative weekly the *National Review*], and she performed beautifully, as you'd expect."

Bob Weidner and the Mouse, Berkeley, 1955.

In fact, it was Buckley who gave Joan her start, putting her writing in his magazine. "Before I got my first byline at *Vogue*," said Joan in 1992, "I was sending things to other magazines. The first piece I ever published was about a quiz show I'd been on. I sent it to the *Reporter* first and got a nice note back, but they didn't take it. Then Noel, who had written for the *National Review*, sent it to *NR* and they published it."

And Parmentel was getting Joan's name in print in more ways than one. For the August 1962 issue of *Esquire*, he wrote a waspish piece about the literary establishment. "The Acne and the Ecstasy," he titled it. To a list that included Ezra Pound, W. H. Auden, and Evelyn Waugh, he added Joan Didion, along with a capsule description: "Joan Didion, the fantastically brilliant writer and *Vogue* editor who, at twenty-six, is one of the most formidable little creatures heard in the land since the young Mary McCarthy."

Nor were Parmentel's efforts on Joan's behalf limited to magazines. "Somebody once said I was to Joan what Boswell was to Dr. Johnson, and

it's true. I got her first novel, *Run River*, published. That book was turned down by everybody. Joan took it hard. She cried for one week, for two weeks—a fortnight. It really messed her up. Finally I said to her, 'You've got to cut this out. Let me see what I can do.' I took the book to Ashbel Green, the greatest editor since Maxwell Perkins, and he gave it to Judith Jones [Knopf editor], who passed on it—which I never let Ash forget. Then I said, 'I'm going to try Ivan [Obolensky of Ivan Obolensky Inc.].' And Ivan fell for it. Now, every Russian says he's a prince, but Ivan really was one, or would've been one if he'd stayed in Russia. And his mother was an Astor, and that's where his money came from. He didn't want to publish Joan's book, didn't like it or understand it, but then neither did anyone else. I just sort of nagged him into it. 'Buy the thing,' I told him. 'It's breaking her heart.'"

"Ivan was lukewarm at best about Joan's novel," said Wakefield. "But Noel knew he could bludgeon Ivan into buying it, and that's exactly what he did."

Joan dedicated *Run River* to Parmentel, though readers wouldn't know it. "For my family and for N," she wrote. He forbade her from claiming him in a more direct way. "Originally she used my whole name," he said. "I told her, 'Just N,' because I preferred to remain private. For somebody who did as many newsworthy things as I did back then, privacy was an unreasonable request, but I made it anyway. Didn't matter, of course. Everyone knew I was 'N.' Norman Mailer and I were great friends. We were amused by one another's outrages, I think. I was writing for *The Mike Wallace Interview* [television show, 1957–60], and I booked Norman as a guest. A short while later, he invited me over to his apartment for a party. It was the one where he stabbed his wife Adele, though I missed that part. Allen Ginsberg and I left early—too many mean drunks and Norman was showing off his muscles. And did you know that I was the one who invented Norman's candidacy? That's right. It was Jack Newfield [journalist] and I who suggested he run for mayor of New York. 'Vote the Rascals In,' that was our slogan. Gloria Steinem was going to run as his controller, but then she got cold feet. Anyway, Norman used to say that he was 'N.' It was sort of a joke between us."

Run River was written for Parmentel. *Run River* was also written about Parmentel. He's Ryder Channing, the book's heartthrob and arch-villain.

Ryder Channing is an adventurer, a smooth-talking, down-at-heel Southerner who "convey[s] the distinct impression that he [can] live by his wits alone." Ryder Channing is, as well, a dandy, a lush, a scoundrel, a brute, and, by the story's end, a corpse, shot by the husband of his lover, Lily Knight McClellan. Lily can't keep away from Ryder. That doesn't mean that she likes him, though, or even respects him. How could she? He's a man of magnetism but no principles.

"That's me, Ryder Channing," said Parmentel lightly.

Maybe so, but Ryder Channing is Parmentel stripped of his redeeming features—nobility of spirit and disinterested generosity among them—his irredeemable ones expanded and distorted. (If it's a portrait, it's strictly of his bad side.) I asked him whether he and Joan ever talked about Ryder Channing. He replied, "I didn't say anything to Joan about Ryder Channing, and Joan didn't say anything to me about Ryder Channing. I tried to ignore the situation. I didn't like what she was doing, except I figured it's an author's right to use people she knows."

To use or abuse? It isn't much of a stretch to see Ryder Channing as Joan revenging herself on Parmentel. In art, she could control him, punish him: he was at her mercy. ("Setting words on paper is the tactic of a secret bully," she once wrote.) In life, it was the other way around.

Or so it must've felt to her.

She wanted him to drink less, write more. "Joan did what she could to get me sober, and behind a typewriter," he said. "Both hopeless causes."

She wanted him to give her a baby. In her 2011 memoir, *Blue Nights*, she flashes back to December of 1958, a panicked visit to the *Vogue* doctor. She was afraid she was pregnant. A rabbit test confirmed her fear. The next day, she started bleeding and then couldn't stop crying. The tears, to her surprise, were not from relief. "I thought I was regretting having missed this interesting moment in Havana [Ed. note: in the fifties, Havana was known as an abortion destination], but it turned out the surge had hit and what I was regretting was not having the baby," she wrote. In late 1958, Joan was with Parmentel. That it was his baby she was carrying—miscarrying—seems certain.

Above all, she wanted him to marry her. "Joan was like a Southern girl about being married," he said. "You know, if you aren't married by eighteen, you're an old maid. And Joan wanted children. She was choked

up about that. But I'd already been married, and I'd had children, and I'd messed that up. One of my lines to women was, 'Get married? No, no, I've tried that.'"

Parmentel sounded like he was joking. He wasn't. He was serious. And one night, he made Joan understand how serious. Afterward, he stopped by Dan Wakefield's place. "I was in a three-story walk-up on Jones Street," said Wakefield. "I heard Noel clomping up the stairs. He told me he'd said something to Joan like, 'There's not going to be a baby-makes-three or a you'd-be-so-nice-to-come-home-to.' He gave it to her straight—no marriage—and that was it for the romance. They were done. He said she went to pieces."

In her swan song to New York, "Goodbye to All That," Joan detailed what going to pieces over Parmentel looked like. "It was very bad when I was twenty-eight," she wrote. "I cut myself off from the one person who was closer to me than any other. I cried until I was not even aware when I was crying and when I was not, cried in elevators and in taxis and in Chinese laundries, and when I went to the doctor he said only that I seemed to be depressed, and should see a 'specialist.' He wrote down a psychiatrist's name and address for me, but I did not go. Instead I got married."

Not to Parmentel, obviously, as he was the one she cut herself off from, the reason for her weeping, her depression. Though, at the same time, absolutely to Parmentel. "I introduced Joan to Greg," Parmentel said. "That's what John Dunne was calling himself in those days—Greg. The furthest thing from Joan's mind was marrying Greg, I can tell you that. But I suggested Greg as a possible husband for her."

More than suggested. According to Wakefield, Parmentel's exact words to Joan were, "This is the guy you ought to marry." Wakefield: "Noel said to me, 'It's time for Joan to get married. I found a guy and told her what I thought she should do.'"

"I liked Greg," said Parmentel. "He'd write down the things I said. And when I'd ask him what he was doing, he'd say, 'So I can remember.' I'd read his stuff in *Time* [Dunne was a staff writer at the magazine], and I thought he was a pretty good writer. I didn't think he was great, but pretty good. And I thought he was bright, not brilliant, but bright. He was a good catch for Joan, I felt. He was a gentleman, semi-rich, from a good family—the Dunnes were the Kennedys of Hartford, you know—knew

his way around the Ivy League circuit. Also, he'd be at the breakfast table every morning, something I'd never be. And he'd edit her line by line."

Parmentel paused at the end of this last sentence, raised an eyebrow at me significantly.

After a confused beat, I said, "Line by line. Wow."

We were sitting on the porch of his house, in Connecticut but not suburban Connecticut, country Connecticut. His partner, Vivian, a shyly friendly woman several decades his junior, had just brought us lemonade. He put down his glass suddenly. Then he leaned forward to make sure I was paying special attention to what he was about to say. "Greg worked every inch of type Joan wrote. Do you understand what I'm telling you?"

I nodded.

"Every inch. That's what she wanted, someone who could do that for her—edit, proofread."

I nodded again, then, sensing a nod wasn't enough, said, "Yes, I understand."

Satisfied, he leaned back in his chair. "I'd edit her, but not like that. I didn't have the patience."

"No?"

"No. But Greg did."

That was Parmentel on Dunne.

Now for Dunne on Parmentel. From the introduction to Dunne's collection *Quintana & Friends*:

> When I arrived in New York in 1956[,] I was the quintessential Ivy League graduate, a receptacle of received wisdom, a memory drum of fashionable and right-minded and untested opinion. I met [Noel] at a party, he insulted the hostess and most of the guests, and left. It still takes my breath away when I think of that evening . . . He was like a stick of unstable dynamite, socially irresponsible, a respecter of no race or tradition or station. He was also smart as hell . . . I was soft and he became the DI of my intellectual boot camp, a professor of life itself. I ranged over New York with him, picking up his lessons by osmosis, Sancho Panza and his demented knight . . . He taught me to accept nothing at face value, to

question everything, above all to be wary . . . "I must love him," Norman Mailer once told me, "otherwise I'd kill him." I feel much the same way.

This description was written in 1978, Dunne a grizzled forty-six, but it sounds as if it were written by a moony-eyed adolescent. It has none of Joan's ambivalence or hostility. Is hero worship without sigh or blush.

What, I wonder, was going through Joan's mind when she consented to let the man she loved fob her off on his little buddy, his sidekick and flunky and second banana? Parmentel offered a possible motive: "Joan was the way she was. She was so tiny—just miniature—and super shy. She couldn't put herself forward. She needed someone to do that for her. And, look, as far as pushing Joan is concerned, I'm the once-and-future all-American. Without me, there might never have been a Joan Didion. I invented Joan Didion. That's why her father, Colonel Didion, liked me and was grateful to me. And before me, there was her brother, Jimmy, pushing for her. Then Greg pushed for her. Greg certainly did his share. So did Dan Wakefield. Even Nick Dunne—you know, Greg's older brother—pushed for her. Nick was a player in Hollywood for a while, and he did what he could to advance her interests and Greg's. We all pushed for Joan."

Getting people to push for her was one of her talents, as she herself knew. An exchange between the Joan-like Lily Knight McClellan and Lily's sister-in-law, Martha, in *Run River*:

"You're so strong."

"I am not," Lily said, jarred by Martha's moodiness and by the note in her voice. "I'm not a bit strong."

Martha shrugged and got out of the car. "All right, you're not a bit strong. It's your act, Lily baby, you play it any way you want. Anyway," she added, "you're strong enough to make people take care of you."

Dunne was an acolyte of Parmentel's and therefore knew the deal, all the ways in which Joan required cosseting and coddling. He could be counted on to take over as her custodian since he'd been de facto groomed for the job.

And maybe there was for Joan something irresistible about the idea of giving herself to a man she didn't love because the man she did love told

her to. It was a chance to stoke the fires of her romantic masochism. To play Ingrid Bergman in the final scene of *Casablanca*, letting Humphrey Bogart tell her that they'd always have Paris before shoving her into the arms of Paul Henreid. (In "On Self-Respect," written for the August 1961 issue of *Vogue*, Joan described her ideal man as "a cross between Humphrey Bogart in *Casablanca* and one of the Murchisons [Dallas businessmen] in a proxy fight," a line she'd, interestingly enough, cut when she included the piece in her collection, *Slouching Towards Bethlehem*.)

Run River was released in the spring of 1963. It didn't get much of a reception, just a few scattered and unimportant reviews. "If Ashbel Green had listened to me, if Knopf had brought out *Run River*, it would've made a huge difference in the way the book was treated," said Parmentel. "Ivan Obolensky wasn't seen as serious. He was seen as a rich boy with the money to form a publishing company. I told Joan she'd written the great American novel. Let's just say, the critics weren't saying about it what I was saying about it, and a lot of the critics weren't saying anything about it at all. She was more or less dismissed. And I've already told you how hard she took things."

Joan was thus twice disappointed: in love and literature. New York must've felt like a failure to her—to have come so close and then not to have made it.

She needed to get away. From Parmentel. From the city.

In 1964, it was on to Dunne. (They married in January.) And on to Los Angeles. (They began renting a house on the Palos Verdes Peninsula in June.)

Joan, in later years, when talking about her early years, gave the impression of one long near frictionless ascent: Berkeley to *Vogue* to a marriage that would become among the most revered in American letters to a first book that made her legitimate to a second book that made her famous. Every step had been a step in the right direction. No wrong turns or dead ends, certainly no guide or protector to help her along the way. She'd done it on her own.

That simply wasn't so.

As you've learned, Reader, Joan suffered the usual indignities of a young writer. A first manuscript that was kicked from house to house, going begging, and only after an older man, a boyfriend-Svengali, took it on (shades of Eve and Joseph Heller), which he did out of pity, to stop her from blubbering, was it bought, and then as a favor to him, and when it finally was published, it was assessed carelessly, crudely, tossed aside. She'd admit to getting rejected—"[*Run River*] got turned down by twelve publishers," she said in a 2000 interview—but not to getting assistance—she declined to mention in the interview that Noel Parmentel was the reason the thirteenth publisher said yes.

Joan suffered the usual indignities of a young woman, as well. Her first adult love affair was a heartache and a humiliation (shades of Eve and Brian Hutton). She'd admit to shedding tears over the end of her romance with Parmentel—in "Goodbye to All That" she cried, you'll remember, in the unlikeliest of places—but not that it was Parmentel who ended the romance—she claimed, you'll remember, too, that it was she who cut herself off from him.

What's more, Joan's self-presentation was undirected, unsure. She didn't yet know how to be herself—that is, how to perform herself—in the world. How to pair up with someone who would augment her rather than overshadow. How to turn a gaucherie, her crippling shyness, into a style; go from Mouse to Mona Lisa.

That was about to change.

Joan Didion's (True) Origin Story, Continued

Noel Parmentel was as for Joan moving to Los Angeles as he was for Joan marrying John Gregory Dunne. "I believed L.A. was an experience that Joan, of all people, needed," he said. "Glamour, flash, extravagance—those were things she could use."

Though he remained in New York, Parmentel often came to L.A., establishing himself in various bohemian circles—movie, rock 'n' roll, literary—and in no time flat, another indication of control and force: he didn't require introductions or connections, was socially self-sufficient. "Noel was here for a few days in the summer," wrote Joan to a friend in a 1968 letter, "& actually seemed pretty good, probably because he had just spent a week in Honolulu with Ricky Leacock doing exactly what he does best in the world, making friends with people (in this case police chiefs, on a convention) so that they wouldn't mind having Ricky around with a handheld camera at all hours of the day and night."

Parmentel was a collaborator of documentarian Richard Leacock (in '68, he and Leacock were working on *Chiefs*, about the seventy-fifth conference of the International Association of Chiefs of Police, held in Hawaii), and of Norman Mailer, then attempting to direct (he appeared in two of Mailer's movies: 1968's *Beyond the Law* and 1970's *Maidstone*). Was the drinking companion of singer Cass Elliot ("Cass was for me because I'd helped out a boyfriend of hers who got busted for dope in Wyoming—I

knew a congressman"), and filmmaker Agnès Varda ("Agnès was what we used to call pushy, but I loved Agnès"), and Howard Hughes aide Chuck Waldron ("Chuck was a jack Mormon. Know what a jack Mormon is? It's a Mormon who drinks. Hughes kept cabins at the Beverly Hills Hotel for his starlet girlfriends, and when one was empty, Chuck would let me have it"). And he spent a good part of the seventies trying to get an adaptation of Walker Percy's *The Moviegoer* off the ground. "Walker didn't need the money and I didn't have the money, so I got the rights practically free. Robert Mitchum was an old friend of mine, and he agreed to play the role William Holden played in the book—remember, when the protagonist spots William Holden in the French Quarter? All you really need to do a movie is a script and a check. I could never get the script. Billy Hale tried, Ulu Grosbard. Even Joan offered to try. She didn't think you could make a movie out of that book, but she would've done it for me because she would've done anything for me. I told her no. Why? For personal reasons. I didn't think it was a good idea for us to be working together like that."

Usually he'd stay with Joan and Dunne. "Noel would show up at their place in Hollywood," said Dan Wakefield. "He wouldn't say he was coming. They'd just wake up and there he'd be. I have this memory of him at the Franklin Avenue house. It was morning and he was in the kitchen in his button-down shirt, his brown and white shoes, his tan socks, and his underwear—no pants—holding a drink with lots of ice in it."

Joan described a visit from Parmentel in a letter:

> It was like having a caged animal in the house, & one who became aggrieved at any visible evidence of daily routine; he was deeply insulted one day when I finally excused myself to go wash a three-day accumulation of dirty dishes. When he finally leaves . . . I think we will just go down and lie on the beach & let the tide come in for a week or so, & then we'll start missing him again.

Joan's tone here is exasperated, affectionate. Clearly time has passed, emotions have cooled. Where she once felt fury, frustration, and passion toward Parmentel, she now feels fondness. Fondness tinged with regret, yes, but only tinged. It's all worked out: she's wound up with the right guy, and Parmentel's still in her life, a beloved friend to her and her husband.

Parmentel was more even than a beloved friend to Joan and Dunne, was a member of their family. His oldest boy, Fielding,* then a teenager, lived at Franklin Avenue for nearly a year. ("Fielding wanted to be in California, and I needed some place to park him.") And he was named Quintana's godfather. "After Quintana's christening, there was a party at a house in Beverly Hills," he said. "I got into a silly argument with some guy there who was half my size—the writer Brian Moore. I told him he looked like Leonard Lyons—you know, the gossip columnist—and he tried to sock me. Well, he *did* look like Lenny Lyons. No, Joan didn't get mad. She just laughed."

And if Parmentel wasn't before Joan's eyes as much as he'd been, he was on her mind more than ever. She kept him on her mind by making him a character in her next novel, *Play It as It Lays*: he's Ivan Costello, the man from Maria Wyeth's past who won't stay there. Ivan Costello is the same kind of bastard as Ryder Channing. ("[Ivan] used to call [Maria] in the middle of the night. 'How much do you want it,' he used to say. 'Tell me what you'd do to get it from me.'") Maria tries to shake free of him, can't quite. "In every book of Joan's—at least the first couple—there's Noel," said Wakefield. "He's the guy in the white suit, the handsome cad who treats women badly but gets them anyway."

Parmentel wasn't any wilder about Ivan Costello than he'd been about Ryder Channing. Once again, though, he held his tongue. "Yeah, I ignored it," he said. "I just kind of wished she and Greg would meet some new people."

Yet he didn't altogether approve of the new people they were meeting. "I remember saying to Joan, 'You have a lifestyle, not a life.' First of all, there were too many drugs on that scene. Drinking is one thing, but I hate drugs, and dope had hit Hollywood. And then there was that Earl McGrath, a name-dropper and a leech. He used to get himself paged at the pool at the Beverly Hills Hotel to look important. I once told him something he didn't want to hear. I said, 'These people are never going to have any respect for you. You're not in their league or their class.' I should've kept my mouth shut but I'd had too much to drink and he annoyed me."

* Fielding, who took on the last name of his mother's next husband—Henderson—was the first love of singer-songwriter Lucinda Williams.

Joan learned her lesson from *Run River*, a historical novel and a little sleepy, a little beside the point. Her follow-up, 1968's *Slouching Towards Bethlehem*, felt, in contrast, urgent, as if it were breaking cultural news. And it gave her what had eluded her in New York: recognition. This attention, though, didn't always bring her pleasure. "Greg was more affected by California than Joan," said Parmentel. "The things he was thinking about became more Californian. Joan might have been from California, but she wasn't any California chick. Her parents were gentlefolk, old-fashioned people, knew how to behave. And that's how Joan was—a native daughter of the Golden West. Her serious work didn't suffer, which is what I thought might happen if she started writing scripts. But something was wrong. She told me people wouldn't leave her alone. People she didn't respect were calling her up, asking her questions, for favors. See, she wanted her name out there, wanted the editorial space, wanted the praise, only she didn't want to have to participate."

It was, according to Parmentel, more than the demands of celebrity getting her down. "I know L.A. was hard for her because she was at her unhappiest there. She would sometimes talk to me when she wouldn't talk to anyone else. Now, Joan was a lady, so she was courteous, had manners. But she wasn't easy to know. I was one of the few who did know her. She let me know her. Why me? Well, I think some of it was that she was her father's daughter. She liked men, trusted men." Ah, so Joan, same as Eve, was a man's woman. It was men with whom she felt a strong and reciprocated affinity; men in whom she confided her vulnerabilities and secrets. Back to Parmentel: "Once she called me up at the Beverly Hills Hotel. 'Can you meet me?' she said. I said, 'Come on, we'll go to the Polo Lounge.' She brought Quintana. It must've been 1972, maybe 1973, because Quintana was only about five years old. And the three of us had a four-hour lunch. Joan was thinking about divorcing Greg. She was worried about violence. He was drinking and acting very crazy. And he was threatening to go to court to take Quintana from her. I said, 'You should take Quintana and go to Sacramento. Your father has enough power and influence there, and you're the apple of his eye, and he will not let anybody get near you. You'll be protected.' It made me sad to say this because I'd brought her and Greg together. But I wouldn't have if I'd known about his crazy Irish temper. And he should not have threatened her with Quintana. Joan asked me my advice and I gave it."

The question is: why didn't Joan take it? Why would a woman of such strength, determination, and accomplishment put up with the bruised ego and black rages of a man less gifted than she?

The writer David Thomson was a Joan watcher and a sharp-eyed one, and this memory of his contains a kind of answer: "I saw Joan and John do an event together once. They had this double act going. Someone asked Joan a question, and she waved a hand at John, and he answered for her. It was quite extraordinary, really. He did all the talking, but all the attention was on her. And then, she, as you know, went out of her way to defer to him in public."

I *did* know. A telling detail: Joan's stationery. While researching this book, I dipped into many an archive. I'd see notes she'd written to people over the years. Engraved at the top of her stationery was JOAN DIDION DUNNE, but she always—at least in the notes I saw—ran a line through the DIDION. If "Joan Dunne" was how she wished to be known, why didn't she order stationery with a JOAN DUNNE engraving? Was it because she wanted to call attention to the fact that she, a major writer, was allowing her identity to be subsumed by that of her husband, a minor writer? Self-assertion in the guise of self-abnegation. Rebellion masquerading as compliance.

Thomson continued: "This seemed a kindness, and maybe it was one, but it also rankled him. You could feel a pent-up energy in John, the smell of gunpowder. Part of it, of course, was very understandable envy."

Surely, though, another part was frustration, equally understandable. (I'm going to address the gunpowder Thomson smelled, the crazy Irish temper that Parmentel didn't know Dunne had. Only not now, Reader, not yet. In a later chapter.) Dunne must've known at some level that her deference to him wasn't real. He might've been ready to fly off the handle at a moment's notice, but his anger and volatility were an obvious cover for fear and weakness. And she might've been skin and bone, but she was, too, iron and steel.

Yet for all her iron, all her steel, she couldn't manage without him. If living was for her merely preparation—that is, material—for the real thing—that is, writing—then he was invaluable. Since marrying him, her fortunes had reversed, and in so many ways. One way: *Slouching*, her first post–New York, post-Parmentel book, her first book edited by him,

was a smash; *Play It*, her second post–New York, post-Parmentel book, her second book edited by him, was a bigger smash. Another way: *The Panic in Needle Park*, scripted by her and him, was an official entry at the 1971 Cannes Film Festival. Still another way: she was given a several-page spread in the October 1, 1972, issue of *Vogue*, and was advertised on the magazine's cover, "Joan Didion's living/working house." (See what I mean? In the rewrite, her early career really *was* one long near frictionless ascent.)

Joan simply couldn't afford to lose Dunne. All of this was doable because of him. He helped her secure the pinnacle. Talent wasn't enough, not by a long shot. Neither was will. You needed cunning too. You had to be on the make but on the make on the sly. Dunne, never in contention for the top spot, was an operator, candidly. ("On my application for admission [to Princeton], there was a question that asked, 'Why do you wish to attend Princeton?' I puzzled over the answer for a few days before writing, 'To make contacts for later life.'") Therefore Joan could be an operator, stealthily. Said Susanna Moore, a friend to both Joan and Dunne, "John was dominant, and Joan was happy to have him so. Their relationship was a bit good cop/bad cop. She'd let him execute the cut or the criticism, make the attack. That way she could stay above it all."

You'd have thought Dunne couldn't afford to lose Joan either. Magazine writing was a key source of income for the couple, especially in their first years in L.A., before they were making a killing from screenplays. "The *Saturday Evening Post* wanted Joan to do a column called 'Points West,'" said Wakefield. "She said she would, but only if she could alternate writing the column with John, and only if she and John could each have their own separate bylines. She said that because that's what Noel told her to say. She and John were going through a rough spot, I guess, and she went to Noel and asked him how she should handle the situation. And he said, 'You've got to bring John up to where you are.' And she tried to. Did you know it was Joan who got John to stop calling himself Greg? She thought 'Greg' made him sound like a college boy. She thought people would take him more seriously if he was known as 'John Gregory Dunne,' and so about a year after they married, that's what he began calling himself. Anyway, Joan and John did that column for years. 1964 to 1969, I think."

And Joan gave Dunne something worth more than money. Gave him what he craved most: access.

A story told to me by Susanna Moore:

I'd give a dinner party and Warren Beatty would call me up and say, "Seat me next to Joan." This amused me, so I'd tell Joan and John. Joan wouldn't say anything, maybe she'd give a little smile, but John would always want to know more. Like, "What exactly did Warren say about Joan?" and "*Really?*" It excited him that a movie star wanted to sleep with his wife.

Yet it seemed Dunne was willing to lose Joan anyway. By the early seventies, their bond had frayed to the breaking point. That her writing was superior to his was evident to anyone able to read, a problem she could do nothing about. That the recurring male lead in her writing was based on a man who wasn't him was evident to anyone able to read between the lines, a problem she could do something about.

And so she did.

Parmentel might have been the one grand passion of her life, but he'd served his purpose. What she needed from him—sustained and fruitful inspiration—he'd provided. She'd already turned him into a character, into multiple characters. And, perhaps more importantly, she'd already turned him into an abstraction. "You can feel in Joan's work a longing for a man who is strong in thought as well as action," said David Thomson. "Some worldly, older man, a Hemingwayesque figure who'd look after her. That man isn't John Gregory Dunne. And yet I always felt she was writing to impress him, to impress that man."

In short, Joan had the immaculate ideal, so could do without the messy human behind it. Parmentel, precious though he was to her, was, finally, expendable.

"In the end," said Wakefield, "Joan and John turned against Noel."

The end began in the summer of 1973, when Joan jotted down notes for what would become her third novel, *A Book of Common Prayer*. "When it came out," said Wakefield, "the guy who was the editor of *Harper's*, Lewis Lapham, excerpted it in the magazine. He called up Noel and said, 'Have you read *A Book of Common Prayer*?' And Noel said, 'No.' And he said, 'Well, you'd better. It's all about you.'"

One of the principals in *A Book of Common Prayer* is Warren Bogart. (The return of that *Casablanca* fantasy.) Warren Bogart is Ryder Channing and Ivan Costello, except even more egregious. And more egregious because he takes up more pages. (Ryder Channing is offstage for much of *Run River*; Ivan Costello only makes cameos in *Play It as It Lays*.) And more egregious because, as a character, he's more egregiously personal. Warren Bogart, the former love of the Joan character—Charlotte Douglas—comes to stay with the Joan character and the Joan character's husband—Leonard Douglas—in California. (Evidence that Joan found being in the simultaneous company of Dunne and Parmentel a more fraught experience than she let on: "[Charlotte] was incapable of walking normally across the room in the presence of two men with whom she had slept. Her legs seemed to lock unnaturally into her pelvic bones. Her body went stiff, as if convulsed by the question of who had access to it and who did not.") Warren Bogart is also the father of the Joan character's child. He and Charlotte share a daughter: Marin, eighteen, part of a band of far-left militants, and wanted by the FBI for detonating a bomb in a San Francisco office building.

Had Joan not miscarried in 1958 but given birth in 1959, that baby would've been eighteen in 1977, the year *A Book of Common Prayer* was published. And the novel can be read as, in the words of journalist-critic Thomas Powers, "an account of an imagined life with [Parmentel]"—a sort of extended what-if. What if they'd had their baby? What if that baby had grown up to be Patty Hearst? (Joan, incidentally, was fascinated by Hearst, the California newspaper heiress who, in 1974, as a teenager, was kidnapped by a terrorist group, coerced into participating in the group's criminal activities, including making explosive devices. Hearst was subsequently arrested by the FBI, charged, and Joan had wanted to cover the trial for *Rolling Stone*. Ambivalence, though, tripped her up. In 2016, she'd write, "I never wrote the piece about the Hearst trial, but I went to San Francisco . . . while it was going on and tried to report it. And I got quite involved in uncovering my own mixed emotions.")

Parmentel's irony and detachment could withstand Ryder Channing and Ivan Costello. Warren Bogart, though, blew both to bits. "I hit the ceiling," said Parmentel. "Walker Percy was the first to call me up. He said, 'Hello, Warren.' And then people from all over the world—London, Paris, Singapore—were doing it. 'Hello, Warren. Hello, Warren. Hello,

Warren.' I was so angry at Joan. I thought it was the height of disloyalty. Worse, I thought it was the betrayal of a friend. To show me, but me at my absolute worst. And it was me and nobody but me. Things I said were in there verbatim. [Ed. note: I know this to be true because what Parmentel told me he told Joan—"You have a lifestyle, not a life"—Warren tells Charlotte, "You don't have a life, you have a 'lifestyle.'"] I'm not blaming Greg for what she wrote, although he read and edited every word. He could've stopped it if he'd said something."

Parmentel was out for blood. "I knew a lot of lawyers, and they smelled a headline lawsuit." And then he wasn't. "In the end, I wouldn't do it. The gossip columnists kept calling me up to ask about a suit. My answer was, 'I've never sued anybody in my life.'"

When I asked Parmentel if it was Joan's failure to warn him that bothered him most, he sighed, shook his head. "If she'd told me in advance, I'd have said, 'Take it out,' and then I would've been ashamed of myself for ruining her novel. I couldn't win. I didn't like that she kept putting me in that position. After the book came out, she tried to call me, she tried to write me, but I wouldn't take her calls or write her back. She'd lost me as a friend, and Joan didn't really have any friends. *I* was her friend." Another sigh. "Years later, people tried to bring us back together. Mary Bancroft [socialite, novelist, spy] had a dinner party and invited us both, and then I didn't show. I regret all of it now. Joan was stupid and I was stupid. And the saddest part is, we were both stupid to the person who was closest to us in the world. It's just—" He cut himself off. I could see from his face that he was falling down a rabbit hole of second thoughts. "You know," he said after a minute or so, "years went by, and even the people who'd told me to sue at the time were telling me I'd overreacted. I told myself I'd overreacted, that it wasn't such a big thing she'd done, that she'd just acted like the novelist she was. But it didn't matter. I couldn't get over it. I tried"—raising his hands, dropping them helplessly—"but I couldn't."

My guess is that he couldn't because only on the surface was what she'd done not such a big thing, a novelist acting like a novelist. No, he had it right the first time. *A Book of Common Prayer was* a betrayal, the ultimate. Joan had taken something between them that was so private they couldn't even say it out loud to each other and turned it into a publicly projected story. Had taken, too, the physical manifestation of their love—a child that

never quite was—and turned it into an abomination. Marin is a terrorist, violent and unhinged. "Fuck Marin," Warren Bogart says.

Up until *A Book of Common Prayer*, Parmentel, not Dunne, had been Joan's true husband. That he was the first man she'd given herself to sexually made him, by her logic—the logic of the unconscious, of dreams, and therefore irrefutable—her true husband. (Of Charlotte Douglas she wrote, "I have never known anyone who regarded the sexual connection as quite so unamusing a contract. . . . Some women lie easily in whatever beds they make. They marry or do not marry with equanimity. . . . They can leave a bed and forget it. They sleep dreamlessly, get up and scramble eggs. Not Charlotte. Never Charlotte.") It didn't matter that she and Parmentel had separated because they would always be together, were mated for life. Consequently, it was his counsel she'd sought, his lead she'd followed.

And then, all of a sudden, she no longer did. She was casting him aside for the sake of her marriage to Dunne, though really for the sake of her career with Dunne since getting married to Dunne was, at least in part, a career move, Dunne her business partner as much as her domestic. (Not as cold an arrangement as it sounds. Joan and Dunne are proof that a marriage of convenience can be a warm connection.)

Warren Bogart was Joan making an offering to Dunne: the head of the rival he would never have dared challenge on a plate. Or, rather, the page.

Fuckable

Nineteen sixty-seven to 1971.

The Franklin Avenue scene was absorbing most of Eve's energy, emotional and psychic, during those years. Most of her time, too. Recalled Ron Cooper, "It seemed like at least three nights a week, Eve and I and Joan and John and Earl would have dinner, either at Joan and John's house, in their kitchen or their backyard, or at Eve's place, or at Earl's, or at my loft."

So where was Eve on the four nights a week she wasn't at Joan and Dunne's house or at her place or at Earl's or at Cooper's loft? On another scene, of course. A scene that ran parallel to, though occasionally intersected with, the Franklin Avenue scene. A scene that was just as hermetic and competitive, fierce and frivolous, vivid and woozy. A scene from which all manner of people derived mad inspiration.

The Troubadour scene.

Eve left New York in early March of '67, but not for L.A.

L.A., I think, represented to her a step backward, and she wouldn't allow herself to take it. "Last night I went to a benefit for the [San Francisco] Mime Troupe at the Fillmore," she wrote Mae in a letter dated April 13, 1967. "Unfortunately, after waiting in line for an hour and a half (COLD!) I couldn't get in." She grumbled for a sentence or two, then noted, "On the other hand, it's much nicer than L.A. where there's no place to go and

where there is, nobody goes there." She was worried, I suspect, that the sense of purpose and urgency she'd gone to such lengths to find in New York would be lost to her in L.A. "Like every Los Angeles person, she was trying to escape," said Chris Blum.

For Eve, though, there was no escape. L.A. was her destiny. It was Jim Morrison who reminded her of this. From "Jim," that piece she wrote for Joan:

> One night the Doors were playing at one of those huge San Francisco auditoriums and Jim was up there wearing black leather, hunched over that microphone like a marble statue, so still that all the other rock groups who specialized in "energy" looked like fools next to him in his blackness. By this time "Light My Fire" was a hit, the Doors' first album had come out, and Jim had become Jimmmeeeee . . .
>
> The "Jimmmeeeee" girls were standing at the edge of the stage ready to tackle him the moment the Doors were through, so that when he passed me, he was so covered with girls' arms, I didn't like to try and say anything such as hello.
>
> "Why did you make us leave the concert?" I heard, unable to believe my ears.
>
> "What?" I looked up at Jim.
>
> He looked at me menacingly, but I was too stunned to believe it. He took le deluge after him to his dressing room and left me there. I decided I couldn't stand San Francisco anymore.

By May, Eve was back in L.A., back on a scene that no longer was one: Barney's. Her old haunt was a shadow of its former self. "I saw Glo and Larry [Bell] at Barney's," she told Walter Hopps in a November 1967 letter. "They're always nice to me—the whole scene seems to have collapsed, however, and all the zip ain't here." Hopps must've taken the zip with him when, earlier in the year, he moved from the Pasadena Art Museum and L.A. to the Corcoran Gallery and DC.

And maybe a bar for fine artists was no longer where Eve belonged in any case, since a fine artist was no longer what Eve aspired to be. A rejection from Ferus—indirect yet, to her, flagrant—seems to have been the last straw. From that letter to Hopps:

Irving [Blum, now running Ferus without Hopps] saw a box I did at Ron
Cooper's house (I lived with Ron for 8 days but he's too short) and dug
it but I don't think he thinks I'm serious—he's right—I'm not serious,
but I'm good so what difference does it make?

It made no difference in terms of her art, obviously. It made all the
difference in the world in terms of how her art was received. To be viewed
as serious was vital for a woman artist—still is vital, I'd argue—since men
artists were—and are—just looking for an excuse to condemn or dismiss.
(That Eve didn't understand this, refused to understand this, was, I think,
why she had one career, Joan another.)

She went on:

I'm afraid to show Irving the others because he's too terrifying and I just
couldn't stand for him to think they were crumby [sic], you know—it's
really painful not to amuse Irving. There are some galleries who want
me to go with them, only I only want to do the Ferus and Irving's just
so tall and all the way up there. Terrifying.

Eve sounded discouraged, almost despairing. But by the end of the
paragraph, she'd bounced back:

What I'm trying to do is album covers because they give you all this money
and the people are groovier and everybody gets to see what you've done.

Not just trying, succeeding. She'd stopped by the L.A. office of the
Monterey Pop Festival, where she made a sale: a Beatles collage for the
festival book. Also, a pick-up: Peter Pilafian, production manager of
the festival in addition to road manager of the Mamas and the Papas,
and, more importantly, lust object of Earl McGrath (and thus point of
entry into the Franklin Avenue scene).

And she had still hotter news for Hopps:

I did a cover for the Buffalo Springfield's new album [*Buffalo Springfield
Again*] and I want you to rush right down to your neighborhood record
store and look at it because it's the first thing I've done that's out and

it's causing a stir (thank Heavens) and teeny boppers all over the world
stand in appropriate awe of me.

From the only pictures of the band she could find, a spread in the fan
magazine *TeenSet*—"Win a Dream Date with Buffalo Neil!"—she'd created
a Joseph Cornell–style collage.

Designing the cover was a coup. She explained to me how it had
happened: "I was renting my own apartment on Formosa. That's where
I was when a friend called and told me Paul Butterfield was playing in
Huntington Beach. Driving the freeway made my hair white." She patted
the top of her head distractedly. "I mean, Joan Didion loved it, but it gave
me a panic attack."

"I didn't know you could live in L.A. and not drive the freeway," I said.

She shrugged. "I could do side streets, though. So I borrowed my
mother's car and drove down. Nobody was in the audience except Stephen
Stills. The rest of the band had gone, and Stephen needed a ride home. I
said, 'I'll give you one if you let me do the art for your new record.' He
said, 'Okay.' I was thinking business, weird as it seems."

Buffalo Springfield, since dropping "For What It's Worth" at the tail
end of '66, was one of the biggest rock 'n' roll bands on the planet. That
Eve had done their cover made her, in a smaller way, big, too.

Rock 'n' roll in L.A. in 1967 was thrilling to Eve because it was what art
in L.A. had been a few years back: Paris in the Twenties, where and when
she always wanted to be. (The defining characteristic of the Moveable Feast
was that it *didn't* stay in one place, one era.) Or it would be Paris in the
Twenties once it had a locus and a hub, a combination salon–hotbed–living
end. The rock 'n' roll version of Barney's, in other words.

In 1968, Eve walked out the front door of Barney's and headed west
on Santa Monica until she hit a Swiss-chalet-looking building just east of
Doheny Drive: the Troubadour.

The Troubadour was a folk club that had, the year before, become a
rock club when Buffalo Springfield played a set with plugged-in amps. "The
folk musicians—Odetta, the Kingston Trio, Peter, Paul and Mary—with
their acoustic sets, their harmonies, were on their way out," said Mirandi.

"And this country-music kind of rock 'n' roll was coming in, and there was just this crazy buzz."

But it wasn't the Troubadour stage that was the attraction for Eve. It was the Troubadour bar. "The bar was the best part," said Mirandi. "That's where it was all happening. Because it wasn't about the people playing. I mean, it was but not actually. Actually it was about the people hanging out. They were the real show."

Of course the stage didn't command Eve's attention because rock 'n' roll didn't command Eve's attention. Not rock 'n' roll in and of itself, anyway. ("God, no," said Laurie when I asked her if Eve had a good ear. "She couldn't tell one note from another.")

And the politics, which were almost as much a part of the rock 'n' roll of this period as the music, she found corny. From "Jim":

The rock scene in San Francisco in 1967 when Winterland and the Fill-more and the Park [were] spiked with LSD, flowers and radicalism. All these were childish considerations to a kid from L.A. like me who [thought] politics was something people had to do like play bridge if they didn't know what was really fun.

And hippies she found even cornier. "It wasn't just that [hippies] were poor, though that was about half of it," she wrote, in a near frenzy of dislike. "The other half was a combination of repulsions." The frenzy building: "I was also enormously horrified by Eastern religions, it was bad enough Western religions." And building: "Buddhism with that fat guy in lotus position was faintly pornographic because I always wondered what his cock could ever be like in all that flab." And finally erupting: "I was repelled by an instinct that ran through me from the tips of my toes to the top of my scalp."

(Interestingly, one of the few people as put off by hippies as Eve was Joan. In "Slouching Towards Bethlehem," Joan described heading to San Francisco "in the cold late spring of 1967"—the same spring Eve was there—because San Francisco was "where the missing children were gathering and calling themselves 'hippies.'" Like Eve, she regarded their naïveté as akin to idiocy. "They are less in rebellion of society than ignorant of it,"

she wrote. "Their only proficient vocabulary is in the society's platitudes. As it happens I am still committed to the idea that the ability to think for one's self depends upon one's mastery of the language, and I am not optimistic about children who settle for saying, to indicate that their mother and father do not live together, that they come from 'a broken home.'" She believed, as Eve did, in a world by adults, for adults. I wonder whether she and Eve commiserated about the awfulness of hippies while she was writing "Slouching Towards Bethlehem." They would've met shortly after she returned from San Francisco, right around the time of the Monterey Pop Festival, which ran from June 16 to June 18, and the piece wasn't published by the *Saturday Evening Post* until the fall.)

So, if it wasn't the aesthetics or the ideology of rock 'n' roll that compelled Eve, what did? The energy. She loved the ebb and swirl, the heat, the light, the noise—the *scene.*

Dickie Davis, manager of Buffalo Springfield, was at the Troubadour bar almost as often as Eve. "Eve had a favorite table. It was in the corner. She'd say to me, 'Look around, Dickie. *This* is Paris in the Twenties. *This* is café society. And sitting here, at this table, I can control the whole room.'"

It was the new Moveable Feast and Eve had scored herself the best seat in the house. Mirandi on the view from that seat: "Who was at the Troub then? God, who wasn't? Okay, well, Jackson Browne, looking like the cutest twelve-year-old you ever saw. And Gram Parsons, who had this suave swankness to him. And Van Morrison—him I just couldn't believe, sounding like the coolest Black singer but white and from Ireland." Ticking off the names on her fingers: "Arlo Guthrie, Neil Young, Randy Newman, Paul Butterfield, Crosby, Stills and Nash. Who else? The guys from the Nitty Gritty Dirt Band, Janis Joplin, the Byrds, the ridiculously funny Steve Martin, the ridiculously cute Linda Ronstadt. Steve and Linda were a couple for about five minutes. He kept taking her out and then not trying to sleep with her. She didn't know what was going on. Diane Gardiner, the Doors' publicist and one of Eve's closest friends, practically lived at the bar. So did J. D. Souther and Glenn Frey. J. D. was from Texas and Glenn was from Detroit and their band was called Longbranch Pennywhistle. And then David Geffen told Glenn that if he wanted to get signed, he needed an entire band. So, then Glenn got together with another Texan hanging

around the bar, Don Henley. That's how the Eagles happened. And J. D. wound up writing a bunch of their songs."

The Troubadour was as overwhelmingly male as Barney's had been. Women were allowed in, but on one condition. "You had to be fuckable," said Mirandi. Which Eve was even though she wasn't, her type—the va-va-voom type, the Marilyn type—no longer everybody's type. "By the time the Beatles trotted out onto Ed Sullivan's stage with those heartrendingly sexy toothpick legs—THWAP—everyone had toothpick legs," she wrote. "Except mine weren't right. The heart of the problem wasn't really my legs [but] my ass . . . It was there, for one thing; and no serious Beatle person's ass was there."

Eve, though, was the rare exception in that she *didn't* have to be fuckable. She was a relative elder—twenty-five in 1968—and relatively established in a place where public attention had yet to definitively land and pecking orders were still working themselves out. "I loved J. D. Souther," she said. "And I couldn't believe it, but he and Glenn Frey loved me. They were fans because of that cover I did for Buffalo Springfield."

So, on the Troubadour scene, Eve was what she'd never succeeded in becoming on the Barney's scene: a recognized artist. To commemorate the occasion, she made a sign.

I USED TO BE A PIECE OF ASS, NOW I'M AN ARTIST

"Oh yeah, I remember that sign pasted to the door of her apartment—the Formosa one," said Blum. "Eve could not abide ignorance or stupidity or bad taste, and any one of those qualities could send her off big-time. So I guess she wanted to make her situation clear to people. She was flat-out telling them, 'I am an artist.'"

Why then did Eve act as if "artist" was her cover story, "groupie"—"groupie" being rock 'n' roll for "piece of ass"—her truth? Both in print and conversation, she'd shrug off her work as an album-cover designer, refer to it laughingly as "an excuse." She was, she insisted, "a daughter of Hollywood, alive with groupie fervor, wanting to fuck [her] way through rock 'n' roll and drink tequila and take uppers and downers, keeping joints rolled and lit, a regular customer at the clap clinic, a groupie prowling the Sunset Strip."

Since I've read her letters and journal, however, I know how it really was. The album covers weren't her excuse, they were her reason. My guess is that she worked hard to give the opposite impression because to cop to seriousness was somehow to violate her sense of self.

I'm not serious, but I'm good so what difference does it make?

Returning, for a moment, to fuckable:

Time was ticking, days becoming months, months becoming years, the Sixties becoming the Seventies. Yet Eve stayed the same. She still drew no distinction between her personal self and her professional self, rejecting the idea that she had a professional self.

She began taking old-fashioned photos of contemporary performers. ("What I'd do was print the pictures in sepia and then hand-color them so they looked like they'd been taken thirty years before," she said. "That's how I liked things to look—old, out of the past.") Of Gram Parsons, who she saw as one of Fitzgerald's Sad Young Men, and so shot in a blazer and tie, white trousers. Of Steve Martin, who she saw as a thirties matinée idol, and so shot as Errol Flynn, bare-chested and under a palm tree. Of Jackson Browne, J. D. Souther, Don Henley, and Glenn Frey, who she saw as surfer-cowboys, and so shot looking home-on-the-range.

And after making love to these guys with her camera, she made love to them with her body. All but for Parsons,* whose room at the Chateau Marmont she managed to get into, whose bed never.

And she continued designing album covers for lovers and friends.

Lovers such as Eric Andersen (album: *Avalanche*). Such as Leon Russell (album: *Hank Wilson's Back Vol. 1*). But not such as Jim Morrison (album: *Waiting for the Sun*), though with Morrison she did come awfully close. From a 1969 letter to Doors manager Bill Siddons: "After [the Doors] got back from Phoenix, Jim called up . . . He asked me to come pick him up

* In *Hollywood's Eve*, I put Jackson Browne on this very short list of rock 'n' rollers Eve had photographed but not seduced. I'd asked her straight out if she'd gotten together with Browne. There was a long pause. "I don't think so," she finally said, though with a question mark at the end of the sentence rather than a period. Turns out, she was right to be uncertain. From her journal, entry dated October 2, 1969: "Jackson Brown [*sic*] drove me home and we talked, fucked and had an enormous fight in that order."

as he was hiding in some phone booth . . . So I found him, [drunk,] his lizard pants torn from crotch to knee with all this peacock blue lining sort of artistically ragged . . . He tells me that he really loves my collages, A LOT, uhhh, especially the octopus ones, and the Spanish Caravan one, REALLY, only they're not using them, he explains and then mentions something about their being too strong."*

And friends such as the Byrds (album: *Untitled*), but in the case of *Untitled* she wasn't hired by Byrd friend David Crosby, was hired by Byrd producer Terry Melcher, also a friend. (From her journal, entry dated January 14, 1970: "Went to a party at Terry Melcher's last night . . . I didn't speak to him except when I came in, he told me he liked my collages. Michelle Phillips has put the Brian Jones collage on the ceiling over her bed, so Terry must be sleeping with Michelle.")

Eve shoots the Byrds.

* I confirmed with Doors drummer—and Eve's first Doors boyfriend—John Densmore that the cover she was describing was for *Waiting for the Sun*. "We all loved Eve's collage, but we were already into discussions with a photographer about shooting us up in the Santa Monica Mountains for the cover." He added, "I think Jim, in his stupor, was coming on to Eve with his octopus comment."

Eve was relentless in her pursuit of assignments. John Van Hamersveld was the art director of Capitol Records when she burst into his office in the late sixties. "She had her collages and her Buffalo Springfield album with her. Her reputation was as a predator. And she chased me around my desk a few times, asked me on dates. But that was just Eve playing around. Work is what she wanted from me."

Sometimes she'd get it, from Van Hamersveld and others, sometimes not. And sometimes she'd get it, from Van Hamersveld and others, and then not. "Some art director would say he loved [my collages] in the morning and get drunk at lunch and call and change his mind before dinner," she wrote. "In the free-lance art world [art directors] felt they were doing me a favor."

So, Eve was more getting by as an album-cover designer and photographer than taking off. At least, though, she could pay her bills. Even when she couldn't. "I looked upon men, in those days, as people who'd never miss my incredibly reasonable fifty dollars for cabfare, which was much too cheap to make me feel like a hooker." And at least she was having a good time. From her journal, entry dated February 2, 1970, "Michael Clarke [Byrds drummer] told Diane Gardiner he was really happy to run into us because he was so bored. Imagine anyone in this day and age admitting to boredom!"

Eve was moving into her late twenties, yet her existence remained as footloose and improvisatory as a teenager's. It was as if she'd tapped into a fountain of youth and sex and high spirits, and it would never run dry.

I can't let the groupie point go quite yet, Reader, because I don't think I've made it quite yet.

Eve walked like a groupie, talked like a groupie, fucked like a groupie, but a groupie she was not. A groupie, as I understand the term, is a person who bestows sexual favors on celebrity musicians. Only the musicians Eve was favoring sexually weren't, at that time, celebrities. As Steve Martin observed to me, "Nobody was famous yet." And besides, Eve wasn't looking to turn a one-night stand into a long-term partner, the groupie goal and endgame. "God, the last thing Eve wanted was a boyfriend," said Laurie. "She didn't want a serious relationship with any of those guys. She just wanted to exchange body fluids."

So, Eve wasn't interested in having a boyfriend. But boy*friends*, now, that was a different story. And all her romances of this period were erratic, casual, fleeting.

A kiss-off letter to "Jack," last name unknown, best captures, I think, the chaos and confusion of her love life during the Franklin Avenue/Troubadour years. It read:

Dear Jack:

I have done a lot of weird things in my life, but going out with a married psychiatrist is the most bizaar [*sic*] to date. I rarely feel ashamed of anything I do for long . . . but the thrill of a rendezvous with the Archbishop of Canterbury couldn't make me think I was walking on a crumbling roof more than you . . . I know the world is polluted, corrupt, and composed of jagged corners and no more pastoral scenes for us. But you, Tory that you are, should not contribute—you should [stay in] your corner and leave bohemian cunts like me to their own destruction . . .

I can't think about you anymore.

Love,

Eve

In her novel *L.A. Woman*—autobiographical because that's the only kind of novel she wrote—the Eve character, called Sophie, has a conversation with the Laurie character, called Ophelia:

"But you know so many men," said Ophelia, "isn't there even one for you?"

"They're all adjectives," said [Sophie], "they all make me feel modified; even a word like *girlfriend* gives me this feeling I've just been cut in half. I'd rather just be a car, not a blue car or a big one, than sit there the rest of my life being stuck with some adjective."

Eve is saying a lot of words here, but really she's only saying four: Don't tread on me. It's an extraordinarily aggressive statement for anyone to make, a female anyone especially. That the language it's delivered in is groping and unsure is irrelevant. Eve wanted sexual freedom, a genuine possibility for women for the first time in recorded human history. Thanks to advances

in medicine, i.e., the Pill, biology no longer reigned supreme. "Stuff like jealousy and outrage and sexual horror tactics like that, which had been used to squash girls like [me] for years, now suddenly didn't stand a chance because [I wasn't] going to get pregnant," she wrote.

What she truly wanted, though, was freedom in general, sexual freedom, dreamy and cat's meow as it was, just a stand-in for something larger. The idea of answering to somebody or explaining herself, of another person having a say in who she saw or where she went or what she did, was abhorrent to her. She would not countenance it.

I misspoke before when I said that all Eve's romances during this period were erratic, casual, fleeting. There was one that was steady (even if destabilizing), serious (even if on the side), and abiding (even if intermittent). It was with a man connected to both the Franklin Avenue scene and the Troubadour scene: Ahmet Ertegun.

Ertegun wasn't the only figure on the Franklin Avenue scene besides Eve who was also on the Troubadour scene. Earl McGrath, in 1970, was given a label to run within Atlantic by Ertegun, so, naturally, he was there. (Was given a label to run within Atlantic by Ertegun but not really, the one hot act he found—Hall & Oates—Ertegun poached.) As were Michelle Phillips and Peter Pilafian, musicians. And Anne Marshall, the girlfriend of a musician, Don Everly, and the ex-girlfriend of another musician, Phil Everly. ("In between the Everly Brothers, Annie had an affair with my husband—well, John and I were separated at the time—and that's how she and I met and became best friends," said Phillips. "And we stayed best friends when John and I got back together.") And Ron Cooper, the boyfriend of a musician, Janis Joplin. ("Ron is bubbling over with stories about the time Janis Joplin gave him the crabs," Eve told Walter Hopps in a letter.) Harrison Ford swung by in his dealer capacity. ("Harrison carried his dope in a bass-fiddle case," said Eve.) And though Joan was unpersuaded by rock 'n' roll as a cultural phenomenon—"On the whole my attention was only minimally engaged by the preoccupations of rock-and-roll bands"—and did not, so far as I know, venture inside the Troubadour, she did occasionally accompany McGrath on his forays into the rock 'n' roll demimonde. "Saw the Burrito Bros at The

Experience Friday," wrote Eve in her journal, entry dated October 18, 1969. "Earl was there with Mrs. Dunn (who looked horrified at what a toilet The Experience is)."

Ertegun, however, was the only figure on the Franklin Avenue scene besides Eve who was also a figure on the Troubadour scene. He was an omnipresent presence at the club, if largely an absent one. "I did see Ahmet at the Troubadour," said Mirandi. "He'd come to check out a band, and would maybe go upstairs to the dressing room afterward. But he didn't go to the bar. He couldn't. He was a record company president. He'd have been devoured. But he was someone everyone there was talking about, that's for sure."

It was through McGrath, of course, that Eve met Ertegun in early 1969. She told me the story:

Ahmet was in from New York, cruising all the bands, trying to get every single one signed to Atlantic. Earl said, "My friend Ahmet is the guy who actually bought that Buffalo Springfield album cover of yours." I said, "Oh, really?" Earl said, "I want to play a trick on him. I'm going to tell him that you make the best frozen potatoes fricassee. Is that okay with you?" I said it was. So Earl called Ahmet at the Beverly Hills Hotel and told Ahmet he had to come to my apartment straightaway and try my frozen potatoes fricassee or whatever crazy thing it was. And Ahmet did because he knew Earl was testing him. He arrived in a wonderful Cadillac convertible, and I showed him all my collages, and then we were together. Ahmet was so much fun. I don't know how I fit in his global plan to take over the world, only somehow I did.

Ertegun wouldn't quite take over the world. But he would take over the music world when, in 1971, he stole Mick Jagger and the Rolling Stones away from Decca Records. Yet while Ertegun was a suit and a shark, a killer by instinct as well as by trade, he was other things, too. He was an art collector, owned paintings by Matisse and Degas and Lichtenstein, murals by Picasso, etchings by Schiele. He was the son of a diplomat, his father Turkey's ambassador to the United States from 1934 to 1944. And he was the husband of a woman soon to be named to the International Best-Dressed List Hall of Fame. All of which is to say, he wasn't the usual

cigar-chomping, moneygrubbing, music-mogul vulgarian. Rather, he was an impresario-potentate, the Monroe Stahr of rock 'n' roll. That, at any rate, was how Eve saw him.

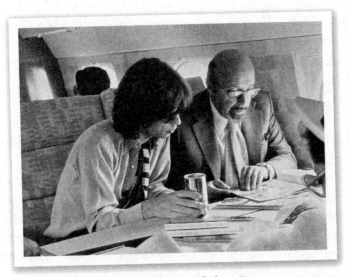

Conspirators: Mick Jagger and Ahmet Ertegun.

Laurie took a dimmer view. "I thought Ahmet was horrendous in every way, and I could see nothing about him that anybody could possibly like. His brother Nesuhi, who Eve also knew, was a lot cooler. Ahmet, though, just struck me as a fame caricature. He was ugly, and he couldn't *do* anything. But Eve talked about him all the time. I don't know why except she once said to me that she was physically turned on by money and power."

Not only by money and power. Ertegun's irreverence and roguery, his moral indifference, I suspect, attracted her equally. There was laughter in his eyes, but when he grew bored—something he did easily—he also grew cruel. And Eve was, compared to him, an innocent. What's more, she lacked awareness of her own vulnerability, the ways in which her intelligence made her arrogant and therefore blind. In a letter to Chris Blum, she wrote, "Earl is so nervous about sex that it's always mysterious and dangerous and he told me that he's only ever made love with 8 people (we're all sure Ahmet's one but Earl will never confess to that)."

If McGrath and Ertegun were indeed lovers or former lovers, then complex duplicities were at play, and the dynamic between them and Eve takes on a Jamesian aspect. It's *The Portrait of a Lady* set to rock 'n' roll. As Isabel Archer was presented to Gilbert Osmond by Madame Merle, Osmond's former lover, so Eve was presented to Ertegun by McGrath. And like Isabel Archer, Eve wasn't just a victim, but a victim who actively participated in her own victimization. That she was rushing headlong into a web spun by people more sophisticated, more worldly, more wicked, than she didn't occur to her until it was too late. She was ensnared.

To Jack, she wrote:

> Did I ever tell you about the Turkish millionaires—two of them, brothers, who come into town separately and take me out. One is shy and conservative and does things like go to Mexico City for the soccer world series and takes me to conservative black people's houses who talk about Billie Holiday. The other one sends cards from Helen Keller's birthplace and roses and perfume and limos and takes me to the most sordid whiskey A Go Go type places and once asked me politely if I'd like to be beaten.

Eve was making no explicit acknowledgment of pain here. Yet you can sense that something delicate in her had been hurt or damaged, maybe irrevocably.

"It started to go bad with Ahmet when Eve made her collage of him in, I think, late 1969 or early 1970," said Mirandi. "The collage showed Ahmet, smiling, holding a glass of champagne, a little coke straw. And Eve put herself in there, too—her naked backside. It wasn't actually her backside. She found some woman in a Renaissance painting with a body exactly like hers, and that's what she used. Eve saw Ahmet so magically, and she wanted to clarify him for the world. And that's what she felt she was doing with the collage. She was saying, 'You're so fabulous, and I'm so fabulous, and we're so fabulous.' She framed it beautifully and she brought it to him at his L.A. office because that's where she thought it should be hung. He took one look and had a fit. He said, 'No one must ever see this.' Eve was just so confused and devastated. It's not that she thought he was going to leave Mica [his wife] for her, but she thought he should

recognize her publicly somehow, you know, as his mistress. And, in that moment, she felt the stone-cold reality of their situation. He would only ever recognize Mica, only ever protect Mica. In fact, he was protecting Mica *from* her. He was keeping the collage out of his office so Mica wouldn't have to know he was cheating on her with Eve. Ahmet ultimately forgave Eve, and Eve didn't stop seeing Ahmet when he came to L.A. Her illusions, though, were in absolute pieces. I mean, she was getting it from all sides at once—first Ahmet, then Earl."

And there was a shift—perceptible—in Eve's psychology. Pre–the Ertegun collage, she courted corruption so giddily, participated in her degradation so eagerly, rolled along the path of sin so merrily, that she was incorruptible, undegradable, and beyond reproach—a lewd angel. That all changed post–the Ertegun collage.

In her novel *Sex and Rage*—autobiographical because, again, that's the only kind of novel she wrote—the narrator explains how it is between the Eve character, called Jacaranda; the Ertegun character, called Etienne; and the McGrath character, called Max:

> The parties would last till 2 or 3 a.m. The girls would tempt Etienne and he'd choose one, perhaps a pretty little laughing blonde he had besieged with dozens of roses, color TVs, and even diamond stud earrings—anything her little heart desired . . . At about midnight, suddenly, the whole thing would become too boring and Etienne would start spewing insults at the little blonde. Or, worse yet, forget her and start on some new woman . . . Since Jacaranda cared so little about what Etienne was doing, she usually wound up being the one with whom Etienne slept. By two or three o'clock, Jacaranda would be the only unpassed-out woman extant, and she, Max, and Etienne would have a nightcap and discuss the evening, until one of them was sent home in a Rolls-Royce limousine—Max.

Eve sounded, for the first time, bored—infected by Ertegun's boredom, contaminated by it. Sounded, too, hard, cold, contemptuous of self and others. Sounded fallen.

The fountain of youth, sex, high spirits, had, at last, run dry.

CHAPTER 6

Double Trouble

Eve left the Troubadour scene in 1971. At twenty-seven, she was aging out. "I was getting too old to be a record album photographer."

Aging out in part because the scene had aged her. "Eve was tough enough to hang at the Troubadour bar," said Mirandi. "There weren't many women who were. A lot of us—not Eve, but a lot of us—wanted the white picket fence, the kids. And the men were like, 'No, no, no, no. We're going to do whatever we want, and we're going to do it with you, and with her, and with her, and with her.' So emotionally that was hard. Physically, though, it was also impossible. I did the best I could. But I had to dive out all the time so I could clean up, pull myself together. Eve never dove out."

Nor was it merely a question of flagging stamina. Eve was bewitched by the scene, and then, suddenly, she wasn't. "[I'd] begun telling rock 'n' roll stars I hated rock 'n' roll and nobody is that cute," she wrote. A problem because her art depended on her infatuation, as she herself was well aware. "The only way my album covers ever worked was by my being a groupie and blazing with tenderness over what idols my idols were."

And even if she'd wanted to stick around the Troubadour scene, she couldn't have. It had left her as surely as she had left it. "The Sixties careened into the Seventies and wandered out the other end," said Dickie Davis.

"The Troubadour bar became the Sad Café. Paris in the Twenties sold to the highest bidder." The Moveable Feast was moving on.

Both Moveable Feasts.

Dating the end of the Franklin Avenue scene is a snap: it was over once Joan no longer lived on Franklin Avenue.

Also over once Joan no longer lived on Franklin Avenue: Sixties L.A. "The Sixties did not truly end for me until January of 1971, when I left the house on Franklin Avenue," she wrote. And yet she recognized that she was out of step with her fellow Angelenos, most of whom would've seen her as having a delayed reaction. "Many people I know in Los Angeles believe that the Sixties ended abruptly on August 9, 1969, ended at the exact moment when word of the murders on Cielo Drive traveled like brushfire through the community."

The murders she's referring to are, of course, the Manson murders. Model-actress Sharon Tate, eight months pregnant, and four others—Jay Sebring, Wojciech Frykowski, Abigail Folger, and Steven Parent—were beaten, stabbed, and shot by followers of the cult leader at the house Tate shared with husband, director Roman Polanski, 10050 Cielo Drive.

Cielo Drive was a bloodbath and an atrocity and a horror. For those on the Franklin Avenue scene, it was also personal.

Eve knew Tate only glancingly. "The first time I saw Sharon was at the Café de Paris in Rome," she said. "It was 1961 [Ed. note: 1962, actually], the same year I saw the Pope. I couldn't believe anyone was that beautiful."

Mirandi, though, was on decidedly more intimate terms with Tate. "Sharon ordered some clothes from the shop, so Clem and I went to her house for a private fitting." (In 1968, Mirandi and Clem Floyd, formerly Mirandi's boyfriend, now Mirandi's husband, had opened a custom-leather boutique on Sunset.) "The house we went to was the one before the Cielo Drive house. Roman was there, and some kind of weird flirtation was going on between them and us. Clem was necking with Sharon. He would have loved the opportunity to get in her pants, but I was so repulsed by Roman that I couldn't imagine any of it. I said to Clem, 'We're leaving.' I never wanted to go back." Mirandi would, however, continue to see Tate.

"I'd hang out with Sharon late into the night when Roman wasn't around. She was so sweet, and—I remember from doing her measurements—a perfect 32-22-32."

Earl McGrath was the upstairs neighbor of Polanski and Tate when, in the mid-to-late sixties, he kept a two-bedroom apartment—Suite 64—at the Chateau Marmont. On Sundays, he'd throw brunch parties on his terrace with a PEACE/LOVE sign hanging from it. Polanski and Tate were frequent guests.

Sharon Tate on Earl McGrath's terrace at the Chateau Marmont, Peace and Love, 1968.

As was Anne Marshall. "I saw Sharon at Earl's, but I already knew Sharon very well. Michelle [Phillips] and I both did. And Wojciech Frykowski had given me and Michelle a pair of wings the year before. We'd used them for our Christmas card. We sent out a picture of ourselves wearing Wojciech's wings—big, huge angel wings—and the words 'Season's Greetings' on the back. Did Eve help us with that picture? I think maybe, but I can't remember."*

* Eve did help Phillips and Marshall with the picture. She tinted it, according to a letter she wrote Walter Hopps in 1972.

Julian Wasser took the famous photo of Polanski's gruesome home-coming. (Polanski, in a white T-shirt, kneeling by the front door of the Cielo Drive house, the word "PIG" scrawled across it in Tate's blood.) "The cops didn't know shit, as usual," said Wasser. "Roman was in Europe when it happened. He flew back to L.A. with Warren Beatty and a few other people. Roman took me and Tommy Thompson [journalist] and a psychic [Peter Hurkos] to the house. It was his first time on the scene. The carpet had a three-foot circle of jellied blood. Roman was crying. He wanted me to take pictures to give to the psychic so he could find out who did it."

Griffin Dunne was at the scene of the crime almost as the crime was being committed. In the early-morning hours of August 10, he snuck out of his mother's house to joyride with his friend Charlie. "I don't remember how old Charlie and I were—fourteen, maybe—but I do remember that we were so short we had to sit on phone books to see over the dashboard. We were in my mom's car, a Mercury Cougar. And we were driving these side streets just off Benedict Canyon, which is where Sharon and Roman's house was. And suddenly there were cop cars everywhere. I mean, every-where. We thought they were after us."

And Michelle Phillips was considered briefly—erroneously—a motive. She and Polanski had had an affair earlier that year, and Polanski became convinced that her ex-husband, John Phillips, butchered his wife in revenge. At one point, he threatened John with a meat cleaver. "It was so sad and so revolting and it had happened to our friends," said Phillips. "Roman and Sharon were close with all of us. This wonderful life that we all had, that we all were sharing, and everyone making tons of money and hav-ing a blast together, and going to the Troubadour, and going to all these wonderful parties, to Earl's, and meeting all these wonderful people—it stopped. There were no parties after that because there was no reason for a party. For me, that was the end of the party."

What's more, Manson and his gang weren't outsiders in Hollywood. The "community" that Joan wrote about? They were part of it. "Their guru, Charlie Manson, was a sociopath," said Mirandi. "But he was also a singer-songwriter. A lot of the scenes he was on, we were on. He'd lived at the house of Beach Boy Dennis Wilson, and Dennis had recorded one of his songs [Ed. note: 'Never Learn Not to Love,' on the Beach Boys' 1969 album 20/20, is a version of 'Cease to Exist,' which Manson wrote for Dennis Wilson but on which

Manson received no credit]. Well, I'd gone to high school with Dennis. Dennis was my friend. And it was Dennis who introduced Manson to Eve's friend Terry Melcher, the record producer. Manson blamed Terry when he didn't land a contract. Terry had lived at Cielo Drive before Roman and Sharon and he's the one they meant to kill. And one of Manson's followers, the musician Bobby Beausoleil, had stayed with Evie for a week, though I don't think she slept with him.* What I'm trying to say is that the Manson people were our kind of people. They were the people we thought would make the world a better place and here they were dripping in innocent blood."

I'd contend that the Manson murders weren't a contradiction of Sixties L.A. so much as an amplification of and elaboration on certain undertones and implications in Sixties L.A.—the shadows creeping into the sunshine. I'd also contend that the Manson murders didn't end Sixties L.A. so much as start the next phase of Sixties L.A., i.e., Seventies L.A. (The Seventies in L.A. weren't, in my opinion, a decade unto themselves but an extension of the previous decade: the Sixties the flower child, the Seventies the juvenile delinquent that the flower child—a bad seed all along—grew into.)

"I was too stupid to know I was in the wrong place," said Eve. "Joan knew, but I didn't. She had to go through the horrible awakening of finding out that California was in dire straits. I never had to find out because I was too drunk and stoned."

If Eve missed the chimes at midnight, she caught the echo.

On July 3, 1971, Jim Morrison, age twenty-seven, died, an event she connected with Charles Manson. "Jim looked like [Manson] in his obit picture in the *Los Angeles Times*," she wrote. As though Morrison and Manson, who looked like Morrison in his picture on the cover of *Rolling Stone* the year prior, were two faces of the same phenomenon: the rock star who dreamed of becoming a homicidal maniac; the homicidal maniac who dreamed of becoming a rock star. (Listen to "People Are Strange" and "The End," both from 1967. Morrison was telling us what Manson had done two years before Manson did it.)

* She didn't. It was his nickname, Bummer Bob, that turned her off. "Anyone who called himself that, I figured, must have the clap."

For Eve, the Troubadour was the quintessence of rock 'n' roll and Morrison was the quintessence of the Troubadour, even if he never stepped foot on the Troubadour stage. "Jim was a regular at the Troubadour bar," said Mirandi. "And he actually did what I thought couldn't be done. He got thrown out for being too drunk and for falling down on too many girls."

Where Morrison's concerned, Eve's feelings aren't easy to sort out. She wrote about him for *Esquire* in 1991, when Oliver Stone made the Morrison biopic *The Doors*. Her attitude toward him in that piece wasn't cruel, not exactly. After all, she was electrified by Morrison the heartthrob, an object of desire so supreme he was also an object of art. "Michelangelo's David, only with blue eyes," she wrote-swooned.

But Morrison the artist provoked another reaction entirely. She spoke of his film-school background with a mixture of contempt and affection: "Being a film major in the sixties was hopelessly square [because] all the movies did was get everything all wrong." Contempt mounting, affection dwindling, she turned her eye to his band: "The Doors were embarrassing, like their name. I dragged Jim into bed before they'd decided on the name and tried to dissuade him; it was so corny naming yourself after something Aldous Huxley wrote." She then called Morrison a poet, only she didn't mean it nice: "If Jim had lived in another era, he would have had a schoolteacher wife to support him while he sat at home writing 'brilliant' poetry." (The quotes around *brilliant* is an especially brutal touch.)

It was, according to Eve, Morrison's girlfriend, Pamela Courson, who was the true spirit of rock 'n' roll. "[Pamela] had guns, took heroin, and was fearless in every situation . . . Everything a nerd could possibly wish to be, Pamela was." Eve didn't need to say that Morrison was the nerd with aspirations to coolness since it went without saying, and only the young and clueless might be fooled into thinking he'd achieved them. "[Jim's] audience was all college kids who thought the Doors were cool because they had lyrics you could understand about stuff they learned in Psychology 101."

Joan was neither young nor clueless when she decided in 1968 to write about the Doors. I already quoted that line of hers: "On the whole my attention was only minimally engaged by the preoccupations of rock-and-roll bands." So, what was it about this rock-and-roll band that maximally engaged her? "Bad boys," she said, after Griffin put the question to her in his 2017 documentary, *Joan Didion: The Center Will Not Hold*. In a

different context, she'd call the Doors "missionaries of apocalyptic sex." And their leader would exceed her expectations, both apocalyptic and sexual, when she finally met him. (It was Eve, by the way, who set up the meeting, arranging for her to sit in on a Doors recording session.) The detail to which she'd attach the most significance was a match Morrison lit. "He studied the flame awhile and then very slowly, very deliberately, lowered it to the fly of his black vinyl pants," she wrote. In short, Joan took Morrison at his persona.

Eve, though, knew that Morrison was the opposite of what he pretended to be. "He never really stopped being a fat kid," she wrote. She saw his incomprehension, his shyness, his sweetness. In other words, she saw *him*— through the persona to the person. (Eve, who was also at that recording session, recalled the lit match. But, in her memory, Morrison was flicking it *at* Joan, a playful gesture. "He was flirting with Joan," she told me.)

The difference between their perceptions of Morrison is the difference, I think, between their roles on the scene: Joan an observer of it; Eve a participant in it. Or perhaps it's the difference between being a starfucker, which Joan and Dunne emphatically were ("They were nice people but they were starfuckers," said writer Josh Greenfeld, a longtime friend of the couple's); and one who fucks stars.

Yet even as Eve dismissed Morrison, she couldn't.

When Eve first encountered Morrison, he was twenty-two and newly slender, having shed thirty pounds after a summer of LSD. He had, until the drinking and drugging left him bloated and ravaged, remarkable beauty, and beauty made Eve reverent. So did fame, fame being to Eve what money was to F. Scott Fitzgerald. The very famous, she believed, are different from you and me. "[People] don't know what it was to suddenly possess the power to fuck every single person you even idly fancied," she wrote in *Esquire*, "they don't know the physical glamour of that—back when rock 'n' roll was in flower."

But a rapturous response to Morrison's looks and legend was only part of it. There was between Eve and Morrison an emotional pull. She identified with him even if she wished she didn't. (This chapter, it should be noted, is the chapter of shifting doubles: Morrison is the double of Manson one minute, of Eve the next.)

Eve and Morrison were alike in the ways in which they were incompatible with rock 'n' roll. Morrison was a rock god who could've passed for a Greek

god. Maintaining his Olympian status, though, was an unending struggle because so was his weight. Wrote Eve, "He used to suggest, 'Let's go to Ships and get blueberry pancakes with blueberry syrup.' 'It's so fattening,' I would point out. I mean, really." And Mirandi, who dressed Morrison as she dressed Sharon Tate, putting Morrison in his stage leathers, said to me this: "Jim started to get heavy. And I could see how self-conscious he was when I measured him. All that alcohol had made him thick, puffy, and he was miserable about it. He could barely look at himself in the mirror. I felt for him." Eve also ran to flesh. And if you wanted to be the one the rock god went home with, you had to be as skinny as a teenager or a junkie. Or a Joan Didion.

Jim Morrison, still beautiful, still thin,
in leather pants made by Mirandi Babitz.

"Mick Jagger hated me because I was fat," said Eve. "I thought I was fat, too. I look at pictures now and see that I looked like a normal person, but that was fat then. The Rolling Stones decided to put out a clothing

line. They were selling wife-beater T-shirts. Mick called up his manager at four in the morning to complain because the only sizes he wanted were small and extra small."

Morrison and Eve must've felt like imposters. Like the spell was going to break at any moment, turning them back into roly-poly outcasts who'd never again make it past that gatekeeper of Enchantment, the Troubadour doorman.

And their incompatibility with rock 'n' roll wasn't just physiological. It was psychological, as well. Both refused to get with the rock 'n' roll program, be rock 'n' roll cool. Eve was an artist. And though Morrison wasn't, in her estimation, an artist, he somehow was, in her estimation, an artist. "I began running into women who kept Jim alive—as did I—because something about him began seeming great compared with everything else that was going on," she wrote at the end of the *Esquire* piece. (What gives that piece its peculiar power is that you can see Eve changing her mind about Morrison on the page. The tenderness she feels for him sneaks up on you as you read it, as I suspect it did on her as she wrote it.) Artists are soft in places where other people are hard. And they need to be soft, stay soft, in those places. It's what keeps them artists.

Yet so many of the people surrounding Eve and Morrison were the hardest of the hard: promoters and producers and managers and flacks and other quasi-gangsters who made their livings sucking on fame's teat.

Eve was on hand to witness Morrison slam up against one of these hard cases. She wrote:

I was in the bungalow of Ahmet Ertegun . . . It was the night of the 1971 moon landing [February 5], and when I came in wearing my divine little black velvet dress, my tan, my blond art-nouveau hair, and my one pair of high heels I used for whenever Ahmet was in town, who should be sitting in front of the TV watching the moon landing but Jim, a Scotch and Coke (no ice) in his hand.

Ahmet proceeded to tell a rather gross story about midgets in India, and when he was through, Jim rose to his feet and bellowed, "You think you're going to *win*, don't you?! Well, you're not, you're not going to win. We're going to win, *us*—the artists. Not you capitalist pigs!"

You could have heard a pin drop in this roomful of Ahmet's fashionable friends, architects from France, artists, English lords, *W*-type women . . .

Everybody was silent (except for the moon-landing reporter on the TV) until I stood up and heard myself say, "But Ahmet *is* an artist, Jim!"

I became so embarrassed by how uncool *I* was, I ran down the hallway and into the bathroom . . . There was a knock on the door.

I opened it and Jim came in and shut the door behind him.

"You know," he said, staring straight into my eyes, "I've always loved you."

Later that night he came back and apologized to Ahmet. But it was too late; by then he was too fat to get away with it. The people who were there refused to remember that it had happened. It was one of those tricky nights when Ahmet was trying to make up his mind whether he was going to seduce Jim away from Elektra Records . . . Of course, today Ahmet might deny this was going on, but at that time Ahmet never saw a rock star who made money whom he didn't want . . . Jim might also have denied anything was going on, or maybe he did notice he was being seduced, maybe that's why he was on about the capitalist pigs not winning. But then, Jim was drunk and uncool, so maybe what he said wasn't about anything.

What I think was going on between Morrison and Ertegun that night: although Morrison appeared to be a drunken oaf spoiling for a fight, he was in fact an innocent—a defiled innocent, but an innocent nonetheless—defending himself clumsily, helplessly, against a snake-like opponent. An opponent who was sleek, subtle, slithering, coiled to strike. An opponent who was, contrary to Eve's claim, not an artist, who was a social person. ("Social person" is Ertegun-speak. He admitted only two categories of human, according to record producer Jerry Wexler, "social people and morons." To be an artist is, at some level, to be a moron willingly, and Ertegun wasn't willing.) An opponent for whom he was no match.

Watching this scene, Eve must've felt a jolt of self-recognition. She, too, was a defiled innocent battling for survival. Not just against Ertegun, against McGrath, though you could argue that since Ertegun co-opted McGrath by giving McGrath a record label, the two men were a single man. (Another set of shifting doubles.)

Eve, in early 1971, at the time of the moon-landing party, was recovering from McGrath's attempt to destroy her. When she met him in 1967, he was a fantasy lover and kindred spirit. "[I] felt very, very close to him

and heard him breathing and saw exactly what he saw and knew exactly why he did things and understood everything without a hitch," she wrote. The affinity between them only strengthened. "The 69/70 season" was, she declared in a letter, McGrath's most brilliant yet—"Social Enchantment on its highest level." But by late 1970, he'd become a stranger and an enemy.

Socially, McGrath twisted the knife in deep, something he could have done only with the tacit consent of Ertegun, who perhaps believed that Eve needed to be punished for the presumption of that collage. "Earl really hurt Eve because they'd been in love, basically," said Mirandi. "Then he started saying things to her like, 'Is that what you're going to wear?' and, 'You got so drunk last night, you made a fool of yourself.' Just these poisonous remarks. And that's where she was vulnerable—her etiquette. She was worried she didn't have it, or that she had it wrong. And what had happened with Ahmet and the collage made her even more vulnerable because she felt she'd done an incorrect thing again. She'd upset him, embarrassed him, whatever, and she didn't quite get why. Later on, she and Earl would make up and see each other. But the I-can't-get-enough-of-you-ever part of their relationship, the love affair part—that was over."

Artistically, McGrath twisted the knife in deeper, and he did it with those six little words. "Oh, Earl, Earl was impossible," said Eve. "He looked at something I was doing—a painting, you know? He said, 'Is that the blue you're using?' That was it. I stopped painting."

A note on those six little words. They were originally spoken by Earl McGrath, obviously. But Eve spoke them, too, and often, and in a variety of contexts. For instance, I once expressed curiosity as to why she'd never gone into the local business—movies—and written scripts in more than a half-assed, quick-buck way. Her reply: "Because you show a Hollywood person your screenplay, and the person asks, 'Is that the blue you're using?' That's what one studio executive said to me."

Another time, I wondered aloud about Duchamp's reason for leaving the art world back in the twenties. (A sudden and overwhelming passion for a board game struck me as a fake-out.) Eve gave me a sideways look and said, "Because some terrible person who was supposed to be his friend asked him, 'Is that the blue you're using?'"

The question clearly had for Eve a meaning beyond its literal. She put it in the mouths of people who radically and profoundly failed to understand how art was made, how an artist suffered to make art. Like the dum-dum studio executive. Or of people who *pretended* to radically and profoundly fail to understand how art was made, how an artist suffered to make art. Like Duchamp's insidious confrere.

Like Earl McGrath.

My intuition is that McGrath was jealous of Eve. That jealousy was sexual: he was jealous of other men for sleeping with her, jealous of her for sleeping with other men. But that jealousy was not sexual fundamentally. Fundamentally that jealousy was artistic.

McGrath resembled, in so many ways, the hero in one of those sprawling nineteenth-century novels about lost illusions: a young person of humble origins with grand hopes and dreams is lured to the big city, where his hopes are dashed, his dreams crushed. Stendhal's *Le Rouge et le Noir*, for example, or Dickens's *Great Expectations*. *À la Recherche du Temps Perdu* by Proust and *The Great Gatsby* by Fitzgerald, the American Proust, are the prime twentieth-century examples.

Eve told me about the transformative effect Proust had on a young McGrath. "He read Proust when he was sixteen and it changed his life," she said. And I don't doubt it. This upstart from the provinces, Superior, Wisconsin—"Superior, of course," he'd joke—who would know privately nearly all the great public figures of his day, seems to have conducted himself as if he were a character in Proust's work. "He was the Gertrude Stein of our era," said Ron Cooper. "He had a salon like Stein. I met Jasper Johns through him, Robert Rauschenberg, Andy Warhol, Jann Wenner and Dennis Hopper, Jack Nicholson. Oh, just an amazing roster of people."

Yet there was to Earl a sadness—sensed rather than seen, guessed at rather than known—a disappointment, a melancholy, an ache. And Eve, both sensing and guessing, was as drawn to his dark depths as she was to his radiant surface. Locked in his secret heart was, she imagined, the same ambition that was locked in her secret heart: to become an artist in the Proustian way.

For much of his youth and slightly beyond, Proust flitted around the beau monde, squandering his time on endlessly trivial pursuits and

unrelievedly fatuous people. ("Fop" was his mask, as "host" was McGrath's, as "groupie" was Eve's.) Only he was actually investing his time, and those pursuits and people were essential, providing him with education and preparation, as well as enough material to last him the rest of his life. Said the Proust-like narrator in *À la Recherche du Temps Perdu*, "The only true book, though in the ordinary sense it does not have to be 'invented' by a great writer, for it exists already in each one of us, has to be translated by him. The function and the task of a writer are those of a translator."

Translator is the function and task of any artist. McGrath, for whatever reason—because he was blocked or stalled or stymied, because his dedication was uncertain or his will insufficient—was unable to translate. Eve, however, was able. Or soon would be. (As a painter and collagist, she never quite made the grade. She'd make it, though, in her next incarnation.) And for one simple reason: her need to be the real deal, an artist, was that strong.

Proust told a friend in a letter that the social life in which he appeared so passionately absorbed was merely "the apparent life," whereas "the real life [was] underneath all this." The "real life" meaning the artistic life. McGrath's sin was in acting as if he believed that the "apparent life" and the "real life" were the same; that having your invitations accepted by everyone was an end in itself; that, in essence, he had no hopes to dash, dreams to crush. (Eve's version of the sin would have been acting as if she believed fucking an artist was as good as being an artist.) And he acted as if he believed it so hard and for so long that, at a certain point, he did believe it, and his mask became his face.

Finally, McGrath was, for all his flamboyance and originality, his extraordinary ability to divert, to charm, to entrance, a will-o'-the-wisp and gadabout; a romantic who lacked the courage and conviction to make the leap of faith romanticism requires and so a cynic; an elegant nonentity. Finally, he was impotent.

I guess the jealousy was sexual, after all.

Eve escaped McGrath.

It was as 1970 was coming to an end that she managed at last to extricate herself from him and the jetsetters he kept company with when

he wasn't keeping company with the Franklin Avenue people. The "barge" is what she called this other crowd. "[Earl] had two kinds of friends," she wrote. "[I] was in the handful of people he took up with because he was in Los Angeles. But the main group belonged to the world, and were not tied down to any particular geography. They were mostly the names you read in *W* and on lists at weddings in *Vogue* or *Queen* . . . The women in this group were never quite in the mood for Los Angeles and often got tired in one day of Rodeo Drive and shopping . . . The men all wanted to become movie producers . . . [I] thought of [them] living on a drifting, opulent barge where peacock fans stroked the warm river air and time moved differently."

Eve was afraid to jump off the barge and into the crocodile-infested waters below. And then, she was more afraid not to jump. By some miracle, she washed up ashore intact. "So many of the ones like [me], the ones who were brought aboard to amuse the barge, disappeared. They'd O.D.'d on Quaaludes or Tuinals or got hepatitis and had to retire forever."

Jim Morrison wasn't so brave or so lucky. Staying in a scene that was killing him finally did just that. A few months after running afoul of Ertegun, he died in Paris, the city Eve hated above all others, his corpse discovered by Pamela Courson in the bathtub of their apartment at 17 rue Beautreillis. "Pam was addicted to heroin," said Mirandi, "but it was Jim who ended up OD'ing on it."

Paradoxically, it was in Morrison's death that Eve found new life because it led her, by a circuitous route, to a new medium. Or, rather, back to an old.

Writing.

Now, I'm about to make a tricky point, so pay attention, Reader, follow the ball. I called the route "circuitous." Here's why: as Eve conflated Morrison in death with a figure of death—Manson—so she'd conflate the death of Morrison, a tragic beauty who overdosed, with the death of Rosalind Frank, a tragic beauty who overdosed. (Morrison and Rosalind Frank, the last of the shifting doubles.) And it was this second death, chronologically first, that impelled her to write "The Sheik."

A telephone conversation I had with her about the piece:

"So, Evie," I said, "what made you write it?"

Eve cracked something with her teeth, a hard something, something with a shell, maybe a pistachio, which she bought in bulk at Trader Joe's. "Rosalind Frank died," she said.

"Who's Rosalind Frank?"

"Rosalind Frank was the most beautiful girl at Hollywood High, and the most beautiful girl at Hollywood High was the most beautiful girl in the world."

I waited for her to continue. When she didn't, I nudged, "Well, what happened to Rosalind Frank?"

"She killed herself."

"How?"

"An overdose."

"All right. And?"

Eve took a drink, likely of coconut water, which she also bought in bulk at Trader Joe's. I gnawed impatiently on a cuticle as she washed down the pistachio or whatever it was. "And," she said, "I thought the occasion shouldn't go unmarked."

More on the occasion being marked:

Apart from a funeral notice in the June 23, 1970, edition of the *Los Angeles Times*, no record of Rosalind Frank's death exists. (Timing, incidentally, is what makes me so certain that Eve garbled Rosalind's death and Morrison's death in her mind. Rosalind died in the summer of '70, and it wasn't until the summer of '71, in late July—mere weeks after Morrison died—that Eve wrote "The Sheik.")

There's barely any record of Rosalind Frank's life. She isn't even in the 1959 Hollywood High yearbook. Or the 1960. Or the 1961. (But then, neither is Eve.)

She is, however, in another book, *Upper Cut*, a memoir by Carrie White, a former *Playboy* Playmate (Miss July 1963) and a well-known hairstylist. White was with both Eve—in art, Ms. Harwood's class—and Rosalind—in a sorority, the Deltas—at Hollywood High.

On a September morning in 2016, I met White, a slender blonde, still girlish at seventy-three, for breakfast at the coffee shop in the Beverly Hills Hotel.

White on the Deltas:

The Deltas were it. We were the rock stars and the beauty queens. We ran everything, including the teachers, who wanted to give up their degrees and date us. It seemed like all the girls in it were famous or about to be famous. Linda Evans was already at Paramount. I think Barbara Parkins had already been cast in *Peyton Place*. Years later Barbara and I were both at Sharon Tate's wedding to Roman Polanski in London. I did Sharon's hair. Stefanie Powers—she was called Taffy Paul then—was discovered by Ann Sothern [the actress] in a Hollywood High musical. Even I got a contract with MGM. I was supposed to be the girl in an Elvis Presley movie called *Roustabout*, but then it fell through.

White on Rosalind:

Roz was the best of us. Everybody in school knew who she was. Everybody. She was that glamorous. We were all like deer in headlights when we looked at her. She had these blue cat eyes, and this delicious skin that was always tan, a perfect straight nose, perfect lips, always with the Max Factor Essence of Pearl lipstick. She wore her hair like Veronica Lake, one strand sort of over her eye. And her clothes! The black dresses that tapered at the knee, black spaghetti-strap sheaths. She kept her diet pills—her Dexedrine—in this little gold box in her purse. I'd cover my awe, but most of the time I just couldn't get over her perfection. She seemed to have the script to life.

White on Rosalind after Hollywood High:

Roz was always in a heartbreak. The man-trap business was the only thing she developed. So if a man left, it just destroyed her. She came into my salon one day. She was hysterical, was so freaked out from all the Dexedrine pills she was seeing spiders. I grabbed them from her and said, "You're still taking these roughhousers?" And then I flushed them down the toilet. She lost it, ran out. Soon after that, I got the call. Her family said it was an accidental overdose, something to do with a miscarriage. I don't know. There were mixed stories.

And now on to Eve marking that occasion:

"The Sheik," about Hollywood High, is set ten years after graduation. The narrator, Eve, sits at the Troubadour bar on an overcast day. "When the weather gets like this," she writes, "and sometimes when I smell rain, the past appears in all its confusion and doubt and pleasure, and my high school days surface."

The girls from her high school days break through the surface first:

These were the daughters of people who were beautiful, brave, and fool-hardy, who had left their homes and traveled to movie dreams. In the Depression, when most of them came here, people with brains went to New York and people with faces came West. After being born of parents who believed in physical beauty as a fact of power, and being born beautiful themselves, these girls were then raised in California, where statistically the children grow taller, have better teeth and are stronger than anywhere else in the country. When they reach the age of 15 and their beauty arrives, it's very exciting—like coming into an inheritance and, as with inheritances, it's fun to be around when they first come into the money and watch how they spend it and on what.

The fairest of them all, Carolyn (so near "Rosalind"), follows:

[Carolyn] was a captive in the Sheik's harem, a stranger from the land beyond the sea who never learned to speak nor the purpose of speech, and it would have been more sensible if she'd been made a mute since occasionally she would unfold and stretch [and] her cupid-bow mouth would unsuccessfully try to suppress a yawn, and her tiny snow teeth would show—then she'd back up, sigh, and say, "Fuck, man, I wish today was Friday."

At the bar, Eve runs into Mark, an old classmate and recovering junkie. She lets him buy her a drink, then asks him about Carolyn:

She was dead, he told me. Died only two months before, in fact. OD'd . . . She had been unhappy, he said, she was on her second divorce. Anyway, she took the pills, got dressed and put on her make-up. When her friend came in that afternoon and found Carolyn on the couch,

at first she thought Carolyn was asleep. But she had been dead since eight a.m.

"With her make-up on, though," I said.

"Yeah," Mark said, "she was always a bitch with the old turquoise eye shadow, no matter how many downers she'd been taking."

And so now it's raining and the scent can make Carolyn appear. I keep hearing Jim Morrison sing over and over, "trapped in a prison of her own devise," and the cars on the wet street outside. The lesson of the Sheik—determined to carry on despite pain, not to stay home, too proud not to venture forth—the power of physical beauty creating a tragedy instead of just a shame, even if it's only a Hollywood devise.

"The Sheik" is sad, tender, wistful, and passionately contradictory: a romance, and enthralled with love without believing, even for a second, that love is other than doomed; a rhapsody, but a rhapsody on regret, decay, decline, ruin, so a rhapsody that's also an elegy; a youthful promise made and a youthful promise broken, and in nearly the same breath. Brightness fades, beauty fouls, time passes, it tells us. Such is the way of the world. Nostalgia thus becomes an almost sacred duty. It's how you keep the faith.

And the style of the piece matches the mood. The writing is warm, lush, doleful, with a sultry, sensuous languor. Is closer to poetry than prose, dependent as it is on rhythm and tempo, melody and tone. Who could read "The Sheik" and not go wild with delight?

Dan Wakefield. That's who.

Out of the Blue

It was 1971, and a sense of crisis had taken hold of Eve. She'd reached a turning point in her life—as an artist and as a woman.

The year was endings galore. The Franklin Avenue scene was done. So was the Troubadour scene. And her time as a collagist and album-cover designer.

Done, as well, the man who represented to her an ideal of artistic conduct: highest-minded, hardest-core ebullience. On April 6, 1971, Eve's godfather, Igor Stravinsky, died.

From the letter of condolence she wrote to Vera Stravinsky:

> Since I was a small girl you both meant sophistication and humor to me and a bountiful geranium flowered life . . . Do you remember the day you told me and my mother about being captured by pirates? Or the time you told us about your one room apartment on street level in Paris with the silver bathroom? Those stories always made me wish I could have the bravery & spirit to live as you have. You both have given me glimpses of great lives, stories of glamor, beautiful clothes, marvelous music, and my name. I will treasure them all—but especially my name.

Eve, too, could've been done. "It's like, you're twenty-eight, and you're maybe losing your looks or whatever it is about you that people go for," she said. "You're having to wrestle with your demons, and nobody likes to do that. I was into astrology totally back then, and the way I thought of it,

Saturn was hitting me [Ed. note: in astrology, Saturn is known as the "disciplinarian planet," ruling over structure, responsibility, restraint]. It was the only way I could get accustomed to what was happening and not kill myself."

The year was also beginnings galore. In early '71, Eve met a new guy. Not just a new guy, a new kind of guy.

Dan Wakefield, thirty-nine, born in Indianapolis but living in New York and Boston since the fifties, was a big-time journalist. (The entire March 1968 issue of the *Atlantic* had been devoted to his ruminations on the Vietnam War and American culture.) He then turned his hand to fiction and was big-time at that, too. His first novel, *Going All the Way*, published in 1970, was a nominee for the National Book Award.

He decided to move to L.A. "It was to write a screenplay but the screenplay was just a pretext," he said. "Thanks to *Going All the Way*, I had some money for the first time in my life. I optioned a novella [*Dump Gull* by Fanny Howe]. I was trying to adapt it but not very seriously. Mostly what I wanted was to have a good time."

By late January, Wakefield had a room at the Chateau Marmont. "Four hundred a month—that's all a studio at the Chateau cost in those days. The second week I was there, John and Sandy Gibson [husband and wife, in the publicity department at Atlantic] fixed me up with Eve. She walked into the bar wearing the shortest skirt and the tightest sweater I'd ever seen, and when she smiled at me, I knew the move to California was going to be everything I hoped." He gave a low whistle, laughed. "Oh, did Eve look good!"

Wakefield knew nobody in L.A. Nobody, that is, except for Joan and Dunne. In fact, he'd known Joan and Dunne since *before* they were Joan and Dunne; since Joan was Noel Parmentel's girl, Dunne Noel Parmentel's boy; since New York in the fifties. "Oh, Joan and John and I started out together," Wakefield told me. "We were close, close friends for a long, long time."

(Confirmation of Joan and Dunne's sly careerism: Do you remember Dunne, in his interview for the Betsy Blankenbaker documentary, mentioning that "someone" wrote a rave of *Slouching Towards Bethlehem* in the *New York Times* in 1968, effectively launching Joan? Well, Dan Wakefield, an intimate of many years, is that "someone." Said Wakefield, "This guy from the *Times* called me up and asked if I wanted to review a book by a new author. I asked who, and he said, 'Joan Didion,' and I couldn't believe it. When I said I'd do the review, I tried to sound as casual as possible. I

didn't want to sound eager, give it away that Joan and I were good friends. I certainly didn't volunteer that the day before I'd agreed to house-sit for her and John while they were in Hawaii!" Do you also remember Parmentel including Wakefield's name on a list of people who had "pushed" for Joan? Well, the *Times* rave is how Wakefield earned his spot on the list.)

Eve soon found herself where she wouldn't be caught dead: in a traditional relationship. "I'd spend my days working at the Chateau Marmont, and at night I'd walk over to Eve's little place on Formosa," said Wakefield. "I loved her."

Eve and Dan Wakefield, cute in matching sunglasses.

He more than loved her. He understood her. "Eve was brilliant, but in an offbeat way. She liked to make pronouncements, and she convinced a lot of people of a lot of things. Did you know she was the one who put Steve Martin in that white suit? And I remember her handing me a stack of books and saying, 'Read these. They're Proust with recipes.' It was M. F. K. Fisher, the greatest food writer in the world. So a lot of those opinions of hers were shrewd. There

were people, though, who were afraid of her. A guy I knew out there wouldn't go to a party if she was going. That's how brutally she'd cut him down."

While in L.A., Wakefield kept up a steady correspondence with Seymour "Sam" Lawrence, his publisher, Boston-based with an independent imprint at Dell. Eve made her first appearance—"my fabulous Hollywood girlfriend"—in a February 2, 1971, letter. Almost immediately, Wakefield began promoting her to Lawrence.

From a letter dated March 24, 1971:

> My lady friend Eve is, as you know, a great artist, and does both Rock and Classical record covers for albums. Also she does a lot of stuff for *West* magazine, the Sunday mag of the *L.A. Times*. She has never done any book stuff tho and would like to. I am enclosing her collage of Jane Fonda which appeared in the last issue of *West* Magazine (last Sunday). Could you please show it to someone in the Dell Art Dept and see if they like it or would give her a chance at some book jacket thing . . . How about a chance for this promising lass, who is nourishing your West Coast office?

Lawrence came up empty but at least Wakefield tried. That Eve was intelligent, assertive, and set on being an artist was an attraction for him, clearly. And he was, for his era, unusually supportive of women. He had many women friends, particularly women writer friends. There was Joan, of course. And the poets Anne Sexton, Maxine Kumin, May Swenson. He even tried to find American representation for novelist Elaine Dundy, having a tough time since her marriage to British drama critic Kenneth Tynan fell apart—"[Elaine is] now in residence at Austin-Riggs booby hatch," he told Lawrence in a letter, "drop her a note and just see if she is free"—and whose second book, *The Old Man and Me*, follow-up to *The Dud Avocado*, had, he believed, only been published in England.

Wakefield—evolved, secure, sane—was a welcome change after the Barney's artists, the Troubadour rock 'n' rollers, Ahmet Ertegun.

Eve had room in her life for Wakefield because Earl McGrath was out of it.

Not Joan, though. Joan was as present as ever, even if physically she'd removed herself, which she did in January 1971, when she gave up the

house at 7406 Franklin Avenue in Hollywood for one at 33428 Pacific Coast Highway in Malibu.

At Franklin Avenue, Joan ran with artists and musicians and moguls. Also, speed freaks and acid casualties and rock 'n' roll trash. Beset and bedeviled people, in short. People who knew the agony and the ecstasy and nothing in between. Exposure to this type of person was good for her art. She found inspiration in the seamy vitality, the flamboyance and raunch and bloodlust. (Jim Morrison wasn't the only one to pick up on the dark energy swirling under the blissed-out surface of hippiedom. "Slouching Towards Bethlehem" is every bit as prophetic about Cielo Drive as "People Are Strange" and "The End.")

Yet even as Joan consorted with upper bohemia (the artists and musicians and moguls) and lower bohemia (the speed freaks and acid casualties and rock 'n' roll trash), she abided by mainstream values. Or if not quite abided by, made serious concessions to.

And then, she conceded too much. She abandoned Franklin Avenue and upper/lower bohemia for the bourgeois idyll that was the Trancas Canyon section of Malibu.

It was Eve, and possibly Eve alone, who understood the significance of this move, what it portended for Joan and Joan's art. "Eve got really, really mad when Joan started living at the beach," said Mirandi. "For Eve, Hollywood was it—*the* place. If art and weirdness is what you wanted, Hollywood is where you went. And Hollywood is where Eve thought Joan—where Eve thought any artist or writer—belonged. And when Eve said 'Hollywood,' she really meant the Sunset Strip. Well, no, because she actually regarded Sunset Boulevard all the way to the Beverly Hills Hotel as Hollywood. The Beverly Hills Hotel was in Beverly Hills, obviously, but it was part of the scene, so it counted in Eve's mind as Hollywood. Anything farther west, though, was not Hollywood, was the end of the world, and forget it. So, you can imagine what she thought of Malibu. She thought it was just crazily square. Like, *Why would you go there?* And she saw Joan moving to Malibu almost as a betrayal. If you were in Malibu, it meant you were in the movie business, because that's who lived in Malibu—movie people. And talk about crazily square."

Eve visited Joan and Dunne in Trancas regularly, a few times with Wakefield but mostly on her own. (Mirandi: "Nobody besides Joan could've

got Eve to go to Malibu more than once.") She usually brought her camera with her. "I took so many photos of Joan and John and Quintana at the Trancas house," she said. "And Joan would always let me. I mean, I was kind of obnoxious. I'd just show up with my Brownie. And when I said I thought a different outfit would look better, she was happy to change. One time, I wanted everyone in white. So Joan got herself in white, got John in white, and got her niece Dominique, who was babysitting Quintana, to get Quintana in white. Those pictures show a more innocent side of Joan and John, I think."

The Trancas house was a Franklin Avenue house by association.

"I'd been dating the French actor-director Christian Marquand," said Michelle Phillips. "At the time, I was trying to move from singing to acting. Christian was the best friend of Marlon Brando, a problem for me since I was also having an affair with Jack Nicholson, and Jack lived on the same cul-de-sac on Mulholland as Marlon. Marlon already couldn't stand me. He used to say to Christian, 'You have to stop seeing her. She's just like Esther.' Don't ask me who Esther is because I have no idea—someone he didn't like, obviously. And I was always afraid he was going to catch me going in and out of Jack's. Anyway, Joan and John used to come to Christian's Trancas house all the time. Christian was going back and forth to Paris constantly, so he was only renting it. Then Joan and John bought it."*

And at the Trancas house, Eve would often encounter Franklin Avenue people.

People such as Griffin Dunne. "I was at Joan and John's a lot," said Griffin. "They weren't getting along with my father during that time,

* Phillips went deeper on the Christian Marquand–Marlon Brando connection, which I can't justify including in the main body of this book but can't bear cutting either. So I've decide to split the difference, stick it in a footnote. "You know," said Phillips, "I think there was probably something going on between Marlon and Christian. There'd been rumors but I didn't believe them until Marlon gave me a wallop on the jaw. Yeah, I've never told this story. Christian was in from Paris and staying at Marlon's. He and I came home from a black-tie event. I was in this long Missoni dress, and I had gardenias in my hair. Christian said, 'I'm going to make us a drink.' I sat down at the piano and started playing. And then I don't know if I heard something or what, but I kind of sensed someone behind me. I turned and Marlon was standing over me with this furious face. He hauled off and hit me so hard and said, 'You're lucky that's all you got.' Later he apologized. He told me he thought I was one of the Manson girls, which was crazy because they'd already arrested Manson at that point."

which was hard because I loved them as much as I loved him. I could make them laugh—that's some of why they liked having me around, I think. And maybe some of it was torturing my dad. You know, 'We won't be nice to you, but we'll be nice to your kid.' For whatever reason, they included me in their dinner parties. I was so young, fifteen, sixteen years old, and they'd sit me in between a movie star—Warren Beatty or someone like that—and some homicide cop John had just met. And Joan would let me borrow her car, the yellow Stingray. I'd cruise up and down the PCH in it, trying to pick up girls. She and John were just a huge part of my growing up."

And such as Anne Marshall, who was also now living in Trancas. "I was on a farm on a hill with Don Everly. I'd been engaged to Don's brother Phil when I was younger. Phil left me on my twentieth birthday, I'd leave Don on my thirtieth."

Living on that farm, too, Harrison Ford. "Harrison stayed on our farm in a teepee during the week," said Marshall. "For rent, he built us a chicken coop and a corral for our goat. On weekends, he'd go home to Mary [his wife] and their kids. He still wasn't acting because he refused to do television. So he was a carpenter instead, working on Joan and John's house, building them a deck."

Building and building, never finishing.

"Joan and John let Harrison get away with murder as far as his carpentry was concerned," said Eve. "They had to wait years for him to finish their balcony or deck or whatever it was. I mean, John actually expected Harrison to act like a carpenter and do the job he paid him to do. But Harrison wasn't going to get around to it. He was just going to lie around smoking pot. The only one who understood how to deal with him was Fred Roos." Roos, an on-again-off-again boyfriend of Eve's, would be the casting director on *American Graffiti* (1973), Ford's first break, and later the casting consultant on *Star Wars* (1977), Ford's big break. "Fred bought this house in Laurel Canyon that was falling apart, needed new everything. Fred made Harrison complete all the tasks he gave him and only then would he make Harrison a movie star."

The Trancas scene, though, was not a continuation of the Franklin Avenue scene, the Franklin Avenue scene picking up where it left off in a different location. Joan and Dunne had found a new scene. On it: movie

people, which is what they, all of a sudden, were. *The Panic in Needle Park*, scripted by them and starring Al Pacino and Kitty Winn—the one-liner: "Romeo and Juliet on junk"—premiered that summer.

Joan and the Dunne brothers on the set of The Panic in Needle Park.

"Joan and John already had the movie stuff going," said Wakefield. "I think that shift happened when they bought the house in Malibu." After buying the house in Malibu, Joan and Dunne would be asked to write a script for, variously, a remake of *Rebel Without a Cause*; a sequel to *The Graduate*; a Western version of *Serpico*. They'd take meetings with Shirley MacLaine, Julie Andrews, Faye Dunaway. Paul Newman would invite them over for dinner. Barbra Streisand would introduce them to her pet lion. And Charlie Sheen, a local kid with a few uncredited appearances in his dad's movies, would become Quintana's first boyfriend. ("Quintana was sweet," said Sheen. "I think I was in the sixth grade.") More from Wakefield: "Joan and John looked at me and Eve—and I don't mean this in a bad way—but they kind of looked at us like we were the riffraff of their friends. They'd started moving in higher circles. Now, listen, we were all perfectly friendly. There was no problem or anything like that. It was just, they were in the movie world."

Wakefield didn't mind being excluded from Joan and Dunne's world because he had access to Eve's. "Eve's world was the rock 'n' roll world," he said. "And the music business then was what you think of as Hollywood—so extravagant, so lavish. The movie business was small-time compared to it. You don't do too many drugs if you're working on a movie because there's a lot at stake, and you have to be up early." (This, incidentally, is why Eve had contempt for the movie business—its middle-classnik, nine-to-five quality; its inability to accommodate truly wild or wicked behavior; its tendency, in brief, to emphasize *business* over *movie*.) "I remember Eve taking me to a party for the release of a new album. It was on the side of a hill in this enormous tent. Beautiful girls in harem costumes were holding gold trays with perfectly rolled joints on them. It was unbelievable!"

One night, Eve and Wakefield ducked into the Liquor Locker, a hundred feet or so from the Chateau Marmont, to pick up a bottle. There, checking out the selection, was Jim Morrison. "Now, I'd got into a terrible fight with Eve over Jim the month before," said Wakefield. "What happened was, it was morning, and that's when Eve liked to talk on the telephone. She never whispered or even lowered her voice. She just figured that if my eyes were closed, I was asleep. I wasn't. So, she was talking to her friend Diane Gardiner. And I heard her defending me to Diane, saying that my private parts were a, quote, *nice change*, unquote, from Jim's, evidently much larger. Well, I jumped out of bed, stormed out of the apartment. Oh, I was so mad—and embarrassed, my God, was I embarrassed! A couple of hours later she called me at the Chateau to tell me that she'd talked it over with her mother—*with her mother!*—and that her mother had explained to her that men were sensitive about size. *That* was her apology! So, we spotted Jim in the Liquor Locker. This wasn't long before he died, by the way. He had his back to us. Eve came up behind him and sort of goosed him. They were friendly, they talked. But he seemed a little scared of her, if you want to know the truth. I think he was nervous of what she might say. And I understood how he felt!"

The year Eve spent with Wakefield—the first three-quarters of it, at any rate—was a restful and recuperative one. It gave her time and space to

think, particularly about what she was going to do next. And then, almost without thinking, she did it: "The Sheik," written in a mad two-day rush in the middle of summer.

Wakefield knew nothing of *Travel Broadens* or Joseph Heller or how close Eve had got to becoming the next Françoise Sagan. When they were together, she'd already given up the visual-arts ghost. She was still going through the visual-arts motions, though, her collages appearing routinely in the *Los Angeles Times*, her cover appearing on the self-titled album of Black Oak Arkansas. Which is why he was under the misimpression that making collages and album covers was the only dream and desire of her heart. It was certainly the only dream and desire of his heart for her. "I've always made it a point to never have a girlfriend who was a writer," he said.

But his point became beside the point when she told him what she'd been working on in secret. ("Dan says I did it in secret?" said Eve. "I don't think I've ever done anything in secret in my whole life. But maybe I did. Maybe I was afraid I wouldn't be able to pull it off.") He didn't take the news well. "Dan smashed every cocktail glass I had."

So, Wakefield was supportive of a girlfriend who was an artist. And of women friends who were writers. Not, however, of a girlfriend who was a writer. So much for evolved, secure, sane.

If he was acting unevolved, insecure, insane, though, at least he had the grace to know it. And to stop it. With a minimum of grumbling, he passed along "The Sheik" to his agent, Knox Burger. "Knox was very smart. And to be nice to me, he sent Eve a two-page, single-spaced letter telling her all the things she had to do to the piece to get it published, and he sent me a copy. So I went over to her place that night and said, 'What did you think of Knox's letter?' She put her hands on her hips in her particular way, then said, 'I hope Knox Burger burns in hell!'"

Her own efforts to place the piece were no more successful. "I'd already sent 'The Sheik' to Jim Goode at *Playboy* and he'd rejected it and told me what was wrong with it," she said. "I hate people who tell me what to do to improve my stuff. They get nowhere with me."

Eve talked tough about Knox Burger, talked tough about Jim Goode. But as her reaction to Robert Gottlieb's turn-down made clear, she was, when it came to her writing, as self-doubting as she was self-confident. How many more rebuffs would she have endured before she stuffed "The

Sheik" into the same drawer she stuffed *Travel Broadens* seven years earlier? We'll never know because someone stepped in to save the day.

Joan.

Joan is the reason "The Sheik" got into print. "Joan liked 'The Sheik,' thought it was a little tour de force," said Eve. "She was all the rage then. Grover [Lewis, an associate editor at *Rolling Stone*] asked her to write for him. She couldn't because of her contract with *Life*. She recommended me." The recommendation:

July 28, '71

Dear Mr. Lewis—

A friend of ours in Los Angeles, Eve Babitz, a few days ago showed me a piece she had written—about Hollywood High, where she had gone, but really about more than that. The piece surprised me—she is a painter, not a writer—& I liked it very much & suggested she send it to you to see if you might be interested in publishing it. So please watch for it.

What's more, Joan is the reason—at least in part—that "The Sheik" got written in the first place.

I'll explain: The year before, in 1970, Joan came out with *Play It as It Lays*, a novel set in an L.A. that's hell on earth even if it looks like an earthly paradise. It's the same L.A. depicted in Nathanael West's *The Day of the Locust*. Eve despised West and *Locust* and said so. She'd tell off West for *Locust* as she'd never dare tell off Joan for *Play It*. (Though her telling off West for *Locust* was, of course, really her telling off Joan for *Play It*.)

An excerpt from her piece, titled "And West (né Weinstein) Is East Too":

People from the East all like Nathanael West because he shows them [L.A.'s] not all blue skies and pink sunsets, so they don't have to worry: It's shallow, corrupt, and ugly . . . [*Locust* is] a little apologia for coming to the Coast for the money and having a winter where you didn't have to put tons of clothes on just to go out and buy a pack of cigarettes . . . [and for] the bougainvilleas [that] are rampant . . .

All the things that Nathanael West noticed are here. The old people dying, the ennui, the architecture and fat screenplay writers who think it's a

tragedy when they can't get laid by the 14-year-old doxette in Gower Gulch, the same 14-year-old who'll ball the cowboys any old time. But if there had been someone, say, who wrote a book about New York, a nice, precise, short little novel in which New York was only described as ugly, horrendous and finally damned and that was the book everyone from elsewhere decided was the "best book about New York there ever was," people who grew up knowing why New York was beautiful would finally, right before dessert, throw their sherry across the table and yell, "I'll pick you up in a taxi, honey, and take you for a fucking guided tour, you blind jerk." . . .

I think Nathanael West was a creep.

Eve must've thought Joan worse than a creep since Joan, unlike West, was born and bred in California. With *Play It*, Joan was, in Eve's view, pandering to the chauvinism of New Yorkers, telling them what they wanted to hear—sucking up, basically. (Why sucking up? Because New York ruled the roost high-culture-wise. If you hoped to make it as a serious writer, it was New York you had to impress.) How could Eve see *Play It* as anything but a flagrant act of betrayal by a native daughter?

And my sense is that Eve started writing again in order to honor the passing of Rosalind Frank, yes; though also in order to right the wrong that she believed Joan had done her city. With "The Sheik," Eve was giving readers *her* L.A., an L.A. of blue skies and pink sunsets, of rampant bougainvilleas, of beautiful girls and the cruel fates closing in on them. The piece was thus a response to—and a rebuttal of—Joan's novel.

So, Eve found herself in a tricky position: the person to whom she owed the largest debt was the person making her see red. And the debt would only get larger, the red redder.

CHAPTER 8

An Epistolary Interlude

We're nearly up to 1972, the year Eve fired off that letter to Joan about Virginia Woolf. The letter so blazingly angry it was still, in 2022, hot to the touch. The letter that made me want to run out and start a riot, or at least stay in and write a book.

You first encountered the letter, Reader, in the preface, before you had enough context to really understand it. Now, though, you're up to your eyeballs in context. So let's take another look, shall we?

Jumping to the second paragraph:

It's so hard to get certain things together and especially you and VW because you're mad at her about her diaries. It's entirely about you that you can't stand her diaries. It goes with Sacramento. Maybe it's better that you stay with Sacramento and hate diaries and ignore the fact that every morning when you eye the breakfast table uneasily waiting to get away, back to your typewriter, maybe it's better that you examine your life in every way except the main one which Sacramento would brush aside but which V. Woolf kept blabbing on about. Maybe it's about you and Sacramento that you feel it's undignified, not crickett [*sic*] and bad form to let Art be one of the variables. Art, my God, Joan, I'm embarrassed to mention it in front of you, you know, but you mentioned burning babies in locked cars so I can mention Art.

I'm breaking in. Eve is criticizing Joan for what she regards as Joan's obsessive and inexplicable machismo. For Joan, strong and hard and clear signifies masculine, while doubts and unsettled feelings are weak, dithery silliness: feminine. And Joan not reading Virginia Woolf isn't, in Eve's mind, Joan making an aesthetic error in judgment but a moral.

Back to the letter:

You said that the only thing you like to do was write. Just think if it were 200 years ago and the only thing you liked to do was write. I know I'm not making sense, but the thing beyond what your article on the women's movement was about was what *A Room of One's Own* is about. The whole women's thing that is going on now is so stark and obscene most of the time that no wonder one recoils in horror. But for a long long long time women didn't have any money and didn't have any time and were considered unfeminine if they shone like you do, Joan.

Just think, Joan, if you were five feet eleven and wrote like you do and stuff—people'd judge you differently and your work, they'd invent reasons . . . Could you write what you write if you weren't so tiny, Joan? Would you be allowed to if you weren't physically so unthreatening? Would the balance of power between you and John have collapsed long ago if it weren't that he regards you a lot of the time as a child so it's all right that you are famous? And you yourself keep making it more all right because you are always referring to your size. And so what you do, Joan, is live in the pioneer days, a brave survivor of the Donner Pass, putting up the preserves and down the women's movement and acting as though Art wasn't in the house and wishing you could go write.

I'm breaking in again. The article that Eve is alluding to—"The Women's Movement," Joan Didion, *New York Times*, July 30, 1972—is written with Joan's usual intelligence and grace. Yet there's something insidious about it. Something dishonest. The movement had its problems, sure. Classism, for one, as she rightly observed. (She zinged the members who claimed trauma from catcalls made by construction workers: "This grievance was not atypic in that discussion of it seemed always to take on unexplored Ms. Scarlett overtones, suggestions of fragile cultivated flowers being 'spoken to,' and

therefore violated, by uppity proles.") The movement, though, also had a point, and she was pretending it didn't. "That many women are victims of condescension and exploitation and sex-role stereotyping was scarcely news," she wrote, "but neither was it news that other women are not: nobody forces women to buy the package." Basically, she's saying to women, "It's all in your head," that sexism is imaginary, which is what people who didn't have migraines would say to her, a chronic migraine sufferer, that migraines were imaginary, only worse because the non-migraine people had never experienced a migraine and she'd certainly experienced sexism.

(It should be said, Eve was as turned off by the women's movement as Joan. In a 1971 letter to Robert Doty, curator of the Whitney, she wrote, "My last boyfriend drove me into the arms of women's lib which didn't take very well, but at least I don't mind being a 'lady artist' anymore. The whole idea used to make me cringe with shame. Not that I have joined or even know any of the 'lady artists' who have banded together to unite under the stern eye of Judy 'Boots' Gerowitz." Judy Gerowitz, real name of artist Judy Chicago, was, in the early seventies, cofounding Womanhouse, a feminist art collective, at CalArts. Among the best-known works to come out of Womanhouse, Chicago's 1972 installation *Menstruation Bathroom*, depicting a white-tiled, antiseptic-looking space; a toilet; a trash can filled with tampons and sanitary napkins, used. It's impossible to imagine Eve reacting to *Menstruation Bathroom* with anything other than derision and disgust. Feminism offended her sense of style: it had no style. Beyond that, feminism offended her sense of efficacy: the conundrum it set out to resolve—women's inability to get a fair shake—it didn't. Joan, though, offended her more by refusing to admit that there was a conundrum.)

Joan, in her career, had beat men at their own game. Proof not that the game wasn't rigged. Proof that a woman playing the game couldn't win without also losing. For instance, so that her writing might be formidable and flashy, Joan made herself itsy-bitsy and meek—a tongue-tied wall-flower. As Eve points out, Joan emphasized, almost fetishized, her frailty. Frailty was, for Joan, a kind of disguise or drag, a way of concealing her boldness, her brashness, her outrageous self-assurance—qualities that she, as a female, had no business having. (Girls weren't supposed to be natural aggressors.) In other words, Joan was a predator who passed herself off as prey. From the closing paragraph of the preface to *Slouching Towards*

Bethlehem: "My only advantage as a reporter is that I am so physically small, so temperamentally unobtrusive, and so neurotically inarticulate that people tend to forget that my presence runs counter to their best interests. And it always does. That is one last thing to remember: *writers are always selling somebody out*." (Italics hers.)

If Joan wanted to sell herself out to maintain her viability as a writer that was okay with Eve. Eve was practical. She understood ugly necessity, the dilemma of survival. What was not okay with Eve: that Joan, with the *New York Times* piece, was selling women out to get in good with men, as Joan, with *Play It*, had sold L.A. out to get in good with New York.

The end of the letter:

> It embarrasses me that you don't read Virginia Woolf. I feel as though you think she's a "woman's novelist" and that only foggy brains could like her and that you, sharp, accurate journalist, you would never join the ranks of people who sogged around in *The Waves*. You prefer to be with the boys snickering at the silly women and writing accurate prose about Maria who had everything but Art. Vulgar, ill bred, drooling, uninvited Art. It's the only thing that's real other than murder, I sometimes think—or death. Art's the fun part, at least for me. It's the salvation.

Eve was tracing the connection she imagined Joan made between women and art: alike in their volatility, their illogic, their wet, tangled profusion and lurid chaos. And both, Eve believed, were appalling to Joan, an affront to Joan's orderly and austere intellect. Which means that Eve, with her double-D breasts and overlapping love affairs and big, unwieldy, slovenly talent, was also appalling to Joan. After all, Earl McGrath, Joan's proxy, rejected Eve as "gross," didn't he? Only Joan, unlike Earl McGrath, *was* an artist, an artist almost in spite of herself, and Joan *didn't* reject Eve. On the contrary, Joan, whose relationship with so many in her orbit was vampiric, nurtured Eve.

But for how long would Eve allow herself to be nurtured? As this letter shows, her deference was growing ever more bitter, her resentment ever more festering.

By the Sea

We're going to leave Eve and Wakefield for now, head to the beach to check in on Joan and Dunne, see what they're up to.

Their new house was in Trancas, and Trancas was in Malibu. But not the Malibu that gleamed in the collective national imagination, a bright shining symbol of the Southern California good life. (Chevrolet introduced its Malibu line in 1964; Mattel brought out Malibu Barbie in 1971.) In other words, not Malibu Colony, i.e., Hollywood Malibu. The dead opposite, in fact: the *anti*-Malibu Colony, the *anti*-Hollywood Malibu.

Jennifer Salt, an actress, her biggest credit to date a small part in *Midnight Cowboy* (1969), moved to Trancas with Margot Kidder, also a struggling actress, the same year as Joan and Dunne. "Malibu Colony had been around for a long time," she said. "So many old movie stars had lived there. And it was a big thing, if you were a new movie star, to have a house in the Colony. Trancas was about as far from all that as you could get. There was nothing chic about Trancas. It was cheap and nobody was there and it was really rustic. Margot and I decided we were going to be roommates. We weren't looking for a fancy house or a big pool or whatever it was people were looking for when they went to the Colony. We just wanted a house on the beach. And that's what we got—a little A-frame hippie pad on Nicholas Beach in Trancas. A year or so later, Margot convinced Michael and Julia [Phillips, producers

who hadn't yet produced] how great Trancas was. They took the house next to ours."

Anti-Hollywood Malibu was about to turn into Hollywood Malibu.

Flashback:

Joan and Dunne came to L.A. from New York in the summer of '64. Both wanted to write books. Both also wanted to write movies, hard to do without connections. As it happened, they had one: Dunne's older brother, Dominick "Nick" Dunne.

In his memoir, *Popism*, Andy Warhol described journeying cross-country at around the same time as Joan and Dunne—fall of '63—and entering a Hollywood that was "in limbo." (While there, Warhol would go to the Duchamp retrospective party at the Hotel Green, get sick on the pink champagne.) "The Old Hollywood was finished and the New Hollywood hadn't started yet," he wrote. Old Hollywood, of course, didn't *know* it was finished. Was carrying on like it was show business as usual.

Nick, young as he was, was Old Hollywood. Professionally, he was flailing—a second-rate producer in a medium that didn't rate at all (TV). Socially, though, he'd made it. He and his beautiful heiress wife, Lenny, threw flamboyant, theatrical parties, and lots of them. A month before Joan and Dunne arrived, they'd thrown their most flamboyant and theatrical yet: a black-and-white ball inspired by the Ascot scene in *My Fair Lady*. Among the splendidly monochromatic were David Selznick, Billy Wilder, Loretta Young, Ronald and Nancy Reagan. Also, Truman Capote, who, in the spirit of homage—or larceny—would stage his own black-and-white ball in New York in 1966. (He'd forget to invite Nick.)

In later years, Joan and Dunne tried to have it both ways with Hollywood: they were insiders who were also outsiders; supported by the industry but not owned by the industry; in the thick of it yet above the fray. In earlier years, though, they were much less ambivalent: they straight-up wanted in.

"We don't go for strangers in Hollywood," is a line from Fitzgerald's *The Last Tycoon*, and one invoked by Joan and Dunne so often you know they thought it gospel. How lucky for them then that they were the brother and sister-in-law of Nick, and therefore part of the Hollywood

family, even if poor relations. And, as poor relations, they were given hand-me-downs.

In the form of clothes. The playwright Mart Crowley (*The Boys in the Band*), who worked for years as Natalie Wood's personal assistant, recalled, "Joan had a lot of Natalie's clothes and underwear. Nick's wife, Lenny, was involved with a charity that sold the castoffs of entertainment people. Lenny would notice when Natalie's stuff came in and she'd hide it, then call Joan to come in, and Joan would buy it all, sight unseen. I'd see her in a great dress or wearing a pair of shades, and John would brag about it all belonging to Natalie." (Dunne would brag about it again in the last piece he ever published: "STAR!," a review of Gavin Lambert's biography of Wood.)

In the form of houses. They rented Sara Mankiewicz's, fully furnished, though Mankiewicz did pack up the Oscar won by her late husband, Herman, for writing *Citizen Kane*. "You'll have friends over," Mankiewicz told Joan, "they'll get drunk, they'll want to play with it."

Hollywood's appeal for Joan and Dunne wasn't hard to fathom. It was one of the few places on earth where a writer could strike it rich. And writing movies for the money and only the money seemed to be how a writer maintained his or her integrity. At least in the eyes of other writers. "[Joan and John] didn't give a shit about the movies except it was a way to make a lot of money," said Dan Wakefield. "And I totally respect that." In brief, books were art, movies were commerce.

Only, that was changing.

In 1969, the summer of Manson, *Easy Rider* roared onto screens trailing clouds of motorcycle exhaust and marijuana smoke. A new era of Hollywood had begun. ("Now the children of Dylan were in control," actor-screenwriter Buck Henry told me.) It was Nouvelle Vague American style. And Joan and Dunne, in their house on the bluff above Nicholas Beach, overlooking the houses of Jennifer Salt and Margot Kidder, Michael and Julia Phillips, were smack-dab in the middle of it. Though I don't think they quite knew what "it" was.

Joan might have had a glimmering. "One night, Joan and John were on their porch, watching a party going on at Michael and Julia's," said

writer-director Paul Schrader. "And Joan turned to John. 'You could power all of Hollywood with the ambition in that house,' she said."

But only a glimmering. "Julia and I hadn't produced *The Sting* yet," said Michael Phillips. "We had a film, though—*Steelyard Blues*—set up at a studio, and that put us half a step ahead of our peers. Every weekend there was a party. It wasn't even a party. It was just, 'Come hang out at the beach.' A group would show, and I'd take a head count to see how many steaks and hamburgers I needed to pick up at the market. I scratched out a list of names of the people who were there, almost all of them unknowns at the time. There was Steven Spielberg and Amy Irving. Julia's and my producing partner, Tony Bill. David Ward, who wrote *The Sting*. Gloria Katz and Willard Huyck—they wrote *American Graffiti*. And John Milius, who wrote *Apocalypse Now*. Harvey Keitel was there. And Scorsese and De Niro and Brian De Palma, who was Margot's boyfriend. For Christmas one year, Brian wrapped two scripts and put them under the tree, one for Margot, one for Jennifer. The script was for *Sisters* [1972]. Jill Clayburgh was around a lot. So was Michael Douglas and Brenda Vaccaro, Bruce Paltrow and Blythe Danner. And Joan and John would stop by sometimes. Listen, they were great, they were wonderful. But they weren't really part of what we were doing. It was like they came down from the clouds to mingle with the hoi polloi. They were always distant observers."

With the Old Hollywood crowd—the Establishment Hollywood crowd—in the mid-sixties, Joan and Dunne were the young marrieds: unheralded, uncertain, in need of advice and handouts. With the New Hollywood crowd—the New *Wave* Hollywood crowd—in the early seventies, in contrast, they were the older married couple: mature, dignified, a trifle staid. "Joan and John were definitely of a different generation," said Salt. "They were elegant, in control of their social lives. They weren't going to be at some party where most of the people were on psychedelics. What they had were dinner parties. If you saw them, it would be because you were invited to one of those."

I asked Salt what Joan and Dunne were like at their dinner parties. A thoughtful pause, and then, "Joan was very, very quiet. She wasn't a sour-puss or anything like that—she was lovely and gracious—but somehow you ended up being the jabber-mouth and the idiot, and she was the cool customer. It could seem like she wasn't particularly present, but then she'd

remember things I said or wore, and she probably even had an opinion on how I fit into the group. John did the talking for both of them. He was friendly, and he loved to gossip, which was fun. There was always a sense of mystique around Joan. Even when you were in her house, you knew she might not appear because she had terrible migraines that would take her down for days. It was a big part of their life together, her migraines. John was very concerned, very doting. Even though he was a writer and quite self-important, he functioned in that relationship like a—like I don't know what—like the wife of a great tycoon, of a great whatever. He made Joan's life what it was. He was the host, the gregarious one. But Joan was the royalty."

Joan and Dunne were living in New Wave Hollywood. Working in it, too. Except they weren't really working in it. Really, they were slumming in it.

In a 1975 interview with the *Atlantic*, Dunne said of himself and Joan, "We write for movies because the money is good, because doing a screenplay is like doing a combination jigsaw and crossword puzzle—it's not writing, but it can be fun—and because the other night, after a screening, we went out to a party with Mike Nichols and Candice Bergen and Warren Beatty and Barbra Streisand. I never did that at *Time*."

Joan would also say movies were about the money, though she'd say it obliquely in her first piece for the impeccably literary, impeccably East Coast *New York Review of Books*. "Hollywood: Having Fun," which appeared in the March 22, 1973, issue, was a takedown of her adopted town. (The piece was the perfect double-agent move: making a show of not going Hollywood so no one would notice she was going Hollywood.) "[Hollywood's] spirit is speedy, obsessive, immaterial," she wrote. "The action itself is the art form, and is described in aesthetic terms: 'A very imaginative deal,' they say, or, 'He writes the most creative deals in the business.'" In short, art isn't the art in Hollywood, business is the art, and only a sucker would think otherwise.

That they weren't suckers—or morons, to use Ertegun's preferred phrase—is something Joan and Dunne very much wanted you to know. Yet a willingness to risk being a sucker is, I'd argue, nearly a prerequisite for creating art. And their unwillingness perhaps accounts for why, in

Hollywood, they didn't. (How could they make a movie that was any good when they were so busy condescending to the medium?) And while they wrote a number of movies in the seventies, they didn't write a single Seventies movie. Meaning, they didn't write a single movie in the seventies that defined or outlasted the decade.

There is, however, a movie they wrote in the seventies that I would like to discuss: *Play It as It Lays* (1972).

First, though, a discussion of *Play It as It Lays*, the book.

Its world is a contrived one, a deliberate artifice even while borrowing the name of a real place (Los Angeles). And not for an instant do you believe that its story can end other than in calamity, that life's random energies have a shot against tragedy's classic structure. Which is why *Play It*, taken on its own terms, is profound, high art; and, not taken on its own terms, is profoundly silly, high camp. The assessment of *New Yorker* film critic Pauline Kael (Kael's review is a twofer: she goes after the book before going after the movie) is so crushing because she laughs at it—"I found the Joan Didion novel ridiculously swank, and I read it between bouts of disbelieving giggles"—and once you start laughing, you can't stop.

Though maybe that's the movie's problem: it takes the book on the book's own terms. It was made, after all, by people inclined to deference. Frank Perry, a self-described "Didion freak," directed it, Joan and Dunne wrote it, and Nick Dunne coproduced it. The movie *is* the book, but without the magic of Joan's prose. And absent that magic, *Play It* is exposed. Suddenly you see its tawdry pathos, how purest-corn and junk-Hollywood it is—the glamour of desolation, the hollowness of fame, how lowlife are those living the high life. You're watching, you realize, intellectualized trash. A soap opera with the look of an art-house film. *The Bad and the Beautiful* reshot by Michelangelo Antonioni, Monica Vitti in the Lana Turner role.

Play It didn't have to be that. Joan's first pick for director was Sam Peckinpah, who, with *The Wild Bunch* (1969), had done for the cowboy picture what *Easy Rider* had done for the biker.

In an April 4, 1970, letter to Peckinpah, she wrote:

My agent at William Morris wants to take PLAY IT AS IT LAYS to a studio before publication, which is July something. A lot of people have asked for it but I told Morris not to show it to anyone until I found out

what you want to do—whether (on reflection) you still want to do it, and if so what studio you would want us to take it to . . . Obviously I want you to—you are the only person John and I can see taking it beyond where it is and bringing back a picture of the very edge.

Peckinpah seems a counterintuitive choice. *Play It* is urban, contemporary, feminine, delicate. He was a director of Westerns, often set in the past, often preoccupied with masculine dilemmas, and invariably extremely violent. Yet his violence was beautiful: sensuous and painterly. And he was a fatalist, and thus close to Joan in terms of sensibility. Her hope, too, was that he would not just film the book—what Perry ended up doing—but reimagine the book, so that he might, as she said in her letter, "[bring] back a picture of the very edge."

Or perhaps over the edge.

It always struck me as false that Maria Wyeth was so tranquil behind the wheel of her Corvette. How much more joy would she have gotten from her rides if she'd left devastation in her wake? Is there a better way for one of the most alienated characters in modern literature to connect than inside her metal shell, her barest touch resulting in blood and guts, severed limbs and spattered brains? Peckinpah's Maria might still have wound up in a sanatorium, but she'd have put a few people in the morgue en route. He'd have shown what Joan couldn't quite bring herself to show: that Maria was a victim who was also a victimizer. And, in so doing, he'd have turned *Play It* into what it was meant to be: Andy Warhol's *Orange Car Crash Fourteen Times* at two hundred and eighty words per page, at twenty-four frames per second; Godard's *Weekend*, only instead of burning cars and oozing corpses littering a highway in the French countryside, burning cars and oozing corpses littering the San Diego Freeway, the Harbor, the Hollywood, etc.

That version, of course, never happened. (The studio balked at hiring a "man's" director to adapt a "woman's" book.) Blown chances are always a shame. This one, though, was especially shameful because it was, as well, Joan and Dunne's best chance to catch the Hollywood New Wave.

"A few decades hence, these years may appear to be the closest our movies have come to the tangled, bitter flowering of American letters in the 1850s." That sentence, written by Pauline Kael, is from the introduction to *Reeling*, her collection of 1972–75 reviews, including those of *Mean Streets*,

Shampoo, The Godfather, Part II, and *Nashville*. In the seventies, movie culture would become central to American culture. Kael was the voice of movie culture, which meant Kael was the voice of American culture, which meant Joan no longer was.

Joan didn't take the usurpation lying down. She went after Kael. Not head-on. She'd leave that to Dunne, who'd pan Kael's *Deeper into Movies* in the March 25, 1973, *Los Angeles Times*. "A year or so ago I was asked to review Pauline Kael's *Raising Kane*, an arrogantly silly book that made me giggle and hoot as much as any I had ever read," was his opener. (Sound familiar?) No, Joan's attack on Kael was a flank. "The review of pictures has been . . . a traditional diversion for writers whose actual work is somewhere else," she wrote, also in 1973. "Perhaps the initial error is in making a career of it." No serious writer takes movies seriously is what she's saying. And yet movies were, at that moment, it, *the* hot art form.

So Joan, who missed nothing, had missed a major cultural shift. All of a sudden, the sharpest point on the cutting edge was dull, blunted, a danger no more.

Eve, with her instinctive hostility toward Trancas, her righteous anger at Joan for defecting there, had anticipated this dulling, this blunting. Yet, at the same time, she was looking to Joan as a model and guide. What I imagine she saw when she looked: a person who'd worked out the problem of being a female artist. Joan's solution? Take for a mate a male artist. By choosing Dan Wakefield, Eve was, whether she knew it or not, imitating Joan.

Which is why I want to turn the spotlight of our attention, Reader, on Joan's marriage.

Still by the Sea

"You married a protector," Griffin says to Joan in *The Center Will Not Hold*, and Joan readily agrees. Dunne, though, only looked like the alpha.

"Michiko Kakutani came to Trancas to do a story on Joan for the *Times*," said Josh Greenfeld, also a Trancas resident. "I told [Michiko], 'What you see in John, you get in Joan.' He came on as tough and blustering, but he was soft. Don't forget, she handled all their finances. She made brilliant real estate deals. And that shyness—that weakness—was actually her strength because it got John to run interference."

Of her courtship with Dunne, Joan would say, "I don't know what 'fall in love' means . . . But I do remember having a very clear sense that I wanted this to continue." It isn't true that falling in love was a concept with which she had no truck. In "7000 Romaine, Los Angeles 38," her piece on Howard Hughes, she wrote of the "apparently bottomless gulf between what we say we want and what we do want, between what we officially admire and secretly desire, between, in the largest sense, the people we marry and the people we love." It's a wildly revealing statement, and she delivers it almost as a throwaway. Blink and you miss it. She's telling the reader that Dunne is the person she married, some other man—Noel Parmentel, because who else?—the person she loved. (See what I mean when I said before that Joan can only be caught in fitful glimpses?)

In any case, Joan and Dunne were very married, presenting themselves to the world as a unit. Not only did they live together, raise a child together,

they also worked together. Dunne was Joan's cowriter, Joan's editor, Joan's first and last reader. As Eve put it, "They were connected at the typewriter ribbon."

And the relationship was more symbiotic even than that. It was Dunne who made it possible for Joan to be Joan. "People often said that he finished sentences for me," observed Joan. "Well, he did." And because he did, she had the power of silence. It was a power she wielded expertly.

"It was in the early sixties, after Ivan Obolensky bought her novel, that Joan started to change," said Dan Wakefield. "She wasn't the aspirant from Sacramento anymore, the little girl who was too scared to speak. Now she didn't speak on purpose. She understood that not speaking gave her mystery and mystery gave her magnetism. People were fascinated by her. I remember I gave a party. A guy was there—Norman Dorsen—a law professor at NYU, involved in liberal politics and all that shit. Joan was just standing there, not saying a thing. She had on this pair of dark glasses. Norman goes up to her and says, 'Ms. Didion, why do you wear those sexy, intriguing dark glasses?' I cracked up and said, 'I think you've answered your own question.' She was like the sphinx. And when the sphinx spoke, everybody listened."

After Wakefield began seeing Eve, he called Joan and Dunne. "I said to them, 'I've met this terrific girl.' I told them her name, and there was laughter. And then John said, 'Ah, yes, Eve Babitz, the dowager groupie.'"

"Dowager groupie" was an insult, Dunne besmirching Eve's honor: she was a fuck-around, he was saying, and an aging fuck-around at that. But it wasn't only an insult. It was also a compliment, a tribute to her prowess and prodigality. "Joan and John loved Eve," said Wakefield. "They got a kick out of her. I think, frankly, John was jealous of me."

That last remark of Wakefield's stuck in my brain the way a piece of food sticks in your teeth. I couldn't leave it alone, kept probing it with my tongue. Did Wakefield think right? I wondered. Did Dunne have the hots for Eve?

During the late sixties and early seventies, Joan and Dunne's marriage was on the rocks, public knowledge since Joan had turned their marital woes into fodder for the column she wrote for *Life*. That famous line of hers, one I've quoted several times already and will quote several times more—"We are here on this island in the middle of the Pacific in lieu of filing for divorce"—she used in her very first column. (A line Dunne would

have edited, by the way.) Never, though, did she explain why divorce was suddenly looking like a possibility.

Eve dropped a clue. Dunne, according to her, was a rager. "Joan had migraines because she was married to John. He'd give anyone a migraine. He was an alcoholic and he broke down doors. That's why Quintana was always trying to get Joan to leave him."

Susanna Moore, who met Joan and Dunne almost exactly when Eve did—1968—and who would also go on to become a writer, described Dunne in much the same way. "John had a terrible, terrible temper," said Moore. "He got angry very quickly. And he was vindictive. He held grudges. He didn't forget. He was clever, he was secretive, and he sought revenge." In her 2020 memoir, *Miss Aluminum*, Moore recounted a scene in a restaurant: an unprovoked Dunne throwing a tantrum, at the end of which he stormed off. She would've stormed off herself only Joan begged her not to. "I regret putting that in the book, actually, because it's come back to haunt me. People have taken it as evidence that John was possibly violent." I pointed out that people have taken it as evidence that he was possibly violent for excellent reason: he acted like a violent person in her telling, and Joan seemed afraid of him. Moore sighed. "He *was* violent. And one was a little bit afraid. After he left the table that night, I was angry because I thought he had behaved just irrationally and so rudely. I said to Joan, 'I'm leaving.' And that's when she grabbed my arm and said, 'No, no, please don't leave me.' She didn't want to be alone with him."

My guess is that Dunne got rough physically when he felt he'd gotten roughed up emotionally. In other words, he had to show how strong he was in order to conceal how feeble. Scratch a bully, find a crybaby.

What Dunne was crying over seems obvious: feelings of inferiority. In 1968, with *Slouching Towards Bethlehem*, Joan became one of the most lauded and lionized nonfiction writers in America; in 1970, with *Play It as It Lays*, one of the most lauded and lionized fiction writers. That couldn't have been easy for Dunne, who also wrote nonfiction and fiction.

Feelings of inferiority in another sense, as well: Joan was what Dunne only pretended to be.

"I was staying with Joan and John," said Wakefield. "This was a couple of years before I moved to L.A.—in 1967, I think. They were both writing for the *Saturday Evening Post*. Things were going well, and they bought

a new car, a Corvette Stingray [Joan's costar in those Julian Wasser photos]. They'd just drove it home, right off the lot, and then they heard that the *Saturday Evening Post* was canceling their column, or maybe that the whole magazine was folding—I forget which—and John said, 'Oh, God, maybe we should take back the car.' Joan looked at him and said, 'Don't think poor.'"

So, it was soft-spoken, bird-boned Joan ("Frail," Nick Dunne called her behind her back), not hotheaded, chest-thumping Dunne ("Big Time," Nick Dunne called him behind his back), who was the real pro and little toughie.

Or maybe what Dunne was crying over was exhaustion from all the caretaking Joan required. There were the migraines, of course. And the temporary blindness. In a 1965 letter to a friend, she wrote, "In all we did not have a very productive spring, mostly because I was exhibiting my constitutional inferiority . . . [It] culminated with a flourish late in March when I colorfully went blind in one eye for several weeks." There was, too, the multiple sclerosis, which she'd been diagnosed with in the mid-sixties and which would go in and out of remission. In the early seventies, it was out. "Poor Joan had everything the matter with her," said Eve. "She was so fragile and falling apart."

Or maybe Dunne was crying for another reason entirely.

In 1974, Dunne published *Vegas: A Memoir of a Dark Season*, a book he carefully characterized in a prefatory note as a blend of fact and fantasy. Yet in a letter to writer Jane Howard, he admitted that this description was misleading, an attempt to throw his mother off the autobiographical scent. "I finally prevailed upon Random House to call [it] 'a fiction . . . that recalls a time both real and imagined,' but I don't think that will fool the Mum."

Vegas is about a writer who leaves his wife, also a writer, and daughter, adopted, in a house on the beach in Los Angeles to live in the city known as Sin. Precisely what Dunne did in the early seventies. In lieu of filing for divorce coming perilously close to actually filing for divorce. (*Vegas*, incidentally, is dedicated to Noel Parmentel of all people.) "There was a period—and no one writes about this, I was thinking about it the other day—when John moved to Las Vegas for a year," said Moore. "It was to write a book, supposedly. But it was also to be away from Joan and Quintana. So I think it was about more than the book. I mean, the book is wonderful. But still, to live in Las Vegas, in a motel, for an entire year

and not be part of the marriage or the family is—well, it's an interesting choice. You know, I remember a time when Joan told Quintana that she was going to leave John and take Quintana with her. But then she didn't do it. She was passive and couldn't do it. In the end, it was he who left."

In *Vegas*, there's a telephone exchange between the protagonist and his unnamed wife:

> She said she was lonely and depressed. The septic tank had overflowed. There was a crash pad next door and one of the couples had taken to boffing on the grass in clear view of our daughter's bedroom window. The wind was blowing and there were fires at Point Dume . . .
>
> "What's new with you?" she said.
>
> "Jackie's got me a date with a nineteen-year-old tonight [Jackie is Jackie Kasey, a nightclub comic]. She's supposed to suck me and fuck me."
>
> "It's research," she said. "It's a type, the girl who's always available to fuck the comic's friend. You're missing the story if you don't meet her."
>
> "But I don't *want* to fuck her."
>
> There was a long silence at the other end of the telephone. "Well, that can be part of the story, too," she said.
>
> There seemed nothing more to say. I was the one who was supposed to be detached.

This isn't dialogue. This is warfare. The wife defeats the husband, and with humiliating ease. She does it by refusing to take offense at his very offensive behavior. He informs her that he might get it on with a teenager, and she evinces neither shock nor anger at the prospect. Instead, she encourages him to, all but dares him to, the exact moment he turns meek and little-boy, backs down and off. Clearly, he's frightened of her. "Living with her was like living with a piranha fish," he writes. I suggested in an earlier chapter that Joan, in her writing, was a predator passing herself off as prey. I wonder, though, if prey passing herself off as a predator was what Joan was in her marriage. I wonder if that's how Joan *survived* her marriage.

For example, in this conversation, Joan seems to be calling Dunne's bluff. But calling it how? In what sense? Was she calm in the face of his cheating because she believed that cheating wasn't fatal to their marriage? (In a 1971 interview with *New York* magazine, after casually confessing that

she and Dunne were having a rough go of it—they'd just passed through what she termed "the season of divorce"—she added, equally casually, "I don't really think infidelity is that important. . . . If you can make the promise over again, then the marriage should survive.") Or was she the one doing the cheating, cheating not as you cheat on a spouse but cheating as you cheat at cards? By which I mean, could she see Dunne's, and that sex with a nineteen-year-old girl wasn't in them.

Or, for that matter, sex with a dowager groupie?

For his 2015 book, *The Last Love Song: A Biography of Joan Didion*, Tracy Daugherty interviewed Don Bachardy, the artist and longtime lover of writer Christopher Isherwood. Said Bachardy, "I always thought, What's [Joan] doing, married to John? I've never been as cruised by anyone as I was by him. He wouldn't take his eyes off my crotch. He always seemed very queer to me, and so did his brother Nick." (Nick would, later in life, describe himself as a "closeted homosexual," though he felt Joan pulled him out of the closet with *Play It as It Lays*. He was sure that the character BZ, a secretly gay producer, was based on him, a secretly gay producer.) Bachardy continued: "I couldn't understand how John could be so obvious about it. It was embarrassing to me. And Joan was around the whole time. She had to know."

After repeating Bachardy's words, getting a scandalous jolt out of them, Daugherty instructs the reader to take them with "heavy pitchers of salt," explaining, "They're best understood in light of Dunne's class background, which made him feel perpetually excluded from whatever was happening, intensely curious about experiences he might be missing." (Well, if you think Bachardy's full of salt—i.e., shit—Tracy Daugherty, why quote him in the first place?) I, too, interviewed Bachardy, got the same words, and am inclined to go low-sodium. Here's why: Bachardy wasn't the only one to speak them.

Before I tell you who else spoke them, I want to establish Joan's attitude toward homosexuality. Hostile, at least when she was young. (There was, I think, too much of the small-town girl in her to feel any other way.) She seemed to imagine that only one type of gay man existed: a mincing parody of a gay man. And early in her married life, she exhibited a kind of repelled fascination with gayness. In a May 9, 1965, letter to friend Mary Bancroft, she wrote, "If I hadn't thought before that Tom Wolfe was queer, I might have suspected it when John got a more or less business letter from him

written on colored construction paper." Then, three months later, "Tom Wolfe is out here right now. He is more androgynous than even you think. I mean I don't even think he's a fairy now that I've seen him." And Don Bachardy told me this, "Chris and I felt that Joan didn't love queers much. As queers, we were highly conscious of whether or not our being queer bothered people. And we believed it did bother Joan. It had to have been a very sensitive subject for her."

And now for those words and who spoke them:

Bret Easton Ellis, for one. In 2019, I did a story for *Esquire* on the writers of Bennington College, Class of 1986: Ellis, Donna Tartt, Jonathan Lethem. While at Bennington, Ellis became a friend of Quintana's (Class of 1988), and then, later on, of Joan and Dunne's.

Said Ellis:

> I would walk into their apartment, and Joan would hand me a drink and she would just stand there and not say anything—terrifying, *terrifying*. Looking back, I often wonder why there were so many young, good-looking guys who were surrounding John, whether it was my boyfriend at the time—Jim—who I think John had a real thing for, or Jon Robin Baitz [the playwright]. My boyfriend Jim was blond, blue-eyed, a lawyer, very straight-acting, very good-looking. So, look, I always assumed John was gay. I never assumed he was *not* gay. It was just one of those things with that whole crowd—Nick Dunne, Tony Richardson, John Dunne. It was a gay man and a wife living the way you were supposed to live. That's how it was back then. You couldn't be open. And there were friends of mine who spotted John in certain gay bars late at night, very drunk. Not the chic, hip gay bars, the Times Square gay bars.

Susanna Moore spoke them, too, though not when I thought she did. In *Miss Aluminum*, she shared a memory of Dunne and Earl McGrath: "Arriving late at a party in a nightclub for a movie star, [Earl] spotted John in a crowded banquette, squeezed against the guest of honor. Earl leaned across the table to shout, 'I *knew* that's where I'd find you,' causing John to throw his drink in his face." During my interview with Moore, I asked her about the movie star and the tossed drink.

An excerpt from our conversation:

"Susanna," I said, "as I was reading that scene, there was one question that kept popping into my mind—was the movie star male or female?"

"A man," she said.

"That's what I was guessing. So, Earl was implying that John was interested in the male movie star sexually, right? That's why John got so mad?"

A short, sharp shake of the head. "No, no, Earl was implying that John was a starfucker." She thought something over, then said, "Earl was never obviously homosexual. I'm sure his life with Ahmet and his life on the road with the Stones was unbelievably wild and licentious and illegal. But I never saw him with a boy. I never heard him talk about a boy. Maybe because he was married to Camilla. She was very stabilizing for him. Now, Earl was deeply in love with Harrison but even that never appeared gay. It just seemed like a very loyal, very long friendship. Do you know what I mean?"

I nodded that I did.

Joan and Earl McGrath, on the deck that
Harrison Ford (finally) built, at the Trancas house.

"Earl often said things that were appalling, just so nasty and rude, and a lot of people disliked him intensely. Not Joan, though. You know, I always got the feeling that Joan's mother was awful, and that Joan hated her and had been very damaged by her. It was her father she was devoted to. And

she didn't have women friends, not really. Of course, I'm a woman and I was her friend, but you could only get so close to her. You'd absolutely never go to her with a personal problem. You'd never say to her, 'I'm depressed because this happened,' or, 'I'm thinking of leaving my husband or partner for this reason.' She didn't want to hear it. You might eke a sentence out of her like, 'Whatever you do, you'll regret both,' but that was it as far as advice went. She was cold. In a way, Earl *was* her woman friend. I'm thinking of a picture of the two of them. They're on the deck of the Trancas house, shoulder to shoulder, looking over the balcony and laughing. There was an intimacy between them that was not sexual, that was like the intimacy between two women who are friends."

"And I'd always heard that Earl was funny," I said.

"Oh, very funny. Earl had an ability to free-associate, to fantasize and to imagine and to be outrageous. I suppose Joan depended on him saying the things she couldn't. Also, I think she understood that he knew exactly who John was, and this gave her comfort. He thought John was a bit of a joke. So, Earl had John's number. But we all had John's number. I might have looked at John at that party and thought, 'Naturally I'd find you squished into the banquette next to—' whichever movie star it was, and I might have smiled to myself. Only I'd never have said anything."

"Ah, okay," I said. "I misunderstood. I thought Earl was calling John, you know, not straight."

Moore started to respond, then paused. And in that pause, I could sense her feeling her way around, trying to shape what she wanted to say next. At last: "Well, one of the other stories I tell about John in my book—the Jann Wenner story—falls more in line with what you're talking about. [In *Miss Aluminum*, Moore recalls a dinner she had with Joan and Dunne in New York. She writes, 'John was infuriated when I said that I'd heard that Jann Wenner was gay. He slammed down his glass of Scotch, shouting that he had never heard such malicious gossip, and he left to recover himself in the men's room.']"

Proceeding cautiously, I said, "When you say, 'falls more in line with,' you mean the story suggests that John was gay or bisexual?"

"There were people who believed that he was."

"His reaction to the Wenner rumor seems like a crazy overreaction to me. Really, really odd behavior."

"It *was* odd," said Moore. "It was particularly odd since John enjoyed gossip. He'd call me every morning with gossip. 'This you won't believe,' he'd say. And, interestingly, the rumor about Jann Wenner turned out to be true! Look, there were people who objected to Joan's book about John's death because they were expecting her to reveal that he was gay or bisexual. And she did not. Obviously. And people were—I don't know why— disappointed. I've had to say to people, 'She's entitled to write whatever she wants. She does not have to write that her husband was gay or was not gay.' And they said, 'It's a lie.' I said, 'No, it's just private.'"

Even Joan spoke the words. Didn't speak them directly, of course. Spoke them by inference. In a 1977 interview with Madora McKenzie for the *Boca Raton News*, she said of her relationship with Dunne, "It wasn't so much a romance as *Other Voices, Other Rooms*." *Other Voices, Other Rooms*, the first published novel of Truman Capote. A love story, but not between a man and a woman, between a man and a man. (Take note, Reader: by '77, Joan no longer sounded like a small-town girl, but a big-city sophisticate; homosexuality, even in the context of a heterosexual marriage, even in the context of *her* heterosexual marriage, barely eliciting a raised eyebrow from her, just another fact of life on planet earth.)

Finally, I put my question—did Wakefield think right, did Dunne have the hots for Eve?—to Wakefield himself. By way of answering, he told me a story:

In the spring of 1968, I was a guest lecturer at the University of Illinois journalism school, which is in Urbana, an awful place. So, I was talking to Joan and John on the phone—that, by the way, is how it worked with them, when you called, they both got on the line—and I said, "I'm through with this teaching thing at the end of May, and I want to finish my book [*Going All the Way*], and I'm trying to figure out where to go." And they said, "Come here and we'll find you an apartment on the beach in Venice." And that's what happened. I lived in Venice in the fall of '68. I'd go over to the house on Franklin Avenue. Joan would be there, alone, and I'd say, "Where's John?" And she'd say, "I don't know." He'd be gone for nights, for whole weekends. And this was before he spent that year

living in Vegas, writing his book, doing whatever it was he was doing there. When John was around again, I said, "Where were you all those weekends?" And he said, "Well, Wakefield, did you ever just take off one night and drive on some road until you came to a diner and get out and meet the good-looking waitress after work and spend the night with her?" And what I wanted to say was, "No, and neither did you." Really what I felt was that John was probably seeing the good-looking waiter.

And then he told me another story:

It was that same period, that period when John kept disappearing. Joan was working on *Play It as It Lays*, and I knew she was having trouble with it because she was wondering where John was, if he'd ever come back. I'm thinking, God, she's never going to write her book hanging around the house, waiting and worrying like this. So I wrote her a note, and I said, "Why don't we both go to Mexico and write our novels?" And then I thought, Well, we'll probably end up having sex if we're in Mexico together. But I sent the note anyway. And then one night I went over to see her, like usual, and John opened the door. I couldn't believe it. Later I whispered to Joan, "I hope you hid my letter." And she whispered back, "I burned it in the fireplace."

Over the next decade, one of two things happened: Dunne's anger mellowed or Dunne's spirit was crushed. Either way, the marriage settled down. And by the eighties, Joan would be telling the *New York Times* that she and Dunne were "terrifically, terribly dependent on one another." A statement that warms the heart.

Or chills the blood.

I'll See You on Johnny Carson

In September 1971, Eve mailed "The Sheik" to Grover Lewis at *Rolling Stone*. Two weeks later, Lewis mailed her a check.

The piece, she was informed, would appear in the magazine's short-story section. ("I thought it was an essay," she said, "but *Rolling Stone* saw it as fiction, and that was fine with me.") She could scarcely believe it. Not only had her work sold, it had sold with ease and speed and to a total stranger. She didn't have to make threats, as she did with Stephen Stills. Or break out the sex appeal, as she did with John Van Hamersveld.

Nor was *Rolling Stone* any old magazine. Started by Jann Wenner and Ralph Gleason four years before, it had fast become the most influential of its generation. Its writers didn't just cover rock 'n' roll stars, its writers *were* rock 'n' roll stars. (For example, that fall, it ran, in two successive issues, Hunter S. Thompson's *Fear and Loathing in Las Vegas*, which turned Thompson, already a voice of the counterculture, into a hero of the counterculture.) And Eve's first piece would be featured in its pages. It was as if Marilyn Monroe had landed, as her first role, not Girl Leaving Church Service in the barnyard comedy *Scudda Hoo! Scudda Hay!* (1948), her actual first role, but her breakthrough role, Angela, the mistress of Louis Calhern's crooked lawyer in the seminal heist film *The Asphalt Jungle* (1950), and so lazy-luscious she pulled off

a heist of her own, stealing the picture right out from under the noses of her higher-billed costars.*

Eve's mother and father were thrilled for her. ("My parents loved me before *Rolling Stone* but they thought maybe they had exotic taste.") So were her friends. ("They were buying issues of the magazine hand over fist to keep the buoyant mood buoyant.") There was one person, though, who wasn't thrilled, not remotely.

"Dan Wakefield, oh yeah," said Eve. "*Rolling Stone* had just turned down something of Dan's. As soon as I told him they were going to publish my piece, he dumped me. And he fucked my friend. 'I'll see you on *Johnny Carson.*' That's what he said to me when he walked out the door."

Wakefield remembered the breakup differently. "Our year together was one of my favorite years, but I couldn't have lived through two of them. My God, the decadence! When I was with her, I tried every drug known to man. At least known to this man. And we were only ever going to be together for a year because I'd already accepted a teaching job at the University of Iowa. From Hollywood to Iowa City—boy, that was an extreme change." After I delicately raised the subject of Eve's friend, he said, "It's true that in my last few weeks in L.A. I was seeing a girl who also lived at the Chateau Marmont. But it wasn't to hurt Eve, no, no. Eve got that wrong." (When I relayed what he said to Laurie Pepper, she laughed. "Yeah, I don't know if Evie got that wrong. I wouldn't be too quick to take Dan's word on that one.")

In the boxes at the back of Eve's closet, I found several drafts of a letter to Wakefield in which she told him, in a variety of ways, to drop dead. My favorite ended thusly:

I am not ready to see you now nor in the future and if you think I'm ready for a round of Jules Fiffer [*sic*] talks on "What I have thought and seen and tried to figure out," you must think I'm not me. Get yourself a Japanese nurse.

* I call *Scudda Hoo!* Monroe's first movie because it was the first of her movies shot. *Dangerous Years,* though, in which she had a bit part as a waitress, was the first of her movies released.

It was a drag about Wakefield. Still, the moment was a triumphant one for Eve. "[I] was twenty-eight," she wrote. "It was time for [me] to O.D., not get published."

Book people were quick to sniff her out. But only because she gave them her scent. Wakefield, perhaps trying to atone for Knox Burger (or for the girl at the Chateau Marmont), had acceded to her demand that he put her in touch with his publisher, Sam Lawrence. And once she established contact with Lawrence, she sent to him, along with two copies of *Rolling Stone*, a letter written by Joan on her behalf.

On January 29, 1972, Lawrence replied:

Dear Eve:

I liked your story THE SHEIK very much and I urge you to send us more of your stories and an outline of your book, or any material about it. I've sent the other copy of Rolling Stone to Kurt Vonnegut. I may be in Hollywood sometime this Spring and I hope we can meet.

Regards as ever,

Sam

Lawrence would make it to L.A., though not in the spring, in the fall. And Eve would have an affair with him. But she'd have an affair with another editor first: Grover Lewis.

Lewis wasn't just an editor, he was a writer, too—of poetry and New Journalism mostly—and originally from West Texas, presently from San Francisco. The letter Eve sent to him after "The Sheik" had been accepted for publication was written care of *Rolling Stone*, on a typewriter, and in business-formal style. ("Enclosed is the 'brief biography' of myself to which you alluded.") A few months later, Eve sent to Lewis another letter, also written care of *Rolling Stone*, also on a typewriter, also in business-formal style, though with a P.S., written by hand and in voluptuous cursive: "I yearn for you tragically."

"Grover came up with the line 'Turn on, tune in, drop out, fuck up, crawl back,'" said Eve. "He was great. I was almost thirty, too old to fuck around, I decided."

And when Lewis, in early '72, asked her if she wanted to move in with him, she said yes.

Grover Lewis was, in so many ways, Dan Wakefield Redux: another writer/editor, another boyfriend/husband, another potential John Gregory Dunne. "I've always associated San Francisco with retirement," said Eve. "So I moved there to become a square. I thought that the move was for good, that Grover and I would get married, and I'd be a grown-up."

"For good" ended up being for three months. As to why only three, Eve offered a friend an elliptical explanation: "This Texan appeared from San Francisco who was an editor at *Rolling Stone* and invited me to live with him, which I did until he became too masculine even for me."

Mirandi offered me a less elliptical explanation: "Grover was rough with Eve. She didn't mind that. To her that was sexy. Unless it wasn't sexy, and then she did mind. I mean, she liked rough sex, but she didn't like rough, awful behavior."

Less elliptical, though not less elliptical enough. I held up a palm like a stop sign, and Mirandi broke off mid-sentence. "By 'rough,'" I said, "you mean that he hit Eve, right?"

"Yeah," said Mirandi. "Yes."

"Okay," I said, then nodded at her to continue.

She nodded back, did: "What happened was, Grover got really mad at Eve when she took money out of his wallet in front of him, which she considered a charming and flirtatious act. She was raised on the 'Diamonds Are a Girl's Best Friend' belief from the Marilyn Monroe movies. She, of course, was always short of her own money and took it for granted that guys should pay. And here was Grover not being up for it. Grover was a heavy drinker and an ugly drinker. That night, he pushed her out the door and then jammed her clothes into pillowcases and pushed those out the door, too. So there she was, penniless and crying on the streets of San Francisco. Oh, and her car had conked out on her."

She begged Mirandi to pick her up. "It took me two days," said Mirandi, "but I got to San Francisco. I parked and went up the stairs of the house she was staying at. She threw open the door and grabbed me and asked, did I have any coke? Then she pulled me into the living room and started

to holler at me and punch me. I caught her arm and said, 'Stop that!' And she stopped. I gave her a few hits of cocaine and then got her and the pillowcases into my car. And by the time we left the city, we were laughing and crying, and she was telling me everything. She said she couldn't stay long at Annie's house because Annie had always wanted her, and she didn't think it was fair to Annie for her to hang around and bawl her eyes out about Grover."

Annie as in Annie Leibovitz, the photographer, only twenty-two but already a star at *Rolling Stone*.

Eve was starting to ascend into the *Rolling Stone* firmament herself. She'd written several autobiographical pieces for the short-lived, L.A.-centric *Rolling Stone* supplement, "The Los Angeles Flyer." She was also, at the behest of Jann Wenner, working on a long-form profile of Ahmet Ertegun for *Rolling Stone* proper.

And yet, as deep in with *Rolling Stone* as Eve had gone, she was unwilling to go any deeper. The reluctance was out of character since she loved scenes, lived for scenes. "I wanted to be part of every goddamn scene there was," she said. So what was it about this one that put her off? Was it too crudely commercial for her? Too obsequiously fannish? Did she suspect that it wasn't a scene at all, but a bunch of strivers and hacks faking a scene? Whatever the reason, she was tied in knots of ambivalence.

About the profile. "I didn't think *Rolling Stone* deserved Ahmet," she said.

About *Rolling Stone* itself. "That sordid National Inquirer [*sic*] of Rock," she called the magazine.

About Leibovitz most of all. "My latest folly is Annie Leibovitz," she told Carol Granison in a letter dated October 30, 1972. "I met her in San Francisco when I was living with Grover. And when I was assigned to do the Ahmet piece, she was the photographer and we got to be what I thought was close . . . Then when Grover and I broke up she let me stay in her apartment, gave me the keys and stuff like that, generally saved my life. The next thing that happens is that this picture of Ahmet and Mic [*sic*] Jagger appeared in RS with a joint being passed over their heads and Annie took it while she was [my] guest at this party . . . I don't think she's a friend at all, come to think of it, I think she's an ambitious journalist and I better get out of her headlong way."

So why didn't she? She was asking herself that very question. More from the letter to Carol Granison: "And by this time Diane [Gardiner] is saying . . . 'Annie's a male chauvinist pig.' And as for myself, though I have no physical relationship with her, she is awfully beautiful and almost 6 feet tall and totally graceless like a boy so I'm beginning to wonder[,] what am I doing?"

In no time, Eve would go from wondering what she was doing to actually doing it. But before we get to Eve's next love, Annie Leibovitz, Eve's previous love, Grover Lewis.

Lewis acted like a lout and lummox that night in his apartment. He couldn't have acted like a lout and lummox normally, though, or Eve wouldn't have put up with him for as long as she did. (Eve and Lewis were through as lovers in 1972 but remained friends until his death in 1995.) She regarded him as the genuine article. The genuine article as a person and the genuine article as a writer. And to me she conceded that she might have overwhelmed him, knocked him off his axis with her abrasive exuberance. "Nobody in San Francisco threw parties," she said. "But I threw parties left and right. It drove Grover to nervous breakdown. I think I bowled him over. I couldn't help it. I'm much too huge for some people."

What's more, Eve wasn't afraid of Lewis. How I know: her response to a letter he sent a few months after their bust-up. "I hope you'll consent to Straight Arrow using your picture of me for my book," he wrote, referring to his poetry collection, *I'll Be There in the Morning If I Live*. "It's very important to me, and certainly shouldn't do your career any harm. Please let Jon Goodchild [art director for *Rolling Stone* and for *Rolling Stone*'s book division, Straight Arrow] or me hear when you get a minute."

Eve didn't appreciate his tone or his presumption. She let him have it for both.

Grover:

Everytime [*sic*] I look at that letter that Jon Goodchild sent I get so mad I can hardly prevent myself from flying up there and pouring orange juice concentrate all over his art supplies.

Do you know what that son of a bitch did? He wrote me this letter TELLING me that they paid $50.00 for a picture. He did not write that

he liked the picture, he did not <u>ask</u> if they could please use the picture, no, he wrote saying that he agreed with you that that picture would be a good cover for the book (isn't that nice of him, he agreed). Why can't anyone at Straight Arrow observe one single fucking amenity? . . .

And what kind of crack was that about this couldn't hurt my "career"? It's your career that it's going to help, Grover, not mine. Nobody will take a picture like that of you again as long as you live and you know it, don't give me that stupid shit about my career. Even YOU don't say you like the picture or please—all YOU fucking say is that it won't hurt my career. Jesus, is that how you ask anyone for a favor?

You boys better shape up there. And without my consent, you publish that picture, I'll sue everyone to death. I'll overkill . . .

Sincerely,

Eve

Cc: Jann Wenner, Jon Goodchild, Annie Leibovitz, Sara, David Felton, Susan Vining, Charles Perry and Stephanie—Hi!

P.S. I am not drunk. It is 8 AM on a Tuesday morning and I figure, fuck it—you guys are loathsome bores and diserve [*sic*] to be exposed.

Grover Lewis by Eve: "Nobody will take a picture
like that of you again as long as you live!"

This letter is a bravura performance, rowdy and raucous and no-holds-barred. You get to the end, and you want to whistle, stamp your feet, same as you would at the end of a wham-bam, slam-bang boxing contest. She laid Lewis—plus Jon Goodchild, the entire staff of *Rolling Stone* magazine—flat. What else this letter is: proof that the fight between her and Lewis was never fair. He only turned it into a physical one because he was losing, which just made him lose faster. (Like I said, scratch a bully, find a crybaby.) He didn't have a prayer, and he knew it.

There was another reason Eve left Lewis. "I was living in San Francisco until two things happened," she told a friend. "One, I decided to murder the guy I was living with, and two, I suddenly found out I had an advance for a book." Sam Lawrence had come through.

June 3, 1972

Dear Eve:

Good news from Boston! I've shown your stories to my partners at Dell and they shared my enthusiasm . . . We will give you a contract with an advance of $1500 on signing and $3000 on delivery and acceptance of a completed manuscript. You're on your way.

Try to think of some way of unifying the stories . . . Of course Eve is the one who holds the book together but I hope you can also find a common thread to give the book a kind of order. Joan may be able to give you advice along those lines.

Be encouraged and impassioned.

Regards as ever,

Sam*

Eve hadn't even written the book yet, and Joan had already shepherded it, championed it, allowed her reputation to be traded on to help Eve sell it. And, as this letter makes plain, Lawrence was hoping she'd advise on

* It wasn't among Eve's papers that I found this letter, by the way. It was among Lewis's. He saved it. An indication, I'd say, of strong attachment, if not outright love.

it, as well. She'd do a whole lot more for it than that. She and Dunne, not anyone at Dell, would edit it. (You might have to be a writer to understand how big a favor this is. Editing a book isn't a casual kindness. It requires time, energy, effort, none of which Joan, whose child was small and whose career was white-hot, had to spare.)

It becomes harder and harder to see it any other way: Eve had a benefactor, and that benefactor's name was Joan Didion.

Female Male Chauvinist Pigs

Eve was back in L.A. by late June. She didn't go out and find herself an apartment to rent. In fact, she didn't go out period, holing up at her parents' house instead. She did, however, let a select few come to her.

Among the select few: Earl McGrath, delivering the social lowdown. "Earl McGrath has been the only one I really see," she wrote to a friend, "which is enough for any spinster like me to know everything in the whole world." She and McGrath had reached a détente. "After about 5 years of something that would never stand up in court as a 'friendship,' [Earl and I] have finally decided, what the hell, why don't we just pretend to like each other this season and it's working out beautifully."

Also among the select few: Ahmet Ertegun. "I am in love with Ahmet, too, you may have noticed," she wrote. "I gave Ahmet a new artwork I'd begun doing before I quit doing art because of no studio and because I became a writer . . . Earl said [Ahmet] put it in the space between the pre-Columbian statue and the Magritte! I have never seen Ahmet's house in NYC but it must have tons of stuff in it. Mrs. Ertegun, especially, liked it." Engaging in an extramarital affair with Ertegun wasn't new territory for Eve, obviously. What was new, her attitude. She was becoming resigned to the fact that mistress—Ertegun's or anybody else's—was the role to which she was best suited. (Mistress and spinster, opposite sides of the same coin: non-wives.) "All those years I lived alone in a giant apartment and everyone asked me wasn't I lonely. Yes, I was lonely, but the way I am built, lonely

is better than guilty and other people make me guilty. I need a giant huge apartment again and friends who travel a lot. Like Ahmet."

Conspicuously not among the select few: Brian Hutton. "Eve couldn't resist Earl or Ahmet—not for long," said Mirandi. "And it used to be that she couldn't resist Brian either. Brian had been giving her money since she was a teenager, and he'd become a big director. *Where Eagles Dare* with Clint Eastwood was a huge, huge hit in, I think, 1968. And he worked with Clint again in *Kelly's Heroes* [1970]. So, he was making a lot of money. And he paid Eve's rent for years. Paid for things like groceries, too. I mean, 'Courtesan' was Eve's middle name. Her feeling was that any money she made shouldn't be spent on something horrible like necessities. She wanted to spend it on books or coke or whatever the hell else. But then Brian found out he had all these paternity suits against him—four or five. That's how prolific he was with women. So, he came to see Eve, drove right up in his gold Mercedes, and told her he just couldn't support her financially anymore. And that was sort of it for the two of them."

Eve was keeping to herself in order to minimize distractions. She wanted to be absorbed totally in her book, which she was now calling *Eve's Hollywood*. "You have no idea what this advance for the book has done for me," she told Chris Blum in a letter. "I'm freed for once in my life to not have to worry about money—it was all I ever needed, after all. Just like I thought." Her delight in not having to worry at present, though, soon gave way to bitterness that she'd had to worry in the past and might again have to worry in the future. "It's not right for me to have to depend on a man to get me money and it's not right for me to be a secretary and I certainly don't want to work for those sleazy scandal mongers at *Rolling Stone* which was what looked like what might have happened without the advance."

Bitterness, too, that she'd never been given a shot as a visual artist. "For once there's one thing I can get people to believe me about—I think it is because there have been so many successful women writers and they've macheted the way for the likes of me. I could never get anyone to believe me about the art thing, even you, or the galleries—nobody would ever believe me about that, so you were right, I should have been writing all the time. However, it's a teensy bit like saying, go home and bake."

Eve here is talking directly about the sexism she'd faced—something I never heard her do in life. And the rare times she did it in print, she did it with a half smile. For example, in one of her stories—"Ingenues, Thunderbird Girls and the Neighborhood Belle"—she runs into an old friend, Wendy (really, Sandy Kirschner, the best-looking and most commanding of the Thunderbird Girls), and Wendy asks her what she's been up to:

> "Oh," I said, in a bad mood that day, "I'm working in an office full of male chauvinist pigs."
> "Yeah?" She paused, her timing always perfect. "What do they look like?"

Eve, though, isn't smiling with Blum. Is about as far from amused as you can get when she tells him that her failure to make it as a visual artist is inseparable from her failure to be born with a penis. And, in this moment, you sense that for all her surface gaiety, there is, at her center, rage, and that that rage is what's concentrating and impelling her ambition.

Eve wrote Blum in the summer of '72, the same summer that Joan published in the *New York Times* her piece on the women's movement, the piece that incited Eve to write a savage letter in response. Joan, Eve believed, was safeguarding herself from the male chauvinist pigs by, in effect, *becoming* a male chauvinist pig, what Diane Gardiner called Annie Leibovitz. If Joan and Leibovitz were both female male chauvinist pigs, they were also two of the biggest female stars Eve knew. No coincidence, in Eve's mind. And, consciously or unconsciously, she began to link them. "Eve used to say that Annie was the son John and Joan never had," an old boyfriend of hers told me.

And yet the irony—a painful one for Eve—was that it was Joan, double-crosser of women, who was offering her, a woman, protection and support.

Summer turned to fall, and Eve was suddenly beset by anxiety. That anxiety had two sources. The first was the profile of Ertegun she was writing for *Rolling Stone*, though by early October she'd stopped writing. How could she write? The profile was the collage all over again. It was supposed to be a way for her to tell the truth about Ertegun—if not the whole truth, her

truth; the felt truth of her lived experience; art's truth—yet Ertegun had forbidden her to reveal that truth.

She struggled to explain herself.

To Walter Hopps: "All the time I knew I'd never publish anything about him or really write anything about him that wasn't fictionalized because he's too much fun and *Rolling Stone* is too dowdy."

To Jann Wenner: "I am dismayed at my ineptitude, but there you are, you see. It turns out that I wasn't a journalist after all. I just can't not become people's friends, and with Ahmet, I was his friend all along . . . Even the people I met through doing the piece, Jann, after I started, got webbed into my life like roots and my perceptions all have to do with friendship and looking on the bright side and nothing to do with scientific perspective or cool reportage or any of that . . . I can't even get a grasp on the situation far enough back to even tell what Ahmet looks like, you know? I mean, he just looks like someone I love and with whom I've shared incredible moments, but I don't know what he looks like after that."

To Ertegun himself: "What happened with the piece, Ahmet, is that what I wanted to do just couldn't be done because of my own limitations—I wanted to do you justice. What I did was merely get a 'sence [*sic*] of your presence' as Joan Didion remarked. But I wanted to tell everything and what [I] turned out to mean by that was a short history of civilization in all its many garbs and Baroque ornaments. And while you kept changing from one thing to another before my already over imprinted eyes, *Rolling Stone* kept saying 'this isn't what we meant' and Earl kept hitting me up on a morals charge, like 'how can you be a creepy journalist, how can you?'"

McGrath's question, an accusation in the guise of a question, must've really rankled Eve since it's the one she was putting to her colleagues at *Rolling Stone*. ("Ambitious journalist," after all, is what she called Annie Leibovitz for publishing that compromising photo of Ertegun and Mick Jagger.) Moreover, "ambitious journalist" is what *Rolling Stone* wanted her to be, is what she was refusing to be. (The editors at the magazine—"those sleazy scandal mongers at *Rolling Stone*"—were looking for dirt on Ertegun, and she was giving them fairy dust—"a short history of civilization in all its many garbs and Baroque ornaments." A romance rather than an exposé.) And now "ambitious journalist" is what McGrath was calling her—well,

"creepy journalist," tomato, to-mah-to—no matter that she was sacrificing her journalistic ambition, i.e., *not* publishing the profile of Ertegun, for the sake of love and friendship.

Journalist was a socially unacceptable position to hold in the Ertegun-McGrath crowd, though an exception was made for Joan, of course. (Joan was, as I just noted, a star, which meant "star" was her label, superseding all other labels.) The disdain derived, I think, from class snobbery. Journalism was writing, yes, but of a plodding, flat-footed sort—practical as opposed to poetic, concerned with utility rather than art or beauty, and dealing in facts not fancy. The disdain also derived from cool snobbery, journalists being uncool, what with their noses pressed against the glass and all.

The second source of anxiety was Sam Lawrence's trip to the West Coast. He was scheduled to arrive on October 20, a date Eve fixated on, cited in letter after letter. To make sure his L.A. experience was a good one, she planned all manner of fun and folly: a dip in the pool at the Beverly Hills Hotel; a game of doubles with Diane Gardiner and Diane's boyfriend, rhythm and blues man Chuck Berry; lunch with Joan and Dunne.

She needn't have fretted. Lawrence's visit went smoothly. So smoothly, in fact, that he slid right between her sheets. He didn't get to stay between them long, though. I asked Eve why not. Her response: "[Sam] bought me a pair of gold earrings because that's what I demanded. But then I didn't like them."

Whether or not Lawrence was wounded by her treatment of him I can't say. But he remained cordial in his letters. "Work hard," he told her from Boston, "finish your book and we'll try to make you a star."

At the close of 1972, Eve went all in on Lawrence's directive of passionate labor. *Eve's Hollywood* was her only focus. She became downright abstemious: champagne cocktails instead of whiskey; no uppers, aside from a little cocaine ("[My friend] had some coke from Germany which . . . just laid the entire population of L.A. out"); and definitely no sex, sex, and more sex with unsuitable partners, though she'd squeeze in five days at the Beverly Hills Hotel with the very unsuitable Tom Dowd, a producer and engineer for Atlantic Records with a wife and kids back in Florida.

From a letter to Carol Granison, written in late November:

> The married man from Miami just left town and I had the most wonderful
> vacation between the end of the book and the final draft with him . . .
> Today I am beginning the final draft . . . It is 4AM which is what time
> I start writing. Can you imagine? Me? I go to bed at like around 8 or so
> and then have insomnia all night and wake up at 4. It's how to do it, is
> all I know.

Two weeks later, she wrote another letter to Granison. (Letter writing
seems to have been the one leisure activity she permitted herself during this
time, the sole outlet for her nervous energy, of which there was a profusion.)
A passage from that letter: "The book is done! It's done! I mean, I <u>think</u> it's
done. It seems done. The more I sleep on it, the more done it seems . . .
Dusty, practically. I can already see it not being checked out of the library."

But when she described *Eve's Hollywood* to Granison, it didn't sound
remotely like *Eve's Hollywood*: "It's written in the third person now and
the girl's name is Jacaranda so I don't know if I should still call it *Eve's
Hollywood* or what."

Eve rushed to get the manuscript into the hands of Joan and Dunne, now
officially her unofficial editors. "I've got the crowned heads of literature . . .
editing it for me," she told Jann Wenner in yet another letter, "so if it's not
good it'll be their fault."

In early January, she received a summons to Trancas: the crowned heads
had reached a verdict. She reported back to Lawrence, "After being very
puzzled for a day or two [the Dunnes] finally figured out what was the
matter with it—it was <u>two</u> books. So I had to take it all apart and make two
books out of it . . . The second book is about luscious love, luxuriously and
opulently floating in the air of Southern California with lots of champagne
and silk stockings and ladies and gentlemen of fashion."

Eve went into more detail on the second book to Hopps:

> I wrote two books; the one I was writing originally called "Eve's Holly-
> wood" and [the second one] which I had in my mind to call "Portrait of
> the Artist as a Lady of Fashion." But the second one, I realized, would
> be better untangled from the first so I've removed it.

(Please note, Reader: Eve is telling Hopps that *she* realized, not that Joan and Dunne realized, which is what she told Lawrence and which was almost certainly the case. Maybe because she knew that Joan and Lawrence were in regular communication, and that she therefore couldn't get away with fudging; that Joan and Hopps weren't, and that she therefore could.)

Eve went into more detail still:

I am going to write the most luxurious, Beverly Hills Hotel greenery, lion's paw amber kind of dangerous book since F. Scott Fitzgerald said [in *Tender Is the Night*]:

Rosemary bubbled with delight at the trunks. Her naivete responded whole-heartedly to the expensive simplicity of the Divers, unaware of its complexity and its lack of innocence, unaware that it was all a selection of quality rather than quantity from the run of the world's bazaar . . . At that moment the Divers represented externally the exact furthermost evolution of a class, so that most people seemed awkward beside them—in reality a qualitative change had already set in that was not at all apparent to Rosemary.

I have a feeling, Walter, that I'm Rosemary.

I'm afraid I've always been Rosemary.

It's clear that Eve imagined she was writing a book she'd lived, and that book was an updated version of *Tender Is the Night*. She saw herself as the updated version of the wide-eyed teenage actress, Rosemary Hoyt. Which made Joan and Dunne the updated version of the catastrophically sophisticated married couple, Nicole and Dick Diver (a corrupting influence on Rosemary, incidentally). Which made the scene of spoiled and successful artists at the Didion-Dunnes' Franklin Avenue house in Hollywood the updated version of the scene of spoiled and successful artists at the Divers' villa on the Riviera. Which made Southern California at the twilight of the Swinging Sixties the updated version of the South of France at the twilight of the Jazz Age.

This second book—the Franklin Avenue book, as I think of it—Eve would shelve. She'd focus her energies and efforts instead on the first book, *Eve's Hollywood*, which was now *Eve's Hollywood* as we know *Eve's Hollywood*.

The list of reasons Eve was beholden to Joan grew ever longer. The thank-you she laid at the feet of Jann Wenner—"[*Rolling Stone*] helped me so much in my life, it practically saved my life"—she mislaid; should've laid at the feet of Joan, as she well knew, even if she liked to pretend she didn't.

She'd acknowledge the truth, though, to Dan Wakefield. In a letter, she tells him about her "last abortive 'happily ever after' love affair in San Francisco with some punk southern journalist with a 'drinking problem' who is the editor at R.S. who accepted my piece <u>The Shiek</u> [*sic*]." And then, almost as an afterthought, "All I can think of is that if Joan hadn't sent him a letter in the first place, he never would have taken the story." In other words, *Rolling Stone* only gave her a chance because Joan already had.

And not just *Rolling Stone*.

The 1971 letters between Dan Wakefield and Sam Lawrence that trace Wakefield's courtship of Eve, trace, as well, Lawrence's courtship of Joan, Wakefield serving as Lawrence's proxy.

On August 11, 1971, Wakefield wrote:

In the more delicate mission I am on for SL [Sam Lawrence] Inc, I am having dinner tonight with Joan Didion and John Dunne. This one, as you know, has to be all mysticism, but I have all my Vibes working; because in fact I know it would be best for her, too.

Eve also served as Lawrence's proxy, though in her case unknowingly.

On November 21, 1972, Lawrence sent to Joan and Dunne a letter, ingratiating to the point of toadying, about the movie version of *Play It as It Lays*. He opened with:

I saw your film yesterday and it was a shattering experience. The substance and mood of the book were recreated in an incredible way and dialogue rang true throughout the picture . . . Accept my congratulations for helping to make a film I'm planning to see again and probably again.

Then, at the end of the letter:

Help Eve and you'll help us all.

With this line, Lawrence puts himself, Joan, and Dunne in one group, Eve in another: they are the adults, she the child; they the experts, she the greenhorn; they the charity, she the charity case. It's an act of bad faith made worse by pretending to be one of goodwill.

My guess is that Lawrence's principal interest in working with Eve was in working with Joan. (How else to explain why he didn't bother assigning *Eve's Hollywood* a proper in-house editor?) And Eve must've sensed this.

Sensed something, at any rate. Evidence of her animal panic can be found in a February 7, 1973, letter from Sam Lawrence. "I'm sorry you were so troubled yesterday," he wrote, "and I could readily sense how anxious you are about your book. You have no cause to worry. I re-read your <u>Rolling Stone</u> pieces last night for the third time and they hold up supremely well. You're a true writer and a very fine one. So. Please. Do. Not. Worry."

But worry Eve did. She sought out her mother's therapist, Mrs. Alcerro. "I am going to kick and scream and follow [Mrs. Alcerro] through the streets until she agrees to Take My Case or whatever you call it," she wrote Dan Wakefield. "Joan of course thinks pain is a Given that we have to accept, but I can't do that and won't do that. It seems to me cowardly rather than brave."

What had Eve so worked up, I suspect, was the fear that she wouldn't be able to pull it off, make the book happen. That's the subtext of all the letters of this period. Pent-up tension had her practically vibrating. The way she finally released that tension was by blasting the real source of her anxiety: Joan.

Joan was wrong about pain. Joan was wrong about her.

CHAPTER 13

Unsent Letters

That first morning I spent at the Huntington Library, I read Eve's letter to Joan from start to finish. The rest of Eve's letters, though, I barely skimmed. Rather, I used my cell to photograph their pages, as many as I could in the allotted time. It was only hours later, lying across the bed in my hotel room, that I was able to look them over properly.

When I came to the opening line of a 1972 letter to Carol Granison— "Today I'm going to mail the letter I write to you instead of sticking it into a file of unmailed letters I've started because they're practically a diary"—I bolted upright.

That's what the boxes were: Eve's file of unmailed letters. Which meant Eve had never mailed that letter to Joan. Or any of the letters she wrote to various friends and lovers about Joan. And yet, she didn't throw away those letters either.

I flashed on something the journalist Janet Malcolm once wrote:

The preservation of the unsent letter is its arresting feature. Neither the writing nor the not sending is remarkable (we often make drafts of letters and discard them), but the gesture of keeping the message we have no intention of sending is. By saving the letter, we are in some sense "sending" it after all. We are not relinquishing our idea or dismissing it as foolish or unworthy (as we do when we tear up a letter); on the contrary, we are giving it an extra vote of confidence. We are, in effect, saying that our idea

is too precious to be entrusted to the gaze of the actual addressee, who may
not grasp its worth, so we "send" it to his equivalent in fantasy, on whom
we can absolutely count for an understanding and appreciative reading.*

The things Eve couldn't say to Joan, she was saying to me. (Me, posterity;
not me, Lili Anolik.)

But also the things she couldn't say to me. (Me, Lili Anolik.)

For instance, I hadn't a clue that Joan edited *Eve's Hollywood*. And
Eve and I had discussed *Eve's Hollywood* constantly when I was writing
Hollywood's Eve. My fascination with the subject of her first book was
endless because my curiosity about it was bottomless. Never, though, did
she mention Joan's pivotal role.

Pivotal from the perspective of Eve. Unprecedented from the perspective
of Joan, who, as far as I can tell, didn't edit the books of people not named
John Gregory Dunne. "Joan wasn't particularly helpful to young writers in
my experience," said Susanna Moore. "Last night I called my sister Tina—
Tina worked for years as Joan's private secretary—to make sure I was right.
I asked her what her recollection was because she was with Joan and John
day in, day out, for so long. And she remembered it as I did. Joan did not
edit people's manuscripts."

Could it have slipped Eve's mind? A detail misplaced, then lost alto-
gether? That seemed impossible to me. She was too preoccupied with it at
the time to forget it later on. In her 1972/1973 letters, she makes continuous,
compulsive reference to the fact that Joan is editing *Eve's Hollywood*. It's
something she can't not say.

In a letter to Walter Hopps written just after Christmas 1972, she
lists the gifts she received, including an Instamatic camera (from Ahmet
Ertegun), a case of French wine (from Ertegun, as well), earrings (from
"everybody"), cocaine (from nobody, at least nobody she cares to identify),
a pair of light blue sunglasses (from "a girl in San Francisco," Annie

* Janet Malcolm, like Joan, married her editor, Gardner Botsford, and dedicated to him her best
work, *The Silent Woman*, about the poet Sylvia Plath and Plath's finest editor, Plath's husband,
the poet Ted Hughes. (The passage I just quoted is from *The Silent Woman*.) There is, I'm con-
vinced, a great book to be written on the subject: women writers marrying men who edit their
writing, i.e., marrying men they believe will make their writing better, i.e., marrying their writing.

Leibovitz—has to be). And: "a book of poems by Berryman from Joan Didion who's editing my book, thank heavens."

There is, too, this sentence, from a letter she wrote to *Rolling Stone* cofounder Jann Wenner in early 1973:

> I am working on this book and its . . . editors [the Didion-Dunnes] are the creme de la creme so if it turns out badly it won't be my fault.

And, finally, there's this paragraph, from a letter Eve wrote to friend Sara Harrison, also in early '73:

> Joan Didion and her husband are editing [the book]. They are terrifyingly exacting, they nearly scared me to death a week ago telling me I was sloppy and they were right. They are like my best self and who can live with that? They actually asked me if someone had edited my early things (which they liked) and nobody had, that was the trouble, I <u>had</u> gotten sloppy.

The tone Eve assumes in all three letters is lighthearted, even breezy. But she's whistling in the dark. Only in the last letter does she come close to dropping the pose, acknowledging her anxiety about the strictness of Joan's judgment.

Anxious or not, Eve was clearly aware of how valuable Joan's patronage was. Patronage that extended, by the way, beyond Eve's literary work. The same year that Joan got Eve's writing into *Rolling Stone*, Joan got Eve's art into *Vogue*. Eve tells an identical story in two different letters. From the first: "These friends of mine, the Dunnes (they're writers who live over this cliff on the Pacific in a beautiful house—the wife is called Joan Didion and wrote *Play It as It Lays* and is the one who told everyone what a good writer I was). Anyway, *Vogue* came to do [the Dunnes'] house in one of their mythic 'California living' epics, and there, caption and all, is my Ginger Baker collage done by 'California artist, Eve Babitz.'"* In the second, she adds, "which is about time."

* Eve got the spirit of the caption right but not the words. Under a photo of the Didion-Dunnes' master bathroom, a block of text: "Oddments—'I've always set great store on them,' said Joan—including baby pictures of Joan and Quintana Roo, a parody on *The New Yorker* by John, an advertisement for *Play It as It Lays*, and a collage portrait of Ginger Baker by Eve Babitz."

It *was* about time, and it was Joan who recognized it was about time. And Eve was both appreciative of and grateful for this recognition. (How you know she was appreciative and grateful: in letters, she started calling Joan "Joan" and spelling "Dunne" correctly.) In turn, Joan—and Dunne— couldn't have been prouder of her and her success.

On May 10, 1972, Dunne sent a letter to "Darling, Eve" congratulating her on a piece for *Rolling Stone*'s "The Los Angeles Flyer": "I simply love what you're doing, and the marvelous thing is that it grows better and more confident every time out," he wrote. "1958 on Roadside [Beach]—it seems so distant and far away that I feel as if I came upon a diary about an ante- bellum plantation family in Georgia in 1853, fresh, strange and wondrous, a complete picture of a society foreign to most of us." He signed off, "Keep it up. Love you, John." In the P.S., he does tumble into condescension: "*The Stone* is going to be inundated with letters, probably, from people saying that Rebecca and Maximilian de Winter lived at Manderly and not Mandalay [Ed. note: actually, Rebecca and Maximilian de Winter lived at Manderley, not Mandalay or Manderly], but fuck them, the piece was about Roadside." He tumbles right back out, though: "Love you again." And then, at the bottom of the page, written by hand (the letter was typed): "Eve—I love the pieces too—they are terrific—the Hollywood <u>and</u> the surf piece—XX Joan."

But, somewhere along the way, Eve's feelings toward Joan changed. Appreciation and gratitude vanished. In their place, indignation and scorn. She didn't want Joan editing *Eve's Hollywood* anymore and told Joan so.

Recalled Paul Ruscha, Eve's boyfriend in 1973, "Eve started saying, 'I fired Joan.' I thought that was crazy. Joan didn't work for Eve. But Eve loved to sort of throw that out there—'I fired Joan.' She was very dramatic about it. I just sort of looked cross-eyed at her and said, 'What? Why did you do that?' Eve didn't explain anything to me, except to say that she felt Joan had made errors in judgment about her writing."

There is in *Eve's Hollywood* a piece titled "The Luau," a veiled (but not very) account of how *Eve's Hollywood* came to be.

From "The Luau":

I have never had any money and suddenly I thought that if I sent a publisher a letter in just the right tone, I might get an advance to do a

book . . . As proof that I could write, I sent the publisher a Xeroxed copy of a letter from [Lady Dana Wreaths,] a writer, an extremely fashionable writer, who thought that a few short pieces I'd written in a local L.A. paper were terrific. I'd known the woman for years and always kind of shrugged off her New Yorky quality, a kind of serious professionalism which didn't allow for any fun. Her books were so brutally depressing that the only way you could be happy about them was to appreciate the style . . .

The Xeroxed copy of [the] letter got an advance from an East Coast Publisher . . . The publisher asked the woman to edit my book, and she said yes and her extreme fashionability was almost a guarantee of an important success . . . All at once I was home writing. I stopped going out and met no one. My only friends were my perpetual girl friends and I didn't fuck anyone new . . . The writing got dismal and you couldn't read it . . . But by that time I couldn't tell anymore. I'd lost my nerve.

[Lady Dana] read the manuscript and called me up to Santa Barbara for a purge. With wrinkled brow she asked me if someone had edited my previous pieces which had appeared in the local publication or what? Its implication was clear: the person who had written those first pieces was not the same person who was writing these. She told me that everything needed a vast amount of work, that I could not have written those earlier pieces in two days like I'd claimed. Read Graham Greene, she told me.

So there I was sitting dry-eyed wondering why I should be allowed to live . . . [A day later I] decided I could go ahead and live and I had also decided that Lady Dana was not going to edit my book, it was a contradiction in terms, mutually exclusive . . . I decided suddenly that her life was ridiculous and her worried brow was merciless and that she, in fact, knew nothing about what I knew.

No prizes for guessing who the real Lady Dana is. ("Lady Dana," so close to "Mrs. Dunn" in its ghastly primness, its lily-livered gentility. If Eve has put Joan in a disguise, it's a disguise carefully designed to be seen through.) Before you lose all faith in my competence, Reader, let me assure

you that I *did* guess. But when I went to Eve with that guess, asked her if Lady Dana was based on Joan, she said, "You know, I can't remember, I was on so many drugs . . ." her voice trailing off into vagueness. And because I never considered the possibility that *Eve's Hollywood* was edited by anyone other than Sam Lawrence or some equally qualified person at Dell, I dropped the matter.

(Something to keep in mind: Earl McGrath is also a character in "The Luau." The "connection," he's called. Eve portrays him as a cutup and a charmer—an entirely winning personality. No mention is made of the fact that it was he who ended her art career by asking her the kind of question that should never be asked of somebody engaged in creative work: "Is that the blue you're using?" Lady Dana and Lady Dana alone is the story's villain.)

What I did know, however, was that Eve was fucked up in the extreme about Joan. I'll get into all the ways in which she was fucked up. First, though, a characterological observation: emotionally Eve was direct. She loved and hated purely. Had the clean eyes and cold heart of a child.

A case in point: Eve and I were at lunch—the Village Idiot, a gastropub on Melrose—and a woman, Eve's age, pleasant-seeming, waved from a neighboring table. Eve didn't wave back. Instead, she stared at the woman, stone-faced, holding her fork the way Bette Davis held a cigarette in *Dark Victory*. At last, the woman dropped her head, tried to dip her embarrassment in her soup. Eve resumed eating her steak and potato pie. I asked her who the woman was, and she said, "That's my enemy." I searched her expression for signs of irony, found none. (Later, I was told by Mirandi that Eve and the woman had, briefly, shared a boyfriend in the seventies. I was also told by Mirandi that Eve didn't like to share, which I didn't need to be told.)

Never, in the entire time that I knew Eve, was she cagey with her feelings. She was utterly straightforward.

Only not when it came to Joan.

When it came to Joan, things got splintered, stunted, thwarted, twisted. Got, in a word, complicated. There were these remarks she'd make that you weren't quite sure she'd made because they were muffled (said under her breath). Or smeared (said as she was turning her head). Or snatched

back (said and then unsaid).* And they were brutal beyond belief. Also, sneaky beyond belief. So devastating and yet so sly you thought your ears were playing tricks on you.

For example: in the winter of 2015, I sent Eve, at her request, a copy of *Blue Nights*, Joan's anguished if oddly elliptical account of Quintana's death. (Joan never makes clear what exactly is wrong with Quintana. Why does this apparently healthy thirty-seven-year-old suddenly fall so very sick?)

I'd forgotten I'd even ordered the book—a few unthinking clicks on the Amazon website—which is why it wasn't on my mind when, a day or two later, I called Eve.

She answered on the first ring. Rather than say hello, she said, "It was the baby advertisements that got to her."

A beat while my brain scrambled to decipher her meaning. "Are you talking about Joan?"

"Yes," she said, exasperated. Like, who else?

"You think baby advertisements are why she adopted Quintana?"

"If you're going to adopt somebody, and you say you have a passion for children, which Joan said she did, you should adopt two." Eve's voice pivoted away from the receiver as she adjusted the dial on her radio—I could hear the theme song to *The Larry Elder Show* rise, fall—then came back. "That way the children can amuse each other. Instead, Joan had one to amuse her."

I held my breath, waiting to see if she was done. She wasn't. She was on to the alcoholism that she believed killed Quintana. "They all had drinking problems," she said of Joan, Dunne, and Quintana. "But Quintana's the one that wound up dead. If Joan had dragged her to Hazelden when she

* This last one occurred only once, but the occasion was memorable. In 2012, when I was writing a profile of Eve for *Vanity Fair*, I brought up Joan. Eve said, "Joan and I connected. The drugs she was on, I was on. She looks like she'd take downers, but really she's a Hells Angel girl, white trash." (Speed, in case you're wondering, is the drug Eve's referring to.) Years later, in 2020, Eve and I were talking—casually, not on the record—and the conversation turned to Joan. I repeated her line about Joan and white-trash drugs. She said, "That was one of my weird comments that should be ignored. Joan wasn't a white-trash girl. She had Spode china. Who could have Spode china and be white trash?" I asked if the speed part of her comment should be ignored, or just the white-trash part. She gave a one-shouldered shrug: whatever.

was twenty, she would've had a chance. Joan dragged her there too late [in 1996]."

The thought of Hazelden must've triggered Eve's memory because she then jolted the conversation onto another track: the AA meeting on Rodeo Drive. And at the AA meeting on Rodeo Drive was where we spent the rest of the call. (To note: Eve is probably right about alcoholism killing Quintana. Though the words "acute pancreatitis" never appear in *Blue Nights*, that's what Quintana died of. The leading cause of acute pancreatitis: alcoholism.)

For another example: one morning, also in 2015, Eve and I were standing at the entrance of the West Hollywood Whole Foods, waiting for Mirandi, who'd run inside to pick up a few items for Eve. I was filling in Eve on my dinner the night before with Bret Easton Ellis. Ellis had told me that in 1991, when *American Psycho* became the subject of bitter controversy—his publisher dumping him, the National Organization for Women boycotting him, the *New York Times* shooting rounds of arrows at the target on his back—Joan remained steadfast. She even co-dedicated her 1992 collection *After Henry* to him, a public show of support.

"It was generous of her, loyal," I said. "It sounds like she was almost motherly with Bret. Maybe because he was a college friend of Quintana's."

Eve began digging in her purse for a vape pen. "Too many people died on her watch," she said, without looking up.

I was stunned. I just stood there, staring, my mouth open, catching flies. Didn't snap out of it until Mirandi tapped my arm, asked me to help her with the grocery bags.

For a final example: in the spring of 2016, I published in *Vanity Fair* a feature on Joan's L.A. years. I knew that Joan was a can of worms for Eve. Not wanting to open it, I said nothing to her about the piece. The chances that she'd see it or hear about it seemed hearteningly small. She went out so rarely, spoke to so few.

The issue hit stands. Days later, my cell rang, Eve's name lighting up the screen. (She almost never called me. Usually when she had the urge to talk, she'd call Mirandi, tell Mirandi to tell me to call her.)

I pressed ACCEPT, a tight ball of dread forming in the pit of my stomach.

In the piece, I'd given Joan her proper due. ("Sentence for sentence, among the best [writers] this country's ever produced.") But I'd also given

Joan what could be perceived as a hard time. (I'd called her a figure of morbidity and destruction. Not, in my view, an insult, though that's how some might take it.) Did Eve, I wondered, think I'd given Joan too hard a time? Was she angry with me? How angry?

I was about to stammer out a greeting. But before I could, she crowed, "Lili, you did it, you killed Joan Didion. I'm so happy somebody killed her at last and it didn't have to be me."

To be clear: I did not kill Joan Didion. I could not kill Joan Didion. No one could. She's too good. That, though, isn't the point. The point is that Eve was overjoyed because she *believed* I'd killed Joan Didion.

"Does anybody know you killed Joan?" she asked.

Not a question that required an answer, so I didn't give one.

"I mean," she said, "anybody besides me?"

Or maybe it was a question that required an answer. I still didn't give one. That my piece evoked in her delight was gratifying, obviously. Her delight, though, struck me as excessive, berserk even. It was as if the piece had released a lifetime's worth of bottled-up energies and emotions. So while I was gratified, I was also confused. A little frightened, too.

After a few minutes, Eve's feelings shrank back down. Only then was I able to hold up my end of the conversation.

An uneasiness is starting to come over me. A guilt, as well, because I think I'm distorting reality. My reports on what Eve said and did are accurate, and yet somehow wrong. I'm not conveying the full light-to-dark spectrum of her feelings about Joan. Am conveying dark-to-darker only.

Most of Eve's memories of Joan were affectionate, not agonized. When I asked her how often she went to Joan and Dunne's house, she responded, "Any time I was invited." She told me, without jealousy or rancor, that Dan Wakefield and Earl McGrath, two men she was in love with, were in love with Joan, adding, unprompted, "I loved Joan, too." And of Joan's work, she remarked, "I love her nonfiction." And then, parenthetically, "I can't really stand fiction anyway, basically," a bit of gallantry on her part, saying, in essence, that the fault for her not liking Joan's novels lay with her instead of the novels. She continued: "The first piece I read by Joan, I was standing in line at Ralph's, reading *Life* magazine. She wrote that

she'd just gone to Hawaii in lieu of divorce. I thought that was the funniest thing I'd ever heard."*

Now, I won't even try to pretend to be a disinterested party here. I've picked my side: Eve's. A no-brainer since I'm crazy for Eve, love her with a fan's unreasoning abandon. Besides, Joan is somebody I naturally root against: I respect her work rather than like it; find her persona—part princess, part wet blanket—tough going; and resent her for siccing on us, the innocent reading public, an army, seemingly unending, of middle-class young-women personal essayists who take their feelings very ultra-seriously and expect us to do the same. (Joan's too-delicate-for-this-cruel-world sensibility is easy to imitate. Her style—durable, intrepid, audacious; in other words, not in the least delicate—isn't. These imposters are Joan without the eternal glitter of that diamond-hard prose. They're just princesses, just wet blankets.)

Still, I realize that Eve is the one to blame for the breakdown in their relations. She became, during the process of writing *Eve's Hollywood*, impossible. Her behavior toward Joan wasn't bad, it was—oh, my—god-awful. Joan was extending herself in a major way for Eve, and Eve repaid her by acting the ungrateful little bitch par excellence.

I fired Joan.

What I imagine was going on between Joan and Eve is this:

Joan and Eve weren't each other's opposite selves so much as each other's shadow selves. Eve was what Joan both feared becoming and longed to become: an inspired amateur. (Why would there be fear if there wasn't also longing?) An amateur not as in someone who is unskilled or inexperienced. An amateur as in someone who is innocent as opposed to calculating; someone who believes in messy and rough, distrusts polished and well-crafted; someone who does a thing only for love or fun, never for money or recognition. And Joan was what Eve both feared becoming and longed to become: a fierce professional. (Why would there be fear if there wasn't also longing?) Just as marriage was, to Eve's way of thinking, hostile

* Proof that Eve was as taken by the piece as she claimed: In one of the boxes was a scrapbook from 1969. Pasted in the scrapbook's pages, a torn-out copy of "A Problem of Making Connections," what the in-lieu-of-filing-for-divorce piece was called when it appeared in *Life*. (It would be given a different title—"In the Islands"—later on.)

to love, i.e., passion uncorrupted by worldly motive; so professionalism was, to Eve's way of thinking, hostile to art, i.e., passion uncorrupted by worldly motive.

Joan was, as a person, diminutive. Not just short, slight. That was a matter of genetics and body type, of course. But also, I suspect, choice. There was an overwrought quality to her thinness, almost a hysteria. She had no flesh, allowed herself no flesh. *Run River*'s Lily Knight McClellan, the Joan stand-in, is described thusly: "No one had ever called [Lily Knight McClellan] beautiful, but there had been about her a compelling fragility, the illusion not only of her bones but of her eyes . . . They seemed larger than anything else about her, making her very presence, like that of someone on a hunger strike, a kind of emotional claim." And then there's *A Book of Common Prayer*'s Joan stand-in, Charlotte Douglas: "It would have been hard to overlook Charlotte Douglas anywhere. There was the extreme and volatile thinness of the woman."

Another reason to think Joan's emaciation was deliberate: she was, by all accounts, a wonderful cook. From Eve's journal, entry dated December 25, 1969, "Went to the Dunns last night for their Christmas Eve party . . . Mrs. Dunn made chicken breasts stuffed with wild rice, creamed artichoke hearts, watercress salad, spiced peaches, and an incredible dessert with little chocolate cookies and some caramel cream custard that just blew everyone's mind." Yet how much of this delicious food could Joan, tipping the scales at ninety pounds, have consumed? Control, evidently, tasted better to her. "Joan once told me that she stopped eating for the first time when her father went away to war," said Susanna Moore. "I thought to myself, 'Gosh, what were the other times?'"

And her sentences were every bit as taut, every bit as spare, as her figure. As a writer, she was driven, disciplined, persevering, precise. Disorder or excess in the work wasn't to be tolerated since tolerance might lead to a softening of potency, a plumpening of will. To, in short, feminization. (It's a point I keep coming back to: Joan's horror of girl stuff.)

In contrast, Eve, as a person, was totally at one with what her senses wanted; that is, was a sensualist. And consuming—overconsuming—delicious food was an impulse she was forever trying to curb. (Just about every entry in her journal contains an exhortation to reduce. March 20, 1970:

"Well, I haven't lost the weight and it is a crummy bore but now I've got to before my 27th birthday." Or, when she did reduce, to stay reduced. May 1, 1970: "I do exercises every day. I run and run and bend and pull . . . My ass is still the worst one there is but it's much better than before.")

What else Eve was as a person: a free spirit, refusing to let the chains that shackle anywhere near her. And as a writer, she was likewise—splendidly deft at catching her thoughts and putting them on paper before they turned perfunctory or stale. At least, that's what she was at her best as a writer, when she whipped off a marvel like "The Sheik" in two days.

But at her worst—both as a person and as a writer—she was disheveled, indulgent, blowsy, and not quite fresh. Which is to say, bad in a way that could be construed as specifically female. And the pieces she submitted to Joan and Dunne sound as if they were that sort of bad. Joan was, unsurprisingly, appalled. (You can imagine her disgust as she uttered her verdict—"sloppy"—the look of disbelief and betrayal on her fine-boned face as she handed back between pincered fingers the offending pages.*)

Yet Eve needed to risk sloppiness. Had to stay loose, resist the urge to tidy or trim, tamp down or cover up, suppress or restrict in any way those anarchic instincts. She knew this. Joan, though, made her question what she knew. In part, I think, because she admired Joan in spite of herself. She wanted to reject Joan. Did, at some level, reject Joan as a person. ("A fool and a jerk," she calls Lady Dana.) But she couldn't reject Joan as a writer.

Eve even tried to follow Joan's example, buckling down and working on her book dutifully, diligently. *That* was the problem, *that* was where she misstepped. What gave her writing its verve and sheen was its lack of inhibition. And now, suddenly, it was inhibited, and therefore, no good.

* I can't help but sympathize with Joan here. Reading Eve's letters—wonderful as they are, rich as they are, as full of feeling and intelligence and inspired turns of phrase—is, for me, a semi-excruciating experience. I get a headache after a while because I want so badly to take a red pen to them, strike the repetitions and surpluses, correct the spelling and punctuation. In fact, I often *did* take a red pen. For example, the quote I used to open Part One, the quote about gossip, was edited. No words were altered or added. A number, however, were killed. Plus, I changed a period to a question mark, slapped accent marks over "spécialité" in "spécialité de ma maison," and got rid of a couple unneeded scare quotes. My headache cleared instantly.

"The unreadable stuff I'd written under the influence of seriousness," is how she described it in "The Luau."

She had to get out from under the influence of seriousness. By which I mean, out from under the influence of Joan. Firing Joan was, in many ways, her most daring act—a violent assertion of self. Justifiably violent, in her mind. Eve felt Joan was trying to murder her, and so she murdered Joan first: self-defense, plain and simple.

All at once, she could write again. From "The Luau":

> I got up the next morning with a hangover and a good idea for a story. The story was written quickly and fell together like a just right deck of cards being shuffled . . . But now that I'd disposed of Lady Dana, naturally that would happen.

Earlier I compared Eve to a clean-eyed, coldhearted child. But with Joan, Eve took on a different identity: surly-lipped teenager. Yes, we've arrived at the moment in the Joan-Eve story where things get—and please excuse me while I blow the dust off this antique buzzword—Freudian.

Eve regarded her mother and father as superb and without flaw. She didn't just love them, she venerated them: Mae, feminine warmth and charm personified; Sol, a tad distant and chilly, as befitted a genius. How could she defy parents as knowing and cosmopolitan as hers? She couldn't. She never broke from them. Never left home either. Besides that one year in New York when she was twenty-four, a few months in San Francisco when she was twenty-nine, she lived in the family house or in an offshoot of the family house or down the block from the family house until there was no family house. (Only at the age of fifty-eight, when Mae was in a nursing facility, Sol in his grave, did she strike out on her own.)

Still, Eve needed, as every girl needs, a mother to challenge and combat in order to grow up, become a woman. Needed, in brief, a Bad Mommy. It was a thankless role, and one Joan was too young to play (she and Eve were, after all, only nine years apart), but Eve cast her anyway.

Joan was the maternal figure Eve had zero trouble rebelling against. And family psychodrama explains, I think, why Eve turned on her with such ferocity. Eve was acting out, behaving in the exasperating and unlovable manner so typical of pubescent girls with their mothers. Joan didn't do

anything wrong except she did everything wrong because whatever she did was wrong as far as Eve was concerned. "Eve began to back away and then backbite Joan," Paul told me. "Joan took on quite a bit with having Eve as her errant daughter."

She sure did.

Hey, Joan, is that the blue you're using?

CHAPTER 14

Back to the Sea

The movie version of *Play It as It Lays* was, as I already noted, surf's-up for Joan and Dunne. It was, unquestionably, their best shot at catching the Hollywood New Wave, and it was, also unquestionably, a wipeout.

Another Hollywood New Wave, though, would come along.

Before *Vegas* was published, Dunne slipped a few chapters to his neighbor, Julia Phillips. Julia, with husband Michael and partner Tony Bill, had produced *The Sting*, the second-highest-grossing movie of 1973 and the winner of Best Picture at the 1974 Academy Awards, making her both New Wave Hollywood and Establishment Hollywood.

From her memoir, *You'll Never Eat Lunch in This Town Again*:

> John Dunne gives me forty-three pages of something he is calling *Vegas*.
> It starts with a three-page rundown on all the facts about *Vegas*: churches, schools, population, on and on and on. On the fourth page, the book finally begins with the sentence: "In the summer of my nervous breakdown I went to Las Vegas, Clark County, Nevada." From there on I am riveted . . . I ask for a free run to set it up and he gives it to me. I start to look for a writer. Nothing in life comes for free.

Julia approached Paul Schrader, a friend of Joan and Dunne's. "I was actually much closer with John," said Schrader. "I liked Joan well enough, but John was a bit of a roustabout and Joan wasn't." Not that Schrader

didn't have a keen appreciation of Joan. "Back then I had an idea for an article called 'I Wish They All Could Be California Girls,' about Susan Sontag, Joan Didion, and Pauline Kael. All three had a similar kind of energy, a smart, go-getter kind of energy that was an influence on me. And I thought I'd write about them as this West Coast female intellectual phenomenon. I proposed it to each of them, and each hated it more than the last." A wave of laughter broke over him. "So that"—he laughed again—"was that."

That was that for *Vegas* the movie, too. "I was supposed to do the script for *Vegas*," said Schrader. "I wanted to do the script for *Vegas*. Julia wanted me to do the script for *Vegas*. But it never proceeded to deal status." The fault of Dunne, according to Julia. "*Vegas* blows because no matter how good a [deal my lawyer] gets him, John Dunne isn't satisfied."

Julia, Michael, and Schrader would move on to that paean to paranoia—and New Wave Hollywood classic—*Taxi Driver* (1976). Too bad for Joan and Dunne. Julia and Michael Phillips were producers with timing and taste. And Schrader, like Peckinpah, was a key figure of the moment and milieu, plus an artist.

Schrader had a guess as to why Joan and Dunne were so conflicted about their movie work. "They wanted to be successful screenwriters first and they wanted to be serious novelists first. That gets a little messy. You run into the whole problem of, 'I've got to be a big-money screenwriter, but I need to be thought of as a serious novelist.' It was the same thing with Gore Vidal. Vidal loved writing for the movies, loved getting those checks. But if you ever suggested to him that he was a screenwriter, he'd take umbrage. Still, Joan, John, Vidal—they all aspired to play the Hollywood game."

Joan and Dunne were playing that game for keeps. They were inveterate party-givers, the ones in Trancas considerably tonier than the ones at Franklin Avenue had been. Writer Sara Davidson recalled a farewell party they gave for documentary-maker Peter Davis in 1974, how A-list the guest list: *Who's Afraid of Virginia Woolf?* star George Segal, *Five Easy Pieces* director Bob Rafelson, *Easy Rider* producer Bert Schneider, and Warren Beatty, then shooting *Shampoo*, about to shoot *The Fortune*. (Beatty, his wandering eye still fixed on Joan, pumped Davidson for details on the back massage she'd administered to Joan earlier in the day.) They were also

inveterate partygoers. "They wouldn't miss a party," said Josh Greenfeld. "They could do four in a night—come, see what had to be seen, go. Buck [Henry] had this picture of John. He'd just broken his arm. It was in a cast. But he was *still* going to a party."

Joan and Dunne were playing another game for keeps, as well: the literary. Don Bachardy remembered their ardent pursuit of Christopher Isherwood, then the big kahuna of belles-lettres L.A. "They were both highly ambitious," said Bachardy. "And Chris was a rung on the ladder they were climbing. I don't like to tell on Chris, but he wasn't very fond of either of them. I think he found her clammy." (Isherwood already told on himself. He called them "Mrs. Misery and Mr. Know-All" in his diaries.)

Isherwood wouldn't let them into his coterie of writers, so they made their own. Part of it: Irish novelist Brian Moore, who'd been in L.A. since writing *Torn Curtain* (1966) for Hitchcock; playwright Josh Greenfeld, who'd co-write *Harry and Tonto* (1974) with director Paul Mazursky; and journalist Barry Farrell, with whom Joan shared her column at *Life*. "The Dunnes had this party and Joan's editor Henry Robbins was there," said Greenfeld. "And Henry turned to me and said, 'How can you live out here? Don't you miss the literary life of New York?' And I said, 'Look, Trancas is great. I'm here. The Dunnes are here. Barry is here. Brian is here, and Brian always has some European writer or poet staying with him. That's enough literary life for me.' And it was."

Eve was either not interested in joining this coterie or not invited to join. I suspect the latter. Brian Moore's wife, Jean, recalled running into Eve in Trancas. "Brian and I were introduced to Eve Babitz by Joan. Eve was unsmiling and apparently not too pleased to meet us. The Dunnes and Earl occasionally mentioned her, but with little 'knowing' smiles. I interpreted that as a joke no one chose to explain."

Eve had to have seen those smiles—or intuited them—doubtless the reason she couldn't muster one of her own. She was too dazed and deceived to charm. At what point, I wonder, did she become for Joan an object of ridicule? There's no way of knowing exactly. But there may be a way of knowing approximately.

First, though, an abbreviated timeline of the Joan-Eve friendship from Joan's perspective:

What Joan must've experienced when she and Eve discovered each other in 1967 was the shock of the new. Eve was unlike anyone she'd ever met before. Eve, Joan sensed, was powerfully talented and had something inside her that was far freer than anything inside Joan. There was nothing middle-class about Eve, nothing scholarly or clerical. She was an artist in the grand and romantic style. And she existed in a state of extremity, of disreputability. Her wit was sordid and stupendous, her temperament odd and delightful. She had a radical turn of mind; also, sexual valor. (Joan, having slept with two men in her entire life, the second man an extension of the first, placed, I should imagine, a high premium on sexual valor.) Eve no-thought grabbed what she wanted and didn't let go. Joan, who stayed so carefully within her limits, whose nature was to wait and watch, had to have been dazzled, excited, maybe even a little intimidated.

In a 1977 interview with the *Paris Review*, Joan said this:

When I was starting to write—in the late fifties, early sixties—there was a kind of social tradition in which male novelists could operate. Hard drinkers, bad livers. Wives, wars, big fish, Africa, Paris, no second acts. A man who wrote novels had a role in the world, and he could play that role and do whatever he wanted behind it. A woman who wrote novels had no particular role. Women who wrote novels were quite often perceived as invalids. Carson McCullers, Jane Bowles . . . Novels by women tended to be described, even by their publishers, as sensitive. I'm not sure this is so true anymore, but it certainly was at the time, and I didn't much like it.

Didn't much like it yet acquiesced to it totally. The role Joan created for herself, operated behind, was that of an invalid. One of her most brilliant pieces, one of her most characteristic pieces, was, after all, "Migraine," written for the *Saturday Evening Post*. (Joan's original twist on the old theme: to make being an invalid glamorous, seductive. "In Bed" is what she'd retitle the piece when she included it in a collection.) Eve, though, with her drinking and drugging, fucking and fighting, outrageousness and bite, appeared to offer up an alternative role, that of an invalid's inverse. (Eve's original twist on a new theme: to make being an invalid's inverse glamorous, seductive. She'd write, "My skin is so healthy it radiates its own kind of moral laws; people simply cannot resist being attracted to what looks like pure health.")

In an earlier chapter, I observed that Eve would've looked to Joan as a model and guide, a person who'd worked out the problem of being a woman artist. Still, it isn't unthinkable that Joan was looking to Eve for those same things, for that same reason. In '67, Joan and Eve weren't so far apart, really.

Weren't so far apart in terms of their psychologies. Both were leery of groups and solidarities, of feminism in particular. Eve, as is evident from her reference to *Menstruation Bathroom* creator Judy Chicago in the letter to Robert Doty, found feminism obvious and corny. (*Blood-soaked feminine-hygiene products as a metaphor for the female condition? Yikes! Say no more!*) She also found it damaging and destructive. It robbed women of their mystery. Robbed women of their power, in short.

Weren't so far apart in terms of where they were in their careers, either. Joan was a promising novelist, an accomplished magazine writer; but Eve was Stravinsky's goddaughter, Duchamp's nude, Morrison's consort, and the album-cover designer for a band whose songs were being played everywhere, by everyone. ("Earl fell in love with Buffalo Springfield the minute they came out," said Eve. "He played their album all day long.") And Eve must've retained her luster for Joan even as Joan surpassed her in starriness.

Retained her luster until 1973, anyway. 1973, the year she and Joan reached the end stages of the *Eve's Hollywood* editing process. 1973, the year she became for Joan a figure of fun.* 1973, the year goodwill was injected with poison.

Mutual disenchantment set in. Where Eve once seemed wild and inspired to Joan, she now seemed slack and slothful. Where Joan once seemed meticulous and masterly to Eve, she now seemed dogged and doctrinaire. The rupture was, of course, a deeper one for Eve. Joan, she felt, posed an existential threat to her as an artist.

* How I dated Eve's figure-of-fun-ness, in case you're interested: Brian and Jean Moore weren't the only ones who ran into Joan and Eve in Trancas. Michael Phillips did, too. He couldn't remember when specifically, but it had to have been sometime between the spring of 1972 (he and Julia moved to Trancas in March '72) and the summer of 1974 (he and Julia broke up in August '74). Joan was extending a helping hand to Eve in 1972, so it's unlikely Joan, that same year, was stabbing Eve in the back. And *Eve's Hollywood*, containing the vicious portrait of Joan in "The Luau," was released in 1974, so it's unlikely Joan, that same year, was seeking Eve's company. What year does that leave? 1973. Voilà.

Though perhaps it wasn't deeper for Eve. Perhaps Eve was as existentially threatening to Joan as Joan was to her. Not to Joan the artist. To Joan the person.

Friendship is, at its most basic level, an act of imaginative sympathy. It means seeing the world through the other person's eyes. Eve was a concupiscent creature. She believed in physicality and sexuality, in passion as a ruling passion. And if that was the lens you used when looking at Joan and Dunne's marriage—well, they didn't have one. So, Joan had to make a decision: Dunne or Eve? And that decision had to be snap since relations between her and Dunne were crumbling fast, might already have deteriorated beyond repair.

She chose Dunne.

Not unrelated: it was in 1973, you'll recall, that Joan started working on *A Book of Common Prayer*, the book that would cause her split with Noel Parmentel.

Not unrelated either: it was in 1973, you'll also recall, that Joan wrote for the *New York Review of Books* "Hollywood: Having Fun," though "Joan's Hollywood" would've been the more apt title. And Joan's Hollywood had—surprise, surprise—a lot less sex in it than Eve's. The piece, which reads like a coded letter to Dunne, contains a passage about Hollywood's libido, barely there, according to Joan:

> Flirtations between men and women, like drinks after dinner, remain largely the luxury of character actors out from New York, one-shot writers, reviewers being courted by Industry people, and others who do not understand the *mise* of the local *scene* . . . There is in Hollywood, as in all cultures in which gambling is the central activity, a lowered sexual energy.

And what little sex there was was, in the main, homosexual sex because a lover of the same gender didn't imperil a marriage the way a lover of the opposite did. Or so said Joan:

> This is a community whose notable excesses include virtually none of the flesh or spirit: heterosexual adultery is less easily tolerated than respectably

settled homosexual marriage or well-managed liaisons between middle-aged women. "A nice lesbian relationship, the most common thing in the world," I recalled Otto Preminger insisting when my husband and I expressed doubt that the heroine of the Preminger picture we were writing should have one. "Very easy to arrange, does not threaten the marriage."

We tell ourselves stories in order to live indeed.

CHAPTER 15

In Every Young Man's Life . . .

Eve's Hollywood was released in March 1974.

The book is a series of autobiographical sketches arranged more or less chronologically. A loose memoir is what I would call it. "The history of an adventuress," is what Eve did call it. *Eve's Hollywood* is not a mature or disciplined work. You'll notice, every so often, a slight strain in the prose, the odd patch of tangled grammar. Certain pieces, you don't know what they're doing there, and none reach the level of "The Sheik," the collection's high-water mark. And yet, riffs that surprise and delight abound.

For example, Eve on watching her classmates dance the Choke in the gymnasium of Le Conte Junior High:

> The Pachucos were what we called kids who spoke with Mexican accents whether they were Mexican or not and who lived real lives . . . They'd been expelled from school for carrying knives, they stole cars, fought, and their style of dance, the Choke, was so abandoned in elegance it made you limp with envy . . . The Choke looked like a completely Apache, deadly version of the jitterbug only you never thought of the jitterbug when you watched kids doing the Choke. There was no swing in the Choke . . . It was Pachuco, police-record, L.A. flamenco dancing.

Or Eve on vamping at the bar of the Garden of Allah hotel with her friend Holly, called Sally:

212

[Sally and I] were in Café Society at night and school in the daytime. We were both virgins, too, as we drank in the Garden of Allah bar with fake IDs . . . We had no more business suddenly finding ourselves in [this] jaded, fast world than we did on the freeway on foot. Things whihhissshed past us dangerously.

And then there's the book's most surprising and delightful riff of all, which isn't, properly speaking, a riff or even in the book qua book; is in the book's dedication (more on that dedication in a moment):

And to the Didion-Dunnes for having to be who I'm not.

A line that is, on first reading, a butter-up of Joan; on second reading, a put-down of Joan; on every reading thereafter, either or both, depending on your frame of mind. (FYI: I'm ignoring Dunne on purpose here because he failed to capture Eve's imagination—"I don't like the way [he] writes," she noted in her journal, entry dated January 13, 1970—and I suspect she only lumped him and Joan together to needle Joan.)

Eve's Hollywood, overstuffed as it is, doesn't seem soft or flabby, but rather baby-fat voluptuous, the extra weight appealing, giving you something to grab, to squeeze, to pinch. If the book has a flaw—non-niggling, I mean—it's connected to identity: L.A.'s and Eve's, one and the same in her view.

Eve takes L.A. personally. And that New Yorkers think they have the right to look down their noses at it galls. She defends her city as she'd never defend herself. Though that's really what she's doing when she squares off against the "stupid asshole creep[s]" and "provincial dope[s]" who miss the "true secrets of Los Angeles [that] flourish everywhere" because they're so determined to believe that something with obvious superficial charms cannot also possess subtle deep ones. In fact, Eve, with the title of her opening piece, "Daughters of the Wasteland," is alluding to that classic New York knock on L.A. ("cultural wasteland"), as well as to Joan ("Notes from a Native Daughter" is among the better-known pieces in *Slouching Towards Bethlehem*). All she has to do to repudiate the wasteland charge is

list the people who walked through the front door of her childhood home: Stravinsky, Schoenberg, Dahl, et al.

So, Eve's parents and the friends of Eve's parents confer legitimacy on L.A. Who, though, would confer it on Eve? She could confer it on herself, of course, sheerly through the force and freshness of her voice and sensibility and observations. Only she doesn't trust these things yet, believe they're enough to compel attention.

Which is why the cover photo taken by Annie Leibovitz: Eve in a white boa and black bikini, face in movie-star profile, cleavage deeper than the San Fernando Valley.

Which is why the blurb on the inside flap that could be the tagline for an exploitation picture: "In every young man's life there is an Eve Babitz. It is usually Eve." Earl McGrath's words, but Eve didn't know this at the time, so attributed them to "Anonymous." ("They won't tell me who said that though I've begged and pleaded," she told Walter Hopps in a 1972 letter.)

And which is why the name-dropping, incessant and unremitting. The dedication page is, in my first-edition copy, eight pages. Eve thanks the greats currently in her life: Ahmet Ertegun ("the record company president of my choice"), Stephen Stills

Eve in starlet mode for the cover of Eve's Hollywood, *shot by Annie Leibovitz.*

("[for] letting me do the art part"), and Steve Martin ("the car"). The greats formerly in her life: Marcel Duchamp ("who beat me at his own game"), Jim Morrison ("running guns on Rimbaud's footsteps"), and Joseph Cornell ("A Real Artist"). The greats she wishes were in her life: Paul Butterfield ("over yonder's wall"), Andy Warhol ("who I'd do anything for if only [he'd] pay"), and Pauline Kael ("who we discovered on KPFA and whose sentences don't parse either"). The style is ultra-insider: half Oscar acceptance speech, half yearbook inscription–ese, and entirely unintelligible to the average reader.

I'll decode for you.

The car is a 1965 VW, a present to Eve from Steve Martin. (It's the one that broke down while she was living in San Francisco with Grover Lewis.) "Linda Ronstadt was his girlfriend and I was his girlfriend and we were both doing him wrong," she said.

Joseph Cornell was Eve's other certified-genius pen pal. "I wrote him a letter after I went to that show in New York with Carol [Granison]. He wrote me back asking for a pinup picture. I knew what he meant but I couldn't give him one. I loved him too much. I just wanted to be his fan."

Pauline Kael was the movie critic for KPFA, a listener-supported radio station in Berkeley, before she was the movie critic for the *New Yorker*. "I was die-hard for Pauline. She was in love with movies the way I was in love with L.A. She'd drive everyone crazy with her opinions. But for me it was simple—she was right and everyone else was wrong."

The implicit message of the dedication page is that if Eve's famous friends think she's all right, so should you. She's unsure of herself, and this lack of sureness is why *Eve's Hollywood* takes a while to get going. It's not until "The Choke," the eighth piece, the one about the sexy Pachucos, that she stops trying to throw stardust in the reader's eyes, dazzle or blind. At last, she breaks out of Sol and Mae's social circle, and her own—for her, vicious circles—to talk about her life, how she experiences it, looks at it, jokes about it. The joking is key. "Los Angeles laughter is the most extreme form of American laughter," wrote poet Peter Schjeldahl. "Such laughter is apparently uncaused, childlike, irresponsible, gratuitous[,] a constant eddy of mirth that is the opposite of irony." L.A. laughter is, I'd argue, the soundtrack to *Eve's Hollywood*.

That soundtrack kicks in right around the one-quarter mark. All of a sudden, the book has pace, control, edge, interest. And the stories it's telling become more and more amusing, more and more moving, more and more involving. Become exactly the stories you want to hear.

Eve's Hollywood was mostly ignored by reviewers. That wouldn't have happened, I'm convinced, if Eve had allowed Joan to give it her imprimatur. ("I fired Joan" was thus a double homicide: Eve, with those words, killing Joan, but also whatever chance her book might have had critically.) And

it didn't fly off shelves either. "It sold, like, two copies," said Eve. "I mean, nobody in L.A. read it. Well, except for Larry Dietz."

Larry Dietz, a journalist and editor, a semi-friend of Eve's, wrote about the book for the *Los Angeles Times*. In his assessment, Dietz posits himself as the stern yet loving schoolmaster, Eve as the showoffy little girl in need of a reprimand. He chides her for insufficiently cultivating her gifts: "To deny the full range of [your] talent because you don't want to work on developing it is not only to diminish yourself, but also all of us who could have been enriched by it." And for failing to live up to the shining example set by Joan Didion: "*Play It as It Lays*—a book so cruelly accurate that it made Nathaniel West look like Shecky Greene." (Dietz, incidentally, spells Nathanael N-A-T-H-A-N-I-E-L. Some schoolmaster.) He ends with a direct address to the reader: "If you don't mind some sloppy and self-indulgent writing, you'll be rewarded with four or five chunks of good work."

Dietz's disloyalty irritated Eve but did not surprise her. "The main thing about Larry was that he was a twat," she said.

Still, *Eve's Hollywood*, low sales figures and twat opinions notwithstanding, changed things for her. No longer was she a girl-about-town with a dubious reputation, or an artist with a sideline in rock-'n'-rollers instead of a gallery. She was now a writer with a book to her name.

And with a new identity came a new scene.

CHAPTER 16

The Queen of Ports

By January of 1973, Eve had left Sol and Mae's house. To a friend she wrote, "I was staying with my parents until I was done with the book to 'save money,' but all it did was take the cream energy to try not to imagine how my father would look with an ax through his forehead."

Her new apartment, at 1409¾ Alta Vista, was a stone's throw from her old apartment, at 1406 North Formosa. Not even a stone's throw from Ports, at 7205 Santa Monica.

Ports: technically a restaurant, really a state of mind.

Ports was run by a New York couple, Michaela Livingston, a painter, and her husband, Jock, an actor, mostly stage. Jock, complicated, erudite, bristling, was a high-gear presence. When he was drunk, which he frequently was, he would give customers the heave-ho for reasons known only to himself. And once, according to a longtime patron, he tried to choke the photographer Paul Strick, whose father, the director Joseph Strick, had declined to cast him in the movie version of Jean Genet's *The Balcony*. (He'd won an Obie for his role in the play back in 1960.) Jock, more than anybody else, defined Ports, made it what it was. "[Ports] was, as far as I could see, exactly where I wanted to spend the rest of my life—living in a sort of L.A. Colette novel," wrote Eve. "[Jock] stood there in this tiny Marseille-looking restaurant [and] all I wanted was to become an apprentice."

Eve was at Ports every night, usually holding court at a booth in the back, above which hung a brass plaque engraved with her name. "I have so entangled my life with Ports that they [don't] bother to charge me for food or drink and I'm interior decorating the new room and otherwise inflicting my personality on the place," she told Grover Lewis in a letter.

Ports didn't care whether you liked it or not, doubtless the reason it inspired such fanatic devotion. From famous people in particular. Warren Beatty and Julie Christie would come in for romantic dinners. Robert Redford for business lunches. And Harrison Ford, no longer a mere working actor, on the verge of true movie-stardom, for the bar. (In the early eighties, Joan and Dunne would take Quintana and a friend to a party at Mick Jagger's. "It was on a school night," recalled the friend. "John said we could go to the party, but that we could not, absolutely could not, go to school the next day—that was sort of the deal." Ford, now the lead in two smash-hit franchises—he became Indiana Jones in 1981 with *Raiders of the Lost Ark*—was also a guest. Quintana found herself struck mute in the presence of his overwhelming celebrity. "What's the matter, Quintana?" he said, with a laugh. "Too good to talk to your old carpenter?") Other habitués included: actress-singer Ronee Blakley; singer-songwriter Tom Waits; blues singer and guitarist Bonnie Raitt; TV personality Dave Garroway; actor Ed Begley Jr.; actress Carrie Fisher; director Francis Ford Coppola, who'd set up his studio, Zoetrope, across the street; Steve Martin, often with Bernadette Peters; and the guys from the Eagles, both separately and together.

Ports, though, wasn't strictly famous people. "There were big names at Ports but it wasn't glitzy," said food writer Colman Andrews. "It wasn't like Ma Maison, which was much more movie-star A-list-y. I remember once walking into Ports and seeing Claes Oldenburg, Milton Glaser, and Antonioni, and all at different tables. A friend of mine used to say it was the kind of place where you were always running into people you'd last seen in Tangier. It was eccentrics aplenty."

Also, writers aplenty. Aside from Eve and Colman Andrews, there was Michael Elias, the comedy writer (he'd co-write *The Jerk* with Steve Martin and Carl Gottlieb); Kit Carson, the actor (*David Holzman's Diary*) and screenwriter (*Paris, Texas*); Nick Meyer, the novelist (*The Seven-Per-Cent Solution*); Elisa Leonelli, the photojournalist (for *L'Uomo Vogue* and other Italian publications); Tom Nolan, the biographer (of Ross MacDonald);

Warren Hinckle (former editor of the muckraking political magazine *Ramparts*, current editor of Coppola's newsweekly *City of San Francisco*); and Tina Moore, not a writer herself but the secretary of a writer (Joan) and the sister of a writer (Susanna). (Incidentally, Tina and Susanna Moore would serve as the inspiration for the sisters in Joan's 1984 novel *Democracy*; as the basis for the sisters in Eve's 1993 story "Expensive Regrets.")

Though not Joan and Dunne. "I don't remember seeing Joan or John at Ports ever," said Griffin. "But I sure went. I'd decided I wanted to be an actor and I was in a class taught by this guy my dad knew, Charles Conrad. The porn star Linda Lovelace was also in the class. Now, *Deep Throat* had just come out maybe the year before. Linda had this kind of frizzy hair. And she was wearing a tank top made of netting—like, the netting you use to catch tuna—and her breasts were poking through. So, Charles says, 'Hey, Griffin, why don't you come up and do your scene with Linda? What scene did you bring?' Well, I'd typed out a scene from *Franny and Zooey*—you know, the Salinger novel. I didn't think Linda was really right for the role of my sister, so I said, 'No, no, that's okay.' Charles said, 'Don't be shy. Get up here.' So Linda and I did the scene, and it was pretty terrible. Afterward, she asked me to walk her to her car. So, we're walking on Ventura and there's this huge 1930s Bentley with a driver standing in front in jodhpurs, and the cap, and the whole fucking thing. Linda leans into the car and yells, 'Sammy, there's somebody I want you to meet.' And out steps Sammy Davis Jr. He sort of skimmed my palm and said, "Thanks for being nice to my lady, Griffin, my young man." Anyway, I stopped going to the class after that. But a guy from it brought me to Ports. I just loved it right away. The people there were so deeply groovy. I mean, you could feel that it was a writer's hangout. I'd sit at the bar and order a glass of wine. I was only seventeen or something, but they never asked for my ID. They didn't give a shit. So, I'd drink the wine and write in my notebook and pretend I was Baudelaire. It was great."

Ports was less like a restaurant or bar than a social club. "You could do coke, fuck in the bathroom," said Michael Elias. "There was a piano that this terrific jazz guy, Freddie Redd, used to sit at. Sometimes there'd be performance art, or someone would put on a play. Jock used to get drunk and decide he was going home. He'd toss us the keys and tell us to lock up when we were done. There really wasn't anything else like it in L.A. When

my first wife and I got divorced, it wasn't 'Who gets the Lakers tickets?' It was 'Who gets Ports?' Eve was the queen of it all."

And every queen must have her king.

Before we get to Eve and Eve's quest for a king, though, a little more on the original queen, Eve's mother, Mae, and Mae's quest for a king.

Mae Babitz, born Lily May Laviolette in Crowley, Louisiana, in 1911, was the daughter of a French Cajun teenager, Agnes, and the man who raped Agnes, name unknown, or at least unspoken. Agnes was pressured by the church to marry her rapist, resisted, was excommunicated. She took Lily May and moved to Sour Lake, Texas, pitched a tent beside the oil rigs, and began cooking chili.

The Depression had just started when Lily May finished high school. She went to work for $4 a week at Agnes's hot dog stand. Her days were spent fending off passes from roughnecks and collecting nickel tips in the pink-checked uniform she'd sewn herself. "Mother was so close with Agnes," said Mirandi. "They were only sixteen years apart. Agnes had bad husbands. The worst was Joe Forman. He was a bootlegger and an alcoholic and a wife beater, and he was after Mother since she was very young. And I don't think Mother felt she could leave Agnes with him."

The hell Lily May was trapped in was a particularly American kind: hard luck, hard times, mother love, self-destructive loyalty.

And then, five years later: deliverance. It came in two forms. The first was a priest, who introduced Lily May to a driver headed west, saving her train fare. The second was a gambler on whom Agnes decided to roll the dice. "Charlie Spillars became Agnes's next husband," said Mirandi. "Either he got rid of Joe or Joe just left. Charlie was always losing money but he was an absolute sweetheart. He and Agnes adored each other. And I think that's what finally freed my mother."

Lily May arrived in Hollywood in 1934. She must've blinked her eyes, dried out from the Dust Bowl and the fluorescent Texas sun and the ugly, oil-reeking air. Maybe she also rubbed them because it would be hard to credit what they were seeing: palm trees, the leaves heavy, fleshy, swaying in the soft breeze; slanting, honeyed light spilling densely across the fronts of the red-roofed, Spanish-style buildings, horizontal rather than vertical

and sleepy looking; trolleys moving people unhurriedly to and fro on wide streets that still had long rural stretches, orange groves on either side; and, most thrillingly of all, in the near distance, above Bronson Canyon, on Mount Lee, the HOLLYWOODLAND sign, the site, the year before, of a spectacular suicide, a young woman named Peg Entwistle jumping off the *H* when she failed to become a star. (Lily May had no interest in movies, but she very much did in the other local product, enchantment.) And as she reached for a flower from a gardenia bush, pinned it to her hair, she probably wondered if she wasn't dreaming. Reality here simply wasn't real.

Lily May immediately dropped the "Lily," along with the hayseed accent, and changed "May," a girl-next-door's name, to "Mae," a vamp's name. She'd change her name again when she married Pancho Alliati, headwaiter at Ciro's, the Sunset Strip's most exclusive nightclub. "Pancho was this knockout-looking guy—from Turin, I believe, which is in the northwest part of Italy," said Mirandi. "Valentino lit a fire under a lot of those poor Italian boys. Valentino came to Hollywood, no money, and it happened for him here, you know? And Pancho had a bit of that Valentino look with the slicked back hair. Anyway, he'd trained as a waiter at the best hotels in Switzerland, and was always dressed to the hilt. He was good friends with the actor George Dolenz, father of Micky Dolenz, the lead singer of the Monkees. Pancho and George ran around together, chased women, sometimes with Errol Flynn."

A stylish couple: Mae Babitz and her first husband, Pancho Alliati, at the Santa Anita race track.

So, when Mae met Sol, a not-quite-divorced New York violinist with an unshakable conviction that the Wagnerian style of playing Bach was wronger than wrong and a cute William Powell wink of a mustache, the timing and circumstances weren't as dire as might initially have been supposed. Mae, in this order: got pregnant, left Pancho, converted to Judaism, married Sol. And a scant four months after the wedding, on May 13, 1943, she gave birth to Eve.

Now, Mae was a woman of immense daring. She put it all on the line. Born into the situation she was, poverty and obscurity a near given, she pretty much had to. But she understood the value of what she'd won and never took it for granted. She'd come so close to having no kind of life at all. (She was almost twenty-three when she escaped Sour Lake, twenty-nine when she and Sol went on their first date.) Which is why she saw L.A. for what it was: a heart-stopping blend of blue sky and green pasture and blue-green sea, and virtually untouched. Paradise, in brief.

And she wasn't about to stand idly by while paradise got desecrated.

In 1959, she and Sol and several like-minded friends founded a committee dedicated to rescuing the Watts Towers. (The city had decided that the towers, constructed over a thirty-three-year period by Simon Rodia—a dirt-poor tile setter from Serino, Italy—out of steel, cement, broken bottles, and seashells, were not a wonder and a prime example of Art Brut but an eyesore and a safety hazard.) The committee successfully rallied le tout L.A., and beyond le tout L.A., tout le monde, on behalf of the towers. Philip Johnson, the architect, got involved. As did Carl Sandburg, the poet. And Saul Bass, the graphic designer. Mae, with the help of Vera Stravinsky, even convinced Picasso to sign the petition. In a letter to the Los Angeles Times, she wrote, "History's tallest structure ever built by a single person shall survive intact." And so it did.

Then there was her own art. As a rage for newer, bigger, better swept through L.A. in the fifties, buildings and houses from the turn of the century were being torn down left and right, junked like old movie sets. In their place, bland monstrosities. "Mother used to bump into the man who ran the Cleveland Wrecking Company," recalled Mirandi. "When he got a job, he'd tell her, 'We're going to be at such and such a place in three months.' She'd grab her card table and her folding chair, her pencils and pads, and go. Usually she'd take me and Evie with her. I'd bring my

homework, and Evie would bring a book, and we'd just sort of hang out while she drew. Mother used to say she was trying to stay one step ahead of the wrecking ball."

Mae's sketches of the Hollywood Hotel and the original Los Angeles High School are among the only records of these buildings that exist. And to see her work in its entirety is to see a city that's vanished, a city that isn't a city at all, but a drowsy Spanish outpost, the ghost town called Los Angeles that haunts the sleek, tense, ultramodern urban experience known as L.A.

Eve inherited her mother's eyes even if they were the color and shape of her father's. Eyes that stayed bright, stayed devious. And Eve did for the most beautiful girl at Hollywood High, Rosalind Frank, what Mae did for the Victorians on Figueroa: protected and saved. Eve kept Rosalind out of harm's way; no matter that the wrecking ball of romantic disappointment and drug addiction and ever-lengthening periods of depression had already swung, smashed her to pieces.

Eve was, same as Mae, a preservationist at heart.

In mid-1973, Eve met her new boyfriend, Paul Ruscha, younger brother of her old boyfriend, Ed Ruscha. (Eve is Girlfriend #1 in Ed's *Five 1965 Girlfriends*.) She was still reeling from the one-two punch of Dan Wakefield and Grover Lewis. "Something about our thing has changed my life," she told Lewis in a breakup letter. "Words like 'love' and 'in love' and 'I love you' have ceased to exist—they just aren't there, anywhere—I can hardly even remember what it was like to feel any of those things, though for the whole first 30 years of my life I thought they were true. However, though they may be true, I don't care about them."

She now cared about different kinds of things and, consequently, was looking for a different kind of partner (non-writer/non-editor) and a different kind of relationship (non-marriage). In short, she no longer cared to have what Joan had with Dunne.

"I left Oklahoma City the summer of the Watergate hearings," said Paul. "My relationship with Larry [Wood], the man who owned the restaurant I worked at, had become unbearable after eight years. He'd started fucking his son's friends, and they were just high school kids, and I'd had it. Ed didn't approve of that side of me—the gay side. But he understood what I

was going through in his Ed way because he'd split with his wife, Danna, the year before and was living with Samantha [Eggar, the actress]. So Ed sent for me, and I was glad of the fresh start. I worked for him as an artist's assistant and stayed with Danna."

Paul was with Danna when Danna ran into Eve at Jack's Catch-All, a thrift store on Alvarado. Eve invited Paul over for dinner. They were a couple from then on.

Paul Ruscha, Samantha Eggar, Ed Ruscha.

Paul, like Ed, was artistic. But Paul, unlike Ed, wasn't an artist. Or at least Paul wasn't only an artist, wasn't an artist exclusively and above all else. The isolation, the rigor, the egotism, that's necessary to make art—art, where there's no objective criteria; art, where you can't look to other people for an endorsement or you undercut the authenticity of the work; art, where you must be obsessed, absolutely and utterly consumed, with

getting something great out of yourself—was against Paul's nature. And it became a thing he was content to do on the side. His brother's art would be his primary focus. "Ed's success was quite daunting," said Paul. "He had the burning desire. I just didn't."

And the difference between Ed and Paul was more than temperamental. Where Ed was laconic, solitary, a little aloof—irresistible to women yet low-key about it—Paul was expansive, effusive, out of breath, the life of the party, any party, every party. "At that time, I wore silver contact lenses and a monkey fur coat. There was this actress I knew who got religion. She wanted me to do the Lord's Prayer in calligraphy for her. She told me that if I did the calligraphy, she'd give me the coat, so I did. L.A. then was the Endless Party. Ed would look at me and say, 'Don't you ever stay home?' When I first arrived, we went to events together often. Then I started to notice that he'd ask me if I was going to a certain party, and if I said yes, he didn't come. I always threw myself into the action. I guess he was afraid I'd make a fool of myself and, because we were related, make a fool of him."

Eve and Paul understood each other. There was between them an instinctive sympathy. "Eve could be wonderful in a way no one else could. I regret not saving a letter she wrote me. It was about my color-blindness. In it, she described the colors, what moods went with which. It was sweet and romantic and totally Eve. Much of her chutzpah came from her blind belief in herself, and I fed into it. She was [then] quite hefty. I just likened her to a masterwork odalisque by Rubens. Friends would ask me how I could stay with her when she was obviously so crazy, but I felt she was as exotic as she thought I was. She certainly had the most interesting mind I was ever privy to. And Ed very much approved of her. He loved her for her notoriety, for the Duchamp photo, for the men, for the fact that she wrote as well as she did."

Eve and Paul figured out a way to be together that largely involved being apart. "I spent the night at Eve's once or twice a week," said Paul. He grimaced and then laughed at himself for grimacing. "I could never have lived with her, couldn't have stood the mess. There'd be cat fur—cat fur!—in her food."

It also largely involved people who were neither Eve nor Paul. Eve had other boyfriends, as did Paul; Paul had other girlfriends, as did Eve. "Eve was my main squeeze—that's what she liked me to call her—but I was

hot on the market then." And Eve was maybe even hotter. "Annie was around a lot. [She] and Eve were getting it on. Annie hated me because Eve was into me."

*Eve takes a picture of Annie Leibovitz before
Annie Leibovitz can take a picture of her.*

On the question of Eve's bisexuality, an ambiguous answer. I remember when over lunch one day early in our acquaintance, she brought up Annie Leibovitz, referred to her as an ex. "But, Evie," I said, surprised, "you're straight." And Eve, reaching for a roll, buttering it, replied in that voice of hers, sexy, lazy, insatiable, "Me? I love everybody." From that point on, I assumed she swung equally hard in both directions. And she did sometimes have sex with women. There was Tina Moore. "Oh, yes, Eve had an affair with my sister," said Susanna Moore. "I also have a very beautiful, tall, handsome brother named Rick. And I was in a restaurant with him, and my then husband, Dick [Sylbert, production designer], and other people—maybe Joan and John—and Eve came and sat down at the table, uninvited, and tried to pick him up. Tina thinks I asked her to

leave, which I don't recall doing, but it would explain why she didn't like me." Elisa Leonelli, too. "Eve really was into guys," said Mirandi. "But if the woman's approach was right, Eve could be had. She liked to be come on to in a certain way—aggressively. And that's how it was with Tina and Elisa." Leibovitz, though, was the only sustained female love interest, the only female love interest to make it into the letters.

Paul was able to give Eve the intimacy and distance she required both as a woman and as a woman who wrote. "On Eve's door was a sign that said, 'DON'T KNOCK UNLESS YOU'VE CALLED FIRST.' She always told me she liked me because I knew when to go home. What would usually happen is, we'd go out the night before, and then we'd come back to her place and fuck and fall asleep. In the morning, she'd drop two scoops of coffee in a pan of boiling water and bang the spoon against the side of the pan loudly so I'd wake up. Then she'd thrust the cup of coffee at me and say, 'Okay, I'm going to start writing now.' And I'd say, 'Okay, okay, I'm leaving.' Then she'd say, 'Would you read something first?' And she'd go over to her typewriter and grab some pages. I'd read them, and she'd ask my opinion. If she liked what I had to say, she'd let me stay a little longer. If she didn't, she'd kick me out. And the next time I came over, she'd show me the piece or the chapter again and ask my opinion. So I ended up reading everything she wrote nine or ten times."

Paul was so like Mae in his beauty, fresh and ingenuous; and his charm, unerring and unswerving. Was so like Mae, as well, in his willingness to play second fiddle to another artist. (In Paul's case, two other artists, Ed *and* Eve—double duty.) "My uncle Sol respected my aunt Mae's art, and if she requested time or space, he gave it to her," said Laurie. "But Mae's attitude was that Sol's needs came first and she intuited what they were. He didn't even have to make demands. He just got what he needed, always."

By the way, that Paul was a dead ringer for Mae wasn't lost on anybody in the Babitz family, least of all Mae. A recollection of Laurie's: "When Evie started going with Paul, bringing him around, Mae said, 'I thought it was supposed to be sons who married their mothers.'"

So, if Paul was Mae, who did that make Eve? Why, Sol, of course. (Eve was her mother's daughter, but she was even more her father's.)

"My mother, Tiby, didn't marry until she was twenty-five, which was late in those days," said Laurie, sitting across from me at a table at Astro, a twenty-four-hour coffee shop in Silver Lake. "She said the reason was that she never found a man as amazing as her brother Sol. If we had any religion in my family, it was that Sol was a fucking genius, the smartest guy in the world. There was a time where I sat down and thought, Gee, maybe that wasn't true. But I couldn't face the possibility. I *still* can't. He formed us all." Laurie put down a forkful of eggs, her face opening at the memory. "Mae started drawing, became an artist, because Sol told her she could be. His power and judgment ruled everything. I don't say I started going with Art [Pepper, famed jazz alto saxophonist] because I knew it would make a splash. But it did. I can't think of anyone Sol would have thought was cooler or hipper than Art Pepper. Getting Sol's attention wasn't easy. Evie would say something clever. That got his attention. She started writing, and the writing was good. That got his attention, too." Laurie popped the bite of egg in her mouth, chewed thoughtfully. "Listen, I'm sure Evie, smart a kid as she was, looked at Sol and looked at Mae, saw Mae running around, doing everything to make Sol happy, and thought, Yeah, he's the one I want to be."

Paul wasn't the only important person to enter Eve's life during this period. There was also Erica Spellman, a hotshot agent from ICM in New York. Eve would describe her in 1979 as a "rust-colored fashion plate with a cement voice." The description still held true in 2016 when I met Spellman at a restaurant on Madison Avenue.

"Kit Carson introduced me to Eve," Spellman told me in her cement voice. "When I got to town, he said, 'There's someone you've got to meet.' Eve and I had lunch—at Ports, naturally. She gave me a copy of *Eve's Hollywood*. I read it. I loved it. I called my sister, Vicky [Victoria Wilson, Knopf editor]. I said, 'Vicky, you're not going to believe this woman I met. She's fabulous and she's going to write this amazing book for you.'"

"What did Vicky say back?" I asked.

"Vicky said, 'Okay.'"

Eve's Hymen, Resewn

The amazing book that Eve wrote for Vicky: *Slow Days, Fast Company*, released by Knopf in spring 1977.

Like *Eve's Hollywood*, *Slow Days* is a collection of stories and reminiscences. And it picks up roughly where *Eve's Hollywood* left off: the beginning and end of her romance with Grover Lewis; the beginning and middle of her romance with Paul Ruscha; other romances in between and during. Topics addressed include: near-fame; stupid questions; the politesse of threesomes; the cats, tabby, sleeping on the roof of the patio of the Polo Lounge in the Beverly Hills Hotel; the spinach, creamed, at Musso's; how to properly ingest a Quaalude (circumspectly); what to wear when taking cocaine on acid (a Finnish cotton kaftan). The setting is Hollywood mostly, but not always. Sometimes it's Bakersfield or Palm Springs or Laguna Beach or Dodger Stadium.

The sensibility Eve was groping and blundering her way toward in *Eve's Hollywood* has been hit upon in *Slow Days*, the craft refined, the style perfected. Gone is the superfluity—there are forty-three stories in *Eve's Hollywood*, only ten in *Slow Days*—that teeming, overabundant quality, which aroused and thrilled but also dismayed and exhausted. *Slow Days* is the achieved work, the best book Eve ever wrote. (Without it, she'd be relegated to literary history's honorable mentions.) It is, too, sheerest bliss to read. A casual masterpiece, free-swinging and easygoing.

How to account for the difference between *Eve's Hollywood* and *Slow Days*. It isn't entirely a matter of sexual experience. Almost, though.

Eve's Hollywood, with its boobalicious Annie Leibovitz–shot cover, was Eve throwing herself at the reader. She didn't give the reader a chance to spot her across a crowded room, strike up a conversation, lean imperceptibly closer to get a whiff of her perfume (Le De, Givenchy), or catch the glints of hazel in her eyes (dark brown). Instead, she propositioned the reader quickly, bluntly. This guns-blazing aggression makes her seem not like a woman of the world, the persona she's going for, but like a high school girl, all bravura and bluff, trying to pass for older.

With *Slow Days*, though, Eve has reached maturity. The book, with its understatedly chic cover by Chris Blum—a sly-eyed saluki sitting at a bar with a glass of wine—is adroit, expert, mysterious, wicked. It's infinitely permissive. Infinitely subtle, too. It would no more say, "Read me," than its writer, thirty-four and wise, would say, "Fuck me." Nor is it merely seductive. No, it's a seduction, quite literally, of an unnamed man (I'll name him: Paul Ruscha), and, by extension, us.

Seduction is, in fact, the structure of the book. In the opening piece, Eve writes:

> Since it's impossible to get this one I'm in love with to read anything unless it's about or to him, I'm going to riddle this book with Easter Egg italics so that this time it won't take him two and a half years to read my book like it did the first one . . . Virginia Woolf said that people read fiction the same way they listen to gossip, so if you're reading this at all then you might as well read my private asides written so he'll read it. I have to be extremely funny and wonderful around him just to get his attention at all and it's a shame to let it all go for one person.

Eve is playing with Paul, playing with us, knowing that he—and we—are in her thrall, confident that he—and we—are going to stay there. She's languid, serene, digressive, so totally in control she can abdicate it.

Eve has acquired patience, and, even more critically, restraint. The dedication is five words long: "To Sol and Mae Babitz." And though *Slow Days* is as star-studded as *Eve's Hollywood*, you wouldn't know it. The stars are incognito, Eve bundling them up in trench coats, slipping Groucho Marx glasses on their faces. Nikki Reese-Kroenberg, the socialite wife of a rich and powerful San Francisco man—"[Nikki] understood everything about

clumsily arranged dinner parties, about divorce and hospitals and who sat where"—is based on Jann Wenner's wife, Jane. Gabrielle Rustler, the ingénue whose evil allure hasn't yet translated to the screen—"The trouble was that the men who cast [Gabrielle] thought she was beautiful, so they put her into wistful, dreamy dresses when they should have handed her a whip and got out of the way"—is based on Michelle Phillips. (Gabrielle's best friend Mary—"Gabrielle and Mary were always together, which was odd because Mary knew that most of her friends were not in the mood to see Gabrielle most of the time"—is, of course, based on Anne Marshall.) And Daniel Wiley, the actor-director set to marry Gabrielle—"I first saw Daniel Wiley fifteen years ago at Barney's Beanery . . . and he told me in all seriousness that he wanted women screaming after him in the way they did for the Beatles"—is based on Dennis Hopper.

In short, Eve is writing about stars because she's writing about her life, in which stars just happen to be bit players. She isn't writing about stars because she's trying to validate her writing.

Furthermore, Eve is now letting L.A. fend for itself. Rather than putting up her dukes, as she did in *Eve's Hollywood*, she's shrugging her shoulders. Also from the opening piece:

> People with sound educations and good backgrounds get very pissed off in L.A. "This is not a city," they've always complained. "How dare you people call this place a city!"
>
> They're right. Los Angeles isn't a city. It's a gigantic, sprawling, ongoing studio. Everything is off the record. People don't have time to apologize for its not being a city when their civilized friends suspect them of losing track of the point.

Eve has come to realize that L.A. doesn't require justification and neither does she.

What else Eve has come to realize: that in order to write the novel she wants to write, she has to reinvent the form. Still more from the opening piece:

> I can't get a thread to go through to the end and make a straightforward novel. I can't keep everything in my lap, or stop rising flurries of sudden blind meaning. But perhaps if the details are all put together, a certain

pulse or sense of place will emerge, and the integrity of empty space with occasional figures in the landscape can be understood at leisure and in full, no matter how fast the company.

And, by God, the pulse and sense *do* emerge. And the space *can* be understood. And a novel has been made, even if it's an unstraightforward novel, a novel that looks nothing like a novel. Eve has pulled off the trickiest of feats. She's figured out a way—technically, through this narrative device she's created—to convey her romanticism, her desolation, her irony, her self.

Yet her formal daring is easy to miss, her art so artful it appears artless. The absence of the clanking of plot can make it seem as if there isn't one. Not true. There's the sustained drama of her boredom, her unending orchestrations and machinations, sexual and social and chemical, to keep that boredom at bay. It's just that the style in which she tells her story is so organic as to be invisible.

The handful of pieces that make up *Slow Days*, stand-alones that overlap and reflect on one another, characters surfacing, vanishing, then resurfacing, increase in power and fascination, scope and grandeur, as the book progresses. They're airy without being lightweight, blithe without being scatterbrained. And while they're full of gaiety—Eve has a knack for recognizing and imparting joy, beaming happiness—they're also full of something else. Tune in to *Slow Days'* music and you'll catch the strains of melancholy.

In "Emerald Bay," for example, the Paul character, Shawn, brings Eve to Laguna Beach to stay with his friends, an older married couple, Mason and Jo Marchese (Paul's real-life friends, the older married couple, Aldo and Petey Mazza). At their house, Eve meets Jo's best friend since girlhood, Beth Nanville (Petey's real-life best friend since girlhood, Peg Thorsdale). "[Beth] wore dismal colors always, powder blue and mustard, and I put her into my 'Empty Lady Hanging On' category," writes Eve. She wounds Beth's feelings, unintentionally but avoidably, by adding dressing to a salad that Beth has already dressed. That's the climax of the story—salad dressing—until the very end, which is a kind of coda, and so brief your eye almost skips over it: Eve, back in L.A., gets a call from Shawn. Beth, Shawn says, has killed herself. "I wish, now, that I could remember [Beth's] face or the sound of her voice. But the only things that I really remember

are that she left her children $2,500,000 in her will and when I tasted her lettuce I was sure there was nothing on it."

The tone of "Emerald Bay" is casual, hard. Never does Eve retract or even modify her original assessment of Beth. The piece, though, is, at the same time, drenched in emotion. Eve is proving herself a master of the juxtaposition of mood and action. You have the unceasingly delightful flow of her narrative—her characters, clever, overgrown children, self-centered and self-indulgent, frisking along, in constant pursuit of pleasure—the charming triviality of it all. And then, out of nowhere: a flash of genuine anguish, reality intruding on the artifice, interrupting the fools at their revels. There, right in the middle of that upscale little beach town, the jewel of coastal Southern California, is Death. And suddenly you understand that what looks like a comedy and trifling is actually a tragedy and profound.

Slow Days is alert to the startling abruptness of life, the brutality of it, how harrowing it can be. Which is to say, *Slow Days* is as dark in its vision as *Play It as It Lays*. Unlike *Play It*, though, it's never a downer. *Slow Days*, with its panoramic, kaleidoscopic view not just of Hollywood but of Los Angeles; its utter lack of interest in approving or disapproving of its characters' morals; and its amused, worldly skepticism, is far too tough-minded—and hip—to give in to despair. Sure, there are unhappy women overdosing on Seconal, leaving behind hugely expensive beach cottages and no notes. Yet there are also private bays as green as emeralds until they're as blue as lapis lazulis; parties with guest lists and armed Pinkertons; tulip-like girls in black chiffon dispensing joints. To quote Eve, "Ahhhh, me."

With *Slow Days*, Eve attained that American ideal: Art that stays loose, maintains its cool. Art so purely enjoyable as to be mistaken for simple entertainment. It's a tradition that includes F. Scott Fitzgerald, Duke Ellington, Fred Astaire, Andy Warhol, and, of course, Marilyn Monroe.

The miracle of *Slow Days* wasn't performed in a vacuum.

To write *Eve's Hollywood*, Eve believed that she had to disappear into it, leave the world behind. By *Slow Days*, she knew better, and she wrote it while very much in the world. And once you understand how to look for her, you see her everywhere. She's the laughing, buxom Zelig in the corner of the frame of so many key scenes and happenings in Seventies L.A.

There she is, on the campaign trail with Governor Jerry Brown, running for president in 1976. "Ronee [Blakley] had just gotten nominated for an Academy Award for playing Barbara Jean in *Nashville*," said Eve. "She was warming up crowds for Brown. And Brown told Ronee she could bring someone with her, and she told him that she wasn't going anywhere without me. The whole time I and everybody else was totally stoned on as many drugs as we could get away with."

There she is—well, not her, but her photograph—on the cover of one of the biggest albums of the decade, Linda Ronstadt's *Heart Like a Wheel*. "Linda and I used to try to lose weight together. We did that diet where we ate nothing except citrus fruit. After a week, we were both twelve pounds thinner. That's when I took the picture. She looked so beautiful and pure, like a girl in a French convent."

And there she is, in one of the biggest movies of the decade, Francis Ford Coppola's *The Godfather, Part II*, the Senate hearing scene. (She's sitting at a table to the right of Al Pacino's and Robert Duvall's.) "I wanted to see what it was like being an extra, so I had Fred Roos get me the job," she said. "Fred was Francis's casting director and producer, and sometimes my boyfriend. He must've been my boyfriend when Francis was filming." I asked her how she liked it on set. She sighed. "They had me in this horrible jacket and it was hot, so I took it off. They had to reshoot the whole scene because the shirt I was wearing was polka-dot and polka dots ruin everything."

And though she isn't in the very biggest movie of the decade—*Star Wars*—her handiwork is. "Eve knew Carrie [Fisher] from Ports," said Griffin. "She called Fred Roos and told him, 'You've got to meet this girl for *Star Wars*.' Fred did, and then he called George Lucas and said, 'I've found Princess Leia.' But Lucas thought he'd already found her and was going to cast that actress. I forget which one—was she British? Anyway, Fred forced him to see Carrie and that was it for the other actress, the maybe British one, whoever she was."*

Nor was the miracle of *Slow Days* performed alone.

Providing crucial aid to Eve were the sisters, Erica Spellman and Vicky Wilson. "I think Eve felt, for the first time, like she had protection—me

* It was Amy Irving, an American actress. Though, according to Sheila Weller's biography of Fisher, Irving, in her audition, spoke in a "soft and stately near-English accent." Which could account for Griffin's transatlantic confusion.

and Vicky, ICM and Knopf," said Spellman. "I never considered calling anyone other than Vicky. Knopf has always been the best publisher, and Eve needed credibility. She was seen as this sexy girl who somehow got [Sam] Lawrence to publish her book. A lot of people knew she'd slept with him, which wasn't helping. I wanted her to be thought of as a serious writer, not just as this strange creature floating around L.A." (Sam Lawrence, by the way, didn't try to buy *Slow Days*, though he did try to buy *A Book of Common Prayer*. Joan would politely turn him down.)

Eve needed credibility not just with the publishing industry, but with herself. She'd landed Erica Spellman and Vicky Wilson on her own. Joan had nothing to do with it. A moment of vindication for her, surely.

"What I did was call her up every single Monday morning for a year," said Spellman. "'How's the book coming?' I'd say."

When I asked how Eve responded to supervision, Spellman shrugged—a gesture of amusement or exasperation—and said, "Eve sent me pages. Really, a mess of pages—not organized at all, just pages jumbled together. I mean, I was lucky the pages came in an envelope is how much of a mess."

"And then Vicky took over?"

Spellman nodded. "Vicky helped her get those pages into shape." Deep breath, long exhale. "And that's how Vicky and I dragged *Slow Days, Fast Company* out of her."

Erica, who babied Eve and bullied them that dared fuck with Eve, was the perfect agent for Eve. In a letter to Dan Wakefield, Eve repeats with glee a conversation between Jim Goode, the editor at *Playboy* who'd turned down "The Sheik," and Erica: "In his bright urbane way [Jim] said, 'Ahh, yes, Eve Babitz, I remember her when she was just a collagist. We really would like to use more of her things.' And Erica looked at him with this ingrown sneer she has for all business dealings and said, 'Well I'll tell ya one thing. You ain't gettin' none of her stuff for no lousy $500 like the last time so you can just forget that shit.'"

And Wilson, who had a vision of the book that Eve could write, poked Eve, prodded Eve into writing it, was the perfect editor for Eve. In fact, it's impossible to overstate how perfect.

Eve had understood early on what *Eve's Hollywood* required of her. "I still haven't figured out how I am going to tie all the stories together and make them fit into one single thing so people'll think of it as a book 'book'

BOOK," she told her aunt Leah in a 1972 letter. "But maybe I'll just have to make them think of 'books' as something other than what they're used to. After all, *The Canterbury Tales* [is] not *War and Peace*." What Eve is saying is that for her book to come off, she'd need to find a way to make it in her image. As Chaucer found a way to make *The Canterbury Tales* in his image. As Tolstoy found a way to make *War and Peace* in his image. As any writer who produces a work of wild originality must find a way.

Only she couldn't find a way. Not with *Eve's Hollywood*. Perhaps she could've with Joan's help, but she refused Joan's help.

Wilson's help, however, she would accept. From a letter Wilson sent Eve about *Slow Days*:

> As you can see, I've taken out quite a bit of material. But what I thought the book needed, when I first read it, was, above all else—thinning. There was just too much. Too much of a particular kind of characterizing that in the end detracts from the more subtle texture that you are trying to recreate that makes up L.A. . . . Before I go over each piece separately and tell you what I did and why, and what I think you should do, I just want to go over the Table of Contents, because I've rearranged the order in which the pieces appear. I think the first part of the book, up through HEROINE, is a slow but somewhat direct seduction into the book. It is less atmospheric than the latter part and is sufficiently plotted and directed to make that L.A.-ness accessible. The latter part of the book is the hardcore. The writing gets more sophisticated, it's more tangled, and much more textured . . . I've ended with THE GARDEN [OF ALLAH] piece because I think it's the strongest one in the book and to follow it would be a tough act . . .
>
> Work fast but carefully.

Wilson knew that Eve had the goods but not always. And she was able to separate the first-rate pieces from the second-rate, and then to sequence the first-rate pieces so that they gathered and gained momentum.

What else she was able to do: give Eve, who was magnificently discursive, i.e., couldn't structure if you paid her, if you put a gun to her head, a structure. The brilliant idea of using the wooing of Paul as *Slow Days'* throughline, a means of linking the pieces together, was, according to Eve,

Wilson's. "Vicky made me do that. She said to me, 'This book makes no sense.' I said, 'Oh, really?' She said, 'Make the whole book to Paul.' So I did."

In Wilson, Eve had more than an editor, had an intuitive, stabilizing, gift-from-God collaborator. *Slow Days* was the product of a talent no longer spinning its wheels. All of a sudden, Eve had found the asphalt, was shooting forward.

And then there's Paul, who provided aid every bit as crucial. He was the perfect muse for Eve. "My boyfriend who I love so well is actually coming closer to me than anyone ever has without stepping on my feet," she wrote to a friend. "It's as though we fit together in a marvelous way."

Eve loved how Paul looked: his tall-drink-of-water-ness, the precise opposite of her more-bounce-to-the-ounce-ness. She loved, too, how he conducted himself, his manner: calm, courtly, decorous. The precise opposite of her own: nervy, barnstorming, sensation-seeking. "There was this one time when Eve and I were leaving Ports," said Paul. "Marva Hannon, an old friend of Eve's from, I think, LACC, was walking in. The next thing I know, a catfight's erupted—slaps, pulled hair, feathers flying. I got Eve back to the car and cooled her down. 'What was that about?' I said. And she said, 'Oh, Marva and I are just that way.' Like, no big deal." He laughed, shook his head. "You know, Eve was destructive to herself more than anyone else. That only made me want to save her. I felt she did better when she was with me, that she was less agitated."

With Paul, Eve achieved a kind of balance. His ambivalent sexuality—drawn as he was to both men and women—his ambivalence in general—drifting along with the current, amiably, absently—kept her off-kilter in a way that allowed her to maintain her equilibrium. And she did the same for him. Because without the weight of her emotionalism, her intensity, her breasts and flesh and need, you feel that Paul, so pretty, so passive, so captivatingly noncommittal and gossamer light, would have floated off into the ether, dissolved like a dream in the warm Southern California air.

Slow Days certainly made more of an impression than *Eve's Hollywood*. Knopf put money, muscle, and hoopla behind it, buying half-page ads in major American newspapers, sending Eve on a series of tours and interviews and promotions. Clearly the publishing house believed in it.

As did Eve. "I thought what Knopf thought—that it would sell a million copies," she said. "But nobody read *Slow Days* either." An exaggeration. The book didn't become a blockbuster. It had its fans, though, as Eve knew. "Jackie Kennedy read it. She loved it. She gave people copies of it before they went to L.A."

And *Slow Days* was widely reviewed, including twice in the *New York Times*. The first review—of the hardcover—was a pan. Novelist Julia Whedon surveyed and rejected Eve in three short paragraphs. In the last, Whedon wrote, "I discern in [Babitz] the soul of a columnist, the flair of a caption writer, the sketchy intelligence of a woman stoned on trivia." But the second review—of the paperback—by critic Mel Watkins, was near glowing and twigged to Eve perfectly. "Eve Babitz is philosopher, quidnunc and wit here, and the amalgam makes for a collection that is light enough not only to entertain and flaunt the West Coast glitter but also insightful enough to reveal its somber underside."

Perhaps even more gratifying, though, was the rave in the *San Francisco Examiner* from the much admired short-story writer Alice Adams. Adams likened Eve (the character) to Christopher Isherwood's Sally Bowles and Truman Capote's Holly Golightly, except Eve (the character) was realer than either. Beyond that, she was, wrote Adams, "infinitely more alive than Didion's trendily alienated heroines," a line that must've sent Eve (the writer) into ecstasy.

Eve wrote Adams a thank-you note. She opened with:

As I sit here with your review before me, I can't seem to shake the eerie feeling that all my most immodest daydreams about how wonderful I am have appeared in print, almost as though I'd written them myself, only better written.

She closed with:

The only fly in the sky [as far as *Slow Days* is concerned] is my horrible past when I used to be a piece of ass . . . And now even if I get the Nobel Prize, I've got a whole lot of High Society friends who will forever send me their dirty linen . . . I'm not the Camille type, dying of

TB just because I once sashayed around town in black limousines . . .
I told Joe Heller to start a rumor that I'd [gone] to Switzerland to have
my hymen resewn.

 Love,

 Eve

Even if *Slow Days* didn't top the bestseller list or become a darling of
the East Coast critical establishment, the experience of publication was a
joyous one, and Eve was at peace with it. The experience of publication was
also, however, a miserable one, and it drove Eve to the point of crack-up,
something I never would have known had her mother not saved her *other*
letter to Joseph Heller.

This second letter, written in 1977, is a feminist cri de coeur as *A Room
of One's Own* is a feminist cri de coeur. Is just as reckless, just as careful,
just as brutal, just as exquisite as Woolf's essay. And it is, after *Slow Days*,
the best and most consequential thing Eve ever wrote.

CHAPTER 18

Joan, 1977

Before we get to Eve's other letter to Joseph Heller, a quick check-in with Joan:

Nineteen seventy-seven was an artistic high point for Eve; for Joan, an all-time low. Trancas did indeed have a deadening effect on her creatively, exactly as Eve predicted it would. Movies had given her financial security, but they'd taken away her cultural relevancy. *The Panic in Needle Park* was a respectable effort, nothing more. *Play It as It Lays* was less than that. And she and Dunne got axed from their one hit, the Barbra Streisand vehicle *A Star Is Born*, a tearjerker musical about the marriage of two singers, John Norman Howard and Esther Hoffman, the problems that ensue when her star eclipses his. (Write what you know, as they say.)

"I never see the Dunnes either," Eve told Grover Lewis in a letter. "This horrible thing happened to them where they worked on this damn screenplay for two years only to have it tossed out by Barbra Streisand's hairdresser."*

* I interviewed Jon Peters, Streisand's former lover, co-producer, and, yes, hairdresser, about *A Star Is Born* in his penthouse apartment on the Wilshire corridor in 2015. He wore black silk pajamas and his hair in a silver mane and was very charming and likable. He requested that I hand over the magazine sticking out of my bag so that he could read a page from it aloud, and thus prove that he did know how to read (according to Hollywood rumor, he didn't). I assured him that I required no proof, but that didn't stop him from giving it to me. Peters remembered little about Joan and Dunne's involvement in the movie. He did, however, remember this: "I wanted Elvis to play John Norman Howard. I mean, can you imagine how that would've gone over—Elvis Presley and Barbra Streisand, together? I went to Vegas to meet him. He was

240

A Star Is Born was a remake of a remake of a remake. There'd been a 1932 version with Constance Bennett and Lowell Sherman; a 1937 version with Janet Gaynor and Fredric March; and a 1954 version with Judy Garland and James Mason. It wasn't just not New Hollywood, wasn't even just Old Hollywood, was Dead-and-Buried Hollywood, was Exhumed-Corpse Hollywood.

For Pauline Kael, who'd won the National Book Award in 1974 for *Deeper into Movies*, the very book Dunne had slammed in the *Los Angeles Times*, *A Star Is Born* offered another opportunity to mock Joan, which she did with lip-smacking relish. "The picture has had the worst advance press I can recall," she wrote in the January 19, 1977, issue of the *New Yorker*. "And those who have written pieces exonerating themselves include John Gregory Dunne, who—along with his wife, Joan Didion, and the director, Frank Pierson—gets the screenplay credit." She'd accuse *A Star Is Born* of having "no controlling dramatic intelligence," and of being "slow and slurpy" to boot. In closing, she'd zero in on the most embarrassing scene in a movie that was, in her opinion, nothing but:

> At the end, there's some sort of commemoration service for John Norman [Howard], and Esther is introduced to sing. Here is the spot for Janet Gaynor's and Judy Garland's great mawkish moment: "This is Mrs. Norman Maine." Streisand does a compromise update on it: she's introduced as Esther Hoffman Howard—which is worse.

How could Joan, who made such a fuss about being addressed as "Joan Dunne" or "Joan Didion Dunne," take Kael's criticism any way other than personally?

Joan did manage to publish that year *A Book of Common Prayer*, but response to the novel wasn't what she'd hoped—or come to expect. The reviews were respectful yet unenthused, the sales so-so. In fact, besides alienating Noel Parmentel, *A Book of Common Prayer* made almost no impact at all.

Joan was floundering.

heavy at the time. He didn't sit in a chair, he sat on the floor. And he seemed upset. 'What's wrong?' I said. He said, 'I had a fight with my girlfriend.' I said, 'Oh yeah? Where is she?' He said, 'She's in my 747, circling above Vegas.' 'What?' I said. 'I've had her up there for three hours,' he said. 'I haven't decided whether or not to let the plane land.' He wanted to play the part, but the Colonel made him turn it down. I don't know what happened to the girlfriend."

Spurts

Now for Eve's other letter to Joseph Heller.

It's five pages, single-spaced, with cross-outs and add-ons and multiple postscripts. There's repetition and excess, not to mention digression. Which is why I'm going to do to it what Vicky Wilson did to that early draft of *Slow Days*: thin it out. Clean it up, too, because Eve's punctuation is as free-wheeling and devil-may-care as ever, her spelling the usual alphabet soup.

First, though, a few thoughts on Eve and letters generally.

Letters for Eve served as a kind of workshop. They were a place to try out new material, see if it connected with a reader. And since she wasn't attempting to write deathless prose for publication, was just gossiping with a friend for a page or two—as if gossip of a high order is ever "just"!—the pressure was off. She could relax, let loose, riff unselfconsciously. In other words, her letters, the best of them, anyway, are lasting literary works in large part *because* they were intended as ephemera, their timelessness inextricable from their fleetingness.

Eve, who knew her Proust, certainly knew this line of Comtesse d'Arpajon's: "Have you noticed how often a writer's letters are superior to the rest of his work?" Eve had noticed and her most successful pieces could be letters. Meaning, they have an informal and unrevised air even when composed with art and time and care in the way that a gifted letter-writer's letters do. Also in the way of a gifted letter-writer's letters, they treat real life as fiction. And they convey, in the way that a gifted letter-writer's letters

convey, not just the writer as a person, but the writer as a character; in our writer's case, a relentlessly social creature of splendid sensibility and spirit moving through various elegant and cynical milieus.

Okay, on to Eve's letter to Heller:

Dear Joe,

I am extremely grateful for the quote you gave me [for the paperback edition of *Slow Days*]. They couldn't believe it at Knopf because my God, you don't ever give in, Joe. You're famous for skirting anything quotable. You might even say that after *Catch 22*, your greatest genius lies in circumspect dubiousness.

I must say that every single East Coast person so far who's said anything about *Slow Days* has been loathe to say that my life ought to be lived at all, but if anyone's going to be shameful enough to actually live it, then I'm not that bad a writer to be writing about it. It seems as though if only I were writing about, say, a leper colony or a coal mining town, then it's O.K. to write about something not in London or New York. Only in London and New York are the people allowed to have money and loll around doing nothing. In L.A., no.

In your little quote you say that I make "even the shoddiest characters interesting and attractive, and even the dreariest of relationships fascinating and exciting." But, Joe, I don't think anyone's shoddy and I think all my relationships are fascinating and exciting and I want you to think so too, and you say you do, so isn't that O.K.? I want to know what's wrong with it. Is it that I don't find the dreary situations dreary or the shoddy characters shoddy? I find what other people regard as worthwhile dread prisons and what people usually regard as crummy, I sometimes can't even blink I'm so enchanted. Are my enthusiasms all too shallow for words? Am I on the wrong track so completely that in unison everyone on the East Coast rises up as one and says, "The poor thing's an idiot but . . ."?

This person Vicky sent my book to named Laurie Colwin [*New Yorker* short-story writer] said, "I also think someone should give the author a good spanking if this is the sort of life she actually leads. Although if some jerk lived this way, it would strike me as extremely squalid, Miss Babitz makes it sound extremely romantic." If I can make it sound that way, then maybe Laurie Colwin is wrong, maybe it's not extremely squalid.

Anyway, what's squalid? And as for the wonderful Larry McMurtry, he wrote this review in the *Washington Post* where he's pissed off because I'm not writing right because of "lack of characterization, story and theme." Now, Joe, if I'm doing "lack" of all those things, I mean, what am I writing? I simply don't see how to jam all the old disciplines into stories I'm telling if they don't go in when I'm telling the stories. And if the stories turn out undisciplined and loose and squalid, yet by some magical feat are able to make dreary, sordid people look glamorous and fascinating, how do I do that? Because most books I read nowadays have dreary, sordid people who seem downright dreary and sordid, and the only fascinating thing about them is how the writer could have stuck to it all that time.

See, I can't even put my nose to the typewriter unless my [characters] slink around in platinum lamé pajamas. That's probably my trouble. Even I can see it's a sign of shallowness. Shit. What I want to know is, if I tell everyone about my impending disease—Huntington's, that's the name of it (I'm inheriting it from my grandfather who gave it to my father and I can tell I'm going to get it, I'm the image of my father)—and about my grandma dying of cancer next door and how horrible it is being in love with a man who supposedly prefers men and how ghastly terrible it is watching my mother succumb to everyone dying around her and what a show stopper it is every time my sister gets cunt cancer, then do you think people will like me better?

No. They'll take one look at my tits and think I've got it made and am shallow and don't know what's what about characterization. (Joe, I mean, you've seen me and know I simply can't complain, it wouldn't be fair, stacked the way I am.) I am the character. I keep feeling as though nobody knows about a person like me and that I'm original and that I ought to be explained before anyone lets me out to do book reviews or otherwise prance forth into the public arena. I mean, what if some poor author on the East Coast heard me sneer at how square and musty he or she is, and the poor author took it personal without knowing about the promiscuous fox coming in from the beach to toss off the review before returning, once more, to her shallow life.

One of the things I'm starting to think about is that serious people just don't think that gossip, the spécialité de ma maison, is serious. It's always been regarded as some devious woman's trick, some shallow, callow, shameful way of grasping situations without being in on the top

conferences with the serious men. Gossip has always been considered tsk tsk. Only how are people like me—women they're called—supposed to understand things if we can't get in the V.I.P. room? And anyway, I can't stand meetings. I'd much rather figure things out from gossip.

I know I'm not a major important serious author who'll be forever under the B's at the library. I'm a gossip storyteller who likes L.A. rather than hates it. I think sometimes that if I were really serious I'd "master my craft," but I have this overriding feeling that I'm inventing my craft as I go along and that all the Rules about what writing is, the things you told me in that postcard—"character, complication, conflict, crisis, climax and resolution"—are perfect. But what if they aren't in the story I'm telling? Does that make people want to listen to the story any less? Not the people I'm talking to usually, it doesn't. Why can't my stories be O.K.? I'm not trying to write *Oedipus* [*Rex*] or anything, I'm just trying to tell these stories I love and can't resist. After all, nobody knows about this place or these people because all the people writing said things are so fucking boring no one can stand listening to them. I'm all that stands between L.A. and the same old crap forever and ever.

You're not going to get mad at me, Joe, because please don't think I'm some kind of bizarre ingrate who doesn't know which side her bread is buttered on. I do know which side my bread is buttered on. I want more butter, too. I remember when I first began writing to you 9 million years ago, you told me real grimly that you hated short stories and only liked novels, and the thing is, I can't even write real short stories. What am I going to do? I am not NOT going to copy out Ernest Hemingway novels by hand to "learn" how to write novels. (Am I?) Maybe I'll have to get so mad, SO MAD at everyone that my next novel is a masterpiece and <u>then</u> I can go back to writing meanderings and people will leave me alone. Maybe I could invent a new form of storytelling and I know just what to call it: spurts.

Eve

P.S. Sitting around watching my father die of what I'm going to die of is a hell of a strain on my shallow nature.

This letter is extraordinary for many reasons, not least of which is its intensity of emotion. Eve's typical mode is one of stoned sensuousness,

torpid abandon: she isn't ever quite paying attention. Here, though, she seems almost violently alert. She's unsheathing her energy, her passion. Letting you see how wracked she is, how embattled, the ferocity of her dedication, the bitterness of her frustration.

Eve created her books from scratch. And a lot of the traditional ingredients that educated writers were taught to put into their writing in order to make it "good writing"—the ingredients Heller had urged on her in that postcard—she left out. What's more, she declined to fashion herself after anybody, wouldn't stoop to mimicry. (Her vehement declaration, "I am not NOT going to copy out Ernest Hemingway novels by hand to 'learn' how to write novels," is, of course, a swipe at Joan.) She therefore had to dream up a form on the spot. Name it, too. Spurts, a sex metaphor, naturally. Yet no credit was given to her. As Simone de Beauvoir observed, "the writer of originality, unless dead, is always shocking, scandalous; novelty disturbs and repels." And that's what Eve did to critics: disturbed and repelled, why their first instinct was to put her down or write her off.

Eve also had the canniness to recognize that anti-L.A. sentiment was just a beard for anti-woman sentiment. "Joan made it okay to be serious about L.A.," she once said to me. True, except that the L.A. Joan made it okay to be serious about was venal, corrupt, depraved, and to seriously hate it was the only sensible response. The sole industry in Joan's L.A. was show business; the sole pastime, shopping (and fucking); the sole conversation, gossip.

Gossip, as in "some shallow, callow, shameful way of grasping situations."

Gossip, as in "some devious woman's trick."

Gossip, as in girl talk.

Eve refused to disavow gossip. She certainly refused to disavow L.A., which she'd treat no way other than frivolously, i.e., *un*seriously. In fact, she explicitly aligned herself with gossip and L.A. in the letter to Heller, as she explicitly distanced herself from seriousness. "I'm not a major important serious author who'll be forever under the B's at the library. I'm a gossip storyteller who likes L.A." (Reader, I know that Eve means for Heller to take her point, not take her literally, but when I get to the words "I'm not a major important serious author," I want to go back in time and shake her.)

Why else the letter is extraordinary: it's a true telling of feeling and Eve didn't, as a rule, tell her feelings. She seems so forthcoming and open, both in her work and in her life. But the closer you look, the more you see

that the candor is an illusion, that she's actually quite guarded. Only not in this letter, which is abashingly private, abashingly personal.

I didn't discover the letter until my second trip to the Huntington Library. And I didn't realize what was in it until I returned to New York, went through all the photographs of the letters I'd taken with my phone. As soon as I read it, I texted it to Laurie. Ten minutes later, my ringtone sounded.

"I can't believe this letter," Laurie said, skipping the niceties. "What an amazing letter! God, Lili, I mean, God!"

"I know," I said, my voice smug, as if I were the one who'd written it.

"You know what stands out for me? How much Evie kept to herself. And I thought we were so intimate. The things she's saying in this letter, though—she didn't talk to me about *any* of this. I don't think she talked to anybody about any of this."

"Except for Heller. I wonder why him."

A long pause. Then Laurie said, "Yeah, I wonder, too."

A longer pause, so long I started to worry that we'd been disconnected. "Laurie?" I said.

"I'm still here. I was just thinking. Maybe she was telling Heller to prove to him that she was a real girl."

"What do you mean, 'a real girl'?"

"Evie was just so mad at all those New York assholes—no offense."

I assured her that none was taken.

"Yeah, those fucking New York writers and reviewers and intellectuals who think that poverty and misery and bugs and dirt and disease are the great things to write about. And Eve thought they were boring and stupid to write about. Worse, they were corny to write about. The notion of style, how important it is, started so young with Eve. She was reading all those books about manners and morals—Henry James and Colette and whoever else. She admired stiff-upper-lip women, women who had too much style to complain. To reveal all this sloppy shit about yourself—that was Evie's idea of uncool. But the New York people kept telling her, 'You're not real, you're not real.'"

"So, basically," I said, "this letter is Eve trying to show Heller that she's not the Eve in her books, that she isn't a character, that she's a human being."

"Right. She was letting him know that she's suffered too."

* * *

This brings us to Eve's suffering, and the causes thereof, which she laid out plainly for Heller.

We'll start with Paul's bisexuality, which was closer to homosexuality ("I liked men and women, but I liked men more")—as obstacles to heterosexual romance go, a formidable one. Eve removed this obstacle by simply denying it was an obstacle. When friends asked her why she'd gotten mixed up with a guy "as obviously gay as Paul," she'd reply, "He's not that gay," a deliriously comic line, as all-embracing and all-forgiving as Joe E. Brown's "Nobody's perfect" at the end of *Some Like It Hot*.

Eve had to court Paul endlessly. "She was determined to win me over to her side of the mattress," he said. On the one hand, how exciting. To settle into a placid domestic routine was against her whirlwind nature, and with Paul there was always novelty, always challenge since she could never quite conquer his heart. On the other hand, though, how exhausting. "Paul just went along with what I wanted to be a sport," Eve told me. "Larry Woods [the Oklahoma restaurateur], that's who he was really in love with."

And Eve was no more to Paul's taste artistically than she was sexually. So, she had to win him over to her side of the mattress in that sense, as well. "Paul didn't really like Evie's art," said Mirandi. "I mean, she's someone who loved colors so much she took acid to see them better. And Paul was color-blind. He didn't like her writing that much either. I don't think he ever finished *Eve's Hollywood*. Evie always said she wrote *Slow Days*—the whole goddamn thing—just to get his attention." Once again: how exciting, how exhausting.

And sometimes she *sounded* exhausted. From a letter she wrote Paul rebuking him for not defending her to an editor-friend: "I've got enough fucking people telling me I've got to compromise, that my writing's not right [and] that I'll never get anywhere unless I report facts, learn to spell . . . I am not brave, Paul, you know I crack and get afraid. They're probably right, those people who say my style's wrong and all that shit . . . Can't you put your arms around me and say that you know life is hard for someone like me who sticks her neck out and says what she thinks and who is an artist? . . . If you do love me, please help me[,] insist that I'm the greatest and the tops. I always do for you. I tell people about you

and go into elaborate speeches on your brilliance and charm and newness and grace. But you, Paul, just get solemn when someone says, 'God, that Eve Babitz . . .' with silent agreement. No wonder people think we're not fucking."

What Eve wasn't getting from Paul, she tried to find in others.

Notches on her lipstick case included Ports regulars: Colman Andrews, Michael Elias, Warren Hinckle.

Also, Ports irregulars, men who stopped in for a drink or a meal, left with Eve. There was singer-songwriter Michael Franks. ("We were in bed," said Eve. "My feet got cold. I said I had Popsicle toes. That's where the title to that song came from ["Popsicle Toes" was on Franks's 1976 album *The Art of Tea*].") Photographer Lloyd Ziff, an ex of Paul's. ("Eve came to dinner with me and my mother," said Ziff. "Afterward she said to me, 'Anyone who has to deal with a mother like that cannot be my boyfriend.'") Painter Larry Rivers, a friend of Earl McGrath's and so already known to her. (Rivers, with assistance from Jasper Johns, made a sketch of Eve. He supplied narration, too, scrawling across the top, "WE DID IT IN THE AFTERNOON.") And Bavarian

nobleman Rupert Loewenstein, financial advisor to the Rolling Stones. (To a friend, Eve wrote, "I go out with a Prince who has a small bank in London and handles Jagger's money and tells me what to read.")

Then there were the old standbys. Eve was still involved with Fred Roos. ("Fred invited me to his birthday party and there were twenty-two women there, and that was it. No men. I left in a huff.") And with Ahmet Ertegun. ("I go along with Ahmet on any kind of sordid escapade he sets up and test my metal [*sic*] by seeing how clear-eyed I can stay," she told Walter Hopps.) With the letter's recipient, too. (From her journal, entry dated May 1, 1970, "J. Heller came and an interesting time was had by all. He was very paranoid

Eve as rendered by Larry Rivers and Jasper Johns, the image conveying one mood, the words another.

lest his wife discover he was seeing me, so he suggested that I bring a girlfriend [to a *Catch-22* screening] and let myself be introduced as someone other than myself.") And with Annie Leibovitz. Julian Wasser, who consummated his decade-plus flirtation with Eve in 1975, remembered, "I was leaving her place the next morning, was just opening the door, and there was Annie. I guess she could smell Eve's pussy on my breath because she looked furious. Boy, did I get out of there fast."

Nor was Eve merely overdoing it sexually. Her drug problem had, by the time the mid-seventies turned into the late, become a problem. "Oh, Evie was all fucked up on coke then," said Mirandi. "She was fucked up constantly and she was fucking everybody constantly."

There's one night—one party, actually—that exemplifies how far the fucked-up-ness and fucking had gone.

In 1976, Eve and John Van Hamersveld, former art director of Capitol Records, decided to start an underground paper, the *L.A. Manifesto*. In the first (also, the only) issue were songs by the Eagles and Terry Melcher, poems by Ronee Blakley and Carrie Fisher, humor pieces by Steve Martin, artwork by Ellie Coppola, and a pinup picture of Ed Ruscha.

To celebrate, a party. Invited, Michael Kovacevich, son of a Bakersfield grape farmer. Recalled Kovacevich:

I'm Frank from *Slow Days, Fast Company*. Eve came to visit me in 1974 during my father's grape harvest. I never saw her take a single note, but she got every detail in that story ["Bakersfield"] right. How I met Eve was, I was a Montessori teacher in Dublin—she changed that to London in her book—and one of the ways I kept up with what was going on in America was *Rolling Stone*. Eve wrote a story for the magazine, and I loved it so much that I taped it to my wall. And when Dubliners would come by and ask me what California was like, I'd point to it and say, "If you want to know, read this." I wrote Eve a letter and she wrote back, and that's how our friendship began. So, she asked me to submit a photograph for this thing she was putting together, the *L.A. Manifesto*, which I did, of an Irish breakfast. And then she asked me to come to a party for the *Manifesto*, which I did, too. Celebrities were there, but I didn't know who they were. I only knew Eve. "This is my fan," she'd say. That's how she introduced me to everyone, which was a little embarrassing, but I

didn't really mind. I met a guy in a white suit, and I gave him my copy of the *Manifesto*, and he signed it. I had no idea it was Steve Martin until I looked at what he wrote. Basically I'm a shy person, definitely not a Hollywood type, so I didn't stay late.

Late, though, is when the party really got started.

"The beautiful Charlotte Stewart threw it for me," said Eve. "Charlotte was already famous for playing the schoolteacher in *Little House on the Prairie*, but she was about to get a different kind of famous for *Eraserhead*. She's the girl in it—you know, the one who has the lizard-looking baby. Anyway, Charlotte had this great house in the Hollywood Hills. The windows were made of Tiffany glass and I loved to look at them while I was on acid, which I was. Acid and other stuff—cocaine, I think. Someone brought Griffin Dunne. He was way too young. Everyone pounced on him. I got him."

Eve and Charlotte Stewart inflicting their personalities on Ports.

So, for Eve, the takeaways from the night were: colored glass; hallucinogens mixed with stimulants; and the sex she had with a barely legal Griffin, the nephew—the nephew who was like a son—of her best friend and worst enemy. ("Evie fucked Joan's kid," said Mirandi. "I don't know how else to see it.")

It was somebody's daughter, though, who made an impression on Griffin. "I'll never forget," he said. "A kid disappeared at that party. A little girl. She and her parents were on their way to Aspen. Her parents must've meant to just stop by for, like, five, ten minutes, and then hit the road, do most of the driving at night when there was no traffic. But we were all coked up, and then they got coked up, too. Hours went by. I was hanging out with them, and they were telling me that they were heading to Colorado. I said, 'Oh, really? I love Colorado.' And they said, 'Yeah, yeah.' And I said, 'Do you guys have kids?' And they said, 'We've got a girl. She's five.' I said, 'Gee, that's great.' And they said, 'Yeah, she's in the car.' And I went, 'Wow. She's in the car. Wait, she's *in* the car?' They'd arrived at the house at maybe eleven p.m., and now it was—what?—four in the morning. So, the mother gets up quietly, goes outside, and then we hear this bloodcurdling scream because the girl's not in the car. I can still remember searching for her with flashlights in those dark, dark woods, the terror of it. She wound up being okay, she'd just wandered off. Jesus, though."

This party—fun but fun stripped of constraints and morality, fun turned labored and grim, fun that doesn't sound very—is, for me, exemplary because it sums up the ugly and desperate mood that was taking over the scene, the decade, Eve. In the past, she'd used sex and drugs to enhance her life, live it more fully. Now she was using sex and drugs to absent herself from her life, so that she didn't have to live it at all. Where did the sudden urge to self-destruct come from?

From another item on her causes-for-suffering list: her "impending disease," Huntington's.

A quick rundown on Huntington's. It's a progressive brain disorder. Symptoms include but are not limited to involuntary movements, lack of impulse control, rage, depression, psychosis, and withdrawal from social activities. These symptoms worsen over time. In the final stages of the disease, the person is unable to walk, talk, or swallow. There is no known cure.

"It was in 1977 that the doctors told us my father had Huntington's," said Mirandi. "He got it from my grandfather. What happened with my grandfather was that he stopped walking normally. He believed cheap shoes were the problem. So he went broke buying expensive shoes. For Dad, it was his arms that went. He became obsessed with the bridge on his violin—thinking that a screwed-up bridge is why he couldn't play—and spent every nickel buying these bridges from Italy. They'd come and he'd start filing them because they weren't ever quite right, filing them until they broke."

One more fact about Huntington's: it's hereditary. If you're the child of somebody with Huntington's, your chances of getting it are one in two—50 percent. Yet somehow Eve knew that her chances of getting it were 100 percent. "Sitting around watching my father die of what I'm going to die of is a hell of a strain on my shallow nature," she told Heller in that letter. *What I'm going to die of.* Not *what I might die of.*

She didn't share this certainty with Mirandi or Laurie. ("Mirandi and I were as scared as she was," said Laurie. "Why didn't she say something to us?") Or Paul. ("She never mentioned anything about it to me. Never.") It was something she shared only with Heller in this letter that he didn't read because she didn't send.*

And disease was assailing the Babitz clan from all sides:

Stomach cancer was coming for Agnes, Mae's mother. "Mother and Dad had moved into the house on Wilton Place, and Mother installed a bed in the kitchen for Agnes," said Mirandi. "Mother was devoted to Agnes and wanted to care for her."

Cervical cancer—"cunt cancer" as Eve termed it—was coming for Mirandi. "There were A-list groupies and B-list," said Eve. "You had to be under a size three to be A-list. My sister was A-list." Mirandi didn't have one-offs with rock 'n' roll crème de la crème as Eve did. She had long-standing relationships. "I don't think you can tell from pictures just how great-looking Mirandi was in her heyday," said Laurie. "When Mirandi was young, she was Brigitte Bardot's twin. She could attract anyone—Ringo [Starr], Jackson [Browne], the Eagles, all those guys. But she didn't get to

* She didn't send Heller this version, but she did send Heller a version, or she delivered a version over the phone or in person, on one of her New York trips, because his blurb changed to "Her words are worth a thousand pictures," which was more like it.

keep them." She did, though, get to mark them. (Mirandi: "I'm the 'one says she's a friend of mine' woman in the Eagles' song 'Take It Easy.'") And they marked her right back. (Mirandi: "We were in that post-Pill, pre-AIDS golden period. We thought we could have all the sex we wanted without consequences. Well, there were consequences.") She contracted HPV, the human papillomavirus, which, in the mid-seventies, led to cervical cancer, which, in the late seventies, led to a hysterectomy. Thirty-two and no longer able to bear children.

And disease of the spirit—despair—was coming for Mae, crushed by the burden of caring for so many hopeless cases. "Mother was just drinking herself to death," said Mirandi. "She couldn't take what was happening to everyone."

Eve's sense of doom was total, and it induced in her not a weary resignation but a kind of energetic fatalism. She felt that she had no future, that her future was all used up, and that she could therefore behave with utter disregard for her health, safety, and peace of mind.

The letter to Heller ends on what seems to be a defiant note, at least where her art is concerned: "Maybe I'll have to get so mad, SO MAD at everyone that my next novel is a masterpiece and then I can go back to writing meanderings and people will leave me alone." Really, though, it's a compliant note. Eve is saying that she's going to stop writing what she wants to write, hold off on pursuing her idea of what's beautiful and interesting, and instead give people what she thinks they want to read, submit to their idea of what's beautiful and interesting.

Eve had already lost her way as a person. She was about to lose her way as a writer.

CHAPTER 20

So Mad, SO MAD

Eve made good on her threat to Joseph Heller and wrote a conventional novel. And, in the fall of 1979, Knopf published it. "Evie knew what she was going to call the book before she wrote it," said Mirandi. "She thought *Sex and Rage* sounded like a bestseller."

Sounded like but wasn't. Was a failure. A poignant failure, a vivid failure, a singular failure, yet an unequivocal failure.

Now, it isn't that Eve whiffed that's significant or compelling here. If a writer takes risks, doesn't just concoct a formula, follow it again and again, the results are sure to be variable. (You can't knock it out of the park every time.) It's why Eve whiffed that's worth contemplating. Because what's changed isn't her style. No, her prose has its usual dash and luster. Nor is it her subject matter, the same as it was in *Eve's Hollywood* and *Slow Days*, and the same as it would be in every book thereafter: Los Angeles and herself.

The difference is her form.

I've already quoted that wonderfully self-aware line of hers from *Slow Days*: "I can't get a thread to go through to the end and make a straight-forward novel." But that's the task she's forced herself to perform in *Sex and Rage*. Instead of multiple spurts, it's a single sustained arc. Instead of the first-person point of view, it's the close third. And instead of indirection and disorder, the very qualities that made *Slow Days*, it's a classic three-act setup-conflict-resolution bildungsroman: L.A. girl artist falls in with a fast crowd; gets her heart broken, her illusions shattered; and

255

then reinvents herself as a writer. (How many young novelists end their autobiographical first novels with the protagonist becoming—dot, dot, dot—a novelist?)

All of which is to say, the novel as a medium of expression has killed Eve's expressive potential. It's the desire for respect that does her in, I think. No longer is it enough for her to please, though pleasing is exactly what her talents are suited for. Now she must also impress. She wants the prestige that comes with being a novelist.

Doing her in, as well: self-consciousness. Eve has become "Eve" (technically, Jacaranda); "I" has become "she"; and what was once fluid, natural, alive, has become fixed, manufactured, dead. Eve has, in effect, novelized herself. Taken her background, her experiences, her thoughts, the way she looks and talks and moves, and set them in the concrete of "the novel." She's turned herself into a thing—a character.

I'll give an example. Jacaranda enters for the first time the living room of Max, the Earl McGrath stand-in, and looks around:

> There was art all over the walls. Jasper Johns, Rauschenberg, a David Hockney swimming pool, and a huge pornographic watercolor by John Altoon. In the front to the right, where people came in, was a carefully framed photograph by Julian Wasser of Marcel Duchamp playing chess with a naked girl. The contrast between Duchamp's dried-out ancient little person and the large young girl's Rubenesque flesh was not (unlike chess) at all subtle . . .
>
> "You've got a print of this," she said, her voice filled with hurt surprise. She'd never imagined that anyone might own a print and not have to tear it out of an art magazine as she had had to do.
>
> "You know this photograph?" Max asked.
>
> "Well, I mean . . ." (She'd have to be an idiot to spend all her time around artists and not know this photograph.)

So, what you have in this scene is Eve the character analyzing and commenting on a photo featuring Eve the person. It's coy, contrived, mannered, too cute by half. Is, in short, everything that the Wasser-Duchamp photo could've been but wasn't. (It's as though the Eve in that photo suddenly turned to the camera, peeked out from behind her hair, and winked

knowingly at the viewer.) Art has been replaced by artifice, spontaneity by premeditation, and—poof—the magic is gone.

Sex and Rage was a mistake and a folly. Eve grasped this, if not in 1979, certainly by the time I got to her in 2012. Her cool-eyed assessment: "Writing a novel was my idea, but I didn't really want to do it. I preferred short stories, short essays, whatever you want to call them. Nobody told me I had to write a novel. Vicky didn't tell me, nobody at Knopf told me. They didn't have to tell me. I just knew. If you were a serious writer, then a novel is what you wrote." And therein lay the problem. Eve *wasn't* a serious writer. Not in the L.A.-pooh-poohing New York literary establishment sense, at least. And a traditional novel was the last thing she should've been writing. That she knew better—and proof that she did is all over that letter to Heller—didn't stop her or even, in the end, matter.

Vicky Wilson, too, came to understand that the book was in need of help yet, in some fundamental way, beyond help. You can hear the frustration and impatience in her letters. "The thing about reading the various stages of *S&R* is that I can barely resist editing the book line by line when what it needs really is some more shaping," she writes. She's reduced to giving Eve Creative Writing 101 lessons, explaining why Eve's characters must have distinct voices, can't all sound like the Eve character. "That is the trick of writing fiction," she tells Eve. And then, as if afraid Eve still might not be getting it, adds, "You have to invent a bit more."

But what if what *Sex and Rage* was crying out for was *less* invention?

Jacaranda, you'll remember, was the name of the Eve stand-in in the other *Eve's Hollywood*, the *Eve's Hollywood* that Eve cut, put aside for later. It was Joan and Dunne, you'll also remember, who realized that *Eve's Hollywood* was two books, not one. And the second *Eve's Hollywood* was almost certainly the basis for *Sex and Rage*, no doubt the reason Eve was able to pump out a first draft so quickly. "I wrote it in one voom of 18 days, an outburst of post alcoholic euphoria," she told Heller.

Eve, in a letter I quoted in an earlier chapter, compared this second *Eve's Hollywood*, i.e., the ur–*Sex and Rage*, to F. Scott Fitzgerald's *Tender Is the Night*, and herself to *Tender*'s ingénue-heroine, Rosemary Hoyt. I then extended the comparison, likening the fervid bohemian atmosphere

of Joan and Dunne's house at Franklin Avenue in Hollywood in the late 1960s to the fervid bohemian atmosphere of Nicole and Dick Diver's villa in the South of France in the late 1920s; likening, too, the ambitious young artists swirling around the Didion-Dunnes' house to the ambitious young artists swirling around the Divers' villa.

And, indeed, it's the players on Franklin Avenue who make up the cast of characters in *Sex and Rage*. Earl McGrath, as I already noted, is Max. ("She saw Oscar Wilde in every move [Max] made.") Ahmet Ertegun is Max's friend and benefactor, Etienne, the possessor of a power both coarse and fine. ("Once Etienne met Max, he could devote himself to taking over the world and know that the half of him that only wanted to play was being fully seen to, and could be dished up, unimpeded by last-minute lack of plans.") Ron Cooper is Tom, a painter. ("Tom was one of the only artists in L.A. who had immediately regarded Max as a crafty hustler and had told Max so.") And Harrison Ford, with a little Peter Pilafian thrown in, is Gilbert Wood—wood, carpenter, get it?—a freshly minted movie star. ("[Gilbert's] mouth looked as though he'd just been hit with the news that he had a week to live and he didn't care.") But these players are supporting players. The lead players, Joan and Dunne, the neo–Nicole and Dick Diver, are nowhere to be found.

When Eve, in '72, told Walter Hopps that she was backing out of doing the Ertegun profile for *Rolling Stone*, she said that she could only write about Ertegun under the cover of fiction. And that's precisely what she did in *Sex and Rage*. Somehow, though, the cover of fiction provided insufficient cover for her to write about Joan and Dunne. (Eve wrote about Joan in "The Luau," of course, but that was one short story out of more than forty, and *Eve's Hollywood* wasn't a Knopf book—that is, a book she thought everybody who was anybody would read.) How come? If it was okay in Ertegun's case, why not in Joan and Dunne's? My guess is that her feelings regarding the couple, Joan in particular, were simply too volatile, too overwhelming, a snarled-up rat's nest of unresolved anxieties, guilts, and fears, and she couldn't bear to expose them.

And so, in the place in the book where Joan and Dunne should be, a gaping hole.

By a curious twist of fate, 1979 is the year that Joan came out with *her* Franklin Avenue book, which *was* a bestseller (her first appearance on the

New York Times's list): *The White Album*, not a novel, a collection of essays, the title essay set between 1966 and 1971 and at 7406 Franklin Avenue. "In the years I am talking about," she wrote, "I was living in a large house in a part of Hollywood that had once been expensive and was now described by one of my acquaintances as a 'senseless-killing neighborhood.'" She'd quote at length the doctor's report of a patient in the psychiatric clinic at St. John's Hospital in the summer of 1968: "In [the patient's] view she lives in a world of people moved by strange, conflicted, poorly comprehended, and, above all, devious motivations which commit them inevitably to conflict and failure." The twist? She was the patient.

So, under Joan's controlled exterior: tumult. The same tumult as under Eve's uncontrolled exterior. And behind Joan's composure: disintegration. The same disintegration as behind Eve's lack of composure. (If Eve had had enough sense to check herself into a psychiatric clinic when she was suffering from squalid overboogie in 1970, then Joan's doctor's report might've been hers.) They'd had, it turned out, an identical experience on Franklin Avenue, only from opposite ends.

Earl McGrath is mentioned by name. (He's the book's co-dedicatee.)

As is Janis Joplin. "Someone once brought Janis Joplin to a party at the house on Franklin Avenue: she had just done a concert and wanted brandy-and-Benedictine in a water tumbler."

As are Michelle Phillips and Anne Marshall. "John and Michelle Phillips, on their way to the hospital for the birth of their daughter Chynna, had the limo detour into Hollywood in order to pick up a friend, Anne Marshall. This incident, which I often embroider in my mind to include an imaginary second detour to the Luau for gardenias, exactly describes the music business to me." (Joan, in fact, wasn't embroidering. "Michelle went into the hospital twice," Marshall told me. "The first labor was a false labor, the second labor was the real one. And during the false labor, we stopped at the Luau for a drink. The drink had gardenias in it, and we put the gardenias in our hair. Then we drove the rest of the way to the hospital.")

Not mentioned by name, Eve. Though there is that famous passage set at the Doors recording session. The session Eve arranged for Joan to attend. The session Eve attended with Joan.

So, each woman wrote the other out of her personal history of that time. And yet each read the other's personal history with keen interest.

In a letter written on August 13, 1979, to friend and documentarian Sarah Kernochan, Eve brought up something she'd heard from Tina Moore, Susanna Moore's sister and her ex-lover, the one who worked for Joan:

> Tina Moore (who is Joan Didion's secy) told me that Joan loaned her the [*Sex and Rage*] galley saying, "It's good." ("So why doesn't the cunt give you a quote?" REDACTED* wanted to know. I explained that Joan was getting real symptoms of MS which she's had in recession for 7 years but which is now appearing again—"So why doesn't she just write it anyway and we'll have someone decipher it for her?" REDACTED asked. "Yeah," I said, "her hand could just scrawl that last thing as they were lowering her coffin before the lid closed." "Oh well . . ." REDACTED sighed, resigned at last.) So Joan didn't mind it which really made me feel tipsy.

The irritation that an indisposed Joan won't cough up a blurb was all REDACTED's. Eve, in contrast, sounded pleased—touchingly pleased—to learn that Joan reacted positively to the book. Eve wasn't bothered that Joan chose not to rouse herself publicly on its behalf. Joan's status as a mentor and famous person must've, in Eve's mind, exempted her from those expectations.

And yet, as it happened, Eve *was* bothered and she exempted Joan from absolutely *nothing*.

Her resentment came out in uncharacteristic, and therefore notable, bursts of temper. "Evie was always so angry at the Dunnes because she felt that they didn't back her up enough," said Mirandi. "She believed that if Joan had really gone to bat for her, it would've made a difference in the way people saw her." (How not to gasp in admiration—in horror—at Eve's nerve? She'd shit-canned Joan for doing her the great favor of editing her first book, then smeared Joan in that book, and still had the gall to get pissed at Joan for not chomping at the bit to help her again a few years later with another book.)

* REDACTED, a former Knopf executive, is still very much alive, and would not wish to have a vulgarism for female genitalia attributed to him/her. In fairness, the likelihood that the former Knopf executive deserves to have the vulgarism attributed to him/her is low. Eve here seems to be going for laughs rather than accuracy.

Reading *The White Album* was for Eve a less happy experience than reading *Sex and Rage* was for Joan. "Eve was just kind of livid about *The White Album*," said Mirandi. "And I don't know if she was livid because she was jealous because Joan got there first. Or if she was livid because Joan had gobbled up that whole scene, and wrote about it, not leaving any room for her to write about it. Or if she was livid because Joan didn't do it as fiction. I do know that Eve was seriously bent out of shape that Joan had named her book after an album [*The White Album*, the Beatles, 1968] when Eve was the one who was rock 'n' roll. My God, nobody was less rock 'n' roll than Joan."

The possibility that the source of Eve's fury was Joan writing a nonfiction account of the Franklin Avenue scene intrigues me most because Eve could've made her account nonfiction. Why that very summer, in the August 23, 1979, issue of *Rolling Stone*, she'd published "Honky-Tonk Nights," a nonfiction account of another scene, the one that was happening in tandem with the Franklin Avenue scene: the Troubadour scene.

"Everyone who was ever at the Troubadour during that time is sort of going around in a trance," she told Kernochan, "and for once in my life I understand Nabokov, in one small way at least, with that title 'Under the Net' because I got the Troubadour and that Era between 1968–71 under my net, frozen, like a pinned-on-a-board butterfly—immortalized."*

The Franklin Avenue scene must've been different for Eve. Was sacred to her in a way that the Troubadour scene wasn't. And she must've believed that Joan had done something wrong in discussing it so openly, so freely—in blabbermouthing, basically. Or maybe it was that Joan was allowed to blabbermouth that got her blood boiling. (Ertegun wouldn't even let her make a collage of him, write a profile.)

Or maybe I'm overthinking. Maybe the obvious motivation, the one Mirandi cited first, is the accurate: jealousy. Eve was hopping mad because it was Joan, not she, who had caught the elusive butterfly that was the Franklin Avenue scene, trapped it in a net, pinned it to a board for the world to see.

In any case, *The White Album* wasn't just a recognized masterpiece, it was an immediately recognized masterpiece, the rare book in which a writer spoke the secrets of her soul and those of her era simultaneously. That *The*

* It was Iris Murdoch who wrote *Under the Net*, not Nabokov. Though Nabokov was, in his spare time, a passionate lepidopterist, likely why Eve was mixed up.

White Album was a touchstone upon arrival was especially remarkable since Joan was starting to seem, by the late seventies, out of touch, as if she'd lost her touch as her star had lost its shine. After moving to Trancas in early '71, she'd produced three duds in a row: the two movies, *The Panic in Needle Park* and *Play It as It Lays*; the novel, *A Book of Common Prayer*. And one success that was a semi-embarrassment: *A Star Is Born*.

And then, at the decade's close, a rebound.

With her Franklin Avenue book, Joan captured, yet again, the *geist* of the *zeit*. Extra satisfying, she wrested the *geist* back from Pauline Kael, who, in 1979, left the *New Yorker* and film criticism to accept Warren Beatty's invitation to produce a James Toback movie. Kael had barely started the job when she was fired from it. This was more than a failure for Kael, it was a humiliation. (Joan's cynicism about the industry now looked like wisdom: play it straight with Hollywood, show Hollywood you cared, and Hollywood made a fool of you. Better to do what she and Dunne did: hang around Hollywood strictly for the paycheck and the gossip, for the ego-stroke—all those famous shadows courting you, hoping and fearing that you'd put them in your next book.)

Extra *extra* satisfying, Joan wrested the *geist* back from Pauline Kael with the character and premise Kael had made such vicious fun of in that *Play It as It Lays* review. "The ultimate princess fantasy is to be so glamorously sensitive and beautiful that you have to be taken care of; you are simply too sensitive for this world," wrote Kael. "The beautiful and damned heroine [Maria Wyeth] walks the tree-lined paths of a sanatorium and tells the story of her disintegration. Needless to say, it is the world that is having the breakdown, not Maria [Wyeth]." Swap out "Maria Wyeth" for "Joan Didion," "sanatorium" for "psychiatric clinic at St. John's Hospital," and you've got *The White Album*. Within the first few pages, Joan has confessed that she snapped one year before Manson did, had to check herself into a hospital as a private outpatient, submit to the Rorschach Test, the Thematic Apperception Test, the Sentence Completion Test, and the Minnesota Multiphasic Personality Index. "An attack of vertigo and nausea," she writes, "does not now seem to me an inappropriate response to the summer of 1968." (In other words: it is the world that is having the breakdown, not Joan.)

Joan's dipping, dimming star rose higher, burned brighter than ever.

Eve's Franklin Avenue book did for her the reverse. Her writing through-out the seventies had been getting better and better. With *Sex and Rage*, it suddenly got worse. She'd struck a deal with the devil—artistic compromise in exchange for commercial success—that was for her a bad deal. *Sex and Rage* was the sellout no one bought. "Like, five people read [it]," she said. It was thumped by critics, too. ("Women's magazine fiction at its most mediocre," concluded the *Los Angeles Times*.) If stardom seemed overdue after *Slow Days*, it seemed beyond reach after *Sex and Rage*.

What I want to know is: was the moment Eve realized she'd lost to Joan the same moment she realized that she and Joan had been in a com-petition all along?

In a competition for material. Joan knew how valuable it was, that it had to be watched over closely, guarded jealously. "When Joan went to L.A.," said Dan Wakefield, "she was looking for a new identity because in New York, she was always going to be 'the correspondent from *Vogue*.' In L.A., she established her own set of people. It was the rock 'n' roll people—Jim Morrison, girl singers like Janis Joplin and Michelle Phillips, the people who knew Manson. She never introduced me to one of them. You know who she introduced me to? The labor editor of the *L.A. Times*. That's it. Even Eve I had to find on my own. I see now that Joan was trying to keep me away from her characters because she knew she was going to write about them. She and John moved to Trancas and they had me over maybe twice, even though I was living in L.A. all of 1971. I'm sure that was Joan, John just fell in line. And when I was in L.A. again doing my TV show [*James at 15*, NBC, 1977–78], there was an early screening. I told my girlfriend at the time, 'Listen, this'll be really hard, but we'll be okay because these great friends of mine will be there.' And then Joan didn't come. It was really awful. She said it was because she felt my girlfriend didn't like her, but that was bullshit. If anything, my girlfriend was intimidated by her. My only real friend in that family then was Quintana. Years later, Joan asked me to have dinner with Quintana, who was going through some drinking stuff, which I was supposed to know all about. I remember saying to Quintana, 'All those years, you were, in my mind, the good Joan.'"

In a competition for men. Dunne and McGrath, naturally, but also Dan Wakefield, Jim Morrison, Harrison Ford, even Griffin—their hearts and minds since Joan wasn't interested in their bodies.

And, most vitally, in a competition for a vision of Los Angeles. It was through Joan's eyes, not Eve's, that generations of readers would see L.A.

Joan, unlike Eve, always understood the stakes. Always understood how desperate, brutal, ruthless, a career must be. She was dead sure of her ambition. She'd crawl over corpses to get to where she had to go. And by 1979, she was there. With *The White Album*, she'd reached a new peak. If *Slouching Towards Bethlehem* and *Play It as It Lays* made her a literary celebrity, *The White Album* made her a cultural institution.

CHAPTER 21

Squalid Overboogie

A new decade was about to dawn: the 1980s. Eve scarcely noticed. She was too busy sliding downhill.

The situation at Wilton Place was grim. Agnes was no longer dying in the kitchen, but only because she was already dead. ("She weighed about 40 pounds—she [was] like a fire that won't go out," wrote Eve to Sarah Kernochan. "She waited for my sister to come sing her a Freddie [*sic*] Fender song before she died.") And Mae's alcoholism was worsening at the same rapid clip as Sol's Huntington's.

Unable to stand the sight of her parents falling apart, Eve fled Hollywood. She moved to Santa Monica, renting the top floor of a house owned by Femmy DeLyser. "Femmy was this crazy Dutch woman," said Laurie. "Ate vegan, macrobiotic, all that. And she was the birth coach to all these movie stars, including Jane Fonda, and in the eighties she wrote Jane Fonda's pregnancy workout book, which was a big, big bestseller."

Soon Mirandi was also renting a floor at Femmy's. "Evie always had one foot where Mother and Dad were. Since it was too much for her to live near them at that time, she demanded that I move into Femmy's with her. I didn't mind. I loved the beach. And it was convenient for me. I was already working for Jane [Fonda, Mirandi was putting on benefit concerts for Fonda's then-husband, political activist Tom Hayden] and hanging out with Jane all the time. Femmy's place was close to where Jane lived."

Mirandi with her boss and friend, Jane Fonda.

Close, too, to where Eve's coke dealer lived. "He was only a block away," said Mirandi. "And whenever she took a break from writing, she'd wind up at his apartment."

Cocaine did bad things to Eve's personality. "Eve started getting crazy with the coke," said Paul. "I would wake up in the morning to her pacing around in circles. She'd say that Erica wasn't doing enough for her, and that she wasn't happy with not having complete access to Vicky. Neither were taking her obsessive calls. I felt sorry for anyone who had to work with her."

Cocaine did worse things to Eve's prose. Recalled novelist and screenwriter Henry Bromell, "I thought Eve was this beautiful, original voice. Completely from L.A. She told great stories. She'd say to me, 'Look at these breasts.' I'd say, 'Nice.' And she'd say, 'Nice? *Nice?* These breasts have conquered the world!' She was so much fun. But she was in a battle with drugs, which was ultimately a losing battle. And the work suffered. Her language was really disintegrating."

And yet, there's something Eve wrote during this period that I absolutely love, *Fiorucci: The Book*, though it isn't a book, not really. Is really an extended magazine piece, which is to say, an extended spurt, on the fashion label started by the Italian designer Elio Fiorucci.

Fiorucci: The Book has none of *Slow Days'* depth. But then, it isn't trying to, surface is what it's all about, and why risk spoiling so alluring a one by scratching?

The opening:

> Fiorucci is the name of a man, the name of a look, the name of a business. A phenomenon. Walking into a Fiorucci store is an event. Milan. New York. London. Boston. Beverly Hills. Tokyo. Rio. Zurich. Hong Kong. Sydney. Fiorucci is Fashion. Fiorucci is flash. Fiorucci stores are the best free show in town. The music pulses; the espresso is free; the neon glows. Even the salespeople are one step beyond—they often wear fiery red crew cuts. But it is, after all is said and done, a store—a store designed to sell clothes. But the difference is all that sex and irony.

Fiorucci: The Book is totally off the wall and so minor it almost isn't there. But it is, in its way, perfection. A daft delight.

The publishing house, Harlin Quist, had sent Eve to Milan to interview Fiorucci. Earl McGrath found her a place to stay. "The woman Earl introduced me to was the most beautiful woman in Italy who wasn't a movie star," said Eve. "She looked like a Botticelli rising out of the sea. And she was rich, an heiress. Her family was the only family in the country allowed to import Scotch or something. I was kicking drugs and everything else, so I slept the entire flight." Eve turned her head on its side, mimed someone snoring. "I had shoes when I got on the plane but not when I got off. I guess I lost them." I asked her what she walked around in, and she explained to me that the Botticelli woman gave her a pair of boots. "They were suede," she said. "I wore them every day I was in Italy. Those suede boots with the same baby-blue skirt and black sweater because I guess I forgot to pack a suitcase."

Eve brought Fiorucci back to America with her. "She took him down to Laguna to stay with Aldo and Petey," said Paul. "Once they were there, they got into this weird sex fit where Fiorucci was asking Eve to fist him,

just not letting up on the subject.* And of course he and Eve were doing so many drugs. Fiorucci was shooting up. Eve was sticking to cocaine, but it was like, good Lord. Aldo called me and said that he and Petey had had it, that they loved me and that they loved my friends, but that Eve wasn't welcome at their house for a while. Eve really could push every boundary there was. And she pushed one too many with Aldo and Petey. She was pushing one too many with a lot of people in those days."

In mid-1980, Eve finished a draft of her new book. "This time she did what Joan did," said Mirandi. "She gave it a rock 'n' roll title. Took the name of a Jim Morrison album [*L.A. Woman*, the Doors, 1971]."

Eve submitted *L.A. Woman* to Erica Spellman and Vicky Wilson. "Vicky and I read it and we were both, like, 'Hey, wait a minute,'" said Spellman. "It needed a lot of work. Eve basically said, 'Fuck you, I'll get somebody else to publish it.' And that was the end of our relationship for a while."†

* In *Hollywood's Eve*, I mentioned the fist-fucking but declined to identify the fist-fucker. On Easter weekend in 2021, while on a vacation with my husband and two sons in the Berkshires, I received through my website an email from a woman named Kathryn Ruskin. It read:

> I just finished *Hollywood's Eve* and was fascinated by her lifestyle. In the chapter where you don't name names, by any chance were the fist fucker's initials [BLEEP]? I had occasion to be in the ladies room and in the next stall there was a couple and I could hear the goings on. She protested at first but the act was completed. I left first and when they came out it was a woman I knew and this actor with the initials [BLEEP]. I am the widow of Mickey Ruskin.

After looking up Mickey Ruskin (Mickey was the owner of Max's Kansas City, a favorite hangout of Andy Warhol, Lou Reed, and Patti Smith in the sixties and seventies), I called Kathryn to find out which actor the initials belonged to. She told me but I'm not going to tell you, Reader. I'm not even going to tell you the initials, the actor being as famous as he is and libel laws being as punitive as they are.

† According to a letter Eve sent Sarah Kernochan, she and Spellman parted ways slightly earlier, in late 1979. She believed that Spellman, who'd left ICM for William Morris, was paying too little attention to her. ("The reason I fired Erica," she wrote, "was because she dumped me into Candace Lake's lap [Candace Lake, an ICM agent] and deserted me over at Wm. Morris and forced me to have lunch with horrible Lynda Obst [producer] and otherwise did her Scorpio behind-the-scenes manipulations.") But Eve continued to drop Spellman's name in letter after letter, alluded to conversations with her, exchanges, meetings. So, my sense is that the break didn't take until *L.A. Woman*, as Spellman said.

Eve was acting like a star, haughty and demanding, but only to keep people from seeing how much like a loser she felt. She was ashamed of what had happened with *Sex and Rage*, as she'd reveal in a letter written on September 30, 1981, to journalist Becki Klute:

Becki Klute,

I read your review of *Sex & Rage* for the first time yesterday in my mother's backyard and I had to write and thank you, even though I know you wrote it 2 years ago and probably don't remember. For some reason, Knopf only sent me the really mean reviews—yours, they sent to my parents, and I might never have read it at all except my mother and I were cleaning out the garage . . .

I am no longer on Knopf . . . It was too hard for me to be that prestidgeous (I can't even spell "prestiege"). I couldn't have enough fun. They told me "keep <u>yourself</u> out of it" and "Read *War & Peace*" all the time. I mean, they expected me to be a hardcover author—and I <u>want</u> to be in supermarkets. And worst of all, my editor at Knopf would always look at me for a long time and then say " . . . <u>think!</u>"

It was depressing.

(Maybe I'll go back once I figure out how.)

Anyway, thank you,

Eve Babitz

P.S. Anyway, even if I could think, I loved Knopf so much that after *Sex & Rage* got so many bad reviews, I was too mortified to face anyone in that office ever again.

L.A. Woman was acquired by Joni Evans, editor in chief of Linden Press, an imprint of Simon & Schuster. "John Gregory Dunne was one of my writers then," said Evans. "I'd spend a lot of time with him and Joan at their house in Brentwood [Joan and Dunne left Trancas for Brentwood in 1978]. John and Joan were crazy about Eve, John particularly. He said, 'Eve is great. You must publish Eve.'"

The advance Eve received for *L.A. Woman* was substantial. It was also insufficient. Cocaine was an expensive habit, and Eve's habit was getting more habitual by the day. "I was worried about her all the time," said

Mirandi. "She had this weird Mexican boyfriend. I don't know where she picked him up. All they did was fuck and snort, snort and fuck. The relationship finally came to an end because they ran out of coke money. It was not a good situation."

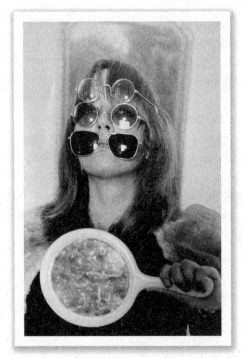

Eve and her coke mirror.

And Eve, at some level, knew how not good. "Eve had blown her *L.A. Woman* advance on coke, fucked up her nose," said Paul. "She called me, begged me to come over. I drove all the way to Femmy's place in Santa Monica. When I walked into Eve's room, I couldn't believe what I saw. There wasn't an inch of floor not covered in bloody Kleenex. The cats were running around high. I boxed Eve up and took her back to my Western Avenue apartment, and she was quite happy easing herself into a long, languid bubble bath. My mind was still trying to get over what it had seen when Eve got out of the tub and insisted that I fuck her. I was dumbfounded. She looked like a Dalmatian she had so many bruises covering her body.

I told her to go to bed, alone, and she got really pissed off and started to scream and pummel me. I took her by the shoulders, shook her, and forced her to turn around and face a full-length mirror. I cried and told her that she was breaking the hearts of those of us that loved her by letting herself get so goddamned low with her life, and did she want to die?"

Paul's words seemed to reach Eve. He wasn't convinced, though, that they'd truly broken through, so he called Mae. "Paul had the good sense to rat out Evie to Mother," said Mirandi. "Mother said to her, 'This is not working. You've got to come home.'"

CHAPTER 22

Beyond Squalid Overboogie

Eve didn't just come home to Hollywood. She came home home, home to her parents' house at 1955 North Wilton Place. In the backyard was a small stand-alone structure: her digs.

Bonna Newman, assistant to Fred Roos, visited regularly. "It was a single room," said Newman. "In the corner was a bed. And maybe a hot plate on the counter. But no shower. Definitely no toilet. If you needed to pee—and to me this seemed wildly bohemian and romantic and writerly—you went out back and squatted in the grass."

Available to Eve when she didn't feel like squatting was the bathroom on the first floor of the main house. Only she used it sparingly so as to avoid run-ins with the other person then living on the Wilton Place property: a man named Sorenson.

To explain who Sorenson is, I'm going to have to tell the story of Eve's childhood, which was also, of course, Mirandi's childhood. The same childhood, radically different experiences of that childhood.

Now, if you listened to Eve, you'd think their childhood was out of a fairy tale. For parents, the brilliant Sol and the magnetic Mae. For godparents, Igor and Vera Stravinsky, better than fairy godparents because the Stravinskys' magic wasn't the hocus-pocus kind. And the family house on Cheremoya, which looked like any other from the outside, a Southern

272

California two-story Craftsman, was, on the inside, something rare and wondrous: the lemons Mae had picked that morning, arranged in bowls (Mae preferred lemons in bowls to flowers in vases), scenting the air; the blues records Sol had spinning on the turntable (Sol preferred Bessie Smith to Billie Holiday, dirty Bessie Smith to regular) scenting the air, too. It was a place where nothing bad could ever happen. Was, in short, charmed.

If you listened to Mirandi, you'd also think their childhood was out of a fairy tale. But bad things happen all the time in fairy tales, which, as every little boy and girl knows, are really horror stories in disguise. Sol and Mae, while doting parents, weren't always mindful ones. They could get distracted—by each other, by their art, by the art of their lives. This was less of a problem for Eve, self-reliant by nature, plus fiercely self-preoccupied. "Eve was not easy," said Mirandi. "She was like, 'Get lost. I'm reading.' She'd only put her book down for people who were really interesting—Lucy Herrmann or Edward James or Vera. Otherwise, forget it."

Mirandi's personality was softer, gentler. She was undefended in a way that Eve was not. She needed defending, in fact, from Eve. When she was a baby, Eve threw an electric heater into her crib. At the last second, Eve called for Mae, and she was saved. Her left hand, though, was incinerated, and required extensive plastic surgery. "To this day I can remember how surprised I was when I realized that she was actually on fire and that it hurt and that I hadn't meant to hurt her," wrote Eve, "I'd only meant to dispose of her permanently."

In fairy tales, princesses and monsters abound. Mirandi, her affect so like that of the former—delicate, tender, pure of heart—had to contend with more than her share of the latter, Eve not the only she faced, Eve not even the only she faced in the house. "Daddy needed to be careful of his hands, and so he couldn't do much around the house, and so Mother went down to Skid Row and picked up this fixit guy," said Mirandi. "Mr. Sorenson. He lived in a shed out back. Oh, Mr. Sorenson."

Sorenson, dirty, derelict, without family or friends, embodies so many clichés about men who prey on children that he's practically an allegorical figure. When Mirandi was five, he started coming to her room on Saturday nights, invading first her ears—"He wore clogs, I could hear the sound they made on the floor"—then her nose—"He always smelled like apricot brandy"—then her doorway, where he would stand and masturbate—"I was too young to know what he was doing, but that's what he was doing." When

she was seven, and taking zither lessons from him in his shed, he raped her orally, this after failing to rape a neighbor boy anally while she looked on in horror. "Mr. Sorenson said he'd put one of my kittens into a sack and beat it to death with his shovel if I told anybody, so I didn't. Not even Mother."

Fortunately, Mirandi, in addition to being a waif and imperiled, was also a plucky kid and resilient. She said nothing to Mae about what Sorenson had done, but she did tell Mae she hated him. And Mae, baffled, let her quit the zither lessons, which got her out of his shed and clutches.

Sorenson's preference was plainly for prepubescents, but he made do with an of-age Eve when the opportunity presented itself. "It was right before the family left for Europe," said Mirandi. "Evie had just turned eighteen. She'd been out that night with Brian, and she'd been, you know, *with* Brian—she was still wearing her diaphragm—and she'd been drinking heavily. She snuck in through the window and passed out in her bed. Mr. Sorenson came in after her. She thought it was Brian and so she participated in the sex until she realized it wasn't Brian."

Eve woke up in the morning confused. She knew something had been done to her, but she wasn't sure what or by whom. "When Eve told me about it," said Laurie, "she told me that it was some guy she knew from Hollywood High, Wolf Santoro, Mamie Van Doren's boyfriend. She said he'd climbed through the window and fucked her. You know, consensually."

And then Mae made a discovery. "Mother found a clog footprint outside Eve's window," said Mirandi. "And Eve remembered the smell—that apricot-brandy smell. Mother told Eve not to tell Daddy. Or me. But of course I found out in about twelve minutes. Eve told me on the plane ride to France. I just started throwing up and couldn't stop."

For Eve, there seems to have been a break in the chain of cause and effect with regards to the Sorenson rape. Meaning, I don't think it had much of an effect. (The only rape she mentions in any of her letters is the near rape that occurred in New York City in 1966.) Her behavior before it and after it strikes me as consistent, of a piece. Maybe she was able to brush it off because she retained no clear memory of it. Or maybe she was able to brush it off because it happened to her not as a child but as a young woman, when she'd already had experiences with men and so the experience with Sorenson wasn't formative. Or maybe she was able to brush it off because it was her temperament to ignore or reject that which

wasn't in her interest to notice or accept. In any case, it scarcely disrupted her flow or emotional reality.

For Mirandi, on the other hand, the effect of the Sorenson rape was profound, woeful. "I started lying. And I'd steal from the local five-and-ten. I didn't need to steal. Mother always gave me money for comics and candy and things like that. But it made me feel good to steal because it went with my image of myself—a bad girl disguised as a good girl."

Shortly before Eve returned to Wilton Place, Mae received a call. "It was Mr. Sorenson," said Mirandi. "He knew he was sick. A heart condition. And he knew that somebody had to take care of him, and that it was going to be Mother. And—and this is very strange—it was Mother who was on his bank account. He was so cheap that he'd held on to every penny of his social security, so he had something like eighty thousand dollars socked away. And Mother had her eye on that money. Now, Mother didn't know what Mr. Sorenson had done to me. I didn't tell her until much, much later—in the early nineties when I'd left rock 'n' roll, left concert promotion, and was sober and studying to be a therapist. And when I did tell her, she was desperately miserable about it. But she said something to me I'll never forget. She said, 'Well, I murdered him for Eve, so I guess I murdered him for you, too.' My jaw dropped to the absolute floor because, up until then, she'd been in complete denial. I mean, when she and Dad came back from Europe, Mr. Sorenson started living in their house again, the house on Bronson. I guess she'd managed to convince herself that Eve was loaded and imagined the rape. But at Wilton Place, she confronted him. She said, 'You're going to die in hell for what you did.' And he knew he deserved it. That's why he left her the money, I believe. So, what Mother did is, she baked him. She stuck him in a stuffy trailer in the backyard, and it was summer, and that trailer was like a sweatbox. It got so hot, and he couldn't move or get out of bed with his bad heart, and she knew he couldn't, and she let him die."

Mirandi told me this story while we were on the phone. We'd been going over, line by line, Eve's 1977 letter to Joseph Heller. Had reached the litany of hardships Eve was living with but not writing about, including "my grandma dying of cancer next door." I read those words out loud and, suddenly, a memory dislodged itself in Mirandi's brain: Sorenson moving into Wilton Place after Agnes's death, Mae taking her revenge on him for atrocities committed decades before.

Mirandi finished talking, and I don't think I spoke for a minute at least. The scene between Sorenson and Mae was so awful and so thrilling, so thrilling in its awfulness. It was an American *Crime and Punishment*. *Crime and Punishment* if it were written by a pulp novelist—Jim Thompson or James M. Cain. The lurid lyricism and filthy-animal behavior were pure Thompson, the final cheaply ironic twist pure Cain: Mae, with her gentle manners and poetical sweetness of disposition, a stone-cold killer.

As soon as Mirandi and I hung up, I called Laurie, relayed to her the conversation I'd just had. When I was done, she repeated the word, "No," five or six times in rapid succession, then sighed heavily. "Okay, Lili, Mirandi's story about Mae cooking Sorenson—I just don't think it's true. When it came to caring for people, Mae was a fucking saint. I used to call her the foul-weather friend."

"But don't you think it's suspicious that he died on her property in the middle of a heatwave?" I said.

"No, not really. Sorenson was the old family retainer, and he was dying, and Mae didn't want him dying alone. He died on her property because that's where he died. The fact that it was hot summertime is neither here nor there."

Now it was my turn to sigh. "I should've known the story was too good to be true," I said, trying to hide my real disappointment behind the pretense of it.

Laurie made a shrugging noise.

"Well," I said, "do you think Mirandi thinks the story is true?"

"Oh, Mirandi more than thinks the story is true, Mirandi needs the story to be true. She needs Mae to have made Sorenson pay for what he did to her. But I know that my mother never wanted to make any of the men who did things to me pay. I was molested when I was four by the janitor in my nursery school. He put his penis against my leg and came down my leg. I didn't know what he was doing. I thought he was peeing on me and that it was disgusting. And my mother took me out of the school because the people there didn't believe me. What my mother told them was that the janitor needed psychiatric help. That was her reaction—to get the guy a doctor. She wasn't looking to retaliate, and neither was Mae. Women like my mother and Mae, women of that generation, they just accepted that men did things like that sometimes, and you either put up with it or you dealt with it in whatever way you could."

"Why couldn't Mirandi just be angry with Mae?"

"Mirandi talks a lot about how abusive Eve was to her when they were little. And Eve *was* abusive to her. But when Mirandi would go to Mae, Mae would say, 'Toughen up.' And later on, when Sol got those grants, Mae pulled Mirandi out of high school. That's a terrible thing to do to a kid. Mae loved Eve and Mirandi. She loved Sol more, though. And she felt that going to Europe was something Sol needed. And then there's Sorenson. Sorenson was a creep, a total creep, but Mae refused to see it because she wanted to have a handyman around. Mirandi was enormously resentful about all this, and I don't blame her. So, yeah, that's what I think is going on with the Mae-cooking-Sorenson story. I think Mirandi invented it to make Mae the mother she would've liked Mae to have been."

"Is it possible," I said, picking my words slowly and with care, "that Mae let Mirandi think she killed Sorenson so that—"

Laurie interrupted me, impatient. "No."

"But it could have happened."

"Not in my opinion, okay?" And when I didn't respond, "You just said that what Mirandi told you was too good to be true, and it is."

I nodded. But not immediately or definitively. Nodded hesitantly, reluctantly.

Laurie groaned. "What's wrong?" she said.

"Well," I said, "what Mirandi told me and what you're telling me are in direct conflict. I'm trying to figure out a way to reconcile the two."

"Then you're wasting your time. The two can't be reconciled."

"But—" I started.

"No, they can't be."

"So what am I supposed to do?"

"It's simple."

"It is?" I said.

"Yeah, tell both versions—Mirandi's and mine. Let the reader decide."

Which is exactly what I'm doing, Reader: letting you decide.

If no longer having to share a washcloth or toothpaste tube with the man who'd forced himself on her when she was an unconscious teenager was a relief to Eve, she didn't show it. Maybe she was incapable of showing it at

this point. "Eve was as off the deep end with the coke at Mother's as she was at Femmy's," said Mirandi. "She was drinking, taking pills—Valium mainly. She was just getting sloppier and sloppier, sloshier and sloshier."

So sloppy and sloshy that she nearly set herself on fire. "I went to spend the night with Eve when she first moved into that garage apartment behind her folks' house," said Paul. "I got there and her bed was a bed of charcoal. She'd thrown a fur coat I'd given her over a space heater at the base of the bed and it caught fire. She would have died because she was dead drunk, but Mae saw it or smelled it and threw water on it, and Eve was okay. I was horrified by the bed. Eve was pissed I'd noticed."

Eve was avoiding that bed even when it wasn't aflame. A recollection of Bonna Newman's:

I'd gone to film school, and decided I wanted to work for Francis Ford Coppola. Fred Roos was at Zoetrope [Coppola's production company], and I became Fred's personal assistant. He had this little house in Benedict Canyon, where I was living, too. The job didn't pay much, but I did get room and board. The room I was in—well, you know that Harrison Ford was Fred's carpenter, right? The closet in my room, which Harrison had built, had these sort of louvered wooden doors, doors that were on a track. They were hard—I mean, really hard—to open and close. I used to curse Harrison's name every time I had to get dressed. Anyway, on the nights that Eve couldn't stand to be at home, she'd come spend the night at Fred's. I'd make the three of us dinner. Afterward, she'd go upstairs with Fred. She might have slept in his bed, or she might have slept on the couch in his office. That wasn't clear to me. But I do know she was a wreck. Her dad was very ill. And my sense is that she arrived looking for comfort, not sex, and Fred was an old friend.

Sol had been in sharp decline since 1977. By January 1982, there was no lower he could go. "Dad was only seventy years old, but he looked ancient," said Mirandi. "Huntington's had turned him so skinny—and so crazy, my God. He refused to take antibiotics. He was convinced they were bad for him. But his teeth were giving him problems. He went to his dentist and his dentist said, 'You've already had one episode with

endocarditis. If you get it again, it'll kill you. You must take antibiotics every time you have your teeth worked on.' And so he snuck around to find a dentist who didn't know his history, had work done without antibiotics, and, lo and behold, got endocarditis. We rushed him to Hollywood Presbyterian, where basically his heart failed and he died. But they brought him back around. He was in the hospital for weeks. Finally, they let us bring him home."

Where Eve made sure she wasn't. "Sol was lying there in the living room," said Laurie. "He kept saying, 'Where's Evie? Where's Evie?' No one knew."

This wasn't the first time Eve had pulled a disappearing act during a family crisis. "It was like when Mother had that kidney stone and had to go to the hospital in Florence in 1962," said Mirandi. "Eve wouldn't visit. Not because she didn't care. But the idea of Mother sick, of Mother possibly dying—she couldn't handle it. That's why Dad let her go to Rome by herself. He knew she needed to run away. And it was the same when he was dying."

Mirandi was sympathetic to what Eve was going through, but her sympathy had its limits. "Mother was collapsed in a pile in the corner, drunk. And I was tending to Dad all by myself, managing the nurses. I tracked Eve down and I slapped her and said, 'You have to go see Daddy.' And thankfully she did go see him because he had just a few days left."

Eve and Sol.

Sol died on February 19, 1982. The cause of death was listed as endocarditis, but it was Huntington's that killed him.

Only Sol didn't have Huntington's. Or so said the doctors. "Mother donated Dad's brain to a foundation at UCLA that was doing research on Huntington's," said Mirandi. "It was such a rare condition that they wanted to study his brain. But then we were told by these people that his brain showed no sign of Huntington's. Actually, I was the one who took the call from that guy, the UCLA doctor guy. He said that the Huntington's diagnosis was a misdiagnosis—he was definitive about this—and that there was a tumor on Dad's brain, and that was it."

Medically, factually untrue. Eve got Huntington's, and the only way a person can get Huntington's is from a parent. Therefore, Sol had Huntington's. And the doctors knew Sol had Huntington's. So why did they suddenly start pretending otherwise? Mirandi has a theory. "Eve and I were still in our thirties in 1982. What I think was going on was that Mother didn't want us worrying all the time that we were maybe about to get this awful, terrible disease. But Mother knows me, and she knows I'm going to dig to find out what the hell is going on. So she got somebody at UCLA— and Mother was working at UCLA at the time, in the research library—to call and pretend to be a doctor and tell me it wasn't Huntington's. I mean, she could sweet-talk anybody into anything. And it worked. I completely swallowed it, and so did Eve."

No sooner was I off the phone with Mirandi than I was on the phone with Laurie. I wanted to run what Mirandi had said by her, get her reaction. "Sounds right to me," she said. "It was absolutely in Mae's makeup to lie about the Huntington's. Mae was the first person to say about some unpleasant thing she couldn't change or help, 'Yeah, let's forget about that. Let's just not think about it.'"

It was three months after Sol died that Eve pulled herself out of the self-destructive spiral she'd been caught up in since the late seventies. "'Eighty-two was a big year for the family," said Mirandi. "First Dad went, and then Art [Pepper, Laurie's husband], and then Evie got into AA." Before Eve could get into AA, however, *L.A. Woman* had to come out.

And now, a few unkind words about *L.A. Woman*:

With *Sex and Rage*, a novel, a roman à clef, a bildungsroman, Eve made a mistake. With *L.A. Woman*, also a novel, also a roman à clef, also a bildungsroman, Eve doubled down on that mistake. *L.A. Woman* even has the same weak-sauce plot as *Sex and Rage*, only further diluted: L.A. girl artist falls in with a fast crowd; gets her heart broken, her illusions shattered; and then reinvents herself as a (screen)writer. It's a depleted book. A lazy book, as well. And Eve should've known better than to publish it.

And Eve knew she should've known better. "There was a review of *L.A. Woman* in the *Times*," she said, "a horrible hideous pan by that P. J. person [P. J. O'Rourke, "Not a Bad Girl but a Dull One," *New York Times*, May 2, 1982]. See, I was sure I'd written a book so wonderful I'd never have to do another thing in my life, only apparently I hadn't. Which meant I needed to clean up my act."

And so she did.

On May 23, 1982, Eve faced the dragon of her addiction. She got sober, and not a minute too soon. "She was having these close calls," said Mirandi. "There was that fire she started with the heater and her fur coat. Then, just after Dad died, Michael Elias and Steve Martin got together money to put her up at the Chateau Marmont—you know, so she didn't have to be at home. She was staying there, and she phoned a friend and said, 'I've overdosed. Can you come?' The Chateau then had this house doctor who'd give you whatever drugs you wanted. This was right around when John Belushi was doing himself in with drugs at the Chateau. So, the friend rushed over and rescued Eve. Eve was killing herself. I mean, she wasn't trying to kill herself. She wasn't suicidal. But she was killing herself anyway."

Eve was killing Eve the person to give life to Eve the writer, just as she always had. And then it dawned on her that maybe Eve the writer was no longer worth the sacrifice. "Eve wasn't able to manage it anymore—the drugs, the alcohol, the sex, the scene, all the things that she imagined fed her writing," said Mirandi. "And when *L.A. Woman* came out, and it didn't work any better than *Sex and Rage* had, she must've thought, 'I ate up all that cocaine for *this*? I'm running myself into the ground for *this*?' And then she got a reprieve—well, two reprieves. Mother gave her the belief that Huntington's wasn't a factor after all. And Dad passed. And, you have to understand, it was Dad she was playing to, Dad she'd been playing to."

So it was Sol all along. He was the goad and the influence. It was his approval she was trying to win, his attention she was trying to hold.

"Eve was being 'Eve,' doing her whole spectacular thing for Sol," said Laurie. "One day, Sol was in the house with a friend. Mirandi walked in and he said, 'That's my daughter, but she's not the one.' *She's not the one?* What a devastating thing to say! I told Eve about it, and she said, 'Yeah, well, it's not so great when he likes you either.' So, yes, Eve wanted to impress those other people, people like Joan and Earl. But it was Sol she wanted to impress most of all. You have no idea how important he was in our family. Sol was the judge. Sol's word was *the* word. Then Sol was dead and Eve didn't have to be spectacular anymore. She was free."

The End

It was when Eve went to her first AA meeting that she broke once and for all from Joan and Earl McGrath. "I had to get sober at forty," she said. "Well, almost forty, thirty-nine, close enough."

Breaking from them wasn't something she wanted to do. "I tried to get Joan to go to AA with me. I mean, her thing about AA was that it was too smoky—that was her complaint. She must've gone to one meeting, decided it was too smoky, and decided she wouldn't go back. So, I finally had to abandon her and Earl. Because, you know, they were too seductive. They didn't realize how seductive they were."

I squinted skeptically at Eve. "You really think they didn't realize?"

"I don't know. Maybe they did realize." Eve let out a heavy sigh, then said, "Anyway, I knew I was doomed if I didn't get a new idea of glamour."

Earlier in the book, I quoted this line of Joan's from *The White Album*: "Many people I know in Los Angeles believe that the Sixties ended abruptly on August 9, 1969, ended at the exact moment when word of the murders on Cielo Drive traveled like brushfire through the community." If the Sixties ended in Los Angeles abruptly on that date, then the Sixties: Part Two—that is, the Seventies—began in Los Angeles abruptly on that date. And the Seventies ended in Los Angeles, equally abruptly, on October 30, 1982, ended at the exact moment when word of the strangling of actress Dominique Dunne by her boyfriend John Sweeney, sous chef at

Ma Maison, a popular West Hollywood eatery, traveled like brushfire through the community.

That the ante could be upped after Manson seems impossible. Yet somehow it was. Sharon Tate and those at her house were friends of the Franklin Avenue people, Dominique Dunne was family of the Franklin Avenue people; and killings that were close to home had become a killing that was inside the home.

And so the Götterdämmerung was complete. The Seventies were well and truly finished, which meant the Sixties were well and truly finished. The Franklin Avenue scene, too. The scene itself had, of course, been finished since 1971, but now even the reverberations were finished.

Done and dusted. Over and out.

The murder of Dominique Dunne, twenty-two years old, serves as a historic marker, a dividing line between past and future, and it's instructive, I think, to look at where Joan and Eve were when it happened.

First, Eve and where Eve was:

"Eve and I cohosted a Halloween party at Ports in 1982," said Colman Andrews. "Though, frankly, if I didn't know for a fact that it was 1982, I would've said 1978 or 1979. When Eve and I started spending all this time at Ports years before, we were both living right there. Eve was on Alta Vista, and I was on Fountain, which Alta Vista dead-ends into. But in '79, I got married, and my wife and I moved to the Westside. Eve had also left the neighborhood. By '82, I wasn't going to Ports very often, and Eve was going to AA. Anyway, the party wasn't on Halloween night. It was a few nights before. I don't remember what Eve wore or how she acted or the mood she was in, but I do remember that Ed Begley Jr. came dressed in a rabbit suit. What I remember most, though, is that Dominique Dunne was there with John Sweeney. Eve must've invited Dominique, who was kind of an up-and-coming star after she did that scary movie—what was it called? *Poltergeist*? Eve would've known Dominique through Dominique's aunt, Joan. Or it could be that I invited John. I'd taken a class he taught at Ma Cuisine, the cooking school next to Ma Maison. I still have a recipe he gave me. I didn't know him very well, but he seemed like a nice guy and was entirely presentable. He and Dominique struck me as an ordinary

happy young couple. They certainly didn't seem like they were breaking up, or that there was any conflict at all. It was only a few days later that he choked her. God, that was awful."

Or maybe what Eve was, not where Eve was, is the question to ponder. She was a ghostly presence at a ghostly party, a party that was attended by a girl who soon would be a ghost, a party that was a holdover from an era gone by.

And yet Eve made it to the next era. She survived. Survived the times, survived her own insanity. But at a price.

"Eve's existence was just so unhinged," said Laurie. "She believed it had to be that way for her to be a writer. She told me she didn't think she could write sober. And she never had. Even when she was a teenager working on *Travel Broadens*, she was taking all those diet pills—speed, basically. She believed drugs were what made it possible for her to create. So, when she decided to get sober, she was making a very conscious decision, and that decision was to live, even if it meant"—a delicate pause—"not necessarily writing."

And now for Joan and where Joan was:

With Dominique's father, Nick, in a bad place. There'd been tension between the two ever since he decided that she'd exposed him in her second novel. (The character of BZ wasn't just her portraying him, after all; it was her portraying the him he was trying desperately to hide from the world.) And that tension hadn't abated in the ensuing years. Nick, tormented over his sexuality, had started abusing drugs and alcohol. By the late seventies, he was living alone in a cabin in Oregon, exiled from Hollywood, where Griffin was thriving. (Griffin wasn't yet a full-fledged leading man—that would happen in 1985 with Scorsese's *After Hours**—but he was already a

* Pauline Kael, who'd loved much of Scorsese's earlier work, loathed *After Hours*. Griffin she'd single out for special negative attention. "[Griffin Dunne] becomes repetitive very fast," she wrote. "Whirling around impishly, he may remind you now and then of Dudley Moore, but it's Dudley Moore without his resourcefulness . . . Dunne makes you think he's got a gopher inside him." Griffin, an avid Kael reader, could quote her review practically verbatim almost forty years later. ("A poor man's Dudley Moore, she called me!") When I told him that there was a solid chance Kael didn't mean what she said, that she was probably just using him to settle a score with his aunt, he looked so happy that, for a second, I thought he was going to jump across the table and kiss me.

player. "My dad really was down and out," said Griffin. "He'd helped Joan and John when they came to L.A. and needed help. And now he needed help, and he felt they didn't reciprocate."

In a 1979 letter to editor Michael Korda, Nick wrote:

> The most difficult area for me to discuss, and I'm not a bit sure that I will, except in the confidence of this letter, is the resentment that I bear my brother and sister-in-law, John Gregory Dunne and Joan Didion. Their dazzling success has spotlighted my failure, the two states being concurrent exactly . . . Once Joan based a character on me, the part of BZ in 'Play It as It Lays,' the bisexual film producer with the rich wife . . . and a house in Malibu where his masseur [Ed. note: "masseur" is Nick code—and BZ code—for "hustler"] came for Sunday lunch. That was me, and I cast Tony Perkins to play the part when I produced the film, although I didn't realize it was me until a couple of years later because she told me it was based on someone I know called Myles Lowell [an L.A. society figure], who didn't bear any resemblance to the character at all, although I believed her, because I hadn't a clue at that time how I must have appeared to other people.

If Joan's relationship with Nick was strained before October 30, 1982, it was broken after. And not for the obvious reason: that Dominique would never have met her killer but for Joan and Dunne. "Joan and John asked my sister to lunch at Ma Maison, where they were regulars," said Griffin. "They'd folded Dominique into their social life the way they did me, though not my brother Alex. Alex was, I guess, a little more awkward. So, after Joan and John finished eating, they left Dominique alone at the table to, you know, work the room, table-hop. And that's when John Sweeney swooped in. He was this big, bearded guy in a chef's apron, and he came over to Dominique and asked her if she'd liked her dish, which he claimed to have cooked—he was full of shit, Wolfgang Puck cooked it—and that's how they started up."

In 1985, writer Joyce Wadler found herself spending a lot of time with Nick, who'd reinvented himself post–Dominique's death. Reinvented himself not only as a journalist covering high-profile murders. (Tina Brown published his piece on the John Sweeney trial in *Vanity Fair*'s March 1984

issue, launching him.) Not only as a crusader journalist covering high-profile murders. (He was always on the side of the victim.) But as a celebrity crusader journalist covering high-profile murders. (Usually he was even more famous than the famous people he was writing about.) "Dominick—that's what he was calling himself when I knew him, Nick was his old name, his Hollywood name—was in Providence for Claus von Bülow's second trial," said Wadler. "I was there for *New York* magazine, he was there for *Vanity Fair*. He was lovely and generous. We had very different feelings about the trial. For me, it had entertainment value. I looked at Claus and thought, 'God, this guy's great. He never goes out of character.' Whereas when Dominick saw Claus, he saw a murderer and did not joke about it. So, he and I were together for weeks, and we had dinner night after night. That's when he told me that awful thing about Joan. He was really appalled by what she'd done."

The awful and appalling thing that Joan had done, according to Robert Hofler's 2017 biography, *Money, Murder, and Dominick Dunne*:

> People often asked Dominick about [Joan]. "You want to know what Joan is really like?" he would say and then tell the following story. The day after John Sweeney's attack on Dominique, John and Joan arrived at Lenny Dunne's house to offer their support before Dominique was taken off life support. Due to her critical condition, the family decided early on to use one phone line in the house to make calls and to keep the other line open in case the doctor or police called. Shortly after asking if there was anything she could do, Joan Didion retired to the master bedroom to place a call on the outgoing line. She closed the door. Later, needing to use the telephone, Dominick walked into his ex-wife's bedroom. There, he found his sister-in-law on the bed, the phone clutched between her neck and shoulder, a pen in hand. Galleys of her next book, *Salvador*, littered the bed spread. She was on the phone with her editor in New York. Joan looked up at Dominick. "Yes?" she asked.

In my mind, this scene between Joan and Nick plays like the final scene of *The Godfather*, with Joan as Michael Corleone and Nick as Kay Corleone. Kay is looking into the office of Michael, who's just lied to her about his role in the murder of his sister's husband. She watches as his capos

pay elaborate tribute, embracing him and covering his hand in kisses, until one of them closes the door in her face. In allowing Kay to be shut out, Michael is allowing his humanity to be shut out. He's no longer Michael. In fact, he's no longer a person at all, he's a personage—the Godfather.

It was the same for Joan. She was now a writer before she was an aunt or a sister-in-law or even a wife. (If Eve had turned into her own ghost, then Joan had turned into her own aura.) And for the writer, the pages could not wait, the show must go on, no matter that a girl was dying in a hospital bed a few miles away.

And so, as the Seventies became the Eighties, Eve was headed in one direction, Joan another. They'd had an identical choice—the life or the work—and they chose opposite.

CHAPTER 24

Montage

The previous chapter came to a close in the fall of 1982, where this chapter is picking up. Eve, thirty-nine, is at the dead center of her life. She'll be doing her thing on our big blue planet for another thirty-nine years. Which puts her at the halfway mark exactly. Yet somehow that's not where she is, somehow she's at the beginning of the end. (Isn't that so like Eve, a creature of extremes, to skip the dreary middle, just sidestep it altogether?)

After 1982, nothing happens to Eve. Or nothing much. The key works have already been written; the key fights already fought; the key love affairs already consummated; and the key turning points—save one—already turned. The narrative suddenly loses its drama and tension, goes slack, and her story becomes just a chronology of facts and events, another tale of time passing. Until 1997, when she sets herself on fire. (The fire is that last key turning point.)

So, my plan is to do what they do in the movies: Fast-forward with montage. Cover the fifteen years between 1982, the year she got sober, and 1997, the year she got burned, with an assortment of moods, moments, and impressions. Make a long, dull period feel short and (comparatively) lively by condensing. Sacrifice temporal accuracy to energy and impetus.

Here goes.

Once Eve committed to the straight and narrow, she found herself at loose ends. It wasn't only her behavior that needed modifying, it was her

instincts. Since birth, she'd had a propensity for jumping on the tiger's back, throwing her body on the live grenade, and now she was eschewing tigers, eschewing grenades. Which meant she wasn't quite she.

British-born, L.A.-based designer Paul Fortune noticed. "When I was with Lloyd [Ziff] and Eve was with Paul [Ruscha]—this was in the late seventies—the four of us would go on these excursions," he told me. "We'd slip a Dimitri Tiomkin soundtrack into the tape deck and drive downtown on rain-slicked streets to get to some weird bar out of *The Big Sleep*. Or we'd stop by Paul's apartment on Western Avenue. He had a sculpture of a hand by his door and in the palm were Quaaludes. We'd take a couple, then catch the Starlight express, spend the weekend in Seattle. And Eve was so much fun. She was happy to do drugs, have sex, go on these strange little adventures. And her writing, it was good. She had that combination of European sensibility and trashy old-movie Hollywood that I love. She really nailed it with *Slow Days, Fast Company*. The things she wrote about in that book—I knew them, I *did* them. But it all seems so magical and mysterious now. Like a dream." Fortune went quiet, and a silence—contemplative, dense—swelled between us. It was he who broke it: "At a certain point, it all got to be too much for Eve. She had to reform or whatever you want to call it." A second silence. And then: "You know, there were these girls—these women—and they had it all, the life they'd always wanted. Then, one morning, they woke up and it was gone. And once it's gone, you can't bring it back. That was Eve in the eighties. You felt she didn't really know what she was about anymore."

Didn't know what she was about as a person. Didn't know what she was about as a writer.

"You have to understand," said Laurie, "Eve was an artist in her soul. The collages and album covers were an outpouring of that. So were the books. And she lived her life like it was art. The incredible evenings she put together, the incredible people she put together—that was art. And she wrote about sex masterpieces somewhere—in *Slow Days*, I think. Well, she created those, too. In everything she did she was an artist. But so much of that was over once she got sober. For a couple of years, she didn't even try to write. She still had her eye, though."

And that eye homed in on one of the biggest books of 1985. "This is the novel your mother warned you about," she proclaimed on the jacket of

the hardcover edition of *Less Than Zero*. And she went on to compare its writer, twenty-year-old Bret Easton Ellis, to a paragon—*her* paragon—of Dionysian excess and youthful rebellion: Jim Morrison.

There are more ironies than can be counted in the fact that Eve was an early booster of Ellis, the spiritual child of Joan; and of *Less Than Zero*, a young-adult version of *Play It as It Lays*. (When I asked Ellis if he'd considered asking Joan for a blurb, he replied in a voice glitching in panic or horror, "Are you *kidding*? I hoped she'd never even see the book. It was such an homage to *Play It as It Lays*. God!")

Eve and Ellis met for dinner shortly after *Less Than Zero*'s publication. "She was very buxom, very flirtatious, great smile," said Ellis. "She wasn't a ditzy Southern California girl. She was almost a parody of that idea. And then, through the parody, this no-nonsense intelligence would come out. She laughed a lot and just seemed really friendly and was all over me in this nice way. I knew Joan through her daughter, Quintana, who went to Bennington with me. And, let me tell you, sitting around with Joan Didion is no picnic. It's the most awkward thing in life. Eve, though, was delightful, so warm and accessible."*

Eve's appetite for scenes hadn't dulled. And she understood that if she didn't want to return to her dissolute ways, she'd have to find a new one. Not that her old was there to go back to. Ports was also on the wagon now. "After Jock died [in 1980], everything changed," said Michaela Livingston,

* In 2020, Ellis had writer Gigi Levangie on his podcast. The subject of Eve vs. Joan came up, and he said, "It's interesting because there is a burgeoning school that prefers Eve Babitz to Joan Didion. I happen to have been—and still am—a massive Joan Didion fan. And I have a special place for *Play It as It Lays*. It's a very powerful, dark book. Joan Didion goes into hell. But, in some ways, it's easier to write hell than it is to write with that light, glancing, comic style [as Eve Babitz did]. I reread *Slow Days, Fast Company*, and, I have to say, that book is a revelation now. It's one of the greatest books ever written about L.A., and it may be the key novel of Seventies L.A." Ellis is Team Babitz. That's what he's saying, right? I'm not crazy? Now, this might just be him gassing and goofing, talking off the top of his head and on a whim rather than expressing a deeply felt change of heart. Still, that Bret Easton Ellis, who'd been so thrilled by Joan as a teenager that he based his entire style and persona on her, should switch sides, even momentarily, is an extraordinary thing. It's Eve's victory, of course. Wheedling wretch that I am, though, I can't help but take it as mine too.

Ports cofounder and Jock's wife. "No one drank like they did before, not after sparkling water was created."

Eve, too, had cultivated a taste for sparkling water. And what Ports once was to her—what Barney's, what Franklin Avenue, what the Troubadour—was what AA became. "AA was the social scene of all time," she said. "All of L.A. was there. And the last straw was different for everybody. My friend Connie said she had to fuck two midgets before she knew it was time to join."

It wasn't enough to just join AA, though. You had to join the right meeting. "The Rodeo Drive was my favorite. It was movie stars galore and a nonstop party. Bobby Neuwirth [musician, former road manager of Bob Dylan] ran it. He used to say he was in AA to recover from terminal hipness. Before AA his nickname was 'the Angel of Death,' because everybody around him kept going kerplunk."

Eve felt she was onto something good, and was, as always, eager to spread the word. "I had Evie as an example," said Mirandi. "Whatever she was doing—coke, alcohol, guys—I was doing a third of it, so I thought I was okay. I wasn't. It was Eve who pushed me into AA. I remember her saying, 'Come on, where else are you going to meet so many good-looking sober guys?'"

Part of AA's appeal for Eve was, undoubtedly, the primo pickup opportunities it afforded. (She and Paul were still together in the eighties. Loosely, though. Paul was engaged to a woman who wasn't her in 1982, again in 1985, is how loosely.) Just her luck that her primo pickup happened to be loaded. "I called him the Last Rock Star," said Eve of singer-songwriter Warren Zevon. "Warren wasn't actually in AA, but he should have been. I guess he came that night because somebody was trying to get him to go. He was addicted to heroin—heroin, Scotch, and the pork at Musso's."

Eve moved in with Zevon. "Warren was so wonderful and funny, but he almost did me in. If he went downstairs in an elevator, he'd come back up with a woman. He couldn't help himself. The only way I could stand to be with him was by going to Ashtanga yoga class every day. Ashtanga yoga is so horrible to do that when you stop doing it, you feel like you're floating on air. But after a while even that didn't work."

Maybe because his womanizing was the least of it. "Evie told me a story about how she did Warren's laundry and then he hit her," said Laurie.

As quickly as Eve moved in with Zevon, she moved out.

It was in the late eighties that Eve began to stir creatively. She and Michael Elias sold a script. "I can't think of the title," said Elias. "Whatever *Send in the Violins* translates to in French [*Envoyez les Violons*, 1988]. It was about an American in Paris. His wife leaves him and he gets back to life by playing the flute. They ruined it by making it a Frenchman in Paris." And short pieces of hers were appearing, scattershot but regularly, in places like *L.A. Style, American Film, Playboy.*

And then, in 1990, Terry McDonell, an admirer of Eve's work, took over at *Esquire.* For McDonell and *Esquire*—the March 1991 issue—she wrote the very splashy "Jim Morrison Is Dead and Living in Hollywood," an expansion of "Jim," the reminiscence she wrote for Joan all those years ago. It's one of her best pieces, the sole instance of her at the top of her game post-sobriety. "She did that Jim Morrison profile for us, and it was great, and people loved it, and I wanted her to do more," said her *Esquire* editor, Bill Tonelli. "It never occurred to me to assign her anything. I didn't feel like you could do that with Eve. I thought, 'What else has she lived through that she could write up?'" There was the Duchamp photo for one ("I Was a Naked Pawn for Art," *Esquire*, September 1992). The Chateau Marmont ("Life at Chateau Marmont," *Esquire*, January 1992) for another. Cielo Drive ("The Manson Murders," *Esquire*, August 1994) for yet another.

Eve's success at *Esquire* helped restore her confidence. She decided she was ready to attempt something longer. "I sent a manuscript to Vicky and am waiting to be rejected," she told Sarah Kernochan in a letter. "Erica called me up and insisted she be the agent if Vicky likes it. But I don't think Vicky will like it because it's [too] much of a mess."

Wilson, however, did like it. And, in 1993, she and Knopf brought out Eve's third collection, *Black Swans.*

The title piece contains the following passage:

Recently someone asked me when was the last time I was in a serious relationship, when I thought I might get married, and I said, "Oh, 1971. Before I got published and knew I was home free."

"Black Swans" is—obviously—about 1971, Eve's year of triumph and defeat, the year in which she became a published writer and had her heart snapped in two by Dan Wakefield, the cost, she believed, of becoming a published writer. In other words, it's a retelling of her origin story. And once again, Eve has excised Joan. Or at least obscured Joan, stashing Joan behind "a friend" and "she." Wrote Eve, "I [sent] off the piece about Hollywood High to one last editor, whom a friend had suggested, at a hipper publication; she'd sent the guy a note already."

And yet Eve can't keep Joan's name out of her mouth. Twice she references Joan in "Black Swans," both times unnecessarily. The first: "I wanted to look up to and admire men, not be like Joan Didion, whose writing scared the hell out of most of the men I knew." The second: "Joan Didion, who knew how to wear clothes, was too brilliant and great for anyone to write like and too skinny and sultry to look like." (Eve, as you can see, Reader, is as ambivalent about Joan as ever: the first reference is a kick; the second a kiss.) It's as if Joan is Eve's secret that won't stay buried because Eve won't stop digging her up.

Grover Lewis also makes an appearance. "Shep Welles," he's called. (Dan Wakefield, incidentally, is called "Walter," Eve exchanging the name of one pivotal boyfriend for another.) "[Shep] really was a cowboy, lean, with great cheekbones, the meanest laugh, and a great east-Texas accent," she wrote.

Lewis sent Eve a letter:

January 3, 1994

Dear Eve,

 I ran into our old pal Shep Welles not long ago on the Third Street Promenade. It had been years since we had last seen each other and we sat down at one of those little yuppie outdoor greasy spoons to catch up.

 We talked about, oh, shoes and ships and sealing wax for a while, and then your name somehow entered the conversation and we discussed your book Black Swans, which by chance we had both read recently.

"You came out rather well in Eve's title story," I remarked, signaling for the check.

"Well, yes," Shep agreed, dropping some coins for the tip. "But compared with what?"

"Oh, come now," I said. "Surely you're not impervious to praise, no matter how circuitous or concealed."

"I've always looked pretty good next to no-talent New York assholes," Shep said a little stiffly. "Or Boston, Omaha—whatever it was." He stood and stretched, and I noticed he was wearing point-toed Texas cowboy boots, just like he'd done in the 1970's. (I have a pair just like them that I haven't taken out of the closet for ten years, the times being what they are.)

"I'm writing my own account of those days," Shep said as we started walking toward Santa Monica Boulevard.

"Not fiction, I take it."

"Not if I can help it."

"Oh my. Wenner and Annie and Hunter and Eve and all those . . . ?"

Shep laughed and lit one of those unfiltered Camels he still smokes. "Overall, I guess I liked Black Swans well enough—but I preferred that one long story to anything else in the book. And not because I entered into it, either. Eve may never really know, but I was honored to publish her first story. At her best, when she's being truest to her gifts, she mixes tenderness and loss and a kind of dumb courage as well as anyone I ever read." . . .

"What are you calling your own book?"

"Goodbye if you call that gone," Shep said, waving and striding away through a congestion of baby prams. But I couldn't tell if he meant that was the title or he was just saying goodbye in his usual curious way.

Anyway, Eve, I thought you might want to know about our meeting and conversation. I guess I can safely say that Shep Welles thanks you and I thank you.

Best wishes,

Grover Lewis*

* This letter was found by Bonna Newman in a first-edition copy of *Black Swans* that she bought at a used bookstore in Venice in 2012. Also in the book: a pink Post-it with the words "'Walter' is Dan Wakefield. 'Shep Welles' is G.L." Eve must've given the book to someone, along with the cheat sheet. I wonder which someone. A someone who knew her well enough to know that "G.L." meant Grover Lewis.

Black Swans is a serious and worthy attempt, a marked improvement over *Sex and Rage* and *L.A. Woman*. It is, too, a kind of homecoming. Eve, I think, knew she'd made a wrong turn after *Slow Days* and was now trying to find her way back. (No more novels, just spurts from here on out.) In fact, the breadth and magic of *Slow Days* is precisely what *Black Swans* aspires to—and falls short of. The ease of *Slow Days*, the effortlessness, has been replaced by counterfeit ease, counterfeit effortlessness. Things that once came naturally to her no longer do. The strain and insecurity are palpable. As you read, you can almost hear her asking, *Is this okay? Am I getting by with this?*

"I keep thinking of Scott Fitzgerald," said Laurie. "I read *The Great Gatsby* a million years ago and I was overwhelmed by it. And, of course, there's *The Crack-Up*—wonderful, wonderful. But the book he was working on when he died, *The Last Tycoon*, I don't think is wonderful. It's like, time had passed him by. The world wasn't his anymore. That's what happened to Evie. She wrote that one book that was great, *Slow Days*. And my attitude is, why should people demand more of her? Look, Eve had this desperation when she was younger. It made her try the hardest she could—at painting, at collage, at album covers, and then at writing, which is what finally worked for her. Really, she tried so hard it almost killed her. She got sober, and the desperation was gone. And so it—her talent, or whatever 'it' is—was gone, too."

When I pointed out that Eve wrote *Sex and Rage* and *L.A. Woman* while still deep into coke and other drugs, Laurie threw up her hands. "So it was gone before she got sober. She was putting herself through hell when she wrote *Sex and Rage* and *L.A. Woman*. And you're right, they weren't anywhere near as good as *Slow Days*. So, yeah, she'd already lost it. She'd lost it, and she knew she'd lost it, but she kept writing, wrote *Black Swans*, because what else was she supposed to do? She was Eve Babitz, even though she couldn't be Eve Babitz anymore."

Yet being Eve Babitz had cachet again in Hollywood. She'd formed a new friendship. It was with actor Joshua John Miller, the trigger-happy twelve-year-old in *River's Edge* (1986), the baby bloodsucker in *Near Dark* (1987), now in his early twenties.

"Eve and I understood each other on the level of willing guilelessness when it came to Hollywood," said Miller. "Hollywood is a jungle, like John Huston said in that Lillian Ross book [*Picture*]. And in the jungle, you need to tread carefully. But Eve and I didn't. We didn't want to get jaded, get hardened, even though that probably would've been the smart thing to do. We wanted to stay romantic about Hollywood. Eve was doing some writing for *Vogue* then. And, because of that, she knew the young stars coming up— Ione Skye and Ione's Beastie Boy boyfriend [Adam Horovitz] and Norman Reedus, who was with the supermodel Helena Christensen then. They saw her as this kind of den mother, Earth Mother, sixties voluptuous iconic character. Why wouldn't they invite her to all their parties? And she usually brought me as her date. I remember Eve and I playing Celebrity—you know, the parlor game—with Ashley Judd and Matthew McConaughey. Playing Celebrity with celebrities is such a—I mean, talk about cognitive dissonance."

Miller was less interested in making the transition from child actor to adult actor than actor to writer. "I was young, and, I guess, horny for experience," he said. "And I felt I could live the literary history of L.A. through Eve. So, I'd just finished my novel, *The Mao Game*, which Eve had worked on with me. And I said to her, 'I'd do anything to have Joan Didion blurb it.' I was like every other L.A. homo writer—I wanted to be taken seriously. Eve said, 'Joan won't do it. She doesn't do anything. But why don't you send her your grandfather's picture of John Wayne [Miller's grandfather was Bruno Bernard, known as Bernard of Hollywood, photographer to the stars]?' I said, 'I don't know. Do you think I should?' She said, 'Yeah, send Joan the John Wayne picture with your book.' Well, I sent Joan the book and the picture, and she sent them both back with a note that said, 'I don't give blurbs,' and then told me to fuck off, basically. The undercurrent was, 'I don't respond to bribes, kid.' God, I was embarrassed! I was like, 'Thanks, Eve.' She just laughed. I'm not sure what the inside joke was but I'm sure she was making one. She was being mischievous. She wanted to get a rise out of Joan."

Old habits, and all that.

Not long after the publication of *Black Swans*, Eve noticed that something was off with Mae. "It was right around the time that O. J. Simpson killed his wife. My mother came into the room when the freeway chase was on

TV. 'What's this, darling?' she asked. I explained what was going on and she went blank halfway through."

Alzheimer's, early stages.

What else was different for Eve: Wilton Place, which had gone from a two-member household to a three. "Eve's old Hollywood High crony, Holly, was living with her and Mother," said Mirandi. "Holly had a rough time of it after high school. The acting thing never worked out. She was a hooker on Hollywood Boulevard."

"Like with a pimp?" I said.

A nod.

"Oh boy."

"And she was a junkie. Once Evie got straight, she went and found Holly, who was also trying to get herself straight and was in this fleabag dive of a sobriety house. Eve took her out of there and stuck her upstairs." Mirandi shook her head, let out a laugh that was like a wince. "Eventually Holly went back to school and paid for it by doing phone sex." Mirandi shook her head again, let out a laugh that was like a laugh. "She was good at it—those old acting skills."

What stayed the same for Eve: a change in scene. "I was with Eve when she got into tango," said artist Mick Haggerty. "To me [that world] was ghastly, about as crude and sad and frightening as possible. But not to Eve. She was having the time of her life. She projected enormous amounts of romance and fantasy onto things. She was an artist doing what she did. Her personal viewpoint was just so heightened. We'd be at some gruesome studio in Glendale or someplace, and I'd look at her face, and she was just entranced."

So entranced that she started writing a book about the L.A. tango scene. Was working on it, in fact, when she struck that match.

CHAPTER 25

Fire

April 13, 1997. A Sunday morning, warm even for L.A. Eve, Mirandi, Laurie, Laurie's mother Tiby, and Mae were having brunch at a restaurant in Pasadena called the Raymond. It was a double birthday celebration: Tiby's had just passed; Mirandi's was just around the corner.

When the meal was over, Eve walked to her car. Once behind the wheel, she took out a Tiparillo cigar and a box of matches. (Less weird than it sounds. In the nineties, women smoking cigars was the raging vogue—Madonna doing it on *Letterman*, Demi Moore on the cover of *Cigar Aficionado*.) She scraped a match against the side of the box. It burst into flame. A second later, so did she.

"She was wearing an Indian skirt, very, very thin, and it burned up like tissue paper," said Mirandi. "Her panty hose melted into the skin of her legs. She stopped the car and rolled on the grass and actually set the grass on fire. But she did manage to put herself out. Then she got back into the car and drove to Wilton Place. I was there because I'd taken Mother home. When she pulled into the driveway, I was talking to Mother's neighbor, Nancy Beyda. I saw Eve, and I was aghast. She was naked from the waist down, and the lower half of her was just this awful charred orange. She was clutching a wool sweater to her crotch, which, if you can believe it, is what saved her crotch. Good wool is hard to burn. 'It's okay,' she said to me. 'I'll put some aloe on it. I can still go dancing.' I guess she was

supposed to have some kind of date that night with Paul. I followed her into the house and called an ambulance."

Eve was admitted to the burn intensive care unit at L.A. County–USC Medical Center, where she promptly lost consciousness. Third-degree burns covered half her body. The doctors gave her a 50 percent chance of survival.

After undergoing two twelve-hour operations in which the skin from her scalp, back, and arms was grafted onto her groin, midsection, and legs, she endured the extraction of the hundreds of staples and stitches that were keeping the grafts in place; hallucinations from ICU-induced psychosis; bedsores that had to be removed with a knife. ("The sores were on my heels. The surgeon came in and gave me the tiniest bit of opium, and then he took out a knife. He used it like a melon baller to dig out the sores. Blood sprayed everywhere. I tried to scream but I was too in shock.") And all of this while kicking smoking. The doctors tried to help her cope with the withdrawal symptoms by giving her a nicotine patch, but they couldn't because there was nowhere to put it. Not a single inch of undamaged skin.

News of her condition spread far and wide. Joan and Dunne received it in New York, where they'd been living since 1988. "Joan did not want to move there but John insisted," said Susanna Moore. "I think he felt that they'd played out Hollywood. He wanted to be more a part of the New York intellectual world, which would've meant Barbara Epstein and Bob Silvers and the *New York Review of Books*. He felt it would be good for his and Joan's—what's it called now? Brand? It wasn't called 'brand' in those days, but that's what he meant. He and Joan were very, very good at that, very conscious of that. They realized, quite rightly, the importance of establishing their reputations—their worth, in a way. It's interesting to go from Franklin Avenue to Trancas to Brentwood to the Upper East Side. And all those moves meant something, you know. It was not haphazard."

The couple sent word through Michael Elias's fax machine:

We just heard about Eve Babitz's accident last night. Dan Wakefield, who we talked to this morning, gave us your fax number and said that you are visiting her at County. Could you please tell Eve that we are thinking of

FIRE

her, and give her our love. She's a tough number and she will not only endure, she will prevail.

John & Joan

This message was written by Dunne. (The language and tone are unmistakably his.) Joan signed off on it, though, and so bears some responsibility for its obscene heartiness, its sham cheer. Reading it, I flashed on Tennessee Williams comparing Joan to Marguerite Duras, an obvious surrogate for Eve, during an interview with Williams biographer James Grissom:

> I love [Joan Didion's] work, but I am aware that she is shrewd about her effects, her twists, her fillips, and her dry perceptions. While I feel that Duras has actually walked through a few fires, and now writes from the perspective of a singed victim, Didion has, perhaps, witnessed a few burn victims and shudders at the vision, wonders how it might have affected her, how the clothes scented with Lanvin smelled when the petrol met the match. Duras has seen the carnage; Didion resides on a hill, in a beautiful home with a good soup on the stove and keens about the arrival of carnage: Cassandra with a good haircut and the phone number of people at Paramount.

Joan's unblinking voyeurism: her tragic flaw; her saving grace.

Whether Eve would in fact endure, never mind prevail, was uncertain for a long time. "If you have third-degree burns, your nerve endings are gone, but I still screamed in pain," she told me. "I was always screaming in pain, morning and night, drugs or no drugs. If I sat up in my bed, it felt like I was sitting on crushed glass."

It's completely nutty, and makes perfect sense, if you, Reader, see the fire as fated, both factually improbable and imaginatively inevitable. There is, after all, something about Eve and fire, some eerie connection: she nearly killed her sister with fire as a child; nearly killed herself with fire as an adult (and this before she *really* nearly killed herself with fire as an older adult); and she was known for having had an affair with a rock star whose most famous song was called "Light My Fire." Fire was thus a running theme

301

in her life to the point that it was practically a running joke. Well, as the poet John Giorno said, "You've got to burn to shine."

Eve at the L.A. County–USC Medical Center.

After spending six weeks at County General, Eve spent two months at White Memorial, a rehab hospital. In late summer, she returned to Wilton Place. She was living as she'd been living all her life: on the edge and on instinct—a dicey strategy, especially as she aged. Sudden poverty was a scary prospect anytime, scarier when you were older. Her medical bills totaled more than half a million dollars, and she was, predictably, without insurance.

To raise money, Mirandi, Laurie, and Paul, along with several of Eve's friends, arranged a benefit at the Chateau Marmont. On October 23, 1997, an auction was held with works donated by, among others, Ed Ruscha, Ken Price, Kenny Scharf, Larry Bell, Billy Al Bengston, Dennis Hopper, and Annie Leibovitz. Even Jack Nicholson, whose assistant was Eve's old Franklin Avenue chum Anne Marshall, took part. He offered up the cowboy hat that he wore in the movie *Mars Attacks!* ("Jack and I didn't have sex, oh, but I loved him!") Steve Martin showed. So did Jackson Browne, Don Henley, and Ahmet Ertegun. "Ahmet was carrying a cane that had belonged to Victor Hugo," said Eve. "One of his French girlfriends gave it to him."

The benefit brought in $30,000. And that was on top of the $50,000 that Steve Martin and Harrison Ford had each already kicked in. (When Laurie

told Eve, still at County General, about Martin and Ford's generosity, she lifted her head. Through dry, cracked lips she croaked out, "Blow jobs," before collapsing back on the pillow.) Ertegun had also given lavishly. As had Jackson Browne and Bonnie Raitt.

And thanks to a fast-thinking Mirandi, Eve had yet more money coming her way. "I'd saved the burnt-up waistband of her skirt, pulled it right out of the trash," said Mirandi. "And Michael Elias showed it to a friend of his who just happened to be Larry Feldman, the lawyer who'd gotten Michael Jackson off for molesting that boy [Ed. note: actually, Feldman represented the boy, won him a twenty-five-million-dollar out-of-court settlement]. Eve's case was ridiculous—she didn't have one. There's no warning on clothes for adults that says, 'This garment may be flammable.' Eve hadn't even bought the skirt at a store. She'd bought it at a Goodwill. But the clothing company was scared to death of Feldman, so they settled for $700,000. $450,000 of that went to medical bills and legal bills. Eve was given a choice as to what to do with the remaining $250,000. She could either take it as a lump sum, or get paid two thousand a month for the rest of her life. She wanted the lump sum, but I was able to convince her that the two-thousand-a-month was a better deal for her. And it *was* a better deal for her because it helped pay for Anna, the lovely Jehovah's Witness who moved into Wilton Place to take care of her and Mother after Holly left."

According to family lore, the fire was Eve's last turning point. It did Eve in not only as a person but as a writer. Yes, *Two by Two: Tango, Two-Step, and the L.A. Night* was published in 1999, post-fire, yet it was written, all except for the epilogue, pre-fire. And, in any case, *Two by Two* wasn't much of a book.

When I was writing *Hollywood's Eve*, I accepted family lore unquestioningly. (Why would I question it? I had no reason to.) And in *Hollywood's Eve*, I cited the calling cards Eve sent to editors to let them know she was on the mend and back in business:

EVE BABITZ

BETTER RED THAN DEAD

Then I quoted Laurie telling this anecdote:

> When we finally took Eve home [from the hospital], she looked at us and said, "People think this will make me a better person. It won't."

And I followed up Laurie's anecdote with my own (rather heavy-handed) analysis of Laurie's anecdote:

> Eve was telling her family, in so many words, that she would not allow the catastrophe that had befallen her and changed her so utterly externally to change her a whit internally, because even to change for the better would be to change for the worse. It was a promise, and a defiant one.

So, basically, I was trying to squeeze every drop of pathos I could from the calling card, from Laurie's anecdote, because Eve was so obviously out of business, because Eve's defiance was so obviously futile.

The boxes in her closet, however, tell a different story, one that directly contradicts family lore. In the last box I opened, I found notes and outlines for two books, both of which she was working on after 1997: the first about Bonnie and Clyde, to be cowritten with novelist Eddie Little; the second about Russia. And then there were the forty or so pages of "I Used to Be Charming," her piece about the fire that she started many times, never finished. "She didn't get very far on any of those projects," said Mirandi.

Still, she had projects, had plans, had her eye on the future.

I found, too, a letter she'd written to the editor of the *Los Angeles Times* in 2000:

> Dear John Carroll:
>
> Steve Wasserman [writer] said you were looking for Los Angeles voices to do columns. It seems to me what the paper needs is some writers that cause such an uproar, people will have to read it in order to stay abreast of the edge. . . . Of course, what Los Angeles is really about is figuring out what the next big thing is, and hitting it at exactly that moment, so you ride in with the tide, home free. Maybe I could do a column called "What's Next," if that's not too presumptuous . . .

My last piece, "Trouble in Mind," was in <u>Avenues</u>. People who like
L.A. consider this piece their sentiments exactly.

Hope to hear from you soon.

Eve Babitz

The letter is vintage Eve. (The *Los Angeles Times*, by the way, would
turn down her offer.)

Also vintage Eve: a phone call she placed to a TV show on C-SPAN that
same year. The name of the show, *In Depth*. The episode's guest, Joan
Didion.

CHAPTER 26

A Friend from Hollywood

It was on May 7, 2000, that Joan appeared on *In Depth*.

The structure of the episode is as follows: a high-angle shot of a book-lined room in which Joan and the host sit as *Masterpiece Theater*–y–sounding classical music plays (to signal to the viewer that an elevated and enriching experience is about to be had); a brief introduction by the host in which Joan's most notable achievements are trotted out (to signal to the viewer ditto); an extended interview in which the host puts hard-hitting questions to Joan (Host: "Are you comfortable talking about your own writing?") and Joan gives point-blank answers, laying bare her hopes, dreams, fears, and character flaws (Joan: "Uhhh").

At last, the call-in portion begins:

HOST: Hollywood, you're next, hello.

 EVE: It's Eve.

JOAN: Eve, how are you?

 EVE: I'm fine.

HOST: And, Eve, who are you?

 EVE: I'm Eve Babitz, a friend of [Joan's] from Hollywood. I wanted to just say how great it is to see her on the air.

JOAN: Well, Eve, thank you.

 EVE: I don't know what to ask you.

JOAN (to the bewildered-looking host): Eve used to come to that house, that old house in Hollywood.

EVE: Yes. It was the first time I ever saw Spode china.

Joan laughs.

HOST: What is that?

JOAN (*laughing again*): It's English china.

EVE: And it was amazing to me because you seemed to be the only sensible person in the whole world in those days.

JOAN: Well . . .

HOST: In what way?

EVE: Well, you could make dinner for forty people with one hand tied behind your back, and things like that. Whereas everybody else was sort of passed out on the floor.

JOAN: Yeah, well, organization was very important to me at that time.

HOST: Baltimore, Maryland, you're next. Hello!

You can track down the clip on YouTube. It's worth the effort. There is, first of all, the fun of seeing Eve charm Joan in real time. (Eve makes Joan, cool as cool behind a pair of oversized sunglasses, break up twice with a single line: "Spode china.") There is, too, the fun of seeing what Joan and Eve must've been like together on Franklin Avenue, their dynamic, because they're reverting to their former selves, slipping into their old roles right before your eyes. Reverting and slipping, it should be noted, at Eve's instigation. She speaks to Joan in a kind of shorthand, a secret language, one made up of shared jokes and references and memories, so that they're having a private conversation in a public setting, cutting out the host, the audience, communicating just with each other.

We understand what Eve is in this moment, or, rather, what Eve is on the cusp of becoming: a wreck and a ruin; a cross between an undiscovered Norma Desmond and Hollywood's answer to Miss Havisham; a writer who no longer writes. (That she identifies herself as "a friend of [Joan's] from Hollywood" instead of as a fellow writer seems to me a tacit admission that she's given up. Compared to Joan I'm not a writer, she's saying without saying.)

We also understand what Joan is in this moment: a writer who's made it to the top; a writer whose talent, will, and drive are prodigious, outlandish;

a writer so potent in her writerliness that her name has practically become a synonym for the word "writer," "Didion" interchangeable with "writer" as "Kleenex" is interchangeable with "tissue." (Her reporter's packing list, the one we're told in *The White Album* she had taped to the inside door of her closet at the Franklin Avenue house—"2 skirts, 2 jerseys or leotards, 1 pullover sweater, 2 pair shoes, stockings, bra, nightgown, robe, slippers, cigarettes, bourbon"—is treated as a fetish object and guide to life. Young literary strivers study it with the same fanatic intensity that haruspices study the entrails of sacrificed sheep.) She grasped the concept of branding before branding was a concept.

And for Joan, there's been no slowing or slackening in the years since Dominique's death. She's kept up the relentless pace: in 1983, *Salvador*, nonfiction; in 1984, *Democracy*, fiction; in 1987, *Miami*, nonfiction; in 1992, *After Henry*, nonfiction; in 1996, *The Last Thing He Wanted*, fiction. Any time she has a new book out, it's noted deferentially, often fawningly, in opinion-shaping publications like the *New Yorker* and the *New York Review of Books*. So eminent a cultural figure is she, in fact, that she's receiving a career retrospective while in the midst of her career. And I'd bet that after 1979, she's given one thought to Eve for every fifty Eve's given to her. Eve is a hazy memory, a vague signal from the past, somebody she'd outdistanced and outclassed long ago. (As possible evidence that she saw Eve in exactly these terms, I cite an email Dan Wakefield sent to her and Dunne in 2003 in which he reflected on their enduring friendship. "Whatever comes, whatever goes," he wrote, "the sense of humor is the same. We three knew the dowager groupi[e]." Eve was being spoken of as if she were set in amber. For Wakefield, Joan, and Dunne, she'd remained Eve of 1971, the dowager groupie in perpetuity.)

That, at least, is the view of what Joan and Eve are from one angle. Our understanding shifts, however, if we look from another.

What Joan and Eve are from that angle: a single woman split in two.

Eve is Joan's ideal self. Earlier, I observed that the person Joan takes pains to present herself as in her writing—a person whose friends in high school were the flamboyant lowlifes hanging around gas stations; a person who believes that with enough courage, a reputation is de trop; and so on—is the person Eve actually is—the Thunderbird Girls; I USED TO BE A PIECE OF ASS, NOW I'M AN ARTIST; and so on.

Yet Eve is proof that being Joan's ideal self is unworkable if being "Joan Didion" is also your objective. Being "Joan Didion" means winning, not just once but over and over. Like a professional athlete, Joan keeps herself under tight and efficient control. And, like a professional athlete, Joan surrounds herself with people who'll aid her in achieving peak performance: Dunne, providing unstinting succor and support, plus editorial skills; Earl McGrath, and others of Earl McGrath's ilk—Michelle Phillips, Harrison Ford, Anne Marshall, and the rest—providing songs of experience; news of the times, the social ruckus, the passing circus.

This last service is, for Joan, the most valuable, I think. She requires handmaidens. Those who live the anarchic and inventive life she can't live. (A life of dull industry is the only life for her if she wants to reach the improbable goals she's set herself.) Those whose lives *are* their art. (Her art, in contrast, breaks away from her life, splinters off.) Those who will, wittingly or un-, enter into a collaboration with her by offering up grade-A source material. (Someone has to do the thing before she can stand back and take notes on the thing, after all.)

A thought, semi-stray, about "Jim," the Morrison piece Eve wrote for Joan but did not give to Joan: Joan dated "The White Album," in which Morrison figures prominently, 1968–78; and "Jim," though undated, was written in 1972 or 1973, and must've been intended to help Joan better understand Morrison as Joan wrote "The White Album." So what prompted Eve to reconsider her gift? Maybe Eve sensed that Joan's idea of collaborating was co-opting, turning friends into employees, and Eve didn't want to be co-opted or turned.

The best-case scenario for Joan's ideal self, i.e., Eve, is that she embraces the chaos, and reaps the benefits of embracing the chaos—spontaneity, energy, immediacy, humor—before the chaos swallows her whole. Which is, of course, precisely what has happened to Eve. She got *Slow Days* out of herself and then the doubts, uncertainties, anxieties, too much coke, and too many of the wrong kind of man got her. Not a chance was she going to have a consistently high-level, decades-spanning career as Joan did. (When Joan isn't on her game, as with *Miami* or *The Last Thing He Wanted*, she's still good. A book of hers might fail to catch fire, but it's sure to be made with care and craft; its structure solid, sturdy; its prose fluid, elegant. When Eve isn't on her game, as with *L.A. Woman* or *Two*

by Two, she's barely mediocre.) For her, losing wasn't just likely, it was inevitable.

If Eve is Joan's ideal self, then Joan is Eve's practical self. And the ambition of Eve's practical self is assured and effective. Ambition coupled with stamina. A winner's ambition.

Only here's the thing: Eve's practical self is, in the end, as much of a loser as Joan's ideal self. By the time of the C-SPAN appearance in the spring of 2000, Joan is, like Eve, washed up. Isn't that the point the career retrospective is implicitly making? That her career is, for all intents and purposes, over? That her best books have already been written? That she can now be treated with that grand-old-timer reverence we reserve for those who were once dangerous, surprising, vital, but are no more?

Joan and Eve couldn't be further apart, yet somehow they've wound up in the same place. (Remember: Hemingway and Marilyn are also seeming opposites—male, female; genius, bimbo; conqueror, victim—who wound up in the same place. Just as their fame coincided, so did their suicides.) And perhaps the career retrospective's point *should* be taken. After all, nobody can keep it up forever, and Joan hasn't had a book that's connected with the public, a genuine hit, since *The White Album*, now more than twenty years in the past. So, while she's being honored on *In Depth*, she's being put out to pasture, as well, told that she's both important and irrelevant. She'll have received this message loud and clear, even if it's inaudible and invisible.

And I'm sure it's killing her.

So, where do Joan and Eve go from here?

In both the letter to Carroll and the call to *In Depth*, Eve sounded as Eve-ish as she'd ever sounded, which suggests that the fire was a false last turning point. And yet she *did* become a wreck and a ruin, a Norma Desmond–Miss Havisham mash-up, and she *did* stop writing. If not in 1997, when? If not because of the fire, why?

The when is easy: 2001.

The why is a little more complicated as it's two whys converging. The first why is the onset of Huntington's, even if the disease won't be diagnosed until much later, 2020. The second why is Mae going into assisted living.

And, really, it's this double whammy—Huntington's + Mae—that's the true last turning point.

"Mother had deteriorated to such a degree with the Alzheimer's that she couldn't continue to stay at Wilton Place with just Eve and Anna," said Mirandi. "She needed full-time care. I arranged it with a lawyer so that Mother owned one-third of the house, Evie owned one-third, and I owned one-third. Then I sold the house. I paid the bills for the nursing home with Mother's share. And Eve used her share—$225,000—to buy her apartment on Gardner Street in West Hollywood. She didn't want to do it, but I just sat her down and made her."

This was the first time in her life that Eve would truly be living apart from Mae because Mae wasn't merely leaving Wilton Place, Mae was leaving Hollywood. "My husband Alan and I had moved to San Pedro," said Mirandi. "That was on purpose. I didn't want to be just down the block from everyone. I knew if I was, I'd be running over every five minutes to deal with somebody or other's problem, Eve's mostly. And when Mother went into a home, it was a home in San Pedro. I was the one who'd be looking in on her—Eve I knew wouldn't come—so I wanted it to be convenient for me."

Eve, Mirandi, Alan, and Anna bundled together Eve's clothing, furniture, appliances, and toiletries. They put them in Mirandi's car, along with the boxes of letters, manuscripts, artwork, and photos that Mae had already packed. (These boxes were Mae's final act as a preservationist, Eve the last neglected L.A. treasure she rescued from oblivion.) And then Mirandi drove the whole kit and kaboodle to Gardner Street.

Eve moved into her new apartment, and her life was effectively over.

Meanwhile, Joan, through the death of another, was about to be reborn.

On December 30, 2003, John Gregory Dunne suffered a massive coronary at the dinner table. (Joan: "John was talking, then he wasn't.") Dead at the age of seventy-one. A year later, Joan had a finished manuscript on her hands. *The Year of Magical Thinking* was her attempt, she wrote, "to make sense of the period that followed, weeks and then months that cut loose any fixed idea I had ever had about death, about illness, about probability and luck, about good fortune and bad, about marriage and

children and memory, about grief, about the ways in which people do and do not deal with the fact that life ends, about the shallowness of sanity, about life itself."

On August 14, 2023, David Thomson sent me an email:

Lili,

I can't remember if I told you this.

Once upon a time I was staying with Sonny Mehta [editor in chief of Knopf] in his apartment on Park Avenue.

He had just received the manuscript of Year of Magical Thinking. Like the day before. He has only read a bit of it.

But next morning he gets a call from Joan. She's fierce and almost desperate according to Sonny, asking, "Will it be a bestseller?"

D

Thomson's story shows what Joan was willing to do for the sake of her writing (anything) and what it cost her in a human sense (everything). When I said earlier that she'd crawl over corpses to get to where she had to go, I was, it turns out, speaking literally. *The Year of Magical Thinking* is her crawling over the corpse of Dunne, crying all the while, but still crawling, still getting to where she had to go.

The answer to the question Joan posed to Sonny Mehta was a resounding *yes*. *The Year of Magical Thinking* would spend twenty-four weeks on the *New York Times* bestseller list. It was not only her most successful work commercially—in excess of a million copies sold—but critically: finalist for the Pulitzer, winner of the National Book Award. She'd made those two incongruous things, the democratic fame of a popular hack and the aristocratic grandeur of an acknowledged literary genius, congruous at last.

For what it's worth, I don't like *The Year of Magical Thinking*. In fact, I hate it. I reject its fundamental narcissism. (It purports to be about Dunne, is really about Joan.) I reject, too, its fundamental dishonesty. (I believe Joan feels grief at Dunne's passing, but not only grief. To be alone was for her, I suspect, a kind of fulfillment—the answer to a wish or prayer—the same as it was for Eve.) And I reject its fundamental falseness. (Joan insists repeatedly that Dunne's death has left her raw and bleeding, an open wound. Yet, Dunne's death isn't just an experience she's lived

through, that is, an experience she has no choice but to undergo. Dunne's death is also an experience she's written about, that is, an experience she's elected to undergo. Which is to say, writing about Dunne's death is a deliberate act. A contrived act, as well, requiring calculation, detachment, exploitativeness—a thick skin, in short, what novelist Martin Amis accused her of having in the *London Review*.)

Moreover, I regard the book as a violation of her misanthropic integrity. If Joan didn't give other people a break, she didn't give herself one either. Was, in her best work—"Some Dreamers of the Golden Dream," "7000 Romaine, Los Angeles 38"—pitiless. Was, in her very best work—"On Self-Respect," "In Bed"—self-pitiless. Here, though, she's engaging in special pleading. ("Marriage is not only time," she writes, "it is also, paradoxically, the denial of time. For forty years I saw myself through John's eyes.") And lying by omission. (Not once does she mention Dunne's temper. "John was volatile," said Susanna Moore. "Very.") Lying by omission two times over. (Not once does she mention Dunne's alcoholism. Or her own. "They were both heavy, heavy drinkers," said Bret Easton Ellis. "Particularly later on. The last time I saw them was at a dinner at Elio's [New York restaurant], and Joan was just asking for a large glass of vodka, no ice.") *The Year of Magical Thinking* has to be art or it's unforgivable. And, to me, it isn't art.

But if it isn't art, if it's a career move and a public-relations gambit and a "that's showbiz," then I applaud it (while still refusing to forgive it). How can I not applaud it? More than applaud it, drop to my knees before it? Thanks to it, America's most compulsively self-referencing, self-fabulizing, self-consuming woman is able to transform herself into a national symbol of spousal grief. Our bereaved wife. Saint Joan. She's reinvented herself yet again, found a way to win yet again.

And to win yet again, and yet again, and yet again, and yet again, until she has no rivals, male or female. In 2009, she'll receive an honorary Doctor of Letters from Harvard. In 2011, an honorary Doctor of Letters from Yale. In 2013, a Lifetime Achievement Award from the PEN Center USA. (For a co-presenter, Harrison Ford, who'll reminisce about his stint as her carpenter. "To be part of Joan Didion's world gave me a sense of support and validation," he'll say from the podium.) That same year, President Obama, in a ceremony in the East Room of the White House, will hang around her reed-like neck a National Humanities Medal

that appears to weigh more than she does, and the crowd will erupt, go absolutely wild.

Post-*Magical Thinking*, she's on a serious hot streak. She simply cannot lose.

The phone conversation on *In Depth* was Joan and Eve's last encounter. They did, however, have one more near-encounter.

Fall 2005. Joan was on her book tour for *The Year of Magical Thinking*. She came to L.A. for an event. "I heard about it, and I thought I'd go," said Eve. "What I did was take the photos I'd taken of her and John and Quintana—the photos from the Trancas house—and got them blown up. I wanted to give them to her as a present. So, I went to where she was reading. I got there, but then I didn't go inside."

When I asked why not, Eve looked at me, looked away. "Too sad," she said.

"Too sad."

There was no such thing as too sad for Joan. The most exciting moment in Griffin's documentary— and the moment is more than exciting, is electric—comes when he asks her about San Francisco, 1967, being a journalist

in the room with the little girl in white lipstick flying on acid while her own little girl was back in Los Angeles.* Joan, who, up until that moment, has been a bit subdued, a bit checked-out, snaps to attention. "Let me tell you," she says, her face and hands suddenly animated, "it was gold."

And it *was* gold. Or, rather, it would be gold by the time she was done with it. She transmuted it into gold in *Slouching Towards Bethlehem*.

As she'd transmute Nick Dunne's tortured gayness and Tamar Hodel's botched suicide attempt into gold in *Play It as It Lays*.

As she'd transmute the Manson-gang killings and Jim Morrison's overdose into gold in *The White Album*.

As she'd transmute Dunne's heart attack into gold in *The Year of Magical Thinking*.

And, finally, as she'd transmute Quintana's unnamed affliction into gold in *Blue Nights*. (The name of Quintana's affliction was, of course, acute pancreatitis, which was really a name for alcoholism. Could Joan not name it because to name it was, at some level, to admit that Quintana suffered from it? And to admit that Quintana suffered from it was a short step from admitting that she herself suffered from it? Was a shorter step from admitting that she had, in a sense, bequeathed it to Quintana, the sins of the mother visiting the daughter, etc.?)

Joan was an alchemist. The pain of life became the gold of literature once she ran it through her typewriter.

Eve, on the other hand, was repelled by sadness, wanted nothing whatsoever to do with it. That's why she couldn't visit her father when her father was dying in the hospital, or her mother when her mother was dying in the nursing home.

* In the fall of 2022, on a Zoom call about a project related to neither Joan nor Eve, Courtney Love told me that she was the little girl in white lipstick—"Susan," the name Joan gives the little girl in the piece. When I got excited, Love amended her claim. "Well," she said, "I probably wasn't Susan, but I could've been Susan. We lived for a while in the Jefferson [Airplane] house, and kids who hung around there were dosed with acid. Put it this way—the people Susan knew, I knew. The scene Susan was on, I was on." I'd always wondered what happened to Susan. That she'd grow up to become Hole's front woman, Generation X's black widow, the girl with the most cake, doesn't, when you think about it, seem all that implausible.

A memory from Laurie:

There was a psychology quiz test that I used to like to give people. I'd ask all these questions. Like, "What's your ideal house? Where is it? Describe it." Or, "You have a coffee table in this house. What's on it?" Then I'd say, "Okay, you're walking in the woods now. You meet a bear. What do you do?" The typical responses were, "I stand very still," or, "I run away," or, "I try to make myself very tall and wave my arms in the air." Everybody answered in the normal way except Eve. She said, "There is no bear." I said, "What do you mean there is no bear? I'm telling you, there's a bear." And she said, "No, it's not a bear. It's a teddy bear. It's a stuffed bear. It's a bear in a Walt Disney cartoon." She could not deal with tragedy. She could not deal with the fucking bear.

The fucking bear would be dealing with her soon enough.

EVE'S LIFE
AFTER DEATH

Los Angeles weather is the weather of catastrophe, of apocalypse, and, just as the reliably long and bitter winters of New England determine the way life is lived there, so the violence and the unpredictability of the Santa Anas affect the entire quality of life in Los Angeles, accentuate its impermanence, its unreliability. The wind shows us how close to the edge we are.

—Joan Didion

From earliest childhood I have rejoiced over the Santa Ana winds. My sister and I used to run outside and dance under the stars on our cool front lawn and laugh manically and sing "Hitch-hike, hitch-hike, give us a ride," imagining we could be taken up into the sky on broomsticks.

—Eve Babitz

Friday, May 4, 2012.

I arrive at the restaurant straight from the airport. Short Order, it's called. It looks like the kind of place that sells hamburgers and hot dogs to beach bums and bunnies, only fancy. I'm an hour early, the first customer of the day, the hostess unlocking the door as I reach for it. I find a table at the back, sit there sipping a seltzer, my stomach a mess from nerves and travel and being six weeks pregnant, and wait for the woman who once said she believed that anybody who "lived past thirty just wasn't trying hard enough to have fun," now sixty-nine.

I don't mind waiting for another—I glance at my cell—fifty-seven minutes. After all, I've already been waiting for Eve Babitz for two years.

My obsession started in 2010. I was thirty-two, living in Kips Bay with my husband Rob, then my boyfriend Rob, in a 350-square-foot apartment subsidized by NYU, where he was a medical resident. I was a writer, though I mumbled when I told people this since I wasn't a published one. It was a weekday evening, rush hour, and I was on the subway, hanging from a pole, reading *Hollywood Animal*, the memoir of screenwriter Joe Eszterhas. At the top of a chapter, I came across a dynamite quote about sex and L.A. It was attributed to a person I'd never heard of before. Eve Babitz. (A curious thing. I can't tell you the exact quote because, evidently, it doesn't exist. Not in *Hollywood Animal*, anyway. I've searched every edition. And yet I'd swear to you that that's how I found Eve: one Hollywood animal giving me the scent of another.)

As soon as I got home, I went on Google, discovered that Eve Babitz was a writer. Went on Amazon, discovered that her books were out of print. Fortunately, secondhand copies were available. I selected the title I liked best—*Slow Days, Fast Company*—clicked on the cheapest option. It was at my door the following week. I read it fast, in a single swallow, skipping meals, hardly even taking pee breaks. When I was finished, I ordered another book, then another, then another.

Eve was good. Her writing—its innocence, its sophistication, its candor, its wit, its lack of respect and willingness to fly in the face of received wisdom, its sheer headlong, impish glee—made me dizzy with pleasure. I had to talk to her. She was the secret genius of L.A., I was convinced.

But L.A.'s secret genius was also, it seemed, L.A.'s best-kept secret. There was scarcely a trace of her online: an interview she'd given to Paul Karlstrom for the Archives of American Art in 2000 (she wasn't even the focus of the interview, the Wasser-Duchamp photo was); a blog post by cultural critic James Wolcott; and an intriguing but brief piece by Holly Brubach for *T* magazine. That was it, the works. And, needless to say, she wasn't on Facebook or MySpace or Twitter or LinkedIn.

She was, however, in the phone book. I scrawled rapturous words on the back of a postcard with Marlon Brando—a favorite of hers—on the front, dropped it in the mailbox. That didn't work. So I hand-delivered a note to the apartment on Gardner Street. (You caught that I live in New York, right?) That didn't work either.

When, a year or so later, I got a nibble, not even a nibble, a "Maybe, could be interesting," from an editor who'd never heard of Eve (Bruce Handy) at a magazine I'd never written for (*Vanity Fair*), I sent an actual letter, claiming with wild—scratch that, with reckless—optimism that she was about to be the subject of a full-length feature and asking if she'd let me take her to lunch. Nothing.

I changed tack. For several months, I stopped concentrating on Eve, concentrated instead on those close to Eve. I reached out to her sister Mirandi, her cousin Laurie. Both were wary initially, warmed eventually. And naturally I was all over Paul Ruscha, referenced in that Archives of American Art interview.

Finally, Eve got either curious or hungry or both, and sent word through Paul that she accepted my lunch invitation. Tomorrow, she said. Noon, she said. Short Order, she said. I bought my plane ticket, flew to L.A. in the morning.

Which is why I'm sitting in a neo-fifties gourmet burger joint in the Farmers Market on Third and Fairfax, my suitcase wedged between the back of my chair and the wall. I keep checking my cell. Am staring at its screen

when 11:59 changes to 12:00. My eyes begin to flick back and forth from the front door to the window overlooking the parking lot.

I've been telling myself a story. Namely, that Eve and I are *in* a story, and one so old it's almost preordained—a romance. She hasn't been rejecting my advances all this time. Rather, she's been testing my devotion, making me prove how much I care. That's the reason she's letting me catch her now: I've passed, I've proved.

And, yes, Reader—*sigh*—I realize how deluded I sound, how close to lunacy. But this is Eve Babitz we're talking about. Eve fucking Babitz. Everything she does has a wild playfulness to it, an erotic sparkle. *Slow Days* is a come-on. That's the book's structuring principle, its framing device: Eve trying to beguile a reluctant lover into turning her pages. I know, of course, that she no longer writes or sees people. This I've been told by everybody. Yet even her withdrawal strikes me as a seductive gesture, made by one who understands in a bone-deep way the nature of desire and how the moment it's fulfilled is the moment it dies.

Again, I glance at my cell to check the time. I get distracted by a text message. When I look up, I spot a woman by the door. I rise from my chair, half sit back down, rise, as I think, *It's Eve, wait, it can't be Eve, wait, it has to be Eve.* Something about her is—and I don't know how else to put this—wrong. It's the hair that tips me off: gray and cut brutally short, almost to her scalp. And then the clothes confirm my suspicions: a dark yet faded T-shirt, stained; shapeless black pants, also stained; glasses with lenses so thick and greasy that the eyes behind them are hugely magnified, distorted.

In a flash, I understand that I've misread her, misread the situation, and so egregiously that I'm disoriented. I start to move in her direction, the click-clack of my high heels on the wooden floor out of sync with my walk. As I get closer, she gives me an unfocused smile. A tooth, I see, is missing, and a line from *Slow Days*—"I also have nearly perfect teeth, which I believe is the real secret to the universe"—begins to run through my brain like a film on a loop. I flinch but I don't break stride.

Eve's first words to me: "I'm starving."

No exaggeration as it turns out. Our grass-fed burgers and russet potatoes fried in truffle oil are placed in front of us and she barely comes up for air. I remember Paul's description of her MO at parties: "She'd bypass the host or hostess and first head to the buffet table and dive into it like

Esther Williams on Dexamyl. She'd bolt if something made her uneasy, then barge back in and demand that I take her home. I'd ask her why. After all, we'd just gotten there, and she'd say, 'So we can fuck!'"

The second she cleans her plate, she pushes it away. "I'm ready to go," she says.

I blink at her. We've been together for twenty minutes. Not knowing what else to do, I signal for the check.

Before the waiter brings it, Eve lurches from the table. I'm afraid that she'll walk back to her apartment, a short distance from the Farmers Market, and that I'll never see her again. Throwing down bills, I run after her. As I follow her out the door, I ask the hostess to call a cab.

Eve talks more in it than she did in the restaurant, except I can't track her sentences: one is about a sugar substitute used only in Japan; the one after that about the queen of England's bra-maker; the one after that about the health benefits of unpasteurized milk. As I lean in to better hear, I become conscious of a smell coming off her. Not body odor—it isn't tart or tangy. Something else, something I can almost identify but can't quite. Something heavy, sweetish. I try to breathe through my mouth.

Before I know it, we're on Gardner and Romaine, a sleepy block just south of Santa Monica Boulevard. Eve's building is right on the corner. It's two stories, a little run-down, a little shabby, but still pretty because of the bougainvillea and rhododendrons surrounding it, the dusty palm tree in the front yard.

The cab hasn't rolled to a complete stop and Eve's already getting out. She's in a rush but not, thank goodness, fast. And, after paying the driver, wrestling my suitcase from the trunk, I catch up with her at the door. She opens it just enough to slip through. I can't see what's inside other than dim clutter. I can smell what's inside, though, and it's the same smell I smelled in the cab, only much, much stronger. It strikes me forcefully, physically, like a blow.

The door closes, the lock turns. There's a mini staircase in front of the building. My legs crumple underneath me, and I drop to the top step. For several minutes, I just sit there, watch the sun dancing in the polished metal of the hubcaps of the parked cars, listen to the breeze rattling through the leaves of the palm, and wait for my head to clear, my stomach to settle. I keep expecting to feel some particular way about the encounter—upset or sad or depressed or frightened. Instead, I feel a jumble of all these things.

What I also feel and what I mostly feel, though, is excitement. Eve and I *are* in a story together, just like I'd thought. Where I was mistaken is in the kind of story. It isn't a romance. Is something far more primal, far more urgent.

A Greek myth.

Of course Eve can't be found in the phone book or West Hollywood or any other location easily got to. No, she's in the underworld, Hades, a place of darkness and dankness, chill and rot. And there she's being held captive by a ferocious dog with three heads, the heads: isolation, decay, despair. (*That's* what she reeks of, what her apartment reeks of. *That's* the smell I couldn't put my finger on.) My task is to rescue her from that monster, return her to life aboveground.

And, yes, Reader, I realize I now sound even more deluded, even closer to lunacy, but I don't care. What I'm saying is real and deep and true.

<p style="text-align:center">*　　*　　*</p>

It took two years for the *Vanity Fair* piece to come out. During those two years, I insinuated myself into Eve's life, flying to L.A. every six to eight weeks to see her, take her to breakfast and lunch. (Normally I'd do two meals a day since no meal lasted longer than half an hour, and never dinner because she disliked going out at night.)

Among the vital things I learned: how to speak Eve. She often communicated in code, and that code was not easy to crack. "Is that the blue you're using?" was, obviously, one example. Another was "little rascals." ("Little rascals" were pills, usually Valium, though not always.) Another was "so-and-so likes baseball." That meant the so-and-so in question, male, was heterosexual and serious about it, macho in attitude and outlook. As in, "Oh, Fred Roos liked baseball too much to be friends with Earl." And then there was "cramp my style," a phrase I'd heard her invoke in response to the Brownies, but also higher education, deadlines, religion, cookbooks, blue jeans—anything, basically, that threatened her ability to do exactly as she pleased.

Equally vital: how much pain she was in at all times. A number of her burns had never fully healed, remained raw, open. And her body couldn't efficiently rid itself of heat since the fire destroyed most of her sweat glands. Sitting for an extended period, especially in warm weather,

was excruciating for her. (Eve didn't tell me this because Eve wouldn't. It was Mirandi who told me.)

And perhaps most vital of all: how little contact she had with the outside world. She'd quit driving years ago. Her only excursions were her twice-weekly strolls to the Farmers Market, her Sunday AA meetings, her Saturday lunches with Mirandi and Alan, Laurie or Dickie Davis occasionally joining. Her phone still rang, though not as frequently as it used to. The fire—or, rather, the effort to drum up money for the hospital bills resulting from the fire—had exhausted many of her friends. Their goodwill was tapped out. Besides, they were, in the main, artists and writers, and artists and writers tend to be politically liberal—as she herself was up until 2001—and were therefore less than keen to discuss with her the sexiness of Israeli ambassador Danny Danon's sneer, or share in her delight at the botched rollout of Obama's healthcare website.

Eve never owned a computer. And she'd gotten rid of her TV at Mirandi's insistence. ("She was going broke from the Home Shopping Network," said Mirandi. "They showed it, she bought it.") All she had was a portable radio with a massive antenna always tuned in to KEIB or KRLA, Los Angeles's conservative talk stations. "Eve started getting into conservatism sometime after 9/11 with Dennis Prager." Mirandi raised her hands, palms turned up, empty. "I don't know," she said. "Dennis is Jewish, from Brooklyn, with a voice exactly like Dad's. Then it was funny guys like Dennis Miller and Larry Elder. I think part of it was that she liked the male company."

Eve had gone from Democrat to Republican. She also, though, had gone from sane to crazy, and one of the forms the craziness took was her Republicanism. (I am not—I repeat, I am not—saying that "Republicanism" and "craziness" are synonymous. They just happen to be in Eve's case.) For instance, late in the Trump presidency, she began to believe that she and Trump were having an affair, and that she was meeting him for trysts at the very bungalow in the Beverly Hills Hotel where she met Ahmet Ertegun for trysts half a century earlier.

I loved having Eve all to myself. She wasn't just L.A.'s secret genius who was also L.A.'s best-kept secret, she was *my* secret genius who was also *my*

best-kept secret. And then I went and blabbed in the March 2014 issue—the Hollywood issue, fittingly enough—of *Vanity Fair*, and the secret was out.

Now, the secret would've come out whether I blabbed or not. Eve's genius was too clear, too shining, too true, to stay under wraps forever. And nowhere was that genius more in evidence than in her books, all seven of which were reissued after the *Vanity Fair* piece appeared. New York Review Books Classics in particular did right by her. They'd bring back her two oldest and best: *Eve's Hollywood* in 2015; *Slow Days, Fast Company* in 2016. And, in 2019, they'd bring out a brand-new collection: *I Used to Be Charming*, the title story a masterful editing job, Sara Kramer somehow turning the forty pages of false starts and disjointed fragments into a coherent and engrossing narrative with a beginning, a middle, and an end.

So, my piece didn't change things so much as goose them. Had it not been written, Eve's late-blooming chic would've bloomed a little later is all. From *Slow Days*:

> During a shaky week-long period of my life[,] I was confronted with the possibility that a book I'd written might become a best-seller . . . I did not become famous but I got near enough to smell the stench of success. It smelt like burnt cloth and rancid gardenias.

Slow Days, though, was published in 1977, when she was in her mid-thirties, and she's describing something that happened—*almost* happened—when *Eve's Hollywood* was published in 1974, and she was in her early thirties. The question becomes: was the smell any sweeter now that she was in her seventies and not just near fame but at it, in it, of it?

Since I started writing this book, I've spent a lot of time holding up my memory of that first meeting between me and Eve, looking at it from another perspective.

Hers.

Eve, I think, also believed we were in a Greek myth. Only, as she saw it, Hades wasn't a place she'd been forcibly consigned to but willingly retreated. The three-headed dog wasn't her vicious captor but her staunch protector. Isolation, decay, and despair weren't sources of torment and terror but

solace and comfort. And I—well, I wasn't a heroic figure, a savior, at all. *I* was the villain. *I* was the monster. A figure of dread and menace intent on thrusting her back into the sunlight, exposing her to its pitiless glare, restoring her to a world that had treated her with cruel indifference, and from which she'd barely escaped with her life.

"Of course Evie was scared of you," said Laurie. "You represented that whole East Coast literary world. She thought East Coast people were snotty, and that they had no right to be snotty. But she also had a lurking fear that maybe they *did* have the right, and that maybe they knew better. To get reviewed in the *New York Times* back then was really just it. And, oh God, the *Times* was horrible to her—horrible! Over and over again. That last review nearly killed her."

That last review: Michiko Kakutani on *Black Swans*. Kakutani closed her assessment—negative, naturally—with the suggestion that Eve (deep breath) "maybe take a vacation from L.A."

Maybe take a vacation from L.A.

But Kakutani's review was in keeping with the reviews Eve had received throughout her career. The Establishment critics always saw her as a ding-a-ling from Lala Land; an airhead attempting to pass for an egghead; Eve Bah-bitz, with the great big tits.

Any time Eve wrote about Marilyn Monroe, she was really writing about herself. Eve on Marilyn's overdose:

> Marilyn kept putting herself in people's hands, believed them. They let her think she was just a shitty Hollywood actress and Arthur Miller was a brilliant genius . . . No wonder she liked to sleep.

And here I was, trying to shake Eve awake.

The *Vanity Fair* piece got the ball rolling, and soon its momentum was unstoppable. It was the reprints of Eve's books, and the ecstasy those reprints inspired, that did much of it, of course. Yet Eve was touching imaginations in ways that couldn't be explained by the brilliance of her books alone. It was something about her, about Eve qua Eve, and what she stood for—free and original thinking, joy, hauteur, endurance, sex-and-drug-saturated bad

behavior redeemed through obsessive hard work—and how it contrasted with the moment we were in—po-faced, whey-faced, mealy-mouthed—a historical period defined by its earnestness and hypocrisy, by its love of hall monitors.

And young women already in style and unassailably cool were confirming and enhancing their vogue by associating with her. To wit: in 2017, *New Yorker* It girl Jia Tolentino, and *Girls* It girl Zosia Mamet, appeared alongside Stephanie Danler, writer of *Sweetbitter*, the It novel of the year before, on a panel dedicated to Eve at the New York Public Library. That same year, actress-ingénue Emma Roberts posted on Instagram a picture of herself lying on a chaise longue, lost in a mood, *Sex and Rage* open on her chest, the blood-red polish on her nails matching the blood-red lettering on the book's cover. In 2019, model-mogul Kendall Jenner was photographed on a yacht off the coast of Miami Beach in the briefest of bikinis, the reissue of *Black Swans* peeking coyly out of her tote.

I suspect, too, that once Eve's second letter to Heller starts to circulate, get known, the nature of young women's interest in her will shift. In the last few years, that interest has lain in her radiant intelligence, her nose-thumbing recklessness, her gift for life. In future years, though, I bet it rests largely on the courage of her efforts, the anguish of her defeats. She'll become a totemic figure, particularly to young women in the arts, the ones who understand from experience what she went through. And when they speak of her, it'll be in hushed tones. Just you watch.

Between 2014 and 2021, Eve went from nowhere to everywhere. It was like she'd skipped fame and fortune—bourgeois aspirations—and gone straight to legend.

To the general public, this was a happily-ever-after ending. A jewel had been fished out of the trash heap of history, and in the nick of time. She was still around to enjoy her glory. But the truth was, she wasn't still around. Since 2001, the year Huntington's began to take her over, she'd existed in a kind of posthumous state. As if she'd somehow contrived to outlive herself.

Which is perhaps why the ending was, for Eve, unhappily ever after. "It's too late," she'd mutter darkly to Mirandi as the media requests began to trickle in, then pour in. Mirandi shielded Eve from the sudden celebrity, responding to all reporters' queries over email in the guise of Eve. Mirandi

also shielded the sudden celebrity from Eve, who simply couldn't be trusted not to blow it up in some spectacular fashion. (Eve almost blew it up spectacularly anyway. In 2017, she got a friend from AA to log her onto Facebook, where she went on quite a spree. "Democrats started the KKK!" she wrote. And, "I love Rush Limbaugh!" Mirandi took down the posts as soon as she was alerted, put up a post stating that Eve's account had been hacked. She then tore into Eve, who was properly chastened, and the AA bud, who was properly terrified. And that was it for the online shenanigans.)

Really, though, and in fact, the ending for Eve was ambiguously ever after. Her new popularity and acclaim only sometimes freaked her out. Other times she thought what was happening to her was pretty okay, and maybe even funny. ("It used to be only men who liked me," she said. "Now it's only girls.") In short, those gardenias blew rancid or intoxicating depending on her mood, the weather, how delicious or not delicious her breakfast had been, the number of Zs she'd copped the night before.

One of the last scenes Eve and I played together:

January 2018. Musso's, the old show-business-crowd steakhouse on Hollywood Boulevard. It had recently been announced in the trades that Hulu was developing a comedy series based on Eve's books, and I was taking her to lunch to celebrate. Mirandi and Laurie were also there. Only, in the case of Laurie, not yet. (Traffic.) And, in the case of Mirandi, yet but not at that second. (Bathroom.) Eve and I were alone.

I was about to ask her if she was going to order the sand dabs—a dumb question, she always ordered the sand dabs—when she turned to me and said, "I guess I ought to thank you."

I didn't respond because I didn't know how to. Was she thanking me? Not quite. And I wouldn't have been able to bear it if she was. (A moist-eyed Eve, humble and full of gratitude, wasn't Eve as far as I was concerned.) The smile on her face flickered on and off—a neon sign with faulty wiring—and she was looking at me intently, something I don't believe she'd ever done before. I felt the need to speak, only I couldn't think what to say.

A frozen moment.

And then the moment passed. Laurie, collapsing theatrically in the seat beside me, wrist flung to forehead, said, "The drive here was cra*aaaaazy.*"

And, before I knew it, Mirandi was at the table, too, and an energetic discussion ensued about whether it was best to take Los Feliz or Franklin when coming to Hollywood from the Eastside at midday.

Yet, for me, the moment never passed. Maybe because it was such a charged one, and for reasons I didn't grasp at the time. I do now. It was the sole instance of Eve acknowledging, even if only obliquely, the complexity—and the complicity—of our relationship.

Eve, near the end, in a pair of sunglasses I sent her.

This relationship was nonexistent when we were actually together. Our in-person encounters were always edgy, jarring, frustrating. I loved her, as it so happened. As it also so happened, she was an absolute terror, and anyone who approached her about her work in a manner she didn't like got a brutal, if hilarious, reception. (A memory of Paul's: "A guy came up to her at a party and told her that she was his favorite writer, and she just looked at him and said, 'Beat it.'") The prospect of annoying her or pissing

her off or losing her respect filled me with dread. How could I ever even consider relaxing around her?

Second of all, there was the game of Beat the Clock that we were never not playing. I knew how quickly she was going to want to leave wherever it was we were. Which is why I overdirected our conversations, tried to rein her in if she wandered off on one of her tangents. ("Where can I find a blouse the same shade of blue as Melania Trump's eyes?") And I'm sure my wound-up intensity was unnerving for her, that habit I couldn't seem to break of looking at her too hard, of lunging at every remark as soon as it dropped from her lips.

This relationship did exist, however, when we were apart. It was conducted entirely over the phone, and was entirely private—just the two of us on the line.

It began on May 5, 2012, the day after the disastrous Short Order outing. I remember the grudgingness with which I reached for my cell that morning. Our lunch couldn't have gone worse. I'd blown it with her, totally and completely. The situation was hopeless. Yet I knew that I had to do the responsible thing, the adult thing, the *right* thing, and finish what I'd started, thank her for meeting me. Oh, but I didn't want to! (Forcing myself on her *again*?) In any case, I was certain she wouldn't pick up.

But, to my astonishment, she did. To my greater astonishment, she sounded pleased that it was me on the other end of the phone. Our exchange was brief. She brought it to a close by saying, "And next time, I want you to take me for barbecue." *Next time.* The relief I felt at hearing those two words was so intense it made my vision blur. As I said a goodbye she didn't catch (she'd already hung up), my heart lifted, lifted, lifted.

I was in.

From then on, Eve took my calls, and I made them, twice a week, minimum, for years. "*Oui, oui?*" she'd say, by way of greeting. I'd tell her who it was. "Lili!" she'd say, the exclamation point audible in her voice, which—and I thought this every time I heard it, the same thought, without fail—was so charming, unusually charming. It was girlish and lilting, its enunciation softly crisp, laughter bubbling up in it like fizz in a bottle of champagne. Yet it was drowsy, too, as if the phone's ringing had wrested

her from a post-sex-romp slumber. And this was what I began to picture: Eve, but not Eve now; Eve then, *Eve's Hollywood*–era Eve, sitting up in bed, tousle-haired and mascara-smeared, a sheet wrapped around her torso, the receiver cradled between her jaw and shoulder, a man beside her, only his back visible, trying to hold on to sleep.

What we mostly talked about was the past. The things she said were invariably sharp and amusing. On the style of Edie Sedgwick: "She used to buy her clothes in the boys' section." On the sexual capacity of Harrison Ford: "The thing about Harrison was Harrison could fuck, nine people a day." On the non-presence of Warren Beatty: "I met him about eight million times but I never recognized him. He's one of those people who doesn't show up for me."

She was great on the present, as well, if you were willing to wait out the political rants. On reading *Life*, Keith Richards's autobiography: "The reason Keith doesn't die is because he doesn't mix his drugs." On Justin Bieber's third album: "So good, and he could get by on sheer cuteness if he wanted to." On her skin after the fire: "I'm a mermaid now, half my body."

It was the last line that knocked me out the most. I loved it not only because it showed how tough she was, how unbowed, what a sport and a champ and a trouper, but because of its sneaky eroticism. She was comparing her burned epidermis, a painful and grisly condition, to the scales on the tail of a mermaid, the femme fatale of the sea. The image is horrifying and titillating at once. As grotesque as it is sexy.

On the phone, she talked like she looked in that photo (Leibovitz's for *Eve's Hollywood*). On the phone, she talked like she wrote in that book (*Slow Days, Fast Company*). On the phone, she was what Laurie said she couldn't be anymore: she was Eve Babitz.

Eve's first successful artistic act was, of course, posing for Julian Wasser— naked, hair covering her face like a veil, trying to checkmate Marcel Duchamp. When the boxes were found, and I saw what was inside them, began to consider retelling her story, it was to the Wasser-Duchamp photograph that my mind kept returning. That photo told a psychological truth about her, I was sure. Expressed succinctly and eloquently her contradictory

attitude toward fame: she wanted to be the person all eyes turned to while simultaneously staying out of sight; to be the center of attention yet offstage; to be a star who was also an unknown.

I was wrong earlier when I said that the secret of Eve would've come out whether I blabbed or not. Or, rather, I was right and wrong. Right since Eve is a literary heroine because of what she wrote, and some well-positioned somebody, at some point, would've stumbled across her books, twigged to how good the best of them are, started shouting, and she'd have assumed her proper place in the pantheon. Wrong since Eve is a cultural heroine because of who she was, something only she could explain to us. And, in 2012, she was already so close to gaga.

I was wrong, too, when I said that Huntington's + Mae going into assisted living was Eve's last turning point. It was, in fact, Eve's second-to-last turning point. The last was, as you've probably guessed, Reader, the *Vanity Fair* piece. It set things in motion for Eve by laying out, in an orderly fashion, her disorderly life. Let people take in the scope of it, the scale, its grandeur and folly, glamour and grime, beauty and horror. And Eve was the one doing the laying, giving me—giving *us*—the lowdown on all of it.

At seventy, she was finally ready to push back the veil of her hair and show her face to the world.

Eve's move from culturally marginal to culturally central was so rapid that my brain never quite caught up, was always lagging slightly behind. I can still remember the shock when, in the summer of 2021, I spotted, on the plywood wall of a construction site on the corner of Canal and Hudson, a poster. It depicted a beautiful female face, the mouth gargantuan and wide open, a miniature copy of *Sex and Rage* being dropped in. Beside the image were the words "Feed your mind." This poster, so blatant, so mysterious, seemed to be speaking directly to me, and I wondered for a second if it was a message from Eve, marooned in the old-age home in Westwood, no phone in her room—a cross-country, telepathic prod: *Call me.* (It wasn't. It was an ad for Folio Bookshop.)

Can remember, too, the shock when, the year before, in the summer of 2020, I heard writer-editor Gerry Howard, as he introduced me at a reading for *Hollywood's Eve* in Tuxedo Park, describe Eve as "one of

late-twentieth-century L.A.'s greatest living chroniclers, starting to eclipse even the mighty Joan Didion." It was his casual tone, like what he was saying wasn't especially daring or controversial, that floored me most.

His words proved that the competition between Joan and Eve wasn't over as it appeared to be in 1979, when Joan came out with *The White Album*; Eve with *Sex and Rage*. Or in 2000, when Joan was invited on *In Depth* for a career retrospective; Eve called in to *In Depth* for no reason at all really, just to say hi. Or even in 2005 and 2011, when Joan published *The Year of Magical Thinking* and *Blue Nights* respectively (the grief memoirs were, I think, her sensing the world's eagerness to sentimentalize her, accommodating that wish), and in 2015, when Joan modeled for the French luxury brand Céline (the high-fashion foray was, I think, her sensing the world's eagerness to glamorize her, accommodating that wish); and Eve barely left the one-bedroom apartment that smelled like pee-you, that smelled like shit, that smelled like insanity.

Joan, a Céline cover girl at eighty.
(*Joan Didion, Céline Campaign SS 2015, New York 2014* © Juergen Teller)

No, the competition was ongoing, the stakes of the competition not just raised but changed. For years it seemed as though Eve had been left behind by Joan. Now it seemed as though Eve had, perhaps, been waiting in front for Joan the whole time.

And, anyway, what if the competition wasn't a competition at all? What if the competition was actually a cooperation, Joan and Eve writing L.A. together? Yes, their sensibilities were polarized, their styles clashing. Their intentions, though, were identical: to make literature that exploited what was novel and exposed what was familiar in a city, a society, and an epoch under convulsive pressure.

Slow Days, Fast Company is, in my opinion, as necessary to *The White Album* as *The White Album* is necessary to *Slow Days, Fast Company*. To read just one of the books is to get just half of the story. I wouldn't go so far as to say that *The White Album* without *Slow Days* is the sun without the moon, but close. Or maybe I would go so far. Maybe I'd also go so far as to say that Joan Didion without Eve Babitz is the sun without the moon.

Joan and Eve are the two halves of American womanhood, representing forces that are, on the surface, in conflict yet secretly aligned—the superego and the id, Thanatos and Eros, yang and yin. (That's why it was so stupid of me to pick a side, declare myself proudly "for" Eve, as though both sides weren't equally essential, equally valid, equally compelling. That's why it was even stupider of me to pretend that a side stayed picked, as though I didn't sometimes stray from Eve's side to Joan's when no one was looking.)

Eve, by the way, *did* go so far as to say it. Said it in her dedication in *Eve's Hollywood*: "And to the Didion-Dunnes for having to be who I'm not," a definition of Joan that is a definition of herself as the un-Joan; a definition that gets to the heart of their circularity and interchangeability; a definition that tells you nothing while telling you all there is to tell. Joan didn't go so far as to say it, but that doesn't mean she didn't go so far as to think it. And though she never dedicated a book to Eve, if she had, that dedication surely would've said, "And to Eve Babitz for having to be who I'm not."

Even the universe said it.

Said it in ways trivial. The cover of the 2011 British edition of *Play It as It Lays* features—perversely, poetically—not Joan but Eve, an outtake from

the Wasser-Duchamp session. (A perfect example of what Andy Warhol called, "[getting] it exactly wrong.")

Said it in ways profound. On December 17, 2021, Eve died of complications from Huntington's. Six days later, on December 23, 2021, Joan died of complications from Parkinson's.

How each handled death is almost as revealing as how each handled life:

Since I'd known Eve, she'd been slowly declining. Then, in that last week, a sudden rush to oblivion.

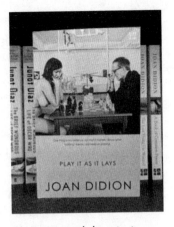

The Brits get it right by getting it wrong.

Her memorial was held as soon as the holidays would permit, shortly after the first of the year, at the Hollywood Forever Cemetery, the final resting place of the Sheik, Rudolph Valentino, and outdoors as the Omicron variant of Covid was surging. Attendance wasn't what it might have been because of the virus, and because it all came together so last-minute, the invitations issued by phone and haphazardly, no list prepared, just whoever happened to jump to mind in the moment. The people who showed up, though, were a game lot. And the *Los Angeles Times* sent a reporter, which made the occasion the exact right amount of official. And it was a good time, weird as that sounds—buoyant. Maybe because Eve's death wasn't premature, was overdue, and therefore a relief. (She was in such bad shape by the end.) Plus, most of those who spoke were professional performers or AA veterans or both, and the stories they told were dirty, nasty, rude, and fun to listen to.

The standout for me was Ronee Blakley, who didn't tell a story, who read a poem, an original composition titled "Eve":

> Oh, Eve, you were hot, you were cool.
> You had the biggest breasts in school.
> You wrote by early day and partied all night.
> How did you ever sleep enough to feel alright?
> [. . .]
> A prose poet in everyday talk,
> You gave it your all as you walked the walk.

You lived like a man, independent and free,
Becoming whoever you wanted to be,
Unimprisoned by femininity.
[. . .]
You documented us in the acts of our age,
In *Eve's Hollywood* and *Sex and Rage*.
None of that phony expected stuff,
Only cold hard news disguised as fluff.
[. . .]
You were fun and smart,
Lovers had to take heart,
For which among them could equal your art?

Joan's memorial was held at the Episcopal Cathedral Church of St. John the Divine, and nine months after her death, on the first day of fall, September 21, 2022, the decision made to stare Covid down, wait Covid out, give Covid not a single inch, as she doubtless would have wanted. Her publisher, Knopf, threw it. (*Threw*, past tense of *throw*, is a party verb and thus an odd verb to use in the context of a memorial, only it's the proper verb to use in the context of this memorial since a party, smooth and elegant if a little dour, is precisely what this memorial was.)

It was covered widely, though most deeply by the *New York Times*. And the title of the *Times*' article, "A Star-Studded Goodbye to All That," best captures its spirit. Packing the pews, celebrity writers: Carl Bernstein (fun fact: Jacob Bernstein, Carl Bernstein's son with another celebrity writer, Nora Ephron, wrote the *Times* article), Fran Lebowitz, Donna Tartt. Celebrity photographers: Brigitte Lacombe, Annie Leibovitz. Celebrity celebrities: Anjelica Huston, Greta Gerwig, Charlie Rose, Liam Neeson, the widower of Natasha Richardson, who'd married her first husband at Joan and Dunne's apartment back in 1990. Speakers included: Natasha Richardson's mother, Vanessa Redgrave, who'd played Joan in David Hare's production of *The Year of Magical Thinking*; *New Yorker* editor David Remnick; writers Susanna Moore, Calvin Trillin, Hilton Als, Jia Tolentino; the longest-serving governor in California history, Jerry Brown; and former Supreme Court justice Anthony Kennedy. Patti Smith, who'd also performed at Quintana's funeral, closed by singing a Bob Dylan ballad, "Chimes of Freedom."

As I scanned the names of the attendees and participants, I thought of a story Griffin had told me. He was a teenager, wandering through one of Joan and Dunne's parties. He ran into Earl McGrath. Happy to see a familiar face, eager to see another, he asked Earl if Earl knew where Dunne was. "And Earl said to me, 'Look for the most famous person in the room, and there you'll find your uncle, following the famous person around like a drooling puppy.'" Were Dunne still alive and at Joan's memorial, he'd have split himself in two, then in four, then in pieces trying to follow multiple famous people at the same time, drool leaking from every pore.

Death, as it happened, suited Joan. She was so good at it. Her memorial was the hottest ticket in town, proof that nobody can keep it up forever, except her. (If *Slouching Towards Bethlehem* and *Play It as It Lays* made her a literary celebrity, if *The White Album* made her a cultural institution, if *The Year of Magical Thinking* made her a secular holy woman, then the memorial made her a fame supernova: she was now someone who turned stars into fans.) To have been invited was a sign of status. Merely to acknowledge her passing was a sign of status. There were posts on social media from actress-producer Reese Witherspoon—"Thank you #JoanDidion"—and singer-songwriter Phoebe Bridgers—"RIP Joan," followed by an extended quote from "Goodbye to All That"—and California governor Gavin Newsom—"California belonged to Joan Didion; we cherish her memory"—and Smiths guitarist Johnny Marr—"a singular genius and inspiration"—and Wonder Woman Lynda Carter—"We will miss you, Joan Didion"—and pop sensation Harry Styles—a photo of Joan with an emoji heart at the bottom. It's impossible to imagine the demise of any other writer commanding such a prolonged and public outpouring of emotion. You might almost be fooled into thinking that the world cared about books or the people who made them.

On the day Joan's obituary appeared in the *New York Times*, journalist and podcaster Maris Kreizman took to Twitter. "I want to believe that Joan Didion lived an extra week out of spite so that she could officially outlive Eve Babitz," she wrote in a tweet that went viral. Reading it, I laughed. It was a funny line, but not, in my view, an accurate assessment. Joan wasn't trying to one-up Eve. Joan was, if anything, trying to join Eve.

As I see it, Eve, with her string of storied lovers, and Joan, with her storied marriage, were both alone. I don't mean alone at the end. I mean

alone always, alone fundamentally. At their cores, these women were solitary, private, implacable, independent in thought and action, near ascetic in habit, almost fanatical in toughness, with spirits indomitable and inviolable. Virgins—or spinsters—in the deepest sense. Brides of Art. No man truly touched either. And each was the closest the other had to a secret twin or sharer.

To a soul mate.

Acknowledgments

"Without you, I'd be nothing." That's how Eve used to inscribe her books—to anyone, to everyone. Here is a list of people without whom I—certainly my book—would be nothing:

Mirandi Babitz and Laurie Pepper. Your generosity with time, with energy, with insight, I can never repay.

Noel Parmentel, Vivian Sorvall, Griffin Dunne, Susanna Moore, Dan Wakefield (R.I.P., Dan), Bob Weidner—I'm in serious debt to you all, as well. Likewise to Ronee Blakley (and, Ronee, your wonderful poem!), Ron Cooper, Anne Marshall, Michelle Phillips, Peter Pilafian, Paul Ruscha, and Julian Wasser (R.I.P., Julian).

For conversation, critique, encouragement, and the like: Chelsea Hodson, Josh Klinghoffer, Mike McNeil, Karah Preiss, Gustavo Turner, and Valerie Van Galder. For even more conversation, critique, encouragement, and the like: David Lipsky.

For tracking down photo credits: Will Coates, who can find anything.

I'd like to thank, at my agency, CAA, Jennifer Joel. Also, Hrishi Desai. At Eve's agency, Trident Media Group, Erica Silverman. (Erica, you're a good sport. I know I've been driving you up a wall for going on ten years now.)

ACKNOWLEDGMENTS

At Scribner, my editor Colin Harrison (you were expecting a different book entirely, Colin, yet you rolled with it), and my associate editor, Emily Polson. Plus: Nan Graham, Stu Smith, Katherine Monaghan, Victor Hendrickson, Dan Cuddy, Hilda Koparanian, Kyle Kabel, Jaya Miceli, Sydney Newman, Annie Craig, Rafael Taveras, Brian Belfiglio, Colleen Nuccio, Brianna Yamashita, Maria Tahim, and Aja Pollock.

At *Vanity Fair*, Claire Howorth and Radhika Jones.

At *Air Mail*, Jensen Davis, Julia Vitale, Alessandra Stanley, and Graydon Carter.

At NYRB Classics, Sara Kramer.

At the Huntington Library, Art Museum, and Botanical Gardens, Karla Nielsen and Sarah Francis.

Thank you to my father, Bill. To my mother, Margie. To my brother, John. To my brother-in-law, David.

And to my husband, Rob. Oh, Robbie, you put up with a lot.

Notes on Sources

I conducted one hundred–plus interviews with Eve Babitz between the years 2012 and 2021. Some of these interviews were in person; some over the phone. Some were formal and scheduled in advance; some casual and off-the-cuff. Some lasted several hours; some lasted as long as it took for her to bark a "yes" or "no" into the receiver before hanging up without so much as a goodbye. I conducted at least as many interviews with Mirandi Babitz and Laurie Pepper. (Both Mirandi and Laurie always said goodbye and never hung up on me, not once.)

I also conducted interviews with Peter Alexander, Colman Andrews, Don Bachardy, Billy Al Bengston, Larry Bell, Ron Bernstein, Tony Bill, Léon Bing, Ronee Blakley, Nan Blitman, Chris Blum, Irving Blum, Peter Bogdanovich, Henry Bromell, Lois Chiles, Ron Cooper, Mart Crowley (by proxy, thank you, James Grissom), Dickie Davis, John Densmore, Laddie John Dill, Ned Doheny, Griffin Dunne, Frederick Eberstadt, Michael Elias, Bret Easton Ellis, Joni Evans, Paul Fortune, David Freeman, Allison Gottlieb, Robert Gottlieb, Josh Greenfeld, Mick Haggerty, Judy Henske, Buck Henry, Dave Hickey, Victoria Leacock Hoffman, Sarah Kernochan, Margot Kidder, Michael Kovacevich, Aninha Esperanza Livingston, Courtney Love (the Courtney Love one was inadvertent), Gerard Malanga, Anne Marshall, Steve Martin, Kristine McKenna, Deanne Mencher, Ralph Metzner, Joshua John Miller, Jean Moore, Susanna Moore, Paul Morrissey, Ed Moses, Bob Neuwirth, Tom Nolan, Noel Parmentel, Jon Peters, Michael

Phillips, Michelle Phillips, Peter Pilafian, Maurice Read, Peter Richardson, Fred Roos, Ed Ruscha, Paul Ruscha, Jennifer Salt, Paul Schrader, Charlie Sheen, Erica Spellman-Silverman, J. D. Souther, David Thomson, Caroline Thompson, Bill Tonelli, Susan Traylor, John Van Hamersveld, Joyce Wadler, Dan Wakefield, Julian Wasser, Carrie White, and Lloyd Ziff.

Valuable to me were the Alice Adams papers at the Harry Ransom Center at the University of Texas in Austin; the Mary Bancroft papers at the Schlesinger Library at the Radcliffe Institute; the Joan Didion papers at the Bancroft Library at the University of California at Berkeley; the Dominick Dunne papers at the Dolph Briscoe Center for American History at the University of Texas in Austin; the Seymour Lawrence Papers at the Archives and Special Collections at the University of Mississippi; the Pauline Kael papers at the Lilly Library at Indiana University Bloomington; the Grover Lewis papers at the Wittliff Collections at Texas State University; the Camilla and Earl McGrath papers at the Manuscripts and Archives Division at the New York Public Library; the Brian Moore papers at the Harry Ransom Center at the University of Texas in Austin; the Sam Peckinpah papers at the Margaret Herrick Library; the Jean Stein papers at the Manuscripts and Archives Division at the New York Public Library; the Dan Wakefield papers at the Lilly Library at Indiana University Bloomington; the Tom Wolfe papers at the Manuscripts and Archives Division at the New York Public Library.

Invaluable to me were the Eve Babitz papers at the Huntington Library, Art Museum, and Botanical Gardens.